D0932552

ANTONIO CANOVA

AND THE POLITICS OF PATRONAGE

IN REVOLUTIONARY AND

NAPOLEONIC EUROPE

THE PUBLISHER GRATEFULLY ACKNOWLEDGES

THE CONTRIBUTION OF THE SAMUEL H. KRESS FOUNDATION

IN SUPPORT OF THIS BOOK.

ANTONIO CANOVA

AND THE POLITICS OF PATRONAGE

IN REVOLUTIONARY AND

NAPOLEONIC EUROPE

CHRISTOPHER M. S. JOHNS

UNIVERSITY OF CALIFORNIA PRESS

BERKELEY LOS ANGELES LONDON

University of California Press
Berkeley and Los Angeles, California

University of California Press, Ltd.
London, England

Library of Congress Cataloging-in-Publication Data

Johns, Christopher M. S.
 Antonio Canova and the politics of patronage in
revolutionary and Napoleonic Europe / Christopher
M. S. Johns.
 p. cm.
 Includes bibliographical references and index.
 ISBN 0-520-21201-0 (cloth : alk. paper)
 1. Canova, Antonio, 1757–1822—Criticism and
interpretation. 2. Art patronage—Europe—History—
18th century. 3. Art patronage—Europe—History—
19th century. 4. Neoclassicism (Art)—Europe. I. Title.
NB623.C2J64 1998
709'.2—dc21 97-43755

Printed in the United States of America
9 8 7 6 5 4 3 2 1

The paper used in this publication meets the minimum
requirements of American National Standard for Information
Sciences—Permanence of Paper for Printed Library Materials,
ANSI Z39.48-1984.

FOR FRED LICHT

WITH GRATITUDE AND AFFECTION

CONTENTS

ACKNOWLEDGMENTS

My interest in the art of Antonio Canova began when I was an undergraduate at Florida State University's study center in Florence. In that great city of Renaissance splendor I often contemplated the neoclassical restraint of the Alfieri monument in Santa Croce and the Venus Italica in the Palazzo Pitti. In doing so I was greatly encouraged by Fred Licht and Patricia Rose, to whom I owe an enormous debt of personal and professional gratitude. While occupied by other projects as a graduate student and assistant professor, I planned to return to the study of Canova, which I did in 1989. Since then, I have incurred numerous debts of gratitude to institutions and individuals that I am pleased to acknowledge.

For financial support at various stages of research and writing I thank Dean Raymond Nelson of the University of Virginia, who granted me leave at a very opportune time and who generously defrayed much of the expense of the photographs. I also thank the Fellowship of Downing College, University of Cambridge, for the Thomas Jefferson Visiting Fellowship, which I held in 1996, when much of the writing was completed in a highly intellectual and sympathetic setting. In particular I would like to thank the Bursar, David Blackadder, for his interest in my work. Peter Gray, Jonathan Hall, Martin Maiden, and Paul Millet also shared their expertise and helped to make my time at Cambridge memorable. I would also like to express my gratitude to the University of Memphis, where I was the Hohenberg professor of art history in 1997–98, for financial and technical support. I am especially grateful to my colleague Melinda Parsons at the University of Memphis for several informative discussions of Canova and early-nineteenth-century art.

Assistance from several Italian institutions has also been vital in the completion of this book, and I would like to acknowledge the Bibliotheca Hertziana, the Accademia di San Luca, the Biblioteca Apostolica Vaticana, and the American Academy in Rome for all their efforts on my behalf. I also appreciate the help of the Museo Correr in Venice, the Gipsoteca Canoviana in Possagno, the Biblioteca e Museo Civico in Bassano del Grappa, and the Museo di Sant'Agostino in Genoa for providing photographs of works of art and photocopies of documents. Without their help, my work would have been much more difficult.

Friends and colleagues have also been exceptionally generous with their knowledge, time, and emotional support, and I would like to thank Constanze Witt, Leslie Rahuba, Jeffrey L. Collins, Jane Gladstone, Nancy Halperin, Cherry Owen, Mary Lee Eggart, Eleanor Owen Kerr, Patrick Kerr, Glenn Tucker, Lauren C. Tucker, Patricia Mainardi, Elizabeth Meyer, Malcolm Baker, Marjorie Trusted, Francis Haskell, Jon Edward Lendon, Robert

Geraci, Paula Warrick, Elizabeth J. Moodey, Edgar Peters Bowron, Rosemary Smith, Karin Wolfe, Franklin Kelly, Admiral Lorenzo Sferra, Giandomenico Romanelli, and Giancarlo Ferri. For enlightening discussions of many intellectual issues I thank my colleagues in the American Society for Eighteenth-Century Studies, especially Barbara Stafford, Mary D. Sheriff, Dorothy Johnson, Vivian Cameron, Paula Radisich, Julie Plax, and Carl Wuellner.

The continuing moral support of Elizabeth C. Owen, Richard B. Wright, and my colleague Paul Barolsky has sustained me in ways that they will never know.

My parents, as always, have been my constant source of help.

This book has been greatly improved by the suggestions of the anonymous readers' reports and by the intelligent and sensitive editing of the Fine Arts Editor of the University of California Press, Stephanie Fay. My graduate students Andrew Graciano, Tara Zanardi, Sara Durr, and Michael Anderson have come through for me on many occasions, and I am deeply appreciative of their help. But my greatest debt of gratitude is to Fred Licht, who introduced me to Canova and to neoclassicism over two decades ago and who still inspires me as a scholar, teacher, and friend.

ILLUSTRATIONS

―――――――――――

INTRODUCTION

THE TRADITIONAL RELATIONSHIP BETWEEN ARTISTS AND PATRONS changed profoundly with the Revolution, the collapse of the ancien régime, continental wars, and the emergence of a class of rulers relatively unfamiliar with the iconographies, visual metaphors, allegories, and general subtleties of the fine arts. This change dramatically redefined the function of art in a political context. Before the end of the eighteenth century, works of art, above all public monuments, could unabashedly proclaim the power and splendor of those who commissioned them. But often the political message of such images, encoded in a complex system of mythological, historical, and literary referents, could be deciphered only by an elite, educated, cosmopolitan audience more or less engaged in preserving the status quo.

Eighteenth-century reforms and radical revolution, however, severely undermined existing assumptions about art. The new elites in the vastly expanded audience for art believed even more firmly than their predecessors that works of art could influence public opinion, promote specific political points of view, and "improve" society. Because the subtleties of the past were suspect, many artists turned deliberately to politically engaged symbols and narratives easy to recognize and interpret. The advantages of this approach are obvious, since art in the service of the state is almost always handsomely recompensed. But what about engaged art in a protean, volatile political climate like that of the revolutionary and Napoleonic period? Here was the danger. The intense labor required for politicized art, especially monumental sculpture and architecture but also such paintings as Jacques-Louis David's *Oath of the Tennis Court* (figure 1), simply could not keep pace with rapid political change. Even in the relatively more stable world of the Napoleonic hegemony from 1800 to 1814, less drastic alterations in the political status quo could have a highly negative impact on artistic practice.

The older notions of metaphor, historical association, and nuance as means of promoting contemporary political leaders or ideologies ran the risk of ancien régime taint or indecipherability, but the artists who employed them in their work were usually safer from radical upheaval than their more engagé counterparts. Dependence on such notions enabled Antonio Canova to pursue a remarkably productive career as a sculptor who could work simultaneously for patrons who were avowed enemies. By using mythological themes, avoiding portraiture whenever possible, and concentrating on funerary images, the artist ensured that he, rather than the patron, controlled the formal and interpretive aspects of art. With a professional practice that began in culturally progressive papal Rome and ended in the politically precarious world of the Restoration, Canova proved remarkably adroit in avoiding

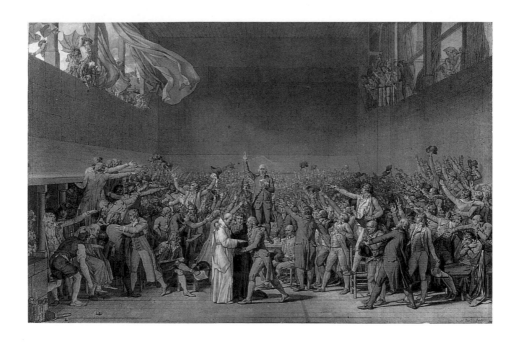

FIGURE 1
Jacques-Louis David, *Oath of the
Tennis Court,* oil on canvas, 1791.
Versailles, Musée National
du Château.

direct political or ideological engagement in his sculpture, a phenomenon even more notable
when one considers his high public visibility as Europe's most celebrated artist, whose chisel
and political loyalties many wished to control for their own purposes. In working for many
he frustrated more than a few, and his insistence on the aesthetic integrity, as opposed to the
political engagement, of his art was a conspicuously successful strategy for an artist who
loathed courts and the subordination of art to politics.

Canova's resistance to politicizing his art in the highly unstable environment of revolu-
tionary and Napoleonic Europe has led many scholars to conclude that he was apolitical,
cynical, or both. Still others, focusing on a single sculpture or a carefully selected group of
works, have argued variously that the artist was a Jacobin agnostic, a moderate or liberal
Bonapartist, a hidebound reactionary, a pre-Risorgimento Italian nationalist, and many
other equally unlikely things. This study attempts to define Canova's personal politics in a
systematic and nuanced manner, examining important works for a variety of patrons of
widely different political points of view. I believe that the evidence of both the artist's life—
sculptures, letters, and biographies—and the range of his European patronage help to re-
construct a political orientation that is complex and highly personal. Although he held de-

cidedly strong opinions about many of the issues of the day, which the following chapters describe, Canova was no ideologue. He hated wars and social revolution because they destroyed both existing art and the normal societal relationships that promote the training of young artists and the production of works of art. In this he was conservative.

The current connotations of such political labels as liberal, moderate, conservative, progressive, reactionary, and so forth, often have only a tangential relation to the meanings of those words during the revolutionary and Napoleonic period. I have tried to understand these terms in their historical context. Modern assumptions about the politics of individuals and institutions in the past are similarly problematic. For example, whereas modern Western observers might characterize the papacy as deeply conservative, even reactionary, most contemporaries considered Pius VI and especially Pius VII moderately liberal or, as I would prefer to say, progressive. Similarly, whereas most of us today would call Napoleon's empire a "fascist" dictatorship—because this totalitarian, militarist state ruthlessly suppressed conquered peoples, gave rise to chauvinistic patriotism, and reinvented hereditary aristocracy in France— most conservative early-nineteenth-century critics considered it little different from left-wing Jacobinism, almost the opposite of what we might consider reactionary conservatism. In sum, politics then differed vastly from politics now. My attempt to understand the "then," while colored by the "now," is based on a careful reconstruction of the context in which Canova lived and worked, a recognition of its complexity, and a weighing of highly particular events and attitudes against more general tendencies; every case, in short, is different.

I freely confess that my own beliefs and political opinions enter into my narrative. How could it be otherwise? Like Canova and many others, I believe that the French occupation of Italy and the spoliation of much of its cultural heritage were immoral, and that the decontextualization of art for whatever reason is, at best, problematic. In reading thousands of letters by the sculptor, his friends, and his patrons, I found it difficult not to sympathize with their dismay and vexation at the humiliation of Italy by the French. I have also found it difficult to see what, if any, good the French episode in Italy accomplished, beyond the predictable and traditional answer that it prepared the peninsula for the Risorgimento and eventual political unification. Given the shaky state of the Italian nation and the still yawning gulf between northern and southern Italy, one may ask whether it was worth it.

Antonio Canova was the subject of a truly remarkable number of biographies during his lifetime, and others appeared with some frequency for at least 150 years after his death. More recently, a number of rigorous and well-researched books, articles, and exhibition catalogues have done much to bring Canova back into the mainstream of European art history of the late eighteenth and early nineteenth centuries, although this phenomenon has had a greater impact in Italy than elsewhere. But none of the works published presents a sustained study of the sculptor's career in relation to his patrons and contemporary politics, an approach that has dominated the study of French art during the same era. This book attempts to fill this gap in our understanding of an artist whose work is crucial for evaluating the European, and not just the French, conjunction of art and politics during the revolutionary and Napoleonic period.

One of the reasons Canova's politics have attracted less scholarly attention from art historians than those of, say, Jacques-Louis David is that the Venetian sculptor scrupulously avoided any court post and refused to work exclusively for one set of politically cohesive patrons. Moreover, unlike David's paintings, Canova's statutes have never entered the canon of the teaching of art and politics, for their ambiguous themes make them a bit slippery to interpret in a Francocentric discourse that demands discernible political commitment. But if we see cultural politics as an uneven power struggle between an artist and a patron to control the meaning of a work of art, Canova's contribution to our modern understanding of the inextricable link between art and politics, between meaning and interpretation, and between thought and action comes into greater focus.

A consideration of the political forces that helped to shape Canova personally and that structured the relations of people and institutions in his society demands an interdisciplinary approach, one that has sometimes proved problematic for me as an art historian. I have generally relied on the historical sources I have used more for their chronicling of events than for their interpretations, and, whenever possible, I have drawn my conclusions from primary materials rather than secondary sources. This approach seems especially important because of the sharp divide between almost all French scholarship and most of the rest in assessing the French presence in Italy, the pivot around which Canova's political world turned. The seemingly scientific and "objective" practice of art restoration may serve as a case in point. Dominique-Vivant Denon's "Discours sur les monuments d'antiquité arrivés d'Italie," read at the Institut de France in 1804, began with a declaration that all the objects transported from Italy had arrived in France without a single mischance or any damage whatsoever. Denon added that victory in war had exacted these cultural trophies as the price of peace and that France had been chosen to oversee their restoration and conservation.[1] The contradiction— that works arriving in perfect condition needed extensive restoration—seems to have gone unnoticed at the time, although some of the works perhaps needed work before they left Italy. This bit of bombast simply repeated an idea promoted assiduously by revolutionary and later Bonapartist France, that trophies of conquest rather than territorial expansion alone constitute the glory of war's guerdon.

The politicization of the rhetoric surrounding art restoration was motivated largely by the propagandistic need to justify culturally despoiling defeated enemies, a practice decried in Europe for generations. The French government circulated the slander that the works of art were in a "ruinous" condition, "neglected," even contaminated by "monkish smoke" in their countries of origin, and only the free air (and conservation laboratories) of France could ensure their survival. The French claimed that "certain paintings" would soon have deteriorated beyond restoration if left in their original settings and that the charge of cultural vandalism that an outraged Europe leveled against France was misdirected.[2] The propagandistic statement that accompanied the report on the cleaning of Raphael's *Madonna of Foligno* (figure 2), that the altarpiece had arrived from Umbria "in a pitiable state," is typical. After describing the process of "conservation," the report concludes,

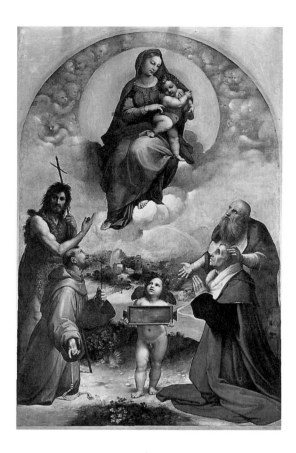

> If a protective power had not charged itself with several monuments from ingenious Italy, the name of Raphael would soon have been no more meaningful, even in his homeland, than that of Apelles. The arts must therefore be grateful to the genius of victory that has gathered these dispersed and neglected monuments, brought them together at the heart of her republic, entrusted them to an enlightened, vigilant administration, and presented them, as in a vast sanctuary, to the admiration of Europe.[3]

Who knows the true condition of the painting when it arrived in Paris? That it was given over to the Louvre restorers is clear, but my argument here is that the French had too much at stake not to control vigorously the information offered in a seemingly scientific and objective format: the report is a deeply dubious document.

French claims about the neglect and abuse of works of art by their former proprietors should be seen as part of the cultural propaganda surrounding the entire issue of spoliation. Conversely, when the works of art in the Louvre were restored to their former proprietors in 1815, these individuals lamented their ruined surfaces, the removal of original paint, and

other restoration "atrocities" committed against them in Paris. According to Antonio D'Este, Canova advised Cardinal Ercole Consalvi to prepare himself for "le rovine in somma di ogni specie" (in short, severe damage of all kinds) in the papal pictures and suggested that Vincenzo Camuccini and Gaspare Landi, prominent Roman painters, be consulted about repairing the damaged pictures after their restoration in France.[4] Even David had complained about the heavy-handed techniques of the Louvre restorers, and Henry Fuseli was outraged by the "sacrilegious hands of the restorers" at the Louvre who, he alleged, had badly damaged Raphael's *Transfiguration* (figure 3). It is true that the French employed conservation and restoration measures different from those used elsewhere, but the vituperative and self-congratulatory rhetoric on both sides of the issue smacks of mere cultural propaganda.[5] The warmth of the Italian reaction did much to counteract the initial French charges that the works were shamefully neglected while in Italy, and of course the Italians claimed that much damage had been done to the pictures by their removal from Italy, French claims to the contrary notwithstanding. In truth, damage must have been done on both legs of the regrettable journey.

In exposing what I believe to be the partisan biases of the historical source materials that form the basis of my argument, I doubtless reveal many of my own, some acknowledged, others unsuspected. Examining a compromised argument, however, is one way of understanding it anew. I deliberately limit myself to discussing monuments commissioned by a few individuals from a single artist, Antonio Canova, for a wide variety of (usually mixed) motives. But I believe that analyzing his politics and those of some of his politically conspicuous patrons will expand and add nuance to the understanding of an era already notable for its politicized visual culture. Indeed, many of the issues that confronted the arts from 1780 to 1820, such as censorship, display, narrative, political engagement, and propaganda, are as problematic for the visual arts today.

The intimate connection between art and politics that historically has characterized the artist-patron relationship changed profoundly during the revolutionary and Napoleonic era: many patrons sought to impose their political will more forcefully than ever on cultural production at exactly the moment when artists began to realize their own augmented authority in a vastly expanded public arena. Ambitious artists yearned for a more decisive and influential position in society, but the rulers and regimes for which they often worked wished only to use artists for their own political purposes. Arguably, the great majority of artists were happy collaborators, glad of patronage in uncertain times, but a few artists of international reputation, cognizant of their fame, chaffed at patrons' attempts to impose political orthodoxy. Among this group of cultural celebrities I would include David, Goya, and Canova. Each of these artists resisted co-option in ways peculiar to their individual circumstances, but I believe that only Canova gained sufficient control over both the production and interpretation of his works to achieve virtual independence of his patrons' political agendas. On a political level the interpretive ambiguity of the statues Canova executed for Europe's rulers of-

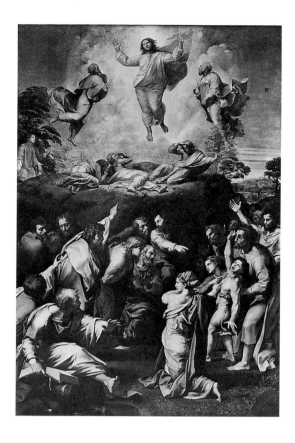

FIGURE 3
Raphael, *Transfiguration,* oil on panel,
1517–18. Vatican City, Pinacoteca
Vaticana.

ten frustrated those who paid for them, while his private patrons, who usually sought only cultural status, were satisfied to select works from a menu the artist devised. Such a situation was possible only because Canova was almost as famous as his patrons, if not more so, and because the public powers to whom he owed political allegiance either allowed themselves to bask in reflected glory, like Venice and the papacy, or, like Napoleon from 1809 to 1814, struggled to obtain mastery over a reluctant and unobliging subject, and ultimately failed.

Canova achieved exalted status vis-à-vis political powers only by incessant struggle; his retiring nature and aversion to political intrigue denied him the even greater public role he could easily have acted. Count Leopoldo Cicognara, a friend of the artist's who became the director of the Venetian Academy, summed up Canova's political potential and historical importance in a letter from Florence of September 19, 1812, addressed to the sculptor in Rome. After commenting generally on the power of prominent cultural figures to make a positive impression on their societies, he added, "You are a true power in this world, but you do not know the power you possess, which should enable you to exert a much greater influence. Notwithstanding, you have a glory common to extraordinary influence, namely, that of having made a revolution in the arts, like the one the military powers are making in politics."[6] Cicognara recognized the political potential of cultural status, even if Canova was

unwilling or unprepared to exercise it fully. But in the interface between art and politics, the sculptor would risk political intervention if he believed it necessary to protect his own interests or those more generally of the fine arts.

Canova's intercession on behalf of jailed Spanish artists during the Napoleonic hegemony, an event I describe in detail in Chapter 3, is especially noteworthy because of the hard line the artist took with the military governor, General Sextius-Alexandre Miollis, who refused to release the prisoners but allowed Canova to make them comfortable while they awaited the result of his direct appeal to Bonaparte. Later, the artist again stuck his neck out, politically speaking, to save a group of German artists of questionable loyalty to Napoleon from immediate deportation from Rome. Opposition to the oath of loyalty in the former Papal States had driven the French emperor to highly repressive measures. In the end, Canova was able to have the order rescinded. Among the beneficiaries of his action was the notable Prussian sculptor Christian Daniel Rauch, who, as an enemy alien, had been ordered to leave Rome.[7] Canova's intercession is even more remarkable when one recalls that he helped the Spaniards at a time when he himself had refused to take the oath to Napoleon, and only much later did he agree to swear a modified version of it. The emperor must have thought both the intercession and the refusal the height of insolence, but Canova's reputation shielded him from any really serious recriminations. These two instances of the artist's political intervention in defense of artistic freedom are characteristic, and indicate the newly recognized authority grudgingly allowed to elite cultural figures like Canova.

The fine arts had long been politicized in papal Rome; Canova evaluated his creative environment and understood how to establish himself securely in it as an independent artist serving no imposed political agenda. Canova's strategic use of ambiguity in his works, in terms of their mythological and allegorical subjects, was paralleled by contemporary institutional attempts to employ the ancient world, ancient art, and modern archaeology in the service of widely differing political positions. The Roman Catholic Church that Canova so admired was a sophisticated player in the struggle for succession to the glories of the Graeco-Roman past. To the extent that archaeology, for the late-eighteenth-century Church, helped to clarify the claimed continuity of caesars to popes, the support for the excavation of antiquities and their display in the pontifical museums of Clement XIV, Pius VI, and Pius VII was a form of self-conscious political rehabilitation. Pius VII's Rome, humiliated and constantly threatened by France, made the crucial role of archaeology and ancient art in papal politics especially explicit. Ercole Dandini underscored this role in his 1805 oration on the Capitoline Hill honoring winners of the *concorsi clementini* (the art students' competitions named for Pope Clement XI); the oration was subsequently published in the Accademia di San Luca commemorative libretto. According to Dandini, the pontiff's "subtle and discerning spirit has fully appreciated this important maxim: That in Rome the arts must constitute one of the principal objects of politics."[8] Antiquity, museology, archaeology, preservation, restoration of monuments, and support for scholarship and learned academies remained, in a depleted papal arsenal, the only potent political weapons. These cultural initiatives had always been vital to the Roman See's political policy, but the revolutionary era

increased their significance, if not necessarily their efficacy. But from the papal point of view, ambiguity of interpretation cast a shadow on the glorification of the ancient past. Revolutionaries and liberals celebrated the achievements of the Roman republic and revered classical Athens as the cradle of democracy. Even caesar as pontifex maximus met his match in Napoleon, who not only claimed ancient imperial authority (using culture to help prove it) but also usurped the heritage of Charlemagne, much to the detriment of the Church and the papacy's pretensions to secular political power. In sum, antiquity became a figurative minefield, traversed at great peril.

Canova was a most cautious artist in the politically problematic world of revolutionary and Napoleonic Europe. Unlike his famous artistic contemporaries David, Antoine-Jean Gros, Andrea Appiani, and others, whose highly politicized iconography gained them fame and patronage but sometimes got them into trouble when political circumstances changed, Canova avoided engagé politics and focused either on "neutral" aesthetic issues related to Truth and Beauty or on highly personal human and moral tragedy, veiled in safe ways. Such a work as *Perseus Slaying Medusa,* undertaken while the artist was in exile in the disastrous year 1799, would be difficult to interpret in isolation.[9] Its thinly veiled theme of madness and civil war reflects Canova's anxiety about the cataclysm in Italy occasioned by the French triumph and his concern with his own professional future. Indeed, as early as 1794 Canova despaired at the danger to Venice and all of Italy posed by the Revolution (Piedmont had already been annexed to France) and thought vaguely about escaping to America.[10] He rarely took the step, however, of directly and unequivocally making political reference or commentary in his art, partly because he sensed his own, and Italy's, vulnerability, but also, I would argue, because he was conditioned to think politically in metaphor, a traditional artistic practice with a venerable pedigree. And given David's political problems during the Directory, perhaps the sculptor's discretion was the wiser policy.

The greatest challenge to Canova's determination to resist politicizing his art and to minimize the negative impact of politics on art generally came, of course, from France. There could be little doubt about the direction of French cultural policies in Rome after its annexation to the empire, only questions about their extent and intrusiveness. After the creation of the Department of the Tiber, Rome was absorbed into the highly centralized bureaucracy based in Paris. Therefore, Napoleon's goal for the arts—to use them fully for his own glorification and that of his empire—became the same in Rome as in France. Art in Rome served as an instrument of state power.[11] Nothing could have been more alien to Canova's desires and disposition, and largely because of the sculptor's understated but firm resistance, five years of French domination had much less cultural impact on Rome than Napoleon might have wished.[12]

A speech by the French functionary Marie-Joseph De Gerando, a member of the governing Consulta Straordinaria, the new provisional Roman government, on the occasion of the Accademia di San Luca's awarding of student prizes in 1810 clearly reveals Bonaparte's vision for the arts in Rome. As Carolyn Springer has observed, Napoleon recognized the conjunction of art and politics in staging impressive paraliturgical ceremonies to honor

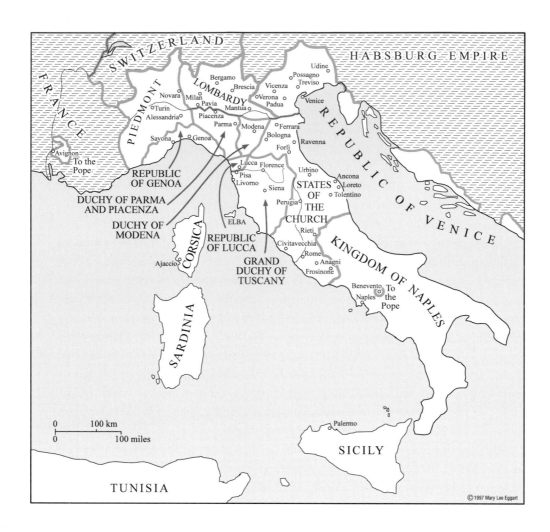

Italy in 1795,
before the French invasion.

artists on Rome's original hill and lost no opportunity of exploiting it. De Gerando exclaimed:

> Winners come forward! . . . This is the first time that the crowns on the Capitoline are to be awarded in the name of Napoleon the Great; this is the first time that here the triumph of the arts concurs with the solemn day in which we celebrate both his august name and the felicity of the peoples under his protection! Oh glory! Oh hope! You may expect all things from your great benefactor! Raise high on the Palatine a new palace to Caesar, raise new arches of triumph where Constantine entered, where another will enter who is greater than he! Paint on your palace walls his marvelous deeds, with which the whole world is resounding![13]

Canova, although he was returning from Paris with major imperial concessions for the arts in Rome, and especially for the Accademia, nonetheless delayed in Florence until after the ceremonies had taken place. Why? It is true that he was to be honored at the Capitoline gala, and he often tried to avoid such displays, which he found embarrassing. He could have delivered news of Napoleon's promised indemnity most spectacularly on this occasion, and I suspect he wanted to downplay its propagandistic value. Above all, he did not want to be seen as Bonaparte's herald. I believe his failure to appear was an act of passive resistance to the French.

Personal feelings aside, Canova opposed the concept of a state-controlled art program because it conflicted with artistic integrity and free expression, ideas he greatly valued. His visits to Paris in 1802 and 1810 must have reconfirmed his negative opinion, for many of the arches, monuments, statues, and paintings he saw there revealed the heavy hand of bureaucracy imposing subject matter and style. By 1810 the Salons were being compared to illustrated war gazettes like the *Journal de l'Armée,* so numerous were state-sponsored battle paintings, treaty scenes, and military genre pictures. Many artists simply followed the preferred iconographies in the hope of attracting state patronage. Canova's friend Quatremère de Quincy shared his sentiments about how unhealthy this was for the arts and deplored the imperial government's "conscription" of culture to serve Napoleonic politics.[14]

The pre-French situation at Rome, with its broad-based international system of patronage and the aesthetic sophistication of many buyers, must have suggested differences between papal Rome and imperial Paris not at all in the latter's favor. Napoleonic Paris, for all its cultural aggressiveness and splendor, must have appeared stifling and parochial to an artist of Canova's background. Ultimately, Napoleon's wish to transform Rome into the second capital of the empire, on the model of the French capital, and make it the chief residence of his heir the king of Rome, came to nothing. The occupation failed to remake Rome; its few concrete accomplishments included some new public parks, a partial redecoration of the Palazzo del Quirinale, and the removal of earth and debris from several major monuments, which resulted in disappointingly meager ancient finds.[15] Canova's minimal involvement in these French efforts was never undertaken in the spirit of collaboration; rather, he served as a sort of guardian, urging circumspection and subtly resisting the more radical proposals, such as the destruction of the Church of SS. Nome di Maria to provide a better "view" of Trajan's column. His efforts, successful on the whole, were acknowledged by Pius VII in 1814.

Another issue directly involving the relationship between art and politics during Canova's lifetime was the cultural rivalry between Rome and Paris that had been initiated by Louis XIV. It would be naive to assume that this competition did not have an important political dimension, because it was closely tied to such ideological controversies as Gallicanism, Jansenism, and the relentless French pressure on the Society of Jesus from about 1760 until the suppression of the order in 1772. Moreover, the political influence accompanying cultural preeminence, thoroughly understood in the eighteenth century, may be less comprehensible today. In the contest between Rome and Paris, Canova was an undisguised partisan of the former, believing it the cradle of the arts and Western culture and the only context in which

artists, especially sculptors, could realize their potential. Even as a young artist in Rome, Canova had no favorable opinion of French taste in the arts, and he saw French hegemony in Europe as deleterious to Rome and Italy. The spoliation of Roman museums and patrician collections surely confirmed his worst fears. John Memes, writing in 1825 about the artist's refusal to settle permanently in Paris, attributed the decision partly to Canova's aversion to French cultural attitudes, adding that the French "are not inspired with genuine love of art: It is merely a love of display. In the composition of his piece, the artist is more solicitous to exhibit his own talents than to represent the simple truth; in purchasing it, the patron is equally desirous of displaying himself. Even their national gallery is display, where the noblest works are prized, not as triumphs of genius, but as trophies of conquest."[16] Although Canova himself would have expressed it less baldly, I believe that these were essentially his views.

One would never guess from reading art history survey books how much French opinion at the end of the eighteenth century still held Rome and Italy superior to Paris and France, both in art instruction and modern production. This feeling of inferiority in France lingered even after the sack of Rome in 1798–99, an act that was partly motivated by cultural hostility over a century old. In 1802, for example, the French ambassador, François Cacault, wrote to the minister of foreign affairs in Paris concerning the French Academy in Rome, making comparisons between art in the two cities that were unflattering to Paris. He states that in European reputation, no modern artist could rival Anton Raphael Mengs in painting, and the same was true of Canova in sculpture. He then asks rhetorically what the government could do to have artists whose glory might surpass that of Mengs and Canova, posing it as the central question of governmental policy for the arts. He acknowledges his own patriotic belief that France has painters and sculptors superior to the Saxon and the Venetian but adds, crucially, that Europe did not think so.[17] To achieve absolute mastery in Europe, Paris must conquer Rome culturally. Cacault understood even as vital a cause as government support for the fine arts primarily as political and cultural propaganda for continental consumption.

The ambassador was not the only prominent French observer to feel a sense of Italy's artistic superiority. In 1806 Napoleon wrote from Saint-Cloud to his chamberlain Martial Daru about his recent portrait by David, betraying an acute awareness of the artistic rivalry of France and Italy: "Monsieur Daru, I have just seen the portrait that David has made of me. It is a portrait so bad, filled with so many errors, that I do not accept it and do not want to send it to any city, above all in Italy, where it would give a very bad impression of our school."[18] If one accepts the traditional art-historical wisdom that French art had surpassed Italian art during the eighteenth century, how, then, does one explain the emperor's refusal to allow a portrait by the nation's best painter to be exhibited even in a provincial Italian town (figure 4)? Military triumph and political domination had not eroded the cultural reputation of Italy, especially Rome. And a final example of Napoleon's lack of faith in French artistic opinion is telling in the present context. Bonaparte was eager to purchase from the Spada collection in Rome a statue of Pompey the Great, reputedly the image at whose base Julius Caesar was assassinated. The emperor's interest, kindled by the sculpture's association with an important event in the history of the Roman Empire, was politically motivated. Spada ini-

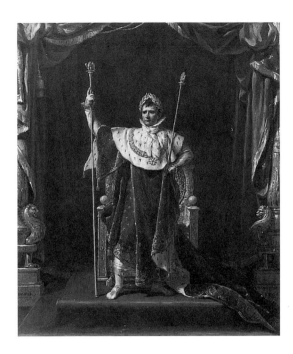

tially asked too high a price, and by 1812 antiquarian opinion unfavorable to the work began
to coalesce. Dominique-Vivant Denon, the director of the Musée Napoléon who had been
with General Bonaparte in Egypt, denied its authenticity. In the end, Canova's opinion that
the head did not belong with the rest of the body determined the emperor to pass on the
statue,[19] a circumstance that must have been galling to the arrogant Denon, who later repaid
Canova with egregious insolence when the sculptor was in Paris in 1815 for the restitution
of the Italian art works looted by the French for the benefit of the Paris museum.[20]

The radically altered Europe in which Antonio Canova lived and worked had become,
for artists and almost everyone, fraught with political danger. The politicization of artistic
production, display, and iconography was the chief threat to the sculptor's professional in-
dependence, his personal desire to avoid court service, and his sincere wish to make statues
on commission in an increasingly isolated, impoverished, and peripheralized Rome. Art for
Canova had to exist in a "morally autonomous ambient," as Corrado Maltese so eloquently
put it,[21] and he, not the patron, would determine the meaning of his works, political or oth-
erwise, as Fred Licht has rightly recognized.[22] Albert Boime has declared that although
Canova was ambivalent toward Napoleon, the sculptor nonetheless served his patron's
agenda "through the formal devices and values assigned to them by the institutional net-
work."[23] But this assessment is too simplistic. The meaning of the works executed for many
of Canova's politically prominent clients, above all the Bonapartes, was problematic in the ex-
treme, for mythology and allegory disguised, confused, and made ambiguous the meaning
of these works so that subsequently they were unable to fulfill any overt political purpose.

1

CANOVA'S BACKGROUND,

RELIGIOUS VIEWS,

AND CULTURAL FORMATION

THE CHARACTER OF THE MOST CELEBRATED ARTIST OF HIS ERA, frequently described as "divine" by his contemporaries, was largely formed in the rural Veneto. Canova was born at Possagno, a village near Treviso, in 1757 to Pietro Canova and Angela Zardo. Essentially orphaned by the age of five by the death of his father and the remarriage and removal of his mother, he was brought up by his paternal grandfather, Pasino Canova, a stonemason who, though he taught the child the rudiments of his future profession, treated him with a severity that the sensitive artist always remembered. Although many of Canova's early biographers mystified his origins to suggest that his career was simply the triumph of genius over difficult circumstances, in fact Canova attained prominence through the same aristocratic patronage system so many promising but impoverished artists had followed before him. Talent was important for patrician interest in a young sculptor, but modesty, good morals, and a grateful attitude toward benefactors were equally essential. We may assume, then, that Canova joined deference and gratitude to his aristocratic patrons to his natural ability in carving stone and that he was a conforming Catholic, like his patrons. If he was typical in his promotion according to the cultural practices of the ancien régime, his transformation of the relation between artist and patron in an era of fundamental societal change could not have been predicted.

The patron who gave Canova a chance to become more than a rural artisan was the Venetian Senator Giovanni Falier, who introduced his protégé into the studio of the prominent Venetian sculptor Giuseppe Bernardi. Although the *Orpheus* and *Eurydice* Canova executed for Falier were relatively minor works, they brought the sculptor much notice in Venice. On the advice of Falier, Procuratore Pietro Vettor Pisani commissioned from Canova a considerably more important statue, *Daedalus and Icarus* (figure 5). With the proceeds from the sale Canova went to Rome, arriving late in 1779. There he soon came under the protection of another Venetian patrician, Girolamo Zulian, who gave him a room and

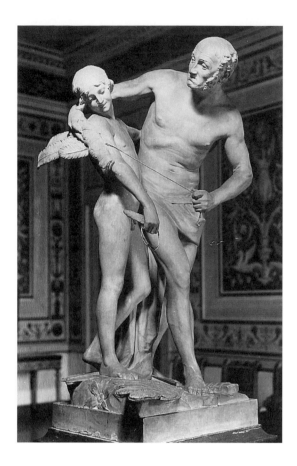

FIGURE 5
Antonio Canova, *Daedalus and Icarus,*
marble, 1777–79. Venice, Museo
Correr.

the use of a studio in the ambassadorial residence, the Palazzo di Venezia. By 1781 Zulian and Canova's patrons in Venice had secured the promising young artist an annuity to allow him to continue his studies in Rome. Thus he made a successful beginning in what was to become a spectacular professional career.

On his initial trip to Rome in 1779, Canova was accompanied by the young architect Gianantonio Selva, who was to remain a lifelong friend. On the way, both artists fortunately kept journals, which reveal the differences in their social class and education. Selva, from the urban middle class, writes correctly and in the rather impersonal manner of a contemporary gentleman of taste. Canova, in contrast, wrote in a dialect, his comments full of naive wonder as he remarks on the quantity of food he ate and expresses vulgar appreciation for his luxurious surroundings.[1] In short, his reactions were exactly what one would expect from a peasant artisan brought up in a Venetian hill town.

Antonio Canova was highly intelligent, however, and soon became aware that professional success in the sphere to which his Venetian patrons had elevated him required that he change his dress, manners, and speech and that he apply himself sedulously to fill in the huge

gaps in his meager education. While still in Zulian's household, he began a course of study with an unofficial tutor, the abbate Bonaiuti, focusing especially on mythology and the classics and on the improvement of his spoken Italian. During the early years of financial success, he began to assemble a modest library, well stocked in classics, which he made available to other artists. Many of the Roman intelligentsia, such as Gavin Hamilton and Giuseppe Cades, were eager to help by reading to Canova from cultivated texts or simply by recounting to him the myths from Ovid and the works of the Greek playwrights. His favorite book was Plutarch's *Lives,* and he often read in Melchior Cesarotti's Italian translation of Homer, which doubtless inspired many of his bas-reliefs of the early 1790s, for example, *Briseis Delivered to the Heralds of Agamemnon* (figure 6). In addition, he studied English and French, primarily to converse more easily with his patrons and studio visitors. Through years of study, Canova became relatively erudite, especially in ancient history, mythology, and archaeology.[2] Only with such learning could he achieve the level of cultural status absolutely necessary to attaining the personal and artistic independence he so highly valued.

Although the sculptor had been eager to gratify his patrons in Venice by accepting commissions for fruit baskets, garden sculptures, portraits, and the like, once established in Rome he became much more ambitious, ultimately refusing to make copies of antiquities and avoiding portraiture whenever possible. He was encouraged in this attitude by such theoretically inclined artists as Hamilton and by general academic precepts that had seemed much less important in Venice. Canova especially despised making portraits on commission, preferring to execute them either as tokens of friendship or as signs of esteem, the various versions of the bust of Pius VII being the most prominent among this latter group. The attitude toward portraiture in Rome was generally more negative than in Venice or northern Europe, and the artist soon adopted the local prejudice. John Moore, in his travel account, commented on the low estimation of portraits, noting that Roman palaces rarely had portraits of their proprietors and that most of the few portraits to be seen (all of inferior quality) represented the reigning pontiff. The local aristocracy "consider a portrait as a piece of painting, which engages the admiration of nobody but the person it represents. . . . Those who die in circumstances to pay the best artists, generally employ them in some subject more universally interesting, than the representation of a human countenance staring out of a piece of canvas."[3] There is no reason to believe the reputation of portrait sculpture, excepting papal busts and funerary images, was much higher than that of painted portraits. Canova's disdain of portraiture was to be fraught with difficulties for the sculptor in his maturity, for the parvenu rulers of the Napoleonic age, greedy for tokens of personal vanity, demanded satisfaction from the best artists.

Possibly because of his youthful dependence on the whims of patrons and his growing awareness of the vulnerability of artists in a revolutionary world where the traditional system of patronage had largely broken down, Canova obsessively secured and defended his independence. To do so he had to invent a decidedly modern new system of working. The vast majority of Canova's mature works were mythologies, which he did, with only a few exceptions, on speculation, in *modello* form. Seeing the scale model, a patron visiting the artist's

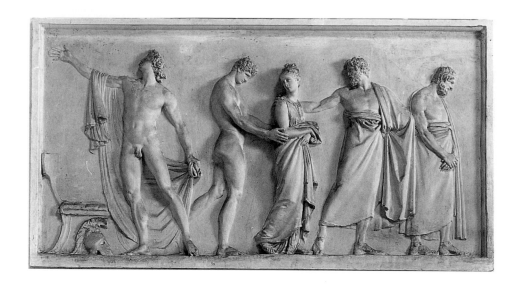

studio might order a marble version, or, on the strength of Canova's reputation, a patron could arrange the commission through an agent or simply by letter. Most of Canova's patrons wanted objects by Europe's most celebrated artist to enhance the cultural prestige of their collections, and only in rare instances was the subject of deep concern to anyone but the sculptor. Although this system tended to reduce the marble sculptures to mere commodities, the artist nonetheless enjoyed tremendous advantages: he exercised great freedom in choosing the subject and manner of execution, and he became the initial interpreter of the meaning of his works.[4]

This studio system would have been impossible in Italy before the end of the eighteenth century; it evolved from the breakdown of the patron-dominated procedures of the past and greatly benefited from the new, culturally inexperienced elites of Napoleonic Europe. Canova's popularity also ensured him financial freedom, even though he was touchy to the point of embarrassment about the prices of his works and usually left the business of his studio to Antonio D'Este, a Venetian friend of his youth who ran the atelier until Canova's death in 1822. An anecdote related by D'Este in his biography of Canova that sheds light on the sculptor's modus operandi also gives a strong indication of Canova's independent spirit and professional pride. In about 1792 a French bureaucrat named Juliot visited Canova's studio and asked the price of the *Penitent Magdalene.* Unsatisfied with D'Este's response, he asked to speak to Canova. Jingling a purse of gold, he offered cash in advance for a lower

price. Canova responded: "One does not show gold to an artist who contents himself with soup and boiled meat," and turned his back on his visitor.[5] Although jealous of his high prices, considering them a tribute to the superiority of his work, Canova nonetheless seems to have deserved his reputation for monetary disinterestedness. His patrons' inability to influence him decisively with financial remuneration was also important to his goal of total independence.

In addition to his studio practices in regard to patrons, Canova also systematically evaded attempts by various rulers to turn him into a court artist. Fully understanding the dependence that such a position, no matter how flattering and sumptuous, would entail, the artist knew instinctively that he could not function freely at any court, however benign. His first court invitation was from Czarina Catherine II shortly after the completion of the tomb of Clement XIV (see figure 65), a request he politely but firmly refused. When he was gently scolded by his patron Falier for passing up such an opportunity, he responded that he had no desire to live in greater luxury or to work less than he did at present, and that court intrigue held no charms for him.[6] This aversion, which remained with him his entire life, helped occasion the most dangerous political crisis he ever had to face. His rural background and natural shyness undoubtedly had much to do with his reluctance to participate in court culture.

Canova first came to Napoleon Bonaparte's notice during the Italian campaigns of 1796 and 1797, when the young general was triumphing over the Austrians, the Venetians, and the northern Italian duchies in the name of the Directory. General Bonaparte offered Canova his protection and greatly flattered the sculptor, and later, when he was military dictator of France as first consul, he sought to enlist Canova's considerable talents for his own glorification. Napoleon also wished to possess works by the Italian artist so as not to be outdistanced culturally by his brother-in-law Joachim Murat, who had earlier, with considerable difficulties, obtained the master's recumbent *Cupid and Psyche* (figure 7). Josephine, a discerning collector, was also wildly enthusiastic for Canova's sculptures. In 1802 Napoleon summoned the artist to Paris to take his portrait for use as the model for a great monument, a project that ultimately became the ill-fated *Napoleon as Mars* (see figure 38).[7] Canova, who clearly did not want either to accept the commission or to visit the French capital, did all he could to avoid going, but in the end power politics, manifested in French pressure on the papacy, forced him to acquiesce. Ferdinand Boyer has argued that Canova's reluctance was occasioned by his general antipathy to courts and nothing more.[8] Canova's resistance to Napoleon had a firm and enduring political basis, however, and much of his energy from 1802 until the end of the empire was absorbed in evading the blandishments and coercion of the Bonapartist regime.[9]

Despite Canova's unwillingness to go to Paris to execute the portrait, Napoleon's reputation was so great at the time (enhanced by the recent peace treaties of Lunéville and Amiens) that the artist's own reputation was helped by association with him, and Canova's return from Paris to Rome was a sort of cultural triumph. Politics aside, Canova must have been deeply flattered by such attentions. He was entertained in Lyon by Cardinal Joseph Fesch, Napoleon's maternal uncle, and by the aristocracy of Turin. In Milan he was toasted

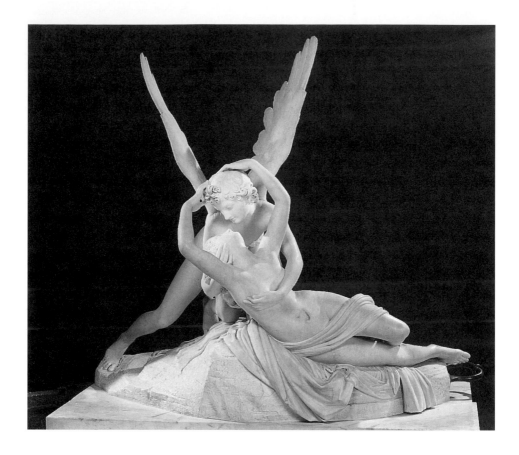

FIGURE 7
Antonio Canova, *Cupid and Psyche*
(recumbent), marble, 1787–93. Paris,
Musée du Louvre.

by General Murat and was honored at an artists' dinner at the Accademia di Brera hosted by
the painter Giuseppe Bossi, who asked Canova to pose the model for the evening's life class.
In Florence Canova was feted by the Tuscan Academy and petted by the new king of
Etruria, Lodovico I.[10] Later, in 1804, Canova was elected an *accademico d'onore* of the Brera
along with Jacques-Louis David, and Bossi's letter politely claimed that it was the institution
that was honored and not the artist.[11] Indeed, of all Canova's testimonials, those from fellow
artists made the greatest impression on him.

 The avoidance of the pomp of court life whenever possible did not shield Canova from
noble honors, no matter how little he valued them personally. Among his various titles were
three conferred by the pope: Cavaliere of the Golden Spur, Cavaliere di Cristo, and, most im-
portant, the marquisate of Ischia, granted to Canova after he had successfully negotiated the

return of the bulk of the papal collections from Paris in 1815. Catherine II of Russia, her chagrin at the artist's refusal to come to Saint Petersburg mollified, designated him a Knight of Saint George, and King Ferdinand IV made him Cavaliere of the Order of the Two Sicilies. Napoleon, in his capacity as king of Italy, appointed him Commendatore of the Iron Crown, while Bonaparte's archenemy, Emperor Francis II of Austria, designated him a Knight of the Aulic Order of Leopold. Even San Marino got into the act, electing the famous artist a citizen of the republic.[12] The honorifics Canova refused or avoided, above all those from France, would form an equally impressive list. Bureaucratic titles were also plentiful, four from the papacy alone: Inspector General of the Fine Arts in Rome and the Papal States, president of the Commission for Acquisition of Art Objects for the Vatican Museums, president of the Pontifical Academy, and Principe for life of the Accademia di San Luca. In addition, Canova was an active or honorary member of all the important academies of Europe and was appointed to the Institut de France and the Istituto del Regno d'Italia by Napoleon. For an artist so independent and so often disobliging to important patrons, the list is truly remarkable and attests to the social and political power afforded high cultural distinction during the period.

Although Canova's fame, wealth, and cultural status could have made him arrogant and insensitive to others, above all other artists, they did not. Indeed, the sculptor's generosity and charity were legendary, though perhaps his motives for pursuing these virtues were more mixed than his hagiographers would have us believe. Possibly because of his youthful poverty and dependence, Canova was rarely backward in assisting struggling artists and cultural institutions in Italy. As Rome became increasingly impoverished and peripheralized in a French-dominated Europe, the sculptor's help proved invaluable to a city with more artists per capita than any other contemporary capital. A few of the myriad examples recounted in early biographies will serve as cases in point.

After the fall of the Venetian republic, the painter Domenico Pellegrini, then studying in Rome, lost his pension and soon became destitute. Canova commissioned a copy of Titian's *Danaë,* then in the royal collection at Naples, from the painter, also paying for his trip. While saving the young artist's feelings, Canova also provided him with an important learning experience; Pellegrini became one of the leading colorists of the early-nineteenth-century Italian school.[13] Artists in Rome during the French occupation, from 1808 to 1814, were in exceptionally dire straits. Tourism had slowed to a trickle, many noble families were ruined, the pope was in exile, and all the cardinals and most of the upper clergy had left or been exiled from the city. The few cultural initiatives of the French could hardly compensate for this loss to the artistic community. During a single year of the occupation, Canova reputedly gave 140,000 francs in alms alone. He used his Tuscan connections to help secure a professorship for the painter Pietro Benvenuti at the Florentine Academy and successfully intervened with the French authorities in Rome for the release from prison of a group of Spanish art students jailed for refusing to swear allegiance to the new Bonapartist king, Napoleon's brother Joseph, styled José I. Canova even persuaded Bonaparte's stepson Eugène de Beauharnais, the viceroy in Italy, to purchase some works by the loyalist Spanish sculptor José Alvaréz y Cubero.[14]

Canova may have had his own political reason for seeking the release of the imprisoned Spanish artists. The sculptor personally believed that art was above politics, and freeing the artists from arrest may have been partly an assertion of this conviction. The usurpation of the Spanish throne by the French may also have dismayed Canova; his attitude toward imperial France was at best ambivalent, and he feared a repetition of the process in Rome, which in fact occurred less than a year later. But Canova also recognized that with the French emperor at the zenith of his power, it was necessary to use his influence to mitigate the effects of French rapacity and the occupation on Rome and Italy while compromising himself as little as possible. It is quite remarkable what Canova was able to obtain from Napoleon while having to do little himself in return.

In 1810, before the delivery to Paris of the *Napoleon as Mars* that Canova had begun during his first trip there in 1802, the sculptor was again summoned to the capital, this time to do a monumental portrait of the new empress, Marie-Louise of Austria. Canova again tried to get out of it, but Napoleon was much more peremptory in his demands as emperor than he had been as first consul. In the French view, Canova, having become a French subject after the annexation of Venice in 1805, did not have to be handled so carefully. Although Napoleon still wanted his collaboration, all but insisting that Canova move his studio to Paris, in 1810 he did not hesitate to threaten the artist, subtly but surely, if he did not come and do as he was told. So Canova went, but he used his opportunity of extended contact with Bonaparte well. In their frank conversations, written up shortly afterward, Canova demanded cultural support for Italy.[15] Touching both political and artistic concerns, he pleaded, unsuccessfully, as it turned out, that Napoleon reconcile with Pius VII. But he did persuade Napoleon to increase funding dramatically for the Roman and Florentine academies and to grant a subsidy for the restoration of the Church of Santa Croce in Florence, where the sculptor had just installed his *Monument to Vittorio Alfieri* (see figure 16). Canova cleverly appealed to Napoleon's supposed Florentine origins and to his historical sense of imperial vanity. It is characteristic of both men that Napoleon wanted to attach Canova to him by enriching and flattering him and that the sculptor asked for nothing for himself. I believe Canova's reticence was due to his wish not to be personally obliged to the emperor. Such personal disinterest, rarely encountered in the imperial entourage, surprised and vexed Napoleon. Ultimately, no threats or enticements could persuade Canova to settle permanently in Paris, and Napoleon let him go when he had completed Marie-Louise's portrait (see figure 47).[16]

Although Napoleon and the Bonaparte family were eager to patronize Canova and even though the famous antiquarian Quatremère de Quincy was his major French critical supporter, Canova's work was less popular in France than almost anywhere else, and he was often subjected to scathing criticism by French connoisseurs and antiquarians who envied his favored position in the scheme of imperial sculptural patronage. Nonetheless the artist was deeply wounded by such captious attacks, which only helped to reconfirm his generally negative opinions about the French. In a letter of December 1, 1806, Canova complained so bitterly to Quatremère about the attacks that he asked him to burn the letter.[17] Quatremère

replied on January 25, 1807, attempting to salve the artist's feelings by assuring him that such philippics were motivated only by jealousy and mediocrity and that they were, in fact, tributes to his true superiority.[18] Canova claimed in his letter that nothing mattered more to him than his reputation, and he realized that such attacks, if coordinated and continuous, could damage him in the one arena he really cared about—public opinion. French criticism arguably hardened Canova's position vis-à-vis Napoleon, for one can never draw an absolute line between art and politics, however advantageous it might be to do so.

Of the score of works by Canova that were exhibited in France, only *The Penitent Magdalene* (figure 8) ever achieved any pronounced popularity. Canova himself had chosen the theme of this sculpture, his first important religious work, finished in 1796 for the Venetian cleric Monsignor Giuseppe Priuli.[19] Unfortunately, in 1798 Priuli was forced to leave Rome with the exiled Pius VI, and he defaulted on the commission, a common enough occurrence during the troubled 1790s. By a torturous route that included its sale to Juliot, the Frenchman who had so angered Canova by waving a purse of money at him, the statue was acquired by that remarkable and rather shady collector of contemporary art Giovanni Sommariva, who exhibited the statue at the Salon of 1808. It created a sensation. A few critics carped about its sentimentality and theatrical effects, but a Paris conditioned by the romanticized, retrospective Catholicism of Châteaubriand's *Génie du Christianisme* and the concordat, which officially reconciled France to papal Catholicism, was most enthusiastic. After its spectacular debut, the statue was installed in a "chapel" in Sommariva's house specially designed for it, and soon the *Magdalene* became an important stop on the cultural itinerary of those lucky enough to gain admittance. Canova himself did not value *The Penitent Magdalene* highly, and its tumultuous reception in Paris must have reaffirmed his low opinion of French taste, throwing into relief the negative response to his more important graceful and heroic works such as *Cupid and Psyche* and *Napoleon as Mars,* the work that was to be Canova's greatest humiliation. But even the popular *Magdalene* had its detractors, the *Journal de l'Empire* calling it flashy and devoid of grace.[20] Canova's combination of sentimentality and latent eroticism, however, made its strongest appeal to French painters, above all to David, Pierre-Narcisse Guérin, and Pierre-Paul Prud'hon. The contemporary revival of Correggio, sparked by the addition to the Musée Napoléon of the duke of Parma and Piacenza's elegant and graceful paintings by him, doubtless fueled the enthusiasm for Canova's *Penitent Magdalene*.[21]

One additional example of the French response to Canova reveals how the sculptor perceived that nation's prejudice against his works. In 1802, to acknowledge his election to the Institut, Canova decided to send a gesso version of his *Creugas,* a work in the *genere forte,* for the evaluation of "codesti valenti Professori," since they had seen only works in his graceful mode. In January 1804 the statue was exhibited at the Louvre. Badly damaged in transit from Rome, it was strongly criticized nonetheless for both its anatomical proportions and manner of execution. Even Quatremère was unable to quell the sculptor's anger over the reception of the work, the Italian arguing that it was mere prejudice against a foreigner and complaining that critics had not taken into account the damage to the work.[22]

Except for the Bonaparte family, Canova had very few French patrons. Sommariva, a

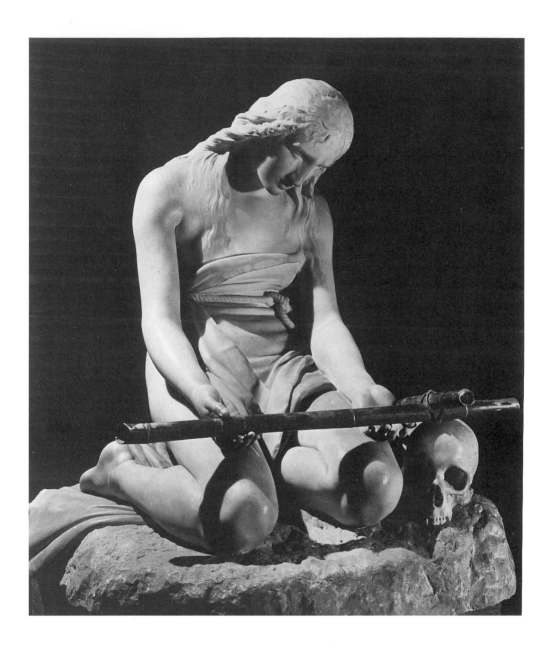

FIGURE 8
Antonio Canova, *The Penitent
Magdalene,* marble and gilt bronze,
ca. 1790–96. Genoa, Museo di Sant'Agostino.

Bonapartist who had helped to introduce Canova's work to Paris, was actually a Lombard, and even though he was an assiduous admirer and collector, Canova nowhere indicates more than a respectful professionalism in his dealings with the dubious nobleman, despite the ardent language in their mutual correspondence on the subject of art. In stark contrast, Canova frankly admired Josephine.[23] It is true that Sommariva commissioned a *Pygmalion and Galatea* from Anne-Louis Girodet-Trioson as a coy tribute to Canova, whose features were given to Pygmalion, but this commission was largely motivated by the patron's desire to publicize his own collection of Canova's works. In typically cynical fashion, in 1822 Sommariva wrote to his son Luigi: "You will have heard of the death of our good Canova. Now the value of his works will be doubled."[24] In sum, Canova's artistic, cultural, political, and professional relationships to France were generally problematic. Already prejudiced against French art as a young sculptor in Rome, Canova was horrified by the Revolution and the rape of Italy, and the sharp criticism of his work, without parallel in a largely adoring Europe, angered and frustrated him personally. How to coexist with the French hegemony became for Canova the chief problem of his existence.[25]

Canova's hypersensitivity to criticism was a corollary to his desire to cultivate his own myth as an artist devoted exclusively to Truth and Beauty, utterly removed from the petty politics of both artists and rulers. His biographers, above all Leopoldo Cicognara, were only too happy to aid the enterprise, going even further to make him truly "divine." To be sure, their support was necessary, since every religion needs its priests.[26] This is not to deny Canova's prodigious talent as an artist, but only to underscore his insight into how best to manage his public image. Achieving quasi-divine status not only appealed to the sculptor's vanity, but also helped greatly in his quest for independence from Europe's competing elites. As his contemporary Ugo Foscolo said, no one could accuse Canova of inconsistency in working simultaneously for Napoleon and Napoleon's enemies, and this was precisely the point.[27] Canova chose ambiguous mythological subjects and portrait conceits as a form of ideological disengagement—not personal, but professional. Although Canova himself had decided political convictions, he determined that his works would have none. Only such perceived neutrality could have allowed him to work steadily in such parlous times.

In Italy, Britain, Austria, and even the United States, Canova had no serious rival. Some thought Bertel Thorvaldsen his equal, and a few in England championed Francis Chantry but, as Augustus von Kotzebue wrote in 1806, those opinions were held only by a few jealous or disgruntled connoisseurs who were trying to create a fashion.[28] The unprecedented decision of Pius VII to place *Perseus with the Head of Medusa* (see figure 14) on the pedestal formerly occupied by the Apollo Belvedere confirmed the consensus that Canova was the greatest sculptor since Phidias and enshrined him as the new Phidias.[29] Canova certainly had the advantage over his Danish competitor in income. Thorvaldsen's modest *Monument to Cardinal Ercole Consalvi* in the Pantheon earned him 764 scudi, while Canova received 9,000

for the modest (by Saint Peter's standards) Stuart cenotaph (see figure 71). In 1813 Crown Prince Ludwig of Bavaria paid 8,000 scudi for one of Rome's most important antiquities, the Barberini Faun, but he also gave Canova 6,000 for the Munich *Paris* (figure 9), a variant of a work originally executed for Josephine. Moreover, Canova received 14,000 scudi from the stingy countess of Albany for the Alfieri monument in Florence and a staggering 35,000 for *Napoleon as Mars*.[30] French criticism notwithstanding, Canova enjoyed unparalleled fame, financial success, and a virtually blameless character on a scale rarely equaled. And while talent, along with the virtues of modesty and charity, did much to create the image he was so eager to promote, he fully understood that the subtle manipulation of his patrons and critics also helped him achieve this end.

Canova's religious beliefs are a fundamental element of his character and political orientation. A few contemporaries, including Pietro Giordani, believed the sculptor an agnostic at best—certainly no friend of organized Catholicism. His work for Protestants and Russian Orthodox patrons and the relatively small number of religious works in his oeuvre perhaps have fostered the view of Canova as religiously neutral. No one, however, would seriously assert a similar indifference on the part of Rubens and Van Dyck, who produced some of their finest paintings for the Protestant courts of James I and Charles I. Although the revolutionary and Napoleonic era was not highly propitious for the patronage of monumental religious sculpture, before the crisis of the 1790s Canova had executed two papal tombs, and religious themes loomed large in his art after 1814.[31] The case for Canova as a freethinker, agnostic, or cynic is wholly circumstantial (and largely posthumous), while there is a great deal of solid evidence to indicate that he was a faithful observant Roman Catholic.

Many of Canova's nineteenth-century biographers attest to the sincerity of his Catholicism and the traditional nature of his piety, unsurprising observations given the ultramontanism of the times. But such testimony from both Melchior Missirini and D'Este, who were writing about the artist with vastly different intentions, is convincing. Missirini, a cleric and associate of Canova's half brother, Giovanni Battista Sartori-Canova, titular bishop of Mindo, claims that Canova's faith was plain, vivid, and based on the precepts of the Gospels. He adds that the sculptor also believed in the political inviolability of religion as a desideratum of government.[32] D'Este attributes Canova's faith to youthful instruction, noting his thankfulness for divine favor when his works were well received and the extraordinary, but usually discreet, acts of charity that followed.[33] Neither biographer says anything to suggest agnosticism or indifference. According to Giuseppe Falier, religion alone enabled Canova to bear the political and military disasters of 1797–99, including the occupation of Rome and its subsequent spoliation; the deposition of Pius VI; the fall of the Serene Republic of Venice; and the sculptor's exile in Possagno, far from his Roman studio, the fate of its contents weighing heavily on his mind.[34] Later, in 1810, distressed at the deposition and kidnapping of yet another Roman pontiff by the French, Canova pleaded with Napoleon to restore Pius

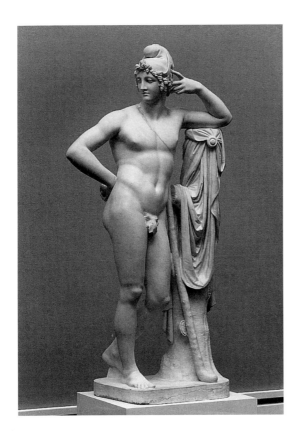

FIGURE 9
Antonio Canova, *Paris,* marble,
1810–16. Munich, Neue Pinakothek.

VII to Rome. And in discussing the emperor's antagonism to the captive pope, Canova even lectured him on papal Catholicism's supreme importance to the fine arts as a source of both patronage and artistic inspiration.[35] Napoleon and Marie-Louise went so far as to agree, the emperor stating that nothing beautiful was to be found in Protestant churches. This exchange indicates the essential link between art and religion acknowledged at the time but too often ignored in the historical research of a more secular age.

Letters and diaries consistently indicate that Canova assiduously attended Mass, a heady proposition at the end of the eighteenth century, when there were no fewer than a hundred feasts in addition to the fifty-two Sundays each year. On his way to Rome in 1779 Canova noted several times that he had been to Mass, and in Bologna, he expressed profound embarrassment at having arrived late, only in time for the Elevation of the Host, and vowed that on feast days in the future, he would hear Mass before doing anything else.[36] Returning home from Paris and London in 1815, he was in Verona for Christmas Eve. Planning to visit Saverio della Rosa, the director of the local academy, he sent him a note, asking him to meet at the Church of Sant'Anastasia, where he was hearing Mass.[37] Such scrupulousness on Canova's part, as a young man and as an old one, demonstrates a religious discipline that belies charges of indifference or heterodoxy. What was perhaps Canova's earliest work, more-

over, a marble relief *Madonna* executed in 1770 for Antonio Rizzo that seems to reflect youthful piety, interested the sculptor in 1803 to the extent that he wrote to Carlo Gaspari, asking if he could locate the work.[38] On his deathbed in Venice in 1822, Canova made his will orally before witnesses, according to Austrian legal practice, opening it with the customary statement of his status as a believer. The first legacy was traditional for an artist of his stature:

> In the first place, the obsequious affection and recognition that I owe to the sacred Person of the Holy Father Pope Pius the Seventh, requires that some public testimony of it be given; and not knowing how I may be able to accomplish it with a legacy worthy of him, I charge my brother D. Giovanni Battista and Signor Antonio D'Este, my testamentary executors, to find some object from my estate that would please him as a memento, either in sculpture or in painting, and humbly present it to him, begging him to honor it by his acceptance.[39]

Canova's first important ecclesiastical monument was the *Tomb of Pope Clement XIV Ganganelli* in the Church of SS. Apostoli (see figure 65). As the pontiff who abolished the Society of Jesus, Clement was certainly the most controversial pope of the Settecento, hailed by progressive Europe as an enlightened opponent of obscurantism and vilified by traditionalists as a tool of the secular monarchies. The ambitious young sculptor, delighted to receive such a spectacular commission, probably concerned himself but little with its problematic subject. Ironically, however, Canova had demonstrable links to the former Jesuits, and more than one of his Venetian friends and patrons were open sympathizers. After arriving in Rome in the autumn of 1779, he wrote in his diary, "This morning I went very early to make my confession to a young priest in the Church of the Gesù and also made my devotions there."[40] Although the society had been officially suppressed, many former Jesuits still performed their duties in the mother church; certainly Canova was aware of the church's traditions and recent history. And for a Venetian who spoke imperfect Italian San Marco, the palace church of the Venetian embassy, which was certainly no farther away than the Gesù, seems a far more obvious choice of church.

During his self-imposed exile in Possagno during the French occupation of Rome in 1798–99, Canova painted a large panel, *Faith,* that was installed in the *salone* ceiling at the palace belonging to his friend and patron in the former Venetian town of Bassano del Grappa, Senator Abbondio Rezzonico. In this Tiepolesque painting, now in poor condition, a female personification of Faith—related to the personification of Religion on the tomb of Clement XIII in Saint Peter's—guides a golden chariot, rays of light emanating from her head. The chariot has a lion's head protome and is accompanied by an angel. The *modello* for *Faith,* in a Florentine private collection, has a blank cartouche between garlands, but in the final version this has been filled in with the Jesuit monogram.[41] Senator Rezzonico's Jesuit sympathies were well known. A letter to Canova from the architect Giacomo Quarenghi, then employed by the Russian court in Saint Petersburg, informs the sculptor of the death of

Father Gabriel Gruber, the acting general of the Jesuits (the brief suppressing the society had not been promulgated in Russia), noting that "such news will greatly distress our Prince Rezzonico."[42] While direct evidence of Canova's personal view of the Jesuits is lacking, the ardent championship of the society by his friend Rezzonico gives strong indication of his familiarity with Jesuit concerns. The artist's agreement to paint *Faith* and include the Jesuit monogram so prominently (if this was the artist's doing, as I believe it was) demonstrates at worst neutral, and quite possibly a sympathetic, attitude.

The question of the continuity of the Jesuits in Russia had broad political implications. Pius VII, at the request of Czar Paul I and the governments of Prussia and Great Britain, who ruled areas with large Catholic populations, had allowed an indulgence for the society in Russia, where the Jesuits were allowed to live in common, teach, and wear their habits. It was widely believed that the Chiaramonti pontiff would soon reinstitute the order. Napoleon hated and feared the Jesuits, who were being supported by three of his leading enemies; he saw hostility in Pius's move and pressured the papal government, making minatory noises about a national church.[43] Such opposition from Napoleon and support from Canova's friends seem to offer further evidence of the artist's favorable view of the Jesuits.

As a Venetian, Canova may have had greater sympathy for the Jesuits than individuals in other parts of Italy and Europe, for the Veneto was an important center of Jesuit thought in the last years of the old regime. The development of the Catholic Enlightenment during the last quarter of the century took on two primary aspects: a Jansenist political theology that promoted a program of social melioration and a more conservative view, championed by the theologian Nicola Spedalieri and supported largely by former Jesuits. This Jesuit ideology hailed the social benefits of rule by a benign patriarch supported by the Church, whose social policies preached patience, persuasion, order, and class equilibrium. In addition to the Veneto, both Emilia and Rome were major centers of Spedalieri's ideas.[44] His *Ragionamento sulla influenza della religione cristiana nella società civile,* published in 1779, became one of the most influential texts of the Catholic Enlightenment.

Canova was familiar with Spedalieri's work. In 1792 his friend and patron Giuseppe Falier wrote from Venice, asking him to bring a copy of the antirevolutionary tract *I diritti dell'uomo* that Spedalieri had published in Assisi. Falier made the request because "this book is prohibited here in Venice; thus it will be well for you to carry it among your papers as if it were old, and for your own use, to avoid any possible inconvenience from the visit of the censors."[45] It is ironic that the work was forbidden in Venice since that city was a stronghold of the ideas Spedalieri championed, but the Venetians were notorious for banning any controversial book. Whether Canova actually read the tract, or others like it, is an open question. While there are strong indications of his lifelong commitment to the Catholic faith and perhaps even to the Jesuits, religious art became a central concern to Canova only with the Restoration in 1814. The cultural fabric of Rome and most of Europe during the Restoration foregrounded sacred concerns, and the heroism of Pius VII's resistance to Napoleon had made papal Catholicism extremely popular, even in such Protestant nations as Prussia and Great Britain.[46] Indeed, the Roman Catholic Church furnished much of the political un-

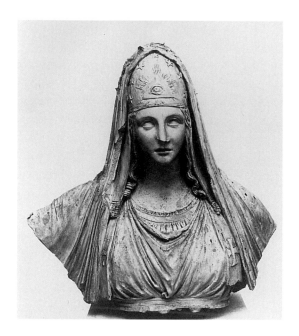

derpinning of the restored Catholic dynasts. Like so many others, Canova was deeply re-
lieved and enthusiastic at the restoration of Pius VII. Almost immediately he began to en-
vision a colossal monument to celebrate the triumph of the Church and the pope. This be-
came the ill-fated *Religion,* one of the sculptor's most unfortunate projects. Ironically, its
failure led to the crowning achievement of Canova's life and religion—the construction of
the Tempio at Possagno.

Although the *modello* for the colossal *Religion* is preserved among the contents of
Canova's studio at Possagno, the marble statue was never executed in that form; another pro-
posed version exists in fragmented form at the Accademia di San Luca in Rome (figure 10).
Initially the sculptor proposed to erect the figure in the right transept of Saint Peter's, near
the altar of Saints Processus and Martinianus. After gaining the approval of the pope and the
cardinal secretary of state Consalvi, Canova encountered the determined opposition of the
chapter, who argued that a monument eight meters high would cause structural damage to
the basilica. The artist tried to allay such fears by consulting the prominent architect
Giuseppe Valadier, who denied that there would be any danger to the building's fabric. The
chapter was still obdurate, and it is hard to avoid concluding that a representation of religion
on such a scale by an artist better known for nude mythological figures might be an inno-
vation uncongenial to the reactionary times.[47] Indeed, the nudity of the genius of death on the
Clement XIII tomb was already creating suspicions about Canova's orthodoxy in some ul-
traconservative quarters, and a few years later the twin nude genii of the Stuart cenotaph
were to raise storms of pious protest. Rebuffed, Canova turned to the clergy at the Pantheon,

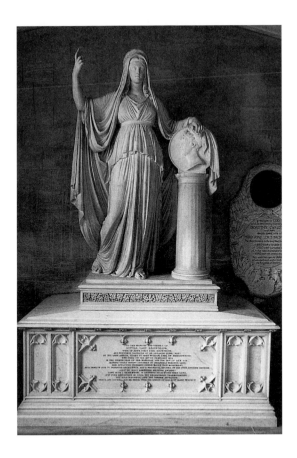

FIGURE 11

Antonio Canova, *Protestant Religion,* marble, ca. 1815–16. Belton, Lincolnshire, parish church.

where he had earlier commissioned a series of busts of great Italian cultural figures from several Roman sculptors. The Restoration Pantheon seems to have been a center for politicized religious imagery after the return of Pius. A prize student of the Accademia di San Luca, Carlo Viganoni, who was supported by the prominent painter Gaspare Landi, successfully exhibited a *Sacred Heart of Jesus Adored by Pius VII and Louis XVI* at the Pantheon,[48] whose proper designation, Santa Maria ad Martyres, may have taken on new meaning in the post-Napoleonic period. When the Pantheon priests rejected the statue (where would they have put it?), Canova applied to the Church of Santa Maria degli Angeli, with the same result.[49] Frustrated, he abandoned the project, afterward producing a much reduced and iconographically altered version for a Protestant parish church at Belton in Lincolnshire (figure 11), commissioned by Lady Sophia Brownlow.

Religion was so important a work to Canova that he sent drawings to Cicognara and Bossi, among others, asking for criticism and discussing his ambitions for the monument that was to honor both religion and the restored pontiff. In October 1814 he described the model for Cicognara and expressed the hope that it could be executed in only two pieces, to facili-

tate both transport and installation and also to save money, since a single marble block would have been prohibitively expensive.[50] The count was highly enthusiastic about the undertaking, and two years later, when Francesco Hayez painted a group portrait of the nobleman's family, Cicognara and his wife, Lucia, are shown admiring an engraving of Canova's *Religion* while a large bust of the sculptor, a gift to his friend, looks on.[51] Bossi, in contrast, disapproved of the design and criticized the lack of symbolic legibility. He questioned what form of religion Canova wished to express: modern, Roman, or papal. Moreover, he rejected the entire notion of the work as a monument for Pius VII, writing, "If you want to make a monument to Pius VII, do it elsewhere."[52] Canova responded to Bossi's criticism when Pius returned from France by sending the pope three small models differing only in the iconographies of the shield held by the figure. Pius selected the one that represented the Princes of the Apostles, Peter and Paul.[53] Yet another option is seen in a model in which Religion's left hand holds a medallion showing Pius VII adoring a crucifix, a sketch given by D'Este to Cardinal Zurla from Canova's studio after the sculptor's death in 1822.[54] Ultimately, however, Canova abandoned this extremely ambitious project, and when in 1818 the townspeople of Possagno asked him to help with the restoration of the parish church, the favorite son decided to build an entirely new church at his own expense, which proved considerable. It is the Tempio, rather than *Religion,* that is Canova's final profession of faith.

Melchior Missirini wrote in 1824, less than two years after Canova's death, that the Tempio at Possagno was an extraordinary tribute for an artist to make to religion in an age many contemporaries perceived as irreligious. Even in France, where Canova was deeply unpopular after the part he played in dismantling the spoils of empire in the Musée Napoléon, the *Journal des Débats* praised him for dedicating such a large sum of money to the glory of religion and eulogized a life spent in the service of art, faith, and his homeland.[55]

The architectural plan of the Tempio, which reflects Canova's syncretic notions and his aesthetic ideology, is highly appropriate for a church dedicated to the Holy Trinity, perhaps the most abstract of all Catholic dogmas. One enters the structure through a Greek Doric colonnade, finding then a Roman Pantheon that leads to a Christian chancel, an architectural metaphor for the chronological progression from classical civilization to the triumphant Christian present.[56] Canova's friend Gianantonio Selva and others assisted in the design, but there is little doubt that the general conception, and some of the decoration, were his own. The building is certainly in sympathy with the spiritual politicization of the Restoration—grand, historically rich, and authoritative—and underscores the faith of an artist who was finally free to express it.

Any discussion of Canova's religious convictions must include *Mourning the Dead Christ,* originally painted in 1799, while the artist was in Possagno, and presented to the parish church, where it was soon placed on the high altar (figure 12). Canova reworked the painting on two occasions, in 1810 and 1821, the second time in preparation for its placement over the high altar of the Tempio, which occurred only after his death. This deeply moving picture, his only monumental religious painting, was executed at one of the most difficult times in Canova's life. The primitive and Purist tendencies in the work are remarkable, as is its

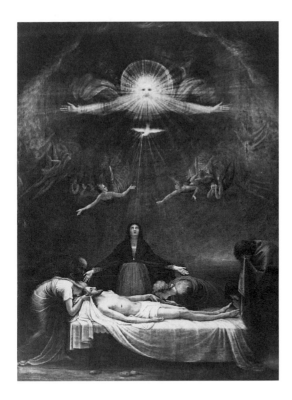

profoundly mystical tone, unusual for a sculptor ordinarily considered a rational classicist. It
is no great stretch to read the dead Christ in contemporary political terms, as a dead Italy,
whose only hope is the mediation of the Mother of Mercy with God the Father. The faith of
Canova's youth had been shaken to its foundations. Rome's churches had been pillaged;
many believed the deposed pope the last of his line; and independent Venice had been des-
olated.[57] Canova's letters from Possagno in 1799 often call on God's mercy as the only help,
and in deciding to give the picture a place of honor in the church that was his last testament,
he must have meant to affirm his belief in divine intervention.

The significance of religious faith to Canova was equaled by his intense interest in the ancient
Graeco-Roman world and his passion for its art and artifacts. Like many of his contempo-
raries, the sculptor saw no contradiction between Catholicism and classicism; indeed, the tri-
umph of the faith over paganism and its absorption of enduring notions of philosophical
truth and universal beauty from pre-Christian culture gave Christianity, above all papal
Catholicism, its unique luster. Canova's avocational obsession with antiquity did nothing to
upset the fundamental importance of his religion, and a balanced consideration of his char-

acter requires a discussion of his attitudes toward ancient art and society and their relevance to the late-eighteenth-century world.

Venice had fewer important antiquities than most Italian cities, but Canova studied and copied plaster casts of famous ancient statues in the academic setting of the celebrated Farsetti collection, although such study seems to have had only limited impact until after the artist had seen most of the originals in Rome and Florence.[58] Venice was rich, however, in architectural fragments and grave stelae of Greek origin, the result of centuries of trading and colonization in the Aegean and Asia Minor. Large numbers of such objects, along with a few statues, were to be seen in the Giustinian and Grimani collections, among others. Rare in Rome but common in Venice were funerary stelae with acroterion palmettes, decorated tympani, and central crowning elements, and many of Canova's later monuments attest to his study of these Greek works in Venice.[59] The monument in the narthex of SS. Apostoli dedicated to his Venetian friend the engraver Giovanni Volpato, to whose daughter Canova was once engaged (she jilted him), is a typical example (figure 13). Crowned with a pediment and palmettes, an idealized female reification labeled "Amicizia" in the ancient Greek manner mourns a bust of the deceased. The low relief and rectangular format are imbued with a lyricism and pathos characteristic of the Greek prototypes. Still, Canova in Venice was much more influenced by the traditions of late baroque naturalism than by antiquity until his initial visit to Rome in 1779–80. In his diary of that journey, he almost never mentions ancient art but lavishes praise on Michelangelo and the Bolognese painters. In Rome, he was enthusiastic about the masterpieces of antiquity, but in an undiscriminating, unfocused way. The friendship and tutelage of Gavin Hamilton, the abbate Bonaiuti, Giuseppe Cades, and Girolamo Zulian quickly "converted" Canova to antiquity, and he never looked back.[60]

On his return to Venice in 1795 to install the *Monument to Admiral Angelo Emo* (see figure 24), Canova took much greater interest in the city's antiquities than he had taken as a young student in the 1770s. He noted the many ancient fragments in squares, courtyards, and even the streets, semiabandoned and neglected, and began to concern himself with their better display and protection. He undertook one major mission to rescue a large statue of a muse he believed to be Melpomene and, with the help of the librarian and antiquarian Jacopo Morelli, secured the statue for the civic collections.[61] As head of the famed Biblioteca Marciana, Morelli was also responsible for Venice's considerable collections of public sculpture, and he asked for Canova's help with their reinstallation; previously, they had been jammed helter-skelter into an anteroom of the library. Canova had been involved earlier with the evaluation and display of Zulian's antiquities, and his help was invaluable when these were donated to the republic. His recommendations to display them with maximum visibility to the public, exploiting their didactic qualities, indicate a thoroughly modern museological sensibility.[62] Unfortunately, lack of space and the political chaos that ensued with the collapse of the Venetian state prevented the full implementation of Canova's suggestions. While in Venice, Canova was also asked to give an opinion on an ancient Greek marble statue, and the response reveals his pedagogical interest in more accurate iconographies for antique statues; in fact, he was really arguing for a more rationally based art history:

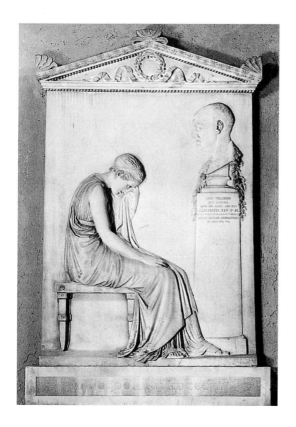

FIGURE 13
Antonio Canova, *Funerary Stele
of Giovanni Volpato,* marble, 1804–7.
Rome, SS. Apostoli.

"The statue is very ancient and perhaps predates Phidias, as the straight lines demonstrate, the stillness of the action, and the head without the minimum inclination. It is six *piedi* high and represents Tragedy, with the tragic mask in the right hand; it lacks the left arm; in the rest it is all ancient."[63] Canova's iconography was borne out by subsequent research, but the work proved to be archaizing rather than archaic. The concern with accuracy and rationalism in the evaluation of antiquities allied Canova to advanced archaeological opinion, represented above all by such scholars as Ennio Visconti and, later, Carlo Fea. In a very real sense, Canova's tribute to the discipline was disinterested, for he wished neither to collect nor to copy. He also consistently declined to be involved in the highly lucrative business of antiquities restoration.

Although not opposed to the contemporary practices of restoration represented, above all, by Bartolomeo Cavaceppi,[64] Canova always urged caution and circumspection. Influenced by contemporary philology, he advocated careful study and a reasoned attempt to determine the correct iconography rather than accept traditional identifications. In his capacity as director of the Vatican Museums, he was able to put his precepts into practice when the pope acquired the so-called Giustiniani Philosopher. After careful study, Canova was convinced that it actually represented a tragic actor, so he ordered its modern head removed and replaced it with an ancient head of Euripides, a more appropriate choice.[65]

Canova was encouraged, not only by his own natural interest in ancient statuary, but also by his close contacts with Rome's British community, many of whom were deeply involved in archaeological excavation, restoration, and the antiquities market. James Byres, Thomas Jenkins, and Canova's mentor Hamilton were prominent members of this group, and their new excavations at such extramural sites as Tivoli and Gabii yielded some of the century's most significant finds. Most locals preferred exploratory digs at sites within the city, which were rapidly exhausted under the constant assault. Clement XIV and Pius VI permitted excavations, in theory for the benefit of the new pontifical museum; the pope and the state were to keep the better half of the works unearthed, while the owners of the sites and the excavators were to split the rest. Certainly arrangements were made to circumvent statutes, and there was considerable corruption, but both the papal collections and the market flourished.[66] Later, as Presidente delle Antichità under Pius VII, Canova proved much more diligent than his bureaucratic predecessors in trying to protect Rome's ancient patrimony.

The papal interest in keeping antiquities in Rome, both those newly excavated and those in private collections, increased dramatically after the spoliation of the museums by the French in 1798. Quatremère de Quincy, among others, had already protested against the dispersal of antiquities through the art market, above all to British private collectors, since it separated students from worthy objects of study and often rendered important works inaccessible.[67] But the insidious flow of objects from Rome and the States of the Church to Britain was nothing compared with the Treaty of Tolentino's depredations, the confiscation of the Albani and Braschi collections, the forced sale of the best part of the Borghese antiquities to Napoleon, and the outright looting that occurred during the two periods of French occupation. Canova sympathized with Quatremère's ideas, arguing at the Tuileries in 1810 that such works as the Farnese Hercules should be allowed to remain in Italy, since the ancient masterpieces (by implication including those in the Musée Napoléon) were part of a context that could not be removed, and it was the context that gave the works their fullest meaning. He also asserted that the Romans had an inalienable right to works excavated from their soil that neither the private owners nor even the pope could abrogate.[68] A strong advocate of the Pacca Law of 1802, Canova was eager to protect potential finds in Rome, which was then undergoing massive treasure-hunting digs directed by the imperial authorities. Napoleon smugly asserted to Canova, when he complained about the loss of so many ancient masterpieces, that Italy could indemnify itself with new excavations.[69]

The issue of export licenses for antiquities was closely connected to the practice of restoration, partly because the more modern work an "antiquity" contained, the more readily an export license for it could be obtained. These procedures were upset during the French interlude, however, because there were very few non-French foreigners buying art in Rome, and there was little incentive for the French to stop the flow of works of art to France. But under Canova's direction during papal rule, the system was more effective than it had ever been. The attempt to export a Cinquecento bronze horse by the collector Ignazio Vescovali in 1815 may serve as a case in point, although it was, properly speaking, not an antiquity. The antiquarian Carlo Fea, a member of Canova's cultural administration, recommended export,

but his opinion was challenged by Giovanni Battista Monti, the assessor for sculptural export licenses, who stated that "the merit of said horse equals the antique." Canova was the arbiter. He examined the horse, three *palmi* high, noting that the legs, head, part of the neck, and all of the tail were modern work and left it to Cardinal Bartolomeo Pacca, the papal chamberlain, to decide.[70] The sculptor, who fought so hard on other occasions, chose not to fight in this instance, and it seems reasonable to suppose that he based his decision on the heavy restoration of the bronze horse. Pacca allowed Vescovali to export it.

Many of Rome's leading sculptors were deeply involved in antiquity restoration when Canova arrived in 1779. Such work was considered a natural sideline in a market where there were far fewer major commissions than in previous periods. Vincenzo Pacetti, Giuseppe Angelini, Domenico Cardelli, and Francesco Massimiliano Laboureur, to name only a few prominent figures, willingly restored antique statues.[71] That Canova refused to do so was extraordinary. And although he also declined to make copies, believing rather sententiously that those who copied were subsequently not copied by posterity, he seems not to have had the same qualms about copies that he did about restorations. I suppose he worked with the understanding that making a copy was better than removing an original from its context; copying, moreover, provided employment for Rome's sculptors. When the king of a rapidly shrinking Poland asked for copies in 1789, Canova recommended his friend Antonio D'Este to the monarch through an agent named Bacciarelli. He also suggested that the prominent Angelini might copy the Farnese Hercules for a price of 1,500 scudi.[72] When Lord Elgin approached Canova to restore the Parthenon marbles, however, he being the best sculptor available, the Italian artist declined, stating that since they had never been restored, it would be best to leave them alone, and that it would be a sacrilege to touch them. Understanding Elgin's desire to enhance their aesthetic and monetary value in the eyes of a public conditioned by generations of restored, "whole" antique statues, Canova suggested that John Flaxman would do less harm to them than anyone.[73] Rarely was the distinction between copies and restorations so clearly defined in terms of the integrity of ancient works of art.

As a champion of classicism and the masterworks of antiquity, Canova was always measured against ancient achievements, and was sometimes found lacking. Working in an academic tradition that favored painting over sculpture, moreover, the artist found it difficult to rise to unquestioned eminence. The conception of ancient standards of beauty rested on a relatively small group of "canonized" statues, the vast majority of which were in the papal collections or in the palaces of the Roman, Florentine, and Neapolitan nobility. Though Canova's contemporaries paid lip service to Winckelmann's notions of the superiority of the Greeks, so little was known of real Greek sculpture that Roman copies were endowed with Hellenic qualities. The arrival of the Elgin marbles in western Europe immediately altered this view, and Canova's art was profoundly affected.[74]

A commonplace criticism of Canova's sculpture was that he was without peer in the beautiful mode, but his work in the *genere forte* was inferior, perhaps because it did not suit his temperament. A subtle gender issue underpins this criticism, since his Venetian heritage of colorism and grace was usually designated feminine and unintellectual, a response doubt-

less encouraged by the preponderance of nude female mythologies in his oeuvre. The choice of such subjects had as much to do with contemporary patterns of patronage and taste as it did with the sculptor's personal preferences. Even when Canova worked in the dynamic (read masculine) mode, he was lambasted for making his figures too agitated and forceful, above all in the *Hercules and Lichas* (see figure 55) and *Theseus and the Centaur* (see figure 63). Canova based his response to such criticism on his superior knowledge of ancient sculpture as much more diverse both formally and stylistically than most imagined it to be, in particular those who had read of the "calm grandeur" of the Laocoön. To Canova, the Uffizi Gladiators, the Borghese Gladiator, and the Laocoön were vital ancient precedents for his more physically expressive works, just as the Apollo Belvedere and the Medici Venus were points of departure for such heroic and beautiful statues as the *Perseus with the Head of Medusa* (see figure 14), the *Venus Italica,* and *The Three Graces* (see figure 52).[75]

The academic tradition that had developed in Italy during the Renaissance before spreading to the rest of Europe generally privileged painting over sculpture, at least in theory, because of the association of sculpture with materiality and intense labor. In practice, however, this mild prejudice had little impact on either academic politics or professional reputation, at least in Italy, as a brief consideration of the fame and influence of Donatello, Michelangelo, Bernini, and Canova himself confirms. Canova was eager to give the sculpture of the ancient world pride of place. Quatremère, reflecting Canova's views, wrote in 1804 that sculpture "was the necessary art, the political art, the dominant art of the ancients. I am persuaded that it continually gave style to painting. A description of ancient painting too much resembles the description of a bas-relief for one to be able to doubt it."[76] This statement seems more than just a philological speculation, and its presence in a "puff" for Canova indicates Quatremère's involvement in the critical construction of the sculptor's international reputation. This widely acknowledged eminence, aided by such critics and scholars as Quatremère, would serve Canova well in his dealings with the various personalities and political ideologies of revolutionary and Napoleonic Europe.

2

CANOVA'S *ITALIANITÀ* AND

A TALE OF TWO CITIES:

VENICE AND ROME

IT IS DEEPLY IRONIC THAT THE FRENCH DOMINATION of Italy during the early years of the nineteenth century that helped to foment the Italian unification movement also encouraged cultural nationalism, an ideology opposed to the synthetic, centralizing tendencies characteristic of both the Napoleonic Empire and the political Risorgimento. Cultural nationalism, its roots deep in the eighteenth century, was at odds with certain rationalist philosophies inspired by Enlightenment thought that helped give birth to Napoleon's empire, above all Josephinism, which attempted, with limited success, to impose standardization and ethnic amalgamation on the polyglot Habsburg empire. Later, Napoleon attempted a similar homogenization on a European scale, only to arouse the hydra of militant nationalism. As Johann Gottfried von Herder argued long before Napoleon, political independence was not a precondition of ethnic pride.[1] Ethnicity, with its cultural particularism and delight in difference, gave rise to the cultural nationalism that was eventually absorbed in Italy by Risorgimento politics.

Antonio Canova was arguably the most important figure in the Italian culturalist paradigm, for he was a dedicated proponent of *italianità* and, simultaneously, one of its cult heroes. But his cultural nationalism was highly particularist; he no more wanted a politically united Italy than a French hegemony in the peninsula. Like Quatremère, Canova believed that the political division of Italy had promoted the rival schools of art, architecture, and literature that had given Europe a profoundly rich cultural heritage.[2] Italy was neither a nation in the political sense nor a "mere geographical expression," to quote Metternich, but a cultural concept. And cultural nationalism, unlike its political counterpart, was essentially not militant but sentimental, and needed only peace and political stability for the highest possible level of cultural production. The thought of a political movement to unify Italy, with its attendant civil wars, destruction, economic ruin, and threat to art and monuments, would have been utterly abhorrent to an individual of Canova's sensibilities.[3]

Perhaps the absence of unified political and military power, in combination with the international attention devoted to works of art and other monuments in Italy encouraged Italians generally, and Romans particularly, to appreciate indigenous artists and works of art. Tourism, a major force in the Italian economies since the end of the seventeenth century, had awakened local populations to the importance of indigenous art, and many Italians understood both the cultural and economic value of their monuments and collections. Until the French conquest of the 1790s northern and central Italy, though long the battleground of Europe, had witnessed little vandalism or looting of works of art since the early Cinquecento, and for this reason the spoliation was especially shattering to the people, causing anti-French violence in many cities, including Verona, Parma, and Rome. After the conquest of his duchy and the French seizure of the masterworks of Correggio from his gallery, the duke of Parma offered a king's ransom for the paintings, but to no avail. The situation at Rome was even worse, since the Armistice of Bologna (1796) and the subsequent Treaty of Tolentino (1797) between the Holy See and France demanded the cession of one hundred works of art, among them the most famous ancient sculptures in the world and beloved paintings by Raphael, Annibale Carracci, and Domenichino, among others. François Cacault, the French minister in the papal capital at the time of the cession, wrote to the Foreign Office in Paris about the desperation of the Romans to save their collections: "The article of the armistice with Rome, which stipulates that the hundred most beautiful works of painting and sculpture be delivered to us, strikes to the heart of the Roman people and of all Italy. . . . Italy would watch the Pope cede to us, without a thought, all the provinces belonging to the Apostolic Chamber, if we wanted to take them in exchange for the monuments."[4] The confiscation of works of art, manuscripts, cameos, medals, jewels, church plate, vestments, botanical and zoological specimens, and other cultural and scientific properties by the French, unprecedented in modern times, did much to turn moderate opinion against them. Italy could tolerate foreign occupation, as it had for centuries, but so humiliating was the removal of works of art that it gave a major impetus to the growth of cultural nationalism.

The looting of Italy's cultural patrimony also focused greater attention on contemporary art and artists. Canova's celebrity gave him the greatest visibility, but others also benefited. Many hoped that works by Canova could help to restore the lost luster of the Museo Pio-Clementino, replacing antique masterpieces with modern ones, a desire celebrated in an 1801 sonnet dedicated to the sculptor by the papal architect Giuseppe Antinori. Four years later, after Pius VII had acquired *Perseus with the Head of Medusa* and the *Pugilists* for the papal museum, an epigram by Giuseppe Capogrossi claimed that the *Perseus* had displaced the Apollo Belvedere not only in the Vatican Museums but also in the popular imagination (figures 14 and 15).[5] The designation "Perseo Consolatore" that Italian visitors to the Pio-Clementino gave Canova's graceful masterpiece was made even more poignant by the statue's display on the Apollo Belvedere pedestal, left behind by the French.

If Canova's sculptures partially compensated Italy for its losses, the artist himself became a prized cultural commodity, as biographers and eulogists apotheosized him during his lifetime and after his death. Pietro Giordani spoke of him as a glorious consolation to the

stricken nation in 1810,[6] and as early as 1803 the architect Giacomo Quarenghi wrote to him in highly flattering terms, claiming that Canova's achievements demonstrated "that our unhappy Italy in such difficult times can still take the leading place in the fine arts."[7] Canova was not the only beneficiary of this new attitude toward contemporary artists. For Romans and Italians, Vincenzo Camuccini, the leading painter of the Roman school, became a symbol of Italian greatness in the arts.[8] Italy, more than other nations (one thinks especially of England, Spain, and the Netherlands), had always prized its prominent artists, but the loss of most of the finest works of art to France seemed to galvanize the public to express unprecedented adulation of contemporary practitioners. Indeed, this adulation reveals a confidence notably lacking in other spheres, and it is easy to understand how this faith in Italian cultural superiority could be transferred into direct political action during the Risorgimento.

The celebrity status famous artists like Canova and Camuccini enjoyed among Italians indicates that in their time, as in the past, the national psyche was receptive to art as a living, organic feature of modern life. Cultural nationalism was intimately connected to emerging ideas of art in context, the belief that art is produced, not in a vacuum, but in a specific environment, which gives it meaning. Because removing a work from its context robs it of that meaning, Canova believed that the Italian patrimony belonged in Italy, where the monuments, other works of art, ancient ruins, and even the sunlight gave it full resonance. The French policies of confiscation and looting had done immense harm to the aesthetic and pedagogical, not to mention the cultural and historical, qualities he believed immanent in works of art. In taking this position he ran headlong into another ideology, art for the museum, represented by France and Napoleon.[9] The Musée Napoléon, besides being a repository of "trophies of conquest," also represented the centralizing tendency characteristic of Directory and Napoleonic politics. Whereas French attitudes arose from rationalist principles established earlier in the eighteenth century, Canova based his ideas on such intangibles as the spiritual power of the original context and the mystery of sacred sites. The museological principle provoked the removal of art from widely scattered churches, galleries, shrines, convents, oratories, and public spaces in Italy and its consolidation under a French roof. What in Italy had been living art became in France dead specimens in a temple of "taste."

Canova, for whom protecting the cultural heritage of Italy was a keenly felt responsibility, used his personal resources and his influence with the political authorities in this cause. In 1803, as inspector general of the fine arts, he presented Pius VII with approximately eighty ancient marble statues, reliefs, and architectural fragments to prevent their export. The collection from which the objects came had belonged to the Giustiniani family, just one of the Roman aristocratic families willing to sell their works of art because of increasing impoverishment. The diminished papal treasury found it more and more difficult to keep works from such private collections from leaving the city. In another preservationist gesture Canova in 1817 presented the important Vitali collection of medals to the pope. Fearing that they would be confiscated or stolen, Canova had hidden them from the French during the occupation. His concern was justified by the activities of the French smelters in 1798 and 1799, when church

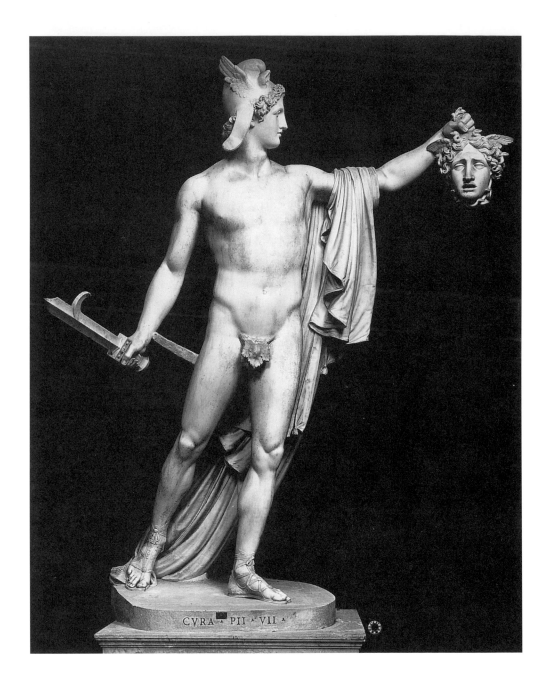

FIGURE 14
Antonio Canova, *Perseus with the
Head of Medusa,* marble, 1797–1801.
Vatican City, Musei Vaticani.

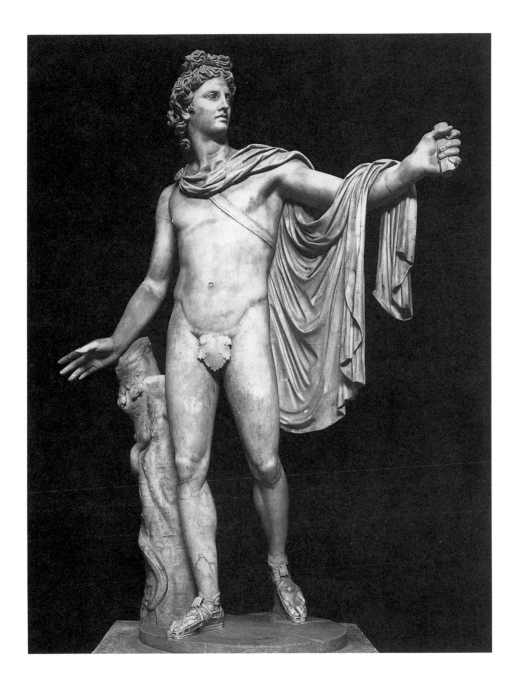

FIGURE 15
Hellenistic, Apollo Belvedere,
marble, ca. 350 B.C. Vatican City,
Musei Vaticani.

plate, rare coins, medals, silverware, and even copper pots were seized and melted down to
make coins to pay the troops and to send back to France.[10] These activities had alerted Canova
to the great vulnerability of small objects, for he understood that artistic value would always
go to the wall in a contest with monetary worth. With an irreplaceable part of Rome's cultural
heritage lost forever, the sculptor determined he would preserve and protect what he could.
The destruction of metalwork, especially church plate, continued during the imperial occu-
pation of Rome and in other French-dominated parts of Italy, but at a diminished rate.

Canova's *italianità* is perhaps best seen in his *Monument to Vittorio Alfieri* in the Church
of Santa Croce in Florence, the capital of Tuscany (figure 16). Although the anti-French
tenor of Alfieri's poetry may have elicited the sculptor's admiration, it did not inspire him, as
it did many others, to dream of an Italian nation. Nonetheless, the subject, site, and iconog-
raphy resonate remarkably with Italian aspirations, but on a cultural rather than a political
level. The monument was commissioned by the dead poet's former mistress, the countess of
Albany, widow of the Stuart pretender to the British throne who had long lived in exile in
Italy. Albany's current lover, the French painter François-Xavier Fabre, was involved in
the project and handled most of the negotiations with Canova.[11] The countess, who origi-
nally suggested something more modest, eventually decided on a grander tomb.

The venerable Church of Santa Croce that housed the monument became associated
with Italian cultural nationalism early in the nineteenth century, aided by the widespread
popularity of Ugo Foscolo's celebrated poem "I Sepolchri." A hope for future political uni-

fication runs through Foscolo's work, and Santa Croce itself later became one of the cult temples of the Risorgimento. That Canova's monument to Alfieri was the first erected in the church by a non-Tuscan artist to honor another non-Tuscan (Alfieri was Piedmontese), helped to give Santa Croce a national, rather than merely local, visibility.[12] Both Alfieri and Canova cherished notions of *italianità*, but they understood it in vastly different ways. To the Venetian artist, Italy was a cultural phenomenon of matchless grandeur; to the Piedmontese poet, Italy's cultural greatness was a principle supporting political action. Both men resented foreign occupation and oppression, but Canova would not have contemplated military resistance. In the traditional Italian way, harsh foreign occupation could be relieved only by another foreign power whose rule might be benign. Italian unification would have meant (and in the event actually did mean) the annihilation of both the Republic of Venice and the secular power of the papacy, an outcome anathema to Canova.

The overt politicization of the Alfieri monument by some scholars, who assume that its later interpretation reflects the intentions of its creator, is based largely on the mistaken belief that the mourning figure of Italia is the first modern representation of Italy.[13] She leans pensively on the sarcophagus of the poet, her headpiece a crenellated tower, a symbol of Italy's august medieval past. Canova had used a similarly attired figure to personify the city of Padua in the *Stele of Nicola Antonio Giustiniani* (figure 17), commissioned in 1796. The archaizing tower in the Giustiniani monument refers to the old city-state of Padua, supposedly founded by the Trojan Antenor; the attribute generally represents the powerful city-states of medieval and early Renaissance Italy, before the beginnings of foreign domination. Canova's was not the first modern use of a crenellated tower as Italia's crown. Between 1788 and 1790 Sigismondo Chigi commissioned a suite of distemper wall murals for the Palazzo Chigi at Ariccia in Lazio from the painter Giuseppe Cades. One of the preparatory drawings for the grisaille decorations shows a female figure, crowned with a crenellated tower, designated "Italia Nova" to distinguish her from her pendant, "Graecia Vetus" (figure 18). The figure of Italia holds a serpent biting its tail, a symbol of immortality later used by Canova in the *Tomb of the Archduchess Maria Christina of Austria* in Vienna (see figure 58); she also wears a tiara and bears a cross-topped scepter. A cornucopia rests against her throne.[14] This Italia not only predates the carved figure in the Alfieri monument but may well have been Canova's source. Cades, who had been a friend of Canova's since the Venetian's arrival in Rome, belonged to the group who helped the artist improve his knowledge of ancient culture, art, and mythology. Canova may well have seen Cades's designs for the Chigi commission. But with or without a direct connection between Cades's "Italia Nova" and Canova's Italia, the political argument that Canova invented the figure is inaccurate, thus making the monument's politicization a much more uncertain, if not wholly ambiguous, proposition.

Even if we reject a politicization of the Alfieri tomb based on the presence of an "original" modern Italia, the monument was nonetheless intended to have a distinctly Italianate flavor, to celebrate cultural *italianità*. And Canova must have known that some viewers would find implicit anti-French, if not pro-unification, sentiments in the monument; I suspect it was for this reason that he declined the request of General Miollis, the governor of

FIGURE 17
Antonio Canova, *Stele of Nicola
Antonio Giustiniani,* marble, 1796–97.
Padua, Museo Civico.

Rome, to visit his studio to see the work in progress. He was never as polite to Miollis as he was to such French functionaries as Camille Casimir comte de Tournon, whom he respected for his attempts to ease the hardships of occupation and whose love of the Eternal City almost equaled his own. But Miollis, the commissioner in charge of the spoliation of the city's museums, was deeply involved in suppressing the papal government, and Canova may well have suspected the general's motives in wishing to see the monument to a cultural hero of Italy who had opposed French imperialism in the peninsula. In sum, if there is a subtle political agenda in the eloquent *Monument to Vittorio Alfieri,* its essence is more anti-French than pro-unification. Italia weeps because she feels keenly Italy's misfortunes at the hands of the French, not because she dreams of yet another war to create a new nation.

Canova's political patriotism had only one true object, his unswerving loyalty to the Serene Republic of Venice, whose extinction at Bonaparte's hands he regretted for the last twenty-five years of his life. This Venetian particularism precluded any desire for a politically unified Italy,

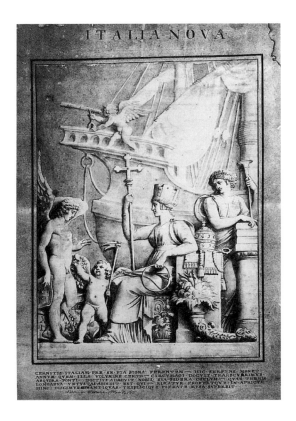

FIGURE 18
Giuseppe Cades, *Italia Nova,*
pen and brown ink drawing, 1788.
Vatican City, Biblioteca Vaticana.

and when Canova used the word *patria* in his letters, especially those written to other Venetians, he usually meant the Veneto. Dismay at the fall of Venice in 1797 was compounded almost immediately for Canova by the arrival in Rome of the French commissioners who would select the hundred works of art to be extracted from the Papal States according to the articles of the Armistice of Bologna. A letter of April 8, 1797, from Antonio D'Este in Rome to Gianantonio Selva in Venice described the sculptor's desolation, which led him to contemplate making an uncharacteristic political sculpture, described by D'Este as "a bas-relief representing the faithful provinces [of Venice] who swear fidelity to their legitimate prince. What this bas-relief will be, and of what merit, I leave it to you to consider. Love, gratitude are what motivate our friend."[15] Canova never executed the work, but that he even considered it indicates the fervor of his attachment to the republic. Numerous anti-French revolts in the Terra Ferma (the worst, at Verona, brutally suppressed) would have helped inspire a tribute to the provinces of the city. The years 1797–1800—from the fall of the republic until the arrival of the newly elected pope, Pius VII, in Rome—were the most difficult of Canova's life. The artist wrote to Quarenghi in Russia that he would never be a *cittadino* of the Cisalpine Republic and later added, "I have Saint Mark in my heart and nothing in the world will change me."[16]

Canova's early success in Venice gained him a reputation that facilitated his entry onto the

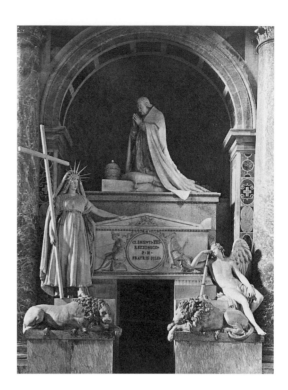

FIGURE 19
Antonio Canova, *Tomb of Pope Clement XIII Rezzonico,* marble, 1787–92. Vatican City, Saint Peter's.

Roman cultural stage, a process accelerated by his contacts with influential Venetian patricians in the papal capital. His acquaintance with the Farsetti family had given him access to the casts of famous works of ancient and modern sculpture in their collection, and the abbate Filippo Farsetti in Rome had introduced him into the progressive cultural circle of Cardinal Alessandro Albani, whose celebrated villa contained one of Rome's most notable private collections of ancient sculpture, including the famous Antinoüs relief. The circle around Ambassador Zulian had a strong British connection that benefited Canova while he was living in the Palazzo Venezia, where he met Gavin Hamilton; and Farsetti, the Scottish artist's close friend, who also knew James and Robert Adam, strengthened Canova's links to the British. In addition, Zulian was first cousin to the deceased pope Clement XIII and played a role in promoting the Venetian sculptor with the Rezzonico family, which ultimately commissioned the *Tomb of Pope Clement XIII Rezzonico* in Saint Peter's (figure 19).[17] Two of Clement's nephews, Cardinal Carlo and Senator Abbondio Rezzonico, patronized and promoted the young sculptor. Through this family, moreover, Canova met Giuseppe Cades, and from Senator Abbondio he received the commission for *Apollo Crowning Himself* (figure 20) as a competition piece to the well-known Giuseppe Angelini's *Minerva the Peacemaker,* the first challenge by the emerging neoclassical style to the lingering *settecentesco* tendencies of the Roman school.[18] Canova's deeply felt gratitude to Farsetti and the Rezzonico family contributed to his political attachment to the Serene Republic and its patrician traditions.

The impact of Venetian nationalism on Canova is perhaps best understood by considering his relationship to the cavaliere Antonio Cappello, a Procuratore di San Marco and successor to Zulian as Venetian ambassador to the Holy See. Cappello and a large group of Venetian patricians asked Canova to execute an imposing monument in honor of the Procuratore Francesco Pesaro, a violently Gallophobic bureaucrat who fled to Vienna when the republic fell, only to return as a commissioner of the Habsburg Empire after Venice's transfer to Austria. Pesaro died in 1799, the year of the commission. At first Canova declined, having too many other projects, including a similarly grand funerary monument for Archduchess Maria Christina that he had accepted the previous year, but ultimately he agreed, saying he was delighted to employ his talents for the *patria*.[19] In short order he produced a small model (figure 21),[20] a combination of freestanding figures and reliefs, the iconography highly patriotic. Pesaro's medallion portrait on the sarcophagus lid crowns a large relief rep-

FIGURE 21
Antonio Canova, *Tomb of Francesco
Pesaro,* wax and wood, 1799.
Venice, Museo Correr.

resenting the Venetian provinces beseeching the Three Fates not to cut the thread of Pesaro's
life. At left, a large female personification of Venice weeps quietly over the sarcophagus,
while a cherub holds the ducal crown. The Venetian lions of Saint Mark appear at either
end. The new Austrian administration, far from frowning on such an overtly nationalistic
project, encouraged it as a way of more closely tying the internationally famous sculptor to
the city. The government in Vienna even considered constructing a studio for Canova in
Venice, hoping he would occupy it for at least part of the year, but this idea came to nothing.
Ultimately, Cappello was unable to sustain the interest of the thirty-three patrician sub-
scribers, and the cession of Venice to France in the Treaty of Pressburg in late 1805 effectively
canceled the project. Canova, understandably disappointed, reproached Giuseppe Priuli,
one of the original commissioners, for Venice's poor showing in the arts, as exemplified in
both the failure of the Pesaro tomb and the abortive monument to Titian.[21] The nature of the
commission and the iconography, however, reveal that Canova could be a political artist
when it was a question of Venetian patriotism.

The failure of the monument to Francesco Pesaro did not dampen Cappello's enthusiasm for Canova or end his efforts to promote an artist whose cultural glory, he hoped, would benefit Venice politically. Cappello, the single most important collector of Canova's bas-reliefs and *modelli,* in 1795 had commissioned a full-length statue of the artist for Padua's Prato della Valle, a public park near the Duomo where statues of worthies were set up as an alfresco hall of fame—an unprecedented honor for a living person. Earlier, Canova had executed a statue of the Venetian mathematician Giovanni Poleni for the same site. In the Procuratore Nuove, a governmental building on the Piazza San Marco, Cappello had the architect Selva install an extensive collection of plaster casts of Canova's works for public display, and he opened his own house so that art students could see his collection of original works by the sculptor.[22] While not nearly so intimate with the artist as Zulian and the Rezzonico, Cappello did as much as anyone to promote Canova's cult in the city on the lagoon.

Unquestionably, the Republic of Venice sought political and cultural advantage through its association with Antonio Canova. The sculptor's triumphs in Rome during the 1780s were closely observed back in Venice, and his fame occasioned several politically inspired commissions, including the *Monument to Admiral Angelo Emo* (see figure 24), and the tomb project for Titian planned for the church of the Frari. Moreover, the Venetian city of Padua ordered the Giustiniani stele for the Loggia del Consiglio and, after the Austrians took over, the Pesaro monument for the Basilica of San Marco. Encomiasts, poets, and politicians encouraged the cult of Canova as the new Phidias and compared Venice favorably to classical Athens. As Giuseppe Pavanello appositely observed, the promotion of the sculptor was Venice's "last attempt to revive its own myth."[23] Official encouragement for Canova's first trip to Rome, in addition to the pleasure it personally offered his patrons, was also a political act of considerable consequence for the republic, since Zulian and others had high hopes that Canova would become a famous artist. There can be little doubt that this was the primary motive behind Zulian's immediate support and protection. Canova's crash course in Italian and the classics was carried out under the ambassador's watchful eye, and Zulian also gently imposed a new regimen on the young sculptor, instilling in him an aggressive attitude toward learning that included early rising and assiduous study in the Pio-Clementino, the Capitoline, and various private collections. In addition, Zulian urged Canova to participate in the life drawing classes in Pompeo Batoni's academy.[24] Canova's course of study also included etiquette and social skills that allowed him to move with relative ease in exalted circles, and Zulian clearly discerned the financial advantage to Canova, and the political advantage to the republic, of introducing Canova to British collectors and figures of cultural importance. While no one, least of all an artist, was able to save Venetian independence, Antonio Canova gave the Venetian twilight a brilliance it otherwise would have lacked.

Venice's great expectations for Canova were fully realized with the triumphant success of the first important work he executed in Rome, *Theseus and the Dead Minotaur* (figure 22),

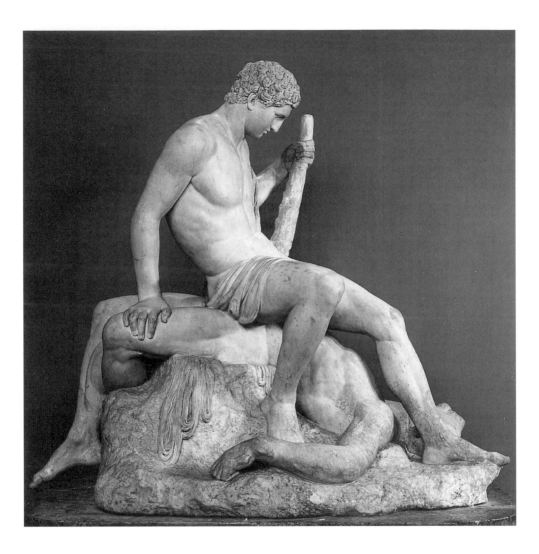

FIGURE 23
Anton Raphael Mengs, *Parnassus,*
fresco, 1761. Rome, Villa Albani.

commissioned by Girolamo Zulian, who generously allowed Canova to sell it to the Austrian count Moritz Christian von Fries. Completed in 1783, the *Theseus* created a sensation and pioneered an entirely new style in European sculpture. It might justly be considered the first neoclassical statue, much as Mengs's *Parnassus* (figure 23), in the Villa Albani, may be seen as the first major essay in neoclassical painting. While the work addresses major aesthetic and narrative issues, the subject may have been chosen partly for political reasons. Isabella Teotochi Albrizzi, a Venetian of Greek heritage born on Corfu, claimed in her book on Canova's sculpture, published in Pisa in 1821–24, that the work had an overt political message. Theseus was a hero who freed his native Athens from a cruel tribute, and Albrizzi understood the reference to Crete and its sadistic ruler. Before the French invasion in the 1790s, Venice's historical enemy was the Ottoman Empire, which as recently as 1715 had conquered Venetian Crete. A revolt by the Cretans, supported by Venice, had been bloodily suppressed as recently as 1770. Theseus, in this reading, is a future hero who will lead Venice to reconquer Crete and to destroy its bestial (and infidel) rulers, represented by the Minotaur.[25]

Albrizzi's political agenda for *Theseus and the Dead Minotaur,* however, has an important Austrian dimension, which has not previously been noted. In fighting the war that resulted

in the loss of Crete, Venice had been rescued by Austria's decision to ally with the republic and declare war on the Ottomans. The Treaty of Passarowitz (1718), imposed by the victorious Austrians on Constantinople, gained Venice some Aegean and Adriatic islands and parts of Dalmatia, securing Venice's territories until the fall of the republic. This treaty led to an Austrian alliance and a general peace for the rest of the republic's existence.[26] The purchase of the statue by an Austrian aristocrat may give even greater resonance to the work's political meaning. The Risorgimento's hatred of the Habsburgs, who long resisted Italian unification, and Austria's invasion of the Veneto and bombardment of the city during World War I, have obscured the close alliance of Austria and Venice during the eighteenth century, which I believe contributed to the initial acceptance of Austrian rule in Venice as vastly superior to that of the French. This was certainly Canova's opinion, as we shall soon see.

The success of *Theseus and the Dead Minotaur* and Canova's growing international reputation proved advantageous when Zulian and other interested patricians attempted to win a pension for the sculptor so that he might continue to study in Rome. Although several patricians petitioned the Senate on Canova's behalf, it still took a year for the government to act, not because of any doubts about his promise, but only because such a pension for a student artist was without precedent, surely enough cause for protracted deliberation by so conservative a body as the Venetian Senate. Finally, a decree of December 22, 1781, awarded Canova a pension of 300 ducats a year for three years. Its terms were unabashedly political, in that the republic was granting this extraordinary measure so that the artist "might in Rome perfect himself in his profession, and reflect honor on the republic."[27]

The most important, and one of the most politicized, commissions Canova executed for the Serene Republic was the *Monument to Admiral Angelo Emo* (figure 24), a stele honoring the intrepid Procuratore di San Marco and Admiral of the Fleet. Emo was the last of the great Venetian naval heroes. He invented a type of floating battery that could broadside the vessels of the Barbary pirates in shallow water, an innovation that effectively ended the seizure of Venetian merchantmen on the seas and the piratical raids on coastal settlements. Government ordinances forbade the erection of full-length, life-size representations of patricians, so Canova chose the stele relief format, depicting Emo as a bust on a column, his floating batteries in the background. A winged Fame crowns the hero in a moment of apotheosis.

Emo was widely mourned when he died in 1792, and a wave of patriotic nostalgia ensued, driven by the increasingly uncertain political situation.[28] Zulian and Falier suggested that Canova be asked to execute the monument, and it was duly ordered in 1795. The original site for display was to be the Palazzo Ducale, but for some reason it was placed in the Arsenal, much to the sculptor's displeasure. Like almost all Canova's dealings with the Venetian government, those for the Emo monument proved problematic, but frustration never eroded his support for his homeland.

It is curious that Canova and the Senate settled no price for the Emo monument; the artist must have wanted to appear modestly confident that the *patria* would amply reward

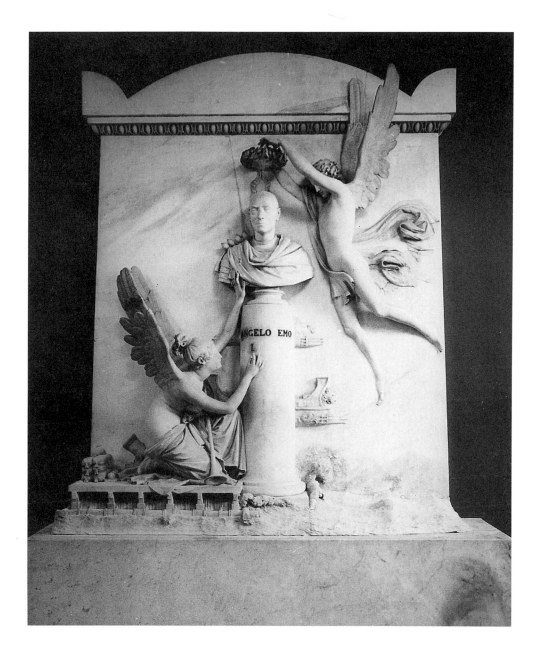

FIGURE 24
Antonio Canova, *Monument to
Admiral Angelo Emo,* marble,
1792–95. Venice, Museo Storico
Navale.

him. This unilateral understanding caused him a great deal of vexation. When the Senate suggested that the modest price proposed by the sculptor be examined, Canova was asked to supply a list of prices for similar works and was made to understand that the monument would have to be reviewed, apparently for quality and artistic merit, by a panel of artists— in short, a classic case of misguided bureaucratic vigilance. With Zulian no longer alive to shield him from the government's conduct, the artist provided the price list but absolutely refused to submit the work to peer review. He proudly stated that princes all over Europe trusted him enough to give him free rein and that a review would insult both him and the republic.[29] He continued his grievance by stating that he would keep the monument rather than subject it to a review and would use it as a memorial to his recently deceased grandmother. Canova's hypersensitivity to criticism made this no idle threat.[30] After the exchange of several letters, the idea of a review was abandoned, and Canova was offered a state annuity rather than a fixed price for the statue, a proposal to which he readily agreed. The intervention of the Savio Cassiere, Nicolo Erizzo, was apparently decisive. In a letter to Doge Lodovico Manin of September 15, 1795, Erizzo spoke of Canova's peerless status as an artist and his belief that, as a subject of the republic, the sculptor would do the best possible work on a monument destined for his homeland. He added that an annuity, rather than a lump sum, would be politically desirable, since it would give Canova "a convincing public testimony to the approbation and protection of his sovereign,"[31] or, more accurately, it would reflect glory on a government fortunate enough to have as a subject a cultural celebrity of the first rank.

The intervention of politics and war in 1797 allowed Canova little time to enjoy the annuity awarded for the *Monument to Admiral Angelo Emo*. The republic awarded Canova the pension to demonstrate to the world the "unequivocal esteem and the protection accorded by this government to those among its subjects capable of winning universal recognition in the fine arts,"[32] but the puppet regime set up by the French had more to worry about than paying a pension promised by its despised predecessor. Not least among the new government's problems was the huge indemnity Napoleon imposed to support the Army of Italy in the continuing war against Austria. Informed that Canova's annuity had been suspended, General Bonaparte wrote to the artist promising to continue its payment, but nothing ever came of the pledge. After the cession to Austria, while Canova was living at Possagno in 1798, he went to Vienna to ask the emperor to continue the pension. Francis II, eager to oblige his most famous Italian subject, agreed but stipulated that Canova live part of the year in Venice, a condition the artist rejected.[33] Canova must have heartily wished he had taken the Emo monument's full price in 1795, even if it had meant subjecting the work to bureaucratic whim.

France's political humiliation of Venice confounded the patriotic artist, but the looting of the city when the French withdrew in favor of Austria appalled and infuriated him. The cynicism of Directory France was clearly revealed when it betrayed the fledgling republic it had established in less than a year. The Treaty of Campoformio traded Venice to Austria in return for Lombardy and the Rhineland bishopric of Mainz; the Veneto was used as occu-

pying powers in Italy had traditionally used it, as a bargaining chip. Many Venetian progressives felt a moral disgust, and most simply wanted the Austrian takeover to be peaceful and quick, restoring some measure of order to the city and the region. As Foreign Minister Charles-Maurice de Talleyrand-Périgord expressed it in a letter to Napoleon of October 26, 1797: "The Directory is content, the public exultant. All goes for the better. The Italians perhaps will squawk some, but it counts little. Farewell, pacifying general."[34] Before the French evacuated Venice, Napoleon ordered it thoroughly sacked. The remnants of the navy and merchant marine were seized along with the naval stores in the Arsenal. Many churches and private residences were pillaged of works of art and precious metals, the loot being sent to Ancona in confiscated ships. The goods in Madonna dell'Orto, the art dealers' quarter, were seized and sold at ludicrously low prices, while French soldiers used the medieval walnut choir stalls from the nearby church for a bonfire. More overtly political looting was aimed at the ancient symbols of the Serenissima. The lion of Saint Mark was pulled down from its column in the Piazzetta and sent to Paris, where it was used as a fountain ornament; the famed horses above the portals of the basilica were deposed and eventually placed atop the Arc de Triomphe du Carrousel. Crusaders had looted these bronze horses from Constantinople early in the thirteenth century, a supposedly darker age. The final degradation was the burning of the *Bucintaur,* the doge's splendid ceremonial barge, to extract its gilding.[35] Napoleon's desire to devastate Venice was probably spurred by the risings in the Terra Ferma against the French occupation earlier in the year in which hundreds of French soldiers and sympathizers were killed in a manner reminiscent of the Sicilian Vespers.[36] The abasement of Venice was complete, and Canova never forgot it or forgave Bonaparte.

A last piece of Napoleonic "looting" that occurred in the autumn of 1807 directly involved Canova. Several years previously, the sculptor had made a standing *Psyche* (figure 25) as a present for Girolamo Zulian, to thank him for his many years of almost paternal support. Unfortunately, Zulian died before the statue could be delivered, and his heirs, members of the Priuli family, had no interest in paying the shipping costs, the import duties, and the cost of striking the medals Zulian had promised to make in honor of the statue and the sculptor in return for the gift. After many difficulties, the statue was sold to Count Giuseppe Mangilli, who exhibited it in his Venetian palazzo. Accompanied by the queen of Bavaria, Napoleon called there, and the queen was deeply impressed by *Psyche.* With typical impulsiveness Napoleon embarrassed the count by demanding to buy it, even though its owner had no wish to sell, especially since he did not want to see the statue leave Venice. Mangilli had to yield to persistent imperial pressure, consoling himself with a very high price. Napoleon then gave the statue to the queen, and it was dispatched to Munich.[37] After the failed projects for the Titian monument for the Frari and the Pesaro tomb for San Marco, the Emo monument and *Psyche* were the only important works by Canova in the city. The artist must have been chagrined to learn that a work he had executed with great affection had been alienated from his homeland through the agency of Napoleon Bonaparte.

Canova's anger at the French destruction of Venice, the reprisals in the Terra Ferma, the looting of the city, and the suppression of the republic stands in stark contrast to his relief at

FIGURE 25
Antonio Canova, *Psyche,* marble,
1793–94. Bremen, Kunsthalle.

the arrival of the Austrians in January 1798. On the twenty-seventh of that month, informed
of the situation in Venice, he wrote, "I do not have to strain [my imagination] to believe the
joy of all the Venetian population and that of the Terra Ferma at the arrival of the Austrian
troops; peace, tranquillity, security are real benefits not to be compared with the fantasies of
hotheads. May it please heaven that here we will be able to rejoice as you do! But here one
is in the hands of the Lord, in whom one greatly hopes."[38]

The temporary political settlement in northeastern Italy was much to Canova's satisfac-
tion. In discussing the division of territories in the Veneto and the Legations (papal territo-
ries, ruled by a cardinal legate responsible to the Holy See, including Bologna, Ferrara, and
Ravenna) in a letter to the abbate Daniele Francesconi of April 18, 1801, the artist expressed
a wish that as much territory as possible go to Austria. He mentioned rumors about the ter-
ritorial division, and hoped that the Habsburgs would acquire Verona and Polesine and that
the papal Legations, then under a military governor, would not be annexed by the Cisalpine
Republic the French had established in Lombardy. They had already turned out the Habs-

burg duke of Modena and transferred his territories to the Cisalpine Republic, a state for which Canova felt great antipathy. As the various secret clauses of the Treaty of Campoformio began to take effect, rumors were rife and fear was widespread, contributing to the high level of anxiety evident in Canova's letter to Francesconi.[39] Later in the letter, Canova gives him a commission relating to the gift Napoleon was to present to the newly crowned Pius VII, a diplomatic gesture much publicized by the French: "Tell Florian [a friend of Francesconi's] that the gift the first consul sent to the pope was the statue of the Madonna di Loreto, which they took some years back."[40] A wooden cult figure looted from the famous sanctuary in the Marches, it had little value besides its spiritual aura, and perhaps Bonaparte was hinting at the similar fate he had in mind for the Holy See. I believe Canova's comment was deeply ironic and unflattering to Bonaparte, who, he observed, was simply returning stolen property. A similar situation occurred in 1804. Napoleon, having forced the pope to come to Paris for his coronation as emperor, presented him with a jeweled tiara, an object the pontiff immediately recognized as a pastiche of tiaras taken from the papal treasury by the French in 1798.[41] Cardinal Consalvi thought the presentation a remarkably insolent gesture, and Canova's comment about the cult statue supports an equally negative view. The Austrians, in contrast to the French, removed very little from Venice, wanting to promote loyalty by showing respect for its cultural and historical traditions.

After the collapse of Napoleon's empire, Canova and many others turned their attention to repatriating cultural properties. The emperor of Austria was eager to restore the works taken from Venice to the city, rather than have them brought to Vienna, which he could have done. This traditional notion of preserving art and monuments in occupied territories was the polar opposite of French practices for the past two decades, and Canova was grateful for Francis II's strong support.[42] The Habsburg ruler involved himself in Canova's mission to Paris and sought the sculptor's advice about it. For example, the emperor asked the sculptor where the four horses of San Marco should be placed on their return, an issue that opened a heated political controversy. Canova mentioned the emperor's request in a letter to Cicognara of October 2, 1815: "The four horses have been lifted off the arch [du Carrousel], and they will return to Venice. The emperor told me that he wanted to have them placed according to my ideas, and I told him that they would be very well placed flanking the portal of the Palazzo Ducale, two on each side, facing San Giorgio [Maggiore]."[43] Characteristically, Canova favored better display for aesthetic reasons, although the Ducal Palace was hardly a politically neutral site, but Cicognara vigorously objected, saying the horses should be returned to their original place over the portal of the basilica because the people understood them as a patriotic symbol. He upheld this position in the treatise *Dei quattro cavalli riposti sul pronao della Basilica di San Marco, narrazione storica,* published in Venice in 1815.[44] Francis gave in to Venetian sentiments and ordered the horses back to their original place, a mollifying gesture in marked contrast to French practice in similar situations. The governor of Venice, Count Peter von Goëss, praised the horses as a worthy ornament to a great capital during a speech at the rededication ceremonies meant to reconcile the people to rule from Vienna.[45] Respect for Venice and Austria's relatively lenient rule there doubtless assuaged

Canova's feelings and confirmed the favorable opinion most Venetians had long held of Austria. But as the independence and unification movement gained strength in northern Italy, Vienna and Venice became bitter enemies.

For Canova, who took enormous pride in the cultural achievements of Venice and the Terra Ferma, and for most Venetians who viewed the extinction of the republic with regret, Austrian rule seemed the better alternative, since the Habsburgs represented that "peace, tranquillity, security" that "Liberty, Equality, Fraternity" had failed to achieve either in France or anywhere else the ideas of the Revolution were carried by conquest. The essential conservatism of Canova's position should not be underestimated, and in a reconstruction of the artist's political personality, I believe it far outweighs the commissions he often executed for Napoleon and the Bonaparte family. The sculptor's traditional loyalty to Venice is related in its conservatism to the other major political enthusiasm of his life: his profound respect for the papacy, his practice of the Roman Catholic religion, and his unstinting admiration of Pope Pius VII.

Before the deposition of Pope Pius VI Braschi in 1798, Canova had relatively little to do with the pontifical court, although two of his most important commissions during Braschi's reign were glorifications of deceased pontiffs—the tomb of Clement XIV in SS. Apostoli and that of Clement XIII in Saint Peter's. I discuss the sculptor's sincere Catholicism in Chapter 1; even though he was not especially favored by the court of Pius VI, there is no reason to suspect his attitude was other than that of a faithful and obedient subject. Braschi, a vain man very interested in the arts, was known primarily for his revival of nepotism; his office was more respected than his person.[46] But the "passion" and "martyrdom" he suffered at the hands of the French did much to rehabilitate his reputation and to prepare for a radical change in the papal public image that was greatly accelerated by his successor Pius VII. Indeed, from the corrupt, despotic spiritual arm of aristocratic absolutism, the papacy in the early nineteenth century came to represent legitimacy and resistance to French tyranny, even to many progressives.[47] Pius VII, as the chief hero of the triumph over Napoleon, augmented the prestige and influence of the papacy for many decades afterward. Canova, a zealous admirer of the institution and of Pius VII, was a concerned witness to the trials, persecutions, and ultimate apotheosis of his papal patron. His political and personal views of Napoleon and France, decidedly influenced by his sympathy for Pius VII, formed a vital component of his character and outlook vis-à-vis many of his patrons. Only Venice enjoyed a greater share of Canova's loyalty and esteem than the papacy.

The imprisonment and death of Pius VI in France focused attention on the papacy; more than a few people believed there would not be another pope. Canova's acquaintance with Braschi was slight, but his patron and intimate friend Abbondio Rezzonico was an important person in the Rome of Pius VI. Before the birth of the Roman republic in 1798, Rezzonico had been a senator of Rome and a commander of the City Guard. While both he and

Canova were in exile in the Austrian Veneto, he persuaded the sculptor to accompany him to Vienna to request that his suspended Venetian pension be renewed. From Vienna, Rezzonico continued with the artist to the Saxon capital, Dresden, and to Berlin, capital of Prussia. Although Canova filled sketchbooks and looked at the famed collections of the Habsburgs and Hohenzollerns and the choice picture gallery of the elector of Saxony, it is unclear what his companion was up to—probably he was on a clandestine mission to anti-French courts[48] rallying support for the exiled Pius VI. Canova's presence would have offered such a mission highly credible camouflage, but I doubt that Rezzonico would have so used his friend had Canova not been a willing accomplice.

Canova's esteem for the institution of the papacy combined felicitously with his admiration for Braschi's successor. The artist's letters reveal a continuing concern with the political vicissitudes of the Napoleonic era as they affected the Holy See and the pope personally, and they never fail to mention Pius in the most respectful and affectionate terms. These events and Canova's reaction to them help to explain his personal views, above all as they increased his antipathy to consular and imperial France.

Pope Pius VII's major political difficulties began during the negotiations for the concordat between the Holy See and France; the Church gained relatively little and made so many concessions that many criticized the pontiff for being a French puppet. Shortly afterward, Pius was summoned to Paris to attend the coronation of Napoleon as emperor of the French. Reluctantly, and against the advice of most of the Sacred College, Pius agreed to go, hoping to influence Napoleon and make him honor the concordat, which France had rendered all but meaningless from the papal point of view by unilaterally appending to it the Organic Articles (stipulations of a decidedly Gallican tone that severely limited papal rights in France). The pope was so concerned for the safety of the papacy that he left instructions for a new election if he were killed or imprisoned in France. Pius was treated as a celebrity everywhere in Paris except at the first consul's court, where Napoleon used him for publicity, refused to discuss religious issues, and embarrassed the pope by trying to give money to his Chiaramonti relatives.[49] But worse was in store for Pius, who was informed that he was not actually to crown the emperor but was merely to bless the proceedings. David's famous painting *Le Sacre* (figure 26), depicting a point later in the ceremony when the emperor crowns a kneeling Josephine, indicates Pius's passive, limited role. As Dorothy Johnson has astutely observed, Pius sits in sad resignation, holding one hand pensively on his knee while lamely offering the benediction with the other. David was greatly impressed with the pontiff, painting his portrait on two other occasions. His sympathy for the humiliated pope is evident in the huge picture of the coronation, a surprising bit of subversion in a painting commissioned by the emperor, who interfered often in its execution. David visualized what the newspapers could not print: that Pius VII was a most unwilling participant in the coronation of Napoleon I.[50]

The conciliatory policy of Pius toward France came under increasing strain in the years after the coronation, and by 1806 the pope began taking a harder line. French abrogations of the concordat and various diplomatic and military outrages created seething resentment in

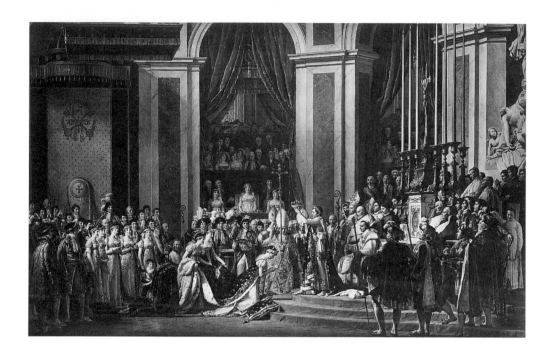

FIGURE 26
Jacques-Louis David, *Le Sacre*, oil on canvas,
1805–8. Paris, Musée du Louvre.

Rome, where Canova and almost everyone lived in a constant state of anxiety. When Napoleon demanded right of passage through the Papal States to attack Naples in 1805, Pius acquiesced, only to discover that the French had occupied and garrisoned the major papal port on the Adriatic, Ancona. When all his protests were ignored, Pius began to listen more attentively to the party in Rome that advocated resistance. In June 1806 he promulgated the bull *Non possumus,* declaring the independence of the papacy from all external political control. The pope's refusal to expel foreign nationals of countries belligerent to France from his territories and his rejection of the continental system (the systematic exclusion of British goods from ports in France and its satellite states) accelerated the rupture. In autumn 1807 Bonaparte came to Milan to plan the occupation of the remainder of the States of the Church in conjunction with his stepson and viceroy in Italy, Eugène de Beauharnais. Early in 1808 France invaded, and by April Urbino, Ancona, Macerata, and Tolentino were annexed to the Kingdom of Italy.[51] Since Napoleon had determined as early as 1805 that the pope's role in the new empire was only that of a feudatory chaplain, in the supposed tradition of Charlemagne, Pius's refusal to annul Jérôme Bonaparte's marriage to the Protestant American Elizabeth Patterson and his denial of Joseph's rights as king of Naples were unacceptable. Everywhere the emperor interfered in religious affairs, instituting a highly unorthodox and

controversial imperial catechism and establishing the suspect "Feast of Saint Napoleon" to coincide with the traditional celebration of the Assumption of the Virgin.[52] The final showdown was inevitable.

A clear instance of the anger of the pope at French arrogance and insolence occurred in Rome in 1806. When Cardinal Fesch, Napoleon's maternal uncle, archbishop of Lyon and ambassador of France to the Holy See, came to take leave of Pius VII, there was an ugly exchange. Fesch reiterated Napoleon's demands and threats, and Pius responded that he would do all in his power to oppose Bonaparte's pretensions, hinting at excommunication. Fesch said that the pope would be wrong to use a sacred power in a secular quarrel. Uncharacteristically, the mild Pius shouted him down and showed him the door.[53] As a deliberate provocation Napoleon sent a new ambassador to the Curia, Charles Alquier, a former Jacobin and anticlerical hard-liner. Problems with Jérôme, Joseph, Napoleon, and Fesch must have wearied Pope Pius of the Bonaparte family well before the controversy arose over the divorce of Josephine.

On January 9, 1808, French Foreign Minister Jean-Baptiste Nompère, comte de Champagny, gave the papacy an ultimatum: Declare war on Great Britain, recognize Joseph Bonaparte as king of Naples, and make one-third of the Sacred College French, or else the secular power would be abolished. The injustice of the demands was felt keenly in Rome, since Pius had just made extraordinary concessions in an attempt to avoid war, including the acceptance of the Organic Articles and the sacking of Cardinal Consalvi as secretary of state, since Napoleon regarded him as a personal enemy.[54] The pope refused the new demands, as the French had hoped he would since the emperor had already decided to occupy the rest of the Papal States. Panic soon hit the city, and on February 2 General Miollis occupied Rome, Pius and some of his aides shutting themselves up in the Palazzo del Quirinale. A battle of wills ensued, and finally on May 17, 1809, Napoleon annexed the States of the Church to France, dividing them into the Departments of the Tiber and the Trasimene. Immediately, Pius's bull of excommunication was posted surreptitiously on the doors of Rome's churches, having been prepared in anticipation of the event by the pontiff and his new secretary of state, Cardinal Bartolomeo Pacca. The bull, *Quam memorandam,* did not name names but explicitly excommunicated anyone who participated in the annexation. A personal brief was sent to the emperor, notifying him of his excommunicate status.[55] Fully expecting to be imprisoned or executed, the pope prepared another bull providing for a papal election. Rome was no longer sufficiently large enough to hold a pope and an emperor.

From winter 1808 through spring 1809 the French ruled Rome, but Pius was still enormously influential among the people. Despite some support for the French from a few patrician families and some of the upper levels of the middle and professional classes, the vast majority of Romans were staunch papalists, and their majority was even higher in the rural areas of the former Papal States. The French had to contend with guerrilla activity in the Roman Campagna and lived in apprehension of a plebeian revolt in the Trastevere. Pope Pius still continued to rule the conscience of Rome from the Quirinale. At the pope's urging, the carnival festivities in 1809 were widely boycotted, an occupied city being no fit setting for cel-

ebrations. Rome was in perpetual Lent. General Miollis had to press laborers to build the viewing stands for the races on the Corso, which few attended.[56] On June 11, 1809, French troops entered the papal palace and confiscated Cardinal Giulio Gabrielli's papers and expelled him from Rome; Cardinal Pacca was saved from a similar fate only by the direct intervention of Pius VII. The pontiff, who complained bitterly at the affront, was backed by the Austrian ambassador, Ludwig von Lebzeltern, who had refused the general order that the diplomatic corps accredited to the Holy See quit Rome, arguing that the pope as spiritual head of the Church needed to be surrounded by representatives of Catholic courts.[57] The crisis was resolved when on the evening of July 9, 1809, a specially selected group of French troops stormed the Quirinale Palace, arrested the pope and Pacca, and secreted them out of Rome. Pius was ultimately sent to house arrest at Savona, in Liguria, while the cardinal, whom Napoleon particularly detested, was sent to the notorious prison at Fenestrelle. Napoleon, pretending to disapprove of the audacious arrest and deportation, mounted a publicity campaign to proclaim his innocence, blaming overzealous subordinates for the kidnapping. He wrote a few days after the event to Joseph Fouché, duc d'Otrante, his minister of police at Paris, from Schönbrunn Palace in defeated Vienna: "I am displeased that they have arrested the pope; it is a great folly. It was necessary to arrest Cardinal Pacca and leave the pope in peace at Rome. But in short, it is not to be remedied; what's done is done."[58] Napoleon goes on to order Pius sent to Savona. Had the emperor been innocent of the abduction (and one wonders who would have dared undertake it without at least his tacit approval), he could simply have sent Pius home or to a more suitable place, such as Castelgandolfo. The perpetrators of the assault on the Quirinale were not punished.

Rome was deeply shocked at French ruthlessness in kidnapping the pope, and many went into deep mourning. Canova, according to D'Este's biography, carved the phrase "modellata nei giorni più tristi di mia vita: giugno 1809" (modeled in the saddest days of my life, June 1809) into the base of a model for a marble dancer he was working on when he heard the momentous news. D'Este paraphrased the actual inscription and wrote "June" instead of July, but even the paraphrase reveals Canova's feelings. D'Este also claimed that the sculptor chose the joyous theme of a dancer as an antidote to his grief at the French occupation.[59] Whether the claim is true or not, Canova's distress was unfeigned, and he continued to show deep concern for Pius's welfare and safety during his captivity in Savona and, later, in France.

After the removal of Pius, Napoleon decided to transfer the seat of the papacy to Paris. This was ominous news to artists in Rome, since Church dignitaries and their families were major consumers of local production, and Bonaparte's plans called for the cardinals and the heads of the religious orders to come immediately to Paris. Canova, already doing much to sustain Rome's struggling artistic community, was concerned for the city's future without so many people of wealth and cultural interests. The removal of the Sacred College to France also exacerbated the political crisis precipitated by the wedding of Napoleon to Archduchess

Marie-Louise of Austria. Eager to make a great show of clerical support for the marriage, Bonaparte insisted the cardinals in Paris attend. Since Pope Pius had declined to annul the emperor's first marriage to Josephine, Consalvi persuaded twelve others to attend, not the ceremony, but only the reception. Furious at the ecclesiastical snub and its implications for the legitimacy of a possible heir, Napoleon had the dissenting princes of the Church violently removed from the reception. Their property was sequestered, and they were forbidden to wear the red habit of their office, giving rise to the famous sobriquet "Black Cardinals." They were soon exiled to the provinces.[60] Consalvi, whom Canova esteemed above the rest, was in jeopardy of execution for instigating the act of disobedience and for his traditional hostility to the emperor.

The popularity of the "Black Cardinals" and of Pius VII in France worsened the ecclesiastical crisis there and caused greater strain between the government in Paris and those in Rome who, like Canova, had not sworn the oath of loyalty to Napoleon. The French clergy, perhaps bolstered by Pius's example, refused to allow metropolitans to invest new bishops without papal approval, an act of defiance orchestrated at the national council of bishops, which Bonaparte had summoned to Paris in 1811 to deal with the problem of thirty vacant dioceses, since Pius VII refused to invest imperial nominees for the empty sees.[61] And clerical resistance was not limited to Paris. The French episcopal problem was compounded by the contumacity of the chapter of Saint Peter's to imperial decrees. Only in 1811 did the canons grudgingly agree to add "Domine salvam fac nostrum Imperatorem Napoleonem" to the daily collects, and when the government ordered a Te Deum sung in the basilica for the birth of the so-called king of Rome, there was open revolt. Led by the celebrated composer and chapel master Niccola Zingarelli, whom the musically inclined Canova admired, most of the choir resigned, and the service was performed by a small rump of the original group. Zingarelli and the other recusants were arrested and imprisoned, the chapel master ultimately being allowed to return to his native Naples the following year, in 1812.[62] Claiming that Pius VII was his sovereign, Zingarelli set an example followed, more or less enthusiastically, by most of the cultural and clerical establishment of Rome.

Canova, in addition to his sympathy for Pius VII in his political problems with Bonapartist France, also had a warm personal attachment to the pope. Pier-Alessandro Paravia, an early biographer of Canova, described his great devotion to Pius as a form of religious veneration of the head of the Church and his legitimate prince.[63] Canova was touched by the high praise and personal notice the pontiff showered on him and his work, in particular Pius's purchase of *Perseus* (see figure 14), *Creugas,* and *Damoxenos* (figures 27 and 28) to prevent their leaving Rome. In early 1802 the pope honored Canova by creating him a Knight of the Golden Spur; this was the only decoration Canova ever agreed to accept personally, such was his dislike of court protocol.[64] During the award ceremony Pius placed the decoration on the artist's chest with his own hands, a mark of distinction much noted at the time. The French minister Cacault related it to Talleyrand at some length in a letter of January 27, 1802:

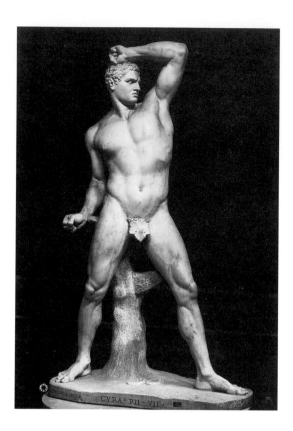

His Holiness summoned to his apartments a few days ago M. Canova, the celebrated Venetian sculptor established in Rome. He spoke to him with great affection and attached to his lapel the Order of the Spur; afterward he embraced him and declared him knight of this order. The brevet that has been presented for this purpose to M. Canova includes the most elegant encomium of his talent and his singular modesty.[65]

As a further gesture toward his celebrated subject, Pius VII asked his architect, Raphael Stern, to draw plans for a studio to be built as a present for the sculptor. Canova dissuaded the pope from this generous plan, indicating he had declined a similar offer from Francis II for a studio in Venice. Possibly Pius was competing with the Austrian ruler, showing his appreciation of the artist by attempting to keep him in Rome. Fortunately for the papacy, Canova never had any intention of leaving. He told Antonio D'Este privately that he had refused the pontiff's offer because he thought the expense of it inappropriate at a time when Rome was in serious financial straits. Canova, knowing that the offer would cause a justifiable public outcry,[66] and wanting to spare his overzealous patron from criticism and to maintain his own autonomy, must nonetheless have been gratified by the gesture.

Canova's own regard for the pope is reflected in the numerous favorable references his

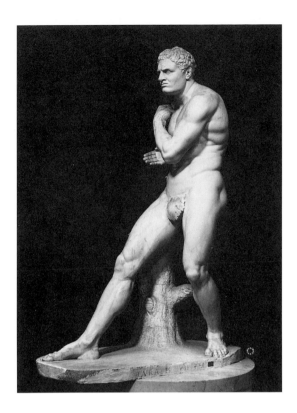

closest friends made to Pius VII in letters they sent the sculptor. Two examples, from Qua-
tremère de Quincy and Gianantonio Selva, may serve as cases in point. On January 25, 1805,
the French antiquarian described the enthusiastic welcome of Pope Pius in Paris: "I cannot
explain to you how much good will your good pope has here."[67] Selva wrote in January 1815
from Venice, in the first months after the papal restoration, asking if the pope had seen the
model for *Religion,* adding, "May heaven preserve him for many years so that we can long
see in the chair of Saint Peter a minister so precious to religion and to art. . . . Oh how His
Holiness is still venerated and esteemed here! . . . I believe that they are few who do not
pray for him, and you must be more tranquil now that you possess such a great treasure."[68]
Such feeling for the pontiff in Venice is especially remarkable, since that city had a long tra-
dition of antipapalism, only partly overcome by the visit of Pius VI to the city in 1782 and by
Pius VII's election and enthronement there. My point is that both Quatremère and Selva
were as familiar with Canova's true opinions as anyone, and they must have made such
good reports of the pope expecting that the sculptor would receive them favorably.

When Pius returned to Rome after his imprisonment in France, Canova went to meet
him even before he entered the city, paying homage and formally asking for protection for
the arts and the Accademia di San Luca. Cynics might argue that Canova, who usually
shied away from the duties of a courtier, was motivated by charges from ultraconservatives

that he had collaborated with the French during the occupation since he had retained his position as director of the museums.[69] The artist, however, had delayed for two years taking the oath of loyalty to the empire, and could have used his post to protect the cultural patrimony of Rome from further depredations. Certainly he showed little enthusiasm for the French; Pius graciously received him at the Restoration and utterly rejected the accusations that the sculptor had collaborated, suggesting that Canova may have secretly obtained the pope's permission to remain in his position.

Just as Canova continued in Pius's good graces after a five-year hiatus, so also did the pope immediately renew excavation and restoration projects in the Forum, the Colosseum, and the Pantheon and at the Arch of Septimius Severus, among other sites, all under Canova's ultimate supervision. Carlo Fea, whom Pius had named commissioner of antiquities in 1801, assisted Canova in the Restoration initiatives.[70] There had been no need to fashion a program of archaeological excavation in Rome when the French took over, because most of their undertakings continued those of Pius VII that had been suspended with the collapse of the pontifical government in 1807.[71] The scale of the French digs and the megalomania of some of their urbanistic schemes for Rome were new, but then they felt an acute political need to connect themselves to Rome's imperial traditions. And after the confiscations, sequestrations, and suppressions of almost all the Church's charitable institutions that traditionally had provided for the poor, there was a compelling need to institute public assistance, which largely took the form of works projects at the various sites. Pope Pius scaled back the archaeological projects pursued so single-mindedly by the French in order to reestablish the pious institutions they had destroyed, but the pope's interest in excavation continued.

The differences between Napoleon's politics of archaeology and those of the papacy may be seen in their respective works at the Colosseum. Both provided employment for the poor, and both wished to gain knowledge of the building's history, but there the similarity ends. The French Consulta Straordinaria effectively de-Christianized the Colosseum by removing altars and crosses from the amphitheater and from the central ground and exposed the subterranean structure in a major excavation. Thus, the "original" building, with all its imperial associations, was made visible. After the return of the pope the Colosseum was targeted as a symbol of restored papal power, and Pius VII deliberately re-Christianized it. The bared penetralia were covered up again, as much as possible with the soil that had been removed by the French, since it was considered to be stained with the blood of the early martyrs. Raphael Stern was employed to shore up the south arcade, and Pius had an inscription placed nearby that proclaimed his intentions. The restoration on the interior ground level of the fourteen stations of the cross originally erected under Benedict XIV (1740–58) helped to promote pilgrimage and the cult of the martyrs (ancient and modern). Thus, as when Sixtus V (1585–90) placed the figures of Peter and Paul atop the columns of Trajan and Marcus Aurelius, once again the august remains of ancient empire were subordinated to the ideological goals of papal Catholicism.[72] It was as if the French had never been there.

3

CANOVA AND THE FRENCH

FROM THE ANCIEN RÉGIME

TO THE RESTORATION

THE CENTRALITY OF FRANCE to the political, social, and cultural life of Europe from 1789 to the fall of Napoleon is indisputable; in Italy and Rome during this tumultuous period French policies, military aggression, and conquest were the defining features of life. The armies of the Directory shattered the status quo and either extinguished or profoundly altered institutions in Italy older even than the French state, deconstructing much of the post-antique Italian establishment in an astonishingly short time, from 1796 to 1798. For all but the most ardent progressives and committed Italian Jacobins, it must have seemed like the end of the world. Unfortunately for Italy, French attempts to reconstruct the region during the Consulate and the empire led to a general view of the peninsula as a political pawn and a helpless victim to be fleeced without scruple. Because Venice and the papacy, both dear to Antonio Canova, were among the chief casualties, any attempt to define his political personality must ultimately focus on his highly complex attitude toward France. While rarely favorable, his opinions of French policies and activities and his reactions to them changed through time. French activities demonstrably influenced both his personal beliefs and his professional practice. In the present context I find the influence on the second element especially intriguing. This chapter traces Canova's Francophobia from its birth in Rome during the 1780s through the calamitous years of the Italian campaigns and the imperial annexation to its afterlife during the Restoration. Such a discussion is absolutely necessary to establish the political context of Canova's works for Napoleon and the Bonaparte family, discussed in detail in this chapter and the one that follows.

Canova's contacts with French artists and potential patrons in Rome during the 1780s were not nearly so extensive as those he had with the British community and the Roman artistic establishment. His initial reaction to the students of sculpture working at the French Academy in Rome was negative, and he much preferred the atmosphere in Pompeo Batoni's life class, where he felt he could improve himself and make more profitable contacts. When

Ambassador Zulian invited the director of the French Academy, the painter Louis La-
grenée, to visit Canova's studio in the Palazzo Venezia to see the young sculptor's *Daedalus
and Icarus* (see figure 5), a cast of which had been sent from Venice, and the newly completed
Theseus and the Dead Minotaur (see figure 22), Lagrenée whispered in French to his com-
panion that Canova had used a cast for the figure of Theseus. This aspersion irritated the
artist, who probably imagined it was prompted by jealousy. This was the first of many un-
pleasant contacts with French criticism he experienced during his career.

In about 1785 the French ambassador to the Holy See, Cardinal de Bernis, proposed to
Canova the commission for a monument to the French medieval hero, the chevalier Bayard.
Bayard, who had become a celebrity to French painters in the wake of the reaction against
the licentious rococo, served Neoclassical artists as one of the great moral paradigms. Al-
though the form the monument was to take and the site it was to occupy were never speci-
fied, Canova promptly declined the honor.[1] There must have been many reasons why a
young, ambitious sculptor would turn down such an opportunity, including the fatigue he
felt after completing one papal tomb and his acceptance of the commission for another (the
funerary monuments to Clement XIV and Clement XIII), but I wonder if a generally neg-
ative attitude toward France might have had something to do with his decision to decline.

Italy and Rome witnessed the fall of the Bastille and the increasing anticlericalism of the
French Revolution with keen interest but no real concern; the radicalization of the Revolu-
tion in 1792 and the abolition of the monarchy, however, soon brought Rome into the gen-
eral upheaval. The French Academy, housed in the Villa Medici, became a center of Jacobin
agitation in the papal capital; many who were students there were members of illegal, po-
litically suspect freemason lodges.[2] Hugo de Bassville, the French republic's new ambassador
to Rome, whose subsequent assassination caused such apocalyptic consequences for the gov-
ernment of Pius VI, found the French Academy a bastion of revolutionary sentiment. Upon
his arrival, the students overturned the symbolic throne and burned the series of royal por-
traits, acts of vandalism that must have shocked Canova and Rome's artistic community. The
Roman people, infuriated, stormed and sacked the academy.[3] Three months later Canova's
friend the Venetian painter Domenico Pellegrini, whom the sculptor often assisted in his
studies, wrote to him from London that Britain was at war with France and that he feared
the French would occupy Rome. The letter concludes with a touching reference to the im-
prisoned Louis XVI, wondering if he was still alive.[4] A sympathetic reference by a Venetian
friend may indicate Canova's own feelings for the deposed Bourbon monarch and his an-
tipathy for the Jacobins. He certainly disliked the agitation and violence the French armies
brought with them to Italy.

With the abolition of the Roman Catholic Church in France, the widening war between
France and the allied powers, and the Terror of 1793–94, Rome began to fill with refugee
priests, ci-devant aristocrats, and other exiles. By the time of Robespierre's fall there were over
seven thousand émigré priests in Rome and the States of the Church. Jacobin agitators and
spies slipped in along with this huge influx, and their political machinations soon changed
Roman suspicion of the French to outright fear and hostility.[5] A number of ugly confronta-

tions took place, and such was the perceived support for the counter-revolution by the papacy that France, even in its somewhat more moderate Directory phase, became the implacable enemy of the Roman court. Both Pius VI and Pius VII would pay dearly for this animosity.

In its propaganda campaign against the Holy See, beginning in 1792, France characterized Rome as backward, superstitious, priest-ridden, badly governed, and deliberately isolated from a more progressive and modern Europe. For the most part, non-Italian historians have accepted this view as uncritically as other French-generated propaganda of the revolutionary era. In consequence, they have seriously underestimated the vitality of Rome as a cultural, intellectual, and even political center of European importance and have accepted the notion that the papacy was grossly intolerant and reactionary. But most contemporaries considered Clement XIV (1769–74), Pius VI (1775–99), and especially Pius VII (1800–1823) liberal rulers. Goethe thought Rome an oasis of liberty where even a pope might be criticized with impunity, and contrasted the freedom possible there with the stifling control of the French court.[6] My point here is to understand Canova's Francophobia as developing in a reasonably tolerant context, not the repressive ecclesiastical backwater described by much Francocentric scholarship.

While based on a youthful aversion to the French Academy in Rome and a lack of sympathy with the art produced there, Canova's antipathy to France assumed a wider political dimension during the agitation and riots that marked the Revolution's debut in Rome. But the sculptor's antagonism became even more pronounced with the invasion of northern Italy during the Franco-Austrian war of 1796–97. Lombardy, Emilia, Liguria, and the Veneto were ravaged by the French armies, and Canova's letters leave no doubt about his hopes for an Austrian victory. In June 1796 he wrote to Gianantonio Selva in Venice: "You have done me a true favor telling me the news that the French have abandoned Verona. Heaven grant that they never return there!"[7] He wrote again on August 13, mentioning that casts were being made of the Vatican sculptures ceded to France by the terms of the Armistice of Bologna and expressing the hope that they might not have to leave Rome: "If the Devil makes these hundred works leave, Rome will be desolate, but we have great hopes since it seems that things are taking a good turn."[8] Ultimately, the artist's hopes were dashed. The French triumphed over the Austrians, and the hundred works of art, along with many others, soon left Rome for Paris.

The preceding chapter notes how bitterly Canova lamented the fall of Venice to France and its transfer to Austria. His concern over the annuity from the republic for the Angelo Emo monument (see figure 24) is well documented, and in 1798 he even went to Vienna to ask for its continuance. But before Venice was bartered to Austria, he also received an offer of assistance in the matter from General Bonaparte, at whose instigation Joseph Bonaparte, the Directory's ambassador in Rome, suggested that the French could arrange a onetime payment of 3,500 zecchini to settle the account. Not wishing to burden the already prostrate Serene Republic, Canova declined, partly, I believe, because he found such an offer from the Bonapartes repugnant. He wrote to Selva: "I refused to avail myself of the favor that to that end was offered to me by Supreme Commander Bonaparte."[9]

Aggrieved by the seizure of works of art, the military occupation and devastation of large areas of northern and central Italy, and, above all, the destruction of the Republic of Venice by the French, Canova attempted to bury his anxiety in work, but with little success. His anguish even led him to suggest, half in jest, that he might immigrate to America.[10] In sum, the military disasters and political havoc loosed on Italy by the Directory's armies transformed Canova's mildly dismissive attitude toward French art into a fixed antipathy toward France.

Canova's practice was severely impacted by the political upheaval in Italy caused by the French invasion. Numerous commissions were annulled or dramatically altered as the political circumstances changed patrons' fortunes and as war prevented the delivery of completed works, above all to the artist's British clients. Canova linked such difficulties directly to the French. The transport problems of the first *Hebe,* commissioned by the Venetian patrician Francesco Albrizzi, were typical (figure 29). In Possagno to escape the Roman republic and to be in a province under Austrian control, Canova wrote to Selva in Venice on January 24, 1799, asking him to inform Albrizzi of the dangers shipment of the statue from Rome would entail and to determine the patron's wishes. A certain Frenchman, designated simply "cittadino Derevijer," had written to the sculptor offering to buy Albrizzi's statue, and D'Este in the studio in Rome had recommended such a sale as the safest course of action.[11] Canova hesitated, however, not wishing to disoblige the Venetian patron and, I suspect, not wanting to sell the work to a French collector who would take it from Italy. By 1799 the artist was alarmed about his business, remarking that the war and the unrest in Rome had prevented him from making any money for eight months. The *Hebe,* however, was finally delivered to count Albrizzi, unlike such statues in progress as *Hercules and Lichas,* the *Penitent Magdalene,* and *Cupid and Psyche,* for which new purchasers had to be found. Canova's financial situation was never more uncertain than during the last months of the eighteenth century.

Early in 1798, it became evident that a French occupation of Rome was inevitable, an event that proved terrifying for Canova and massively inconvenient for his professional activities. The fall of Pius VI was made a certainty by the murder of General Léonard Duphot during an anti-French riot in the Trastevere, a misfortune that gave the Directory the excuse it needed to take over the Papal States and depose the pope, establishing in his place a puppet republic along the lines of those already existing in the Netherlands, Switzerland, and northern Italy.[12] Thus began a period of both systematic and spontaneous looting, exactions, and acts of iconoclasm unmatched in Rome since the infamous sack of 1527. Among the chief victims was public sculpture, as statues, reliefs, and escutcheons were destroyed or defaced all over the city, appalling acts of ideological vandalism that shocked Canova. Also victimized were portraits; church plate and furnishings; vestments; the papal library and museums; coins, medals, and cameos; and any portable objects thought valuable. The losses to the cultural and artistic patrimony of Rome were incalculable.

When a tree of liberty (actually a wooden pole) was planted on the Capitoline on February 15, 1798, it became immediately evident that the vast majority of Romans wanted

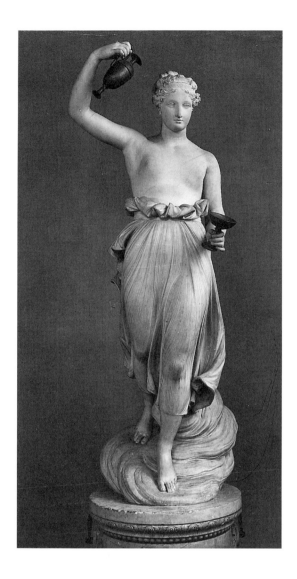

FIGURE 29
Antonio Canova, *Hebe,* marble,
1796. Berlin, Dahlem Museum.

nothing to do with the republic. Although the tree had to be guarded day and night to prevent its destruction, it attracted relatively little attention otherwise. Many Romans considered the new government farcical, since France stripped it of most of its profitable territories, adding Pesaro, San Leo, and the former Legation of Urbino to the Cisalpine Republic and occupying outright the enclave of Benevento and the lucrative alum mines at Tolfa.[13] Bologna, Ravenna, and Ferrara had already been severed from the Holy See. In addition, strong garrisons were placed by the occupiers in Civitavecchia and Ancona, and customs tolls from these strategic ports were taken into French coffers. The powerless republic was also compelled to pay for the French garrison in Rome, ostensibly there to protect the city. Ironically, without the French bayonets, the Roman republic would not have outlasted the day.

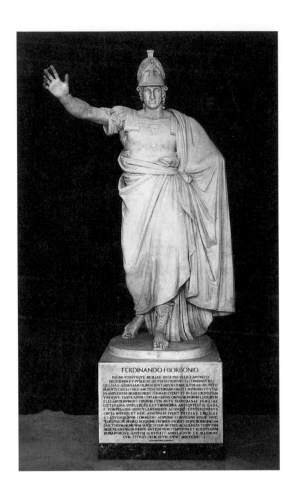

Canova shared the widespread resentment of France and the Roman republic. As one of the most popular and famous people in Rome, he was courted by the government but refused cooperation. He temporarily accepted election to the newly formed institute, hoping to help the arts. In a ceremony at the Vatican to initiate new members, however, Canova declined to take the required oath of hatred to monarchs, declaring in Venetian dialect, "Mi non odio nissun!" ("I don't hate anybody!"). Perhaps fearing for his safety after this public act of defiance, he immediately went to the authorities and demanded a passport. The administration attempted to assure him of his safety and its esteem, but the sculptor was adamant. Less than three months after the fall of the papacy Canova went home to Possagno in the Austrian Veneto and did not return to Rome until after the fall of the republic.[14] His precipitate flight may have been wise, since shortly afterward a republican mob stormed his studio, attempting to destroy the *modello* for the statue of King Ferdinand IV of Naples, an act of vandalism prevented only by police intervention.[15] The finished marble version of this work was not completed until 1820 (figure 30).

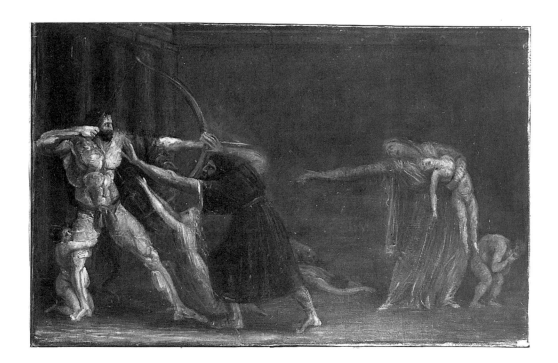

Canova's self-imposed exile from Rome was a period of intense anxiety as the sculptor wondered whether he would ever be able to return to work and worried ceaselessly about his studio. While in Possagno he turned to painting, partly for lack of materials to make sculpture, executing works in both mythological and religious genres and often treating themes of death, insanity, and mourning. Ottorino Stefani has argued that Canova, in such works as *Hercules Murdering His Children* (figure 31), was working through a state of depression.[16] Hercules, standing in for a mad France, mercilessly slays his youthful victims, who may be seen as a helpless Italy. Whether or not this was the case, the ubiquity of such themes during the long months in Possagno indicates a deeply troubled and uncharacteristically pessimistic state of mind.

As a contrast to Canova's dramatic departure from Rome and his personal despair in Possagno, it might be instructive to look briefly at another important Roman sculptor's reaction to the fall of the papacy and the establishment of the republic. Vincenzo Pacetti, one of the Venetian sculptor's few serious rivals during the 1790s, remained in the city and outwardly conformed to the changed circumstances. He did not much like conscription, at age

fifty-two, into the Civic Guard and the tiresome task of standing guard duty, but he used the *cittadino* designation in references to people in his diary. He even made a sketch for a figure of liberty for the republican Consulta. But Pacetti was a close friend of the British artist Guy Head, who had to flee Rome ahead of the French occupation, and the Italian sculptor personally safeguarded Head's possessions and sent them on after him. Perhaps this act of friendship and kindness to an enemy of France indicates Pacetti's real political opinions.[17] One suspects that many others who outwardly cooperated with the Francophile regime did so only from fear or financial necessity. Canova was sufficiently rich to follow his conscience into a bitter exile.

When Napoleon was campaigning in Egypt in 1798, the Austrians and Neapolitans reasserted themselves militarily and put the French on the defensive in Italy. These events necessitated the French evacuation of Rome, and the republic disappeared, unlamented, not to return for half a century. Pius VI, who had died in exile at Valence, was succeeded by Pius VII, who was elected and enthroned in Venice in 1800 and was received joyously in Rome, arriving shortly after Canova's return from the North. From 1800 until the reoccupation in 1808, an uneasy truce existed between France and the papacy. But the Rome that welcomed Pius VII and Canova in 1800 was dramatically altered. François Cacault, in a letter written on New Year's Day 1802 to Talleyrand, described the situation at the beginning of Pope Pius's reign: "The passage of the revolution is already forgotten, but Rome diminishes and loses population. This city has lost all the foreign sources of its grandeur and the pope half of his state. . . . The poor and the wretched here are beyond all proportion."[18] Before the French incursion Rome had a population of approximately 170,000, twice that of Turin and in Italy second only to that of Naples. By 1814 the number had fallen to less than 113,000; from 1782 to 1816 the population of the Papal States increased by only about 2,000.[19] This dramatic decrease caused acute problems for the Roman economy, and the flight or exile of numerous cardinals and nobles, not to mention the virtual cessation of tourism, left the large community of Roman artists in desperate straits. Canova undertook his efforts, praised by many at the time, to ameliorate a bleak situation that had been occasioned by French oppression.

By the time of the annexation of Rome in 1809 Canova, while still cautious and polite in his personal dealings with the authorities, had resolved to distance himself as far as possible from the usurping regime. The one exception was his retention of his post in the cultural bureaucracy, where he was director of the museums. He made this concession to the government because it promised him that no additional works of art would be taken from the prostrate city; the sculptor, moreover, refused to take a salary from the imperial government.[20] Early on, the French had sought to rally him to the new regime, but Canova consistently refused to consider any other office or to accept any of the honorifics the French government wished to bestow on him. For example, shortly after the annexation a Roman Senate with sixty members was established by the government in Paris to publicize local support. The noble members were carefully selected from among those families that seemed most likely to participate, especially the Doria, Braschi, Altieri, and Santa Croce. Among the

bourgeois members nominated were the banker Giovanni Torlonia and Antonio Canova. While over half of those named accepted, many simply failed to assume their seats. Canova declined the nomination outright.[21]

More significant was the artist's refusal to become a member of the Legion of Honor and the Imperial Senate. The legion, the emperor's own creation, symbolized both his confessed devotion to meritocracy and his increasingly aristocratic sensibilities and love of orders, decorations, and ceremonies. Stendhal, the famed writer and cousin of the French administrator in Rome, Martial Daru, said Canova rejected the legion because an oath of loyalty to the empire was required of its members, an explanation that seems likely. The determination not to accept election to the Imperial Senate, however, is more problematic. Quatremère de Quincy's biography states that the sculptor was offered a seat and declined it, an assertion taken up in most of the subsequent scholarship, including Malamani and Rava.[22] Only Ferdinand Boyer and Léon Lanzac de Laborie doubt that Canova refused the legion and the Senate, but much of their aim was to portray Canova as an ardent admirer of the Man of Destiny who simply was too shy and obstinate to enjoy the honors offered him by a generous ruler.[23] A letter written by Count Sommariva from Paris, September 1, 1809, to Canova in Rome congratulates him for his election to the Senate but does not specify whether it was the Roman or the imperial body.[24] While it cannot be determined with certainty, the testimony of Quatremère's contemporary account seems compelling, and the offer was in keeping with Napoleon's misjudged attempts to rally Canova's support by flattery and bribery. I believe the emperor, whose practice of buying support for the regime had generally worked well, never understood the depth of the sculptor's resentment, which was almost always concealed in direct dealings.

During his trip to Paris in 1810 to execute the empress's portrait, Canova received many favorable financial concessions from Bonaparte for the arts and for the Accademia di San Luca, discussed in detail in the next chapter. What concerns me here is the mileage, in cultural propaganda, that the government in Rome hoped to extract, at Canova's expense, from the imperial largesse. The sculptor's return to Rome, timed to coincide with the Accademia's award ceremonies on the Capitoline, was a perfect opportunity to associate the reluctant artist with the regime. Canova, having just returned from the imperial capital with a major Napoleonic commission, would appear an instrument of Napoleon's support for art and culture in his second capital. A bust of Canova was put in a place of honor at the ceremony, and the sculptor was to be feted by the authorities, including the military governor, General Miollis, and the prefect of the Department of the Tiber, Camille Casimir de Tournon. Perhaps forewarned and certainly disinclined to attend, Canova, as I have mentioned, simply prolonged his visit to Florence, supposedly to attend to some details of the Vittorio Alfieri monument, avoiding the Capitoline panegyrics altogether.[25] While it is true that he did not like public honors, he rarely missed Accademia functions, since he took his position as Principe very seriously. I believe part of the motivation was to avoid associating his reputation with the politics of the empire, and on this occasion he was highly successful.

Another political brouhaha that engulfed Canova during the period of imperial rule at

Rome was the question of the oath of loyalty to Napoleon and the empire. After the annexation, large numbers of people were required to swear the oath, among them artists acting in any official capacity, as Canova did as director of the museums. Because he was among the highly visible recusants, the sculptor was constantly pressured by Martial Daru to swear, but he still considered Pius VII to be his legitimate sovereign and said so. Many others followed Canova's example, often facing prison or exile thereby, and always forfeiting their jobs. The oath had been so widely disdained in the former Papal States that by mid-1811 an impatient Napoleon, who was planning a state visit to Rome, wrote to the duc d'Otrante with orders for Miollis concerning the oath of allegiance, stating that all who refused, especially the higher clergy, were to be arrested, and that vigorous measures must be taken to end "cette ridicule situation."[26] It was still several months before Canova could be prevailed upon to swear, and then he swore a modified version that, as I have suggested, may have been approved by the exiled Pius VII.[27]

As director of the Roman museums Canova was also charged with supervising the numerous archaeological excavations conducted in the forums, at the Pantheon, at the Colosseum, and elsewhere. This charge directly involved him as Principe of the Accademia di San Luca. In 1809 the provisional government formed a committee for the preservation of ancient monuments and appointed Canova as one of the four inspectors, a post he declined.[28] Indeed, the artist seems to have wanted no part of the ambitious, even megalomaniacal, French plans to turn much of Rome into an archaeological park. His goal in carrying out the duties incumbent on him in his roles at the museums and the academy was to delay and minimize the French schemes as much as possible. Prefect Tournon, in typical rationalist fashion, attributed the inertia and passivity he perceived in the Roman people to a decayed urban fabric; the clearing of monuments would reinvigorate the people with fresh air, and they would become the Romans of old, especially since they had been freed from the "corruption" of papalism. He funded the programs of urban renewal from the sale of property and the liquidation of the endowments of suppressed charitable foundations, believing work a more virtuous activity than charity.[29] What was to be done about those too old, young, weak, or ill to work remains unclear. Such well-intentioned activities took no account of the traditions of the city and the habits of the people; widespread corruption and administrative incompetence only complicated the situation. Without doubt, many of the poor in Rome were worse off than ever, in particular those who lost employment in the myriad religious establishments the French suppressed and those evicted from the houses and market stalls that were razed to provide a "better" view of ancient monuments.

The problems inherent in the French approach to urban monumental archaeology in Rome are evident in their attempted restoration of the Arch of Titus, an initiative that involved Canova in an official capacity. The aim of the project was to isolate the arch from structures that had largely absorbed it and to create a space around it large enough to provide an unimpeded view (figures 32 and 33). The desire to isolate the monument seriously underestimated the arch's reliance on the earth in which it was partly buried and on the surrounding building, which was a part of the fabric of the convent of nearby Santa Francesca

Romana. Canova warned Tournon in 1810 that the demolition of the convent and the excavation had put the arch in grave danger of total collapse, but in response the prefect only charged him and the academy to see that no additional damage was done, leaving the Arch of Titus in the lurch until more serious attention could be given to it during the Restoration by Giuseppe Valadier in 1818.[30]

Although Canova, in acquiescing to the French government's plea that he stay on as director of the museums, hoped to influence cultural policies for the protection of works of art and the benefit of the Roman artistic community, he achieved at best only mixed results. In 1811 Dominique-Vivant Denon, the director of the Musée Napoléon, descended on Italy to collect large numbers of early Italian Renaissance paintings, then just coming into fashion, for the Louvre. The suppression of both religious orders and many churches in the former Papal States and the confiscation of their art collections made his task much easier, although Tuscany, Lombardy, and the Emilia-Romagna, rather than the States of the Church, were hardest hit. Canova had relatively little aesthetic sympathy for the art of the Tre and Quattrocento but, rightly viewing it as a vital part of the Italian cultural heritage, loudly decried Denon's activities. This legalized looting—yet another spoliation of Italy—must have further increased Canova's resentment of France.[31] At the heart of the artist's objections was his belief that art has a morally inviolable relationship to its context of creation; on the walls of a Parisian museum the spoils of war would be little more than aesthetic and historical curiosities. Moreover, the French had broken the spirit of their promise to him that no additional works of art would be extracted from the former Papal States if he agreed to remain as director of the museums. Even more appalling than seizures for the Louvre was the sale, often for a mere pittance, of works of art and ecclesiastical furnishings from the suppressed religious houses. Unfortunately for Italy, virtually none of the works taken in 1811–12 ever returned to the peninsula. Objects extracted from Italy by the Louvre's former director still constitute a considerable portion of the museum's early Italian painting section.

Canova's more decisive influence over contemporary art in Rome was often exerted through his personal patronage rather than his official directorship of the museums. Most official works of art, above all paintings, were commissioned from French artists resident in occupied Rome. Jean-Auguste-Dominique Ingres, who had been a rather isolated figure in the Rome of Pius VII, came into great favor under the empire. He painted portraits for the leaders of the French bureaucracy, including the comte de Norvins and the comte de Tournon, and received from Miollis the commission for *Vergil Reading the Aeneid to Augustus*. In addition, Ingres executed the *Dream of Ossian* for Napoleon's bedroom at the Quirinale. The French painter's real coup, however, was the commission for a large picture for the same palace, which was then being refitted as an imperial residence for the king of Rome.[32] Canova, whom the authorities tried to involve actively in the project, declined any commission, consenting only to advise the undertaking. Ingres's *Romulus, Victor over Acron* (figure 34) was the choice commission among those given to the painters, and the favoritism shown a French artist on this occasion did not augur well for Italian and other non-French artists working in a reduced market where the French were the only game in town. Canova's lack

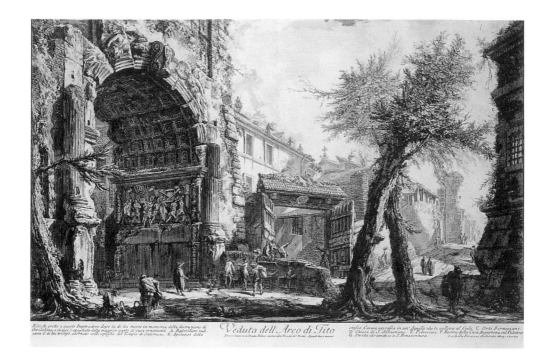

FIGURE 32

Giambattista Piranesi, *View of the Arch of Titus,* etching, 1756, from *Le Vedute di Roma.*

of real involvement in the Quirinale project may reflect Ingres's prominence; Canova seems not to have valued the French painter very highly, preferring Francesco Hayez, a fellow Venetian, whose career the sculptor was then actively trying to promote.

As an inhabitant of occupied Rome Canova witnessed the attitude toward the French among the populace, a profound unpopularity that was exacerbated by tyranny and oppression and the perceived contempt in which the conquerors held the Romans.[33] This general Roman Francophobia must be considered in any attempt to understand and evaluate Canova's political point of view.

It is not surprising that in a city with an enormous clerical population, as well as a significant number of others directly or indirectly dependent on the clergy, one of the most controversial elements of the imperial occupation was the relentless French persecution of priests, nuns, and monks and the wholesale confiscation of their property. Ecclesiastics, in turn, were the empire's most resolute foes, encouraging the people to (usually) passive resistance. Shortly after the annexation the government ordered all the churches in Rome to sing a Te Deum in thanksgiving for "unification" with France, but only one church, San Luigi dei Francesi, the church of the French nation, actually complied, and then only after

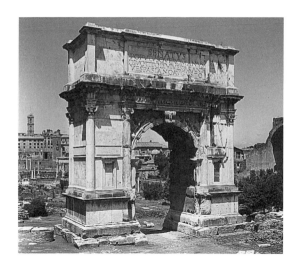

FIGURE 33
The Arch of Titus, ca. A.D. 80,
restored by Giuseppe Valadier,
1815–18.

troops fetched the organist and the choir and forced them to perform.[34] The oath of alle-
giance that had been such a stumbling block for Canova proved even more onerous for the
clergy. Over half the episcopate of the Departments of the Tiber and the Trasimene re-
fused, and fewer than 10 percent of the basilican canons swore the oath; in consequence, they
were expelled from their houses. Many were forced to accept public charity. Tournon pri-
vately called the nonjurors "those brave victims of an absurd persecution."[35] Their contu-
macity made it difficult for the regime to order the solemn church ceremonies wanted for
propagandistic purposes by the regime, since they were usually conspicuous figures in such
sacred services. The lower clergy, both in Rome and the hinterland, accepted the oath at an
even lower rate than the canons, and in about 1810, when Pius VII secreted instructions out
of his place of captivity at Savona forbidding the clergy to swear, the government was
swamped with retractions. A crisis ensued when in 1810 the government required that the
formula "Domine, salvum fac nostrum Imperatorem Napoleonem" be added to the general
collects at mass. The archpriests of Saint Peter's and Saint John Lateran, Rome's most im-
portant patriarchal basilicas, forbade their chapters to use the formula, and both were ar-
rested and deported. The diarist Francesco Fortunati recorded an even more telling incident
of the people's animosity to the empire. When a directive of November 28, 1810, com-
manded that all parishes in Rome pray for a male heir from the pregnant empress Marie-
Louise, only the priests present at a mass in the Pantheon, Santa Maria ad Martyres, recited
the prayer, since all the people walked out.[36]

The harsh excesses committed against the ubiquitous religious houses, convents, abbeys,
schools, and hospitals after the suppression of the orders increased Francophobia in the for-
mer Papal States. Few families were unconnected to members of these foundations by blood
and affection. On June 14, 1810, the convents of the Paoletti and the Convertite were occu-

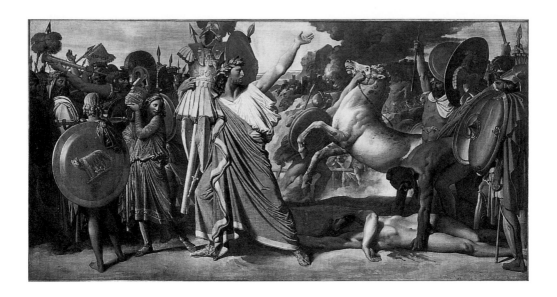

FIGURE 34
Jean-Auguste-Dominique Ingres,
Romulus, Victor over Acron, oil on
canvas, 1812. Paris, École Nationale
Supérieure des Beaux-Arts.

pied violently and the nuns cast into the streets; a similar incident occurred in the Umbrian town of Narni a few weeks later. At Rieti, in Lazio, the possessions of the oblates of the Bambino Gesù were illegally auctioned off, and at nearby Anagni works of art and furnishings from two convent chapels were sold, even though they also served as parish churches. Violence against monks and nuns and the systematic looting of their property were so widespread that the police could do little to stop them.[37] Especially grievous was the confiscation of church bells to be melted down for ornaments and coinage; in villages and small towns these bells had civic as well as religious functions.[38] Over a thousand were melted down in 1813 alone.

The persecution of the clergy and religious foundations was accompanied by a rigorous purging from the civil service of papalists and those suspected of indifference to the new regime. All twenty-five of the lay employees of the Monte di Pietà, the major banking house of Rome, were dismissed. Many lawyers, thought to be less legitimist than other bureaucrats, surprised the French by refusing the oath. In fact, many nonjurors from both the Church and the bureaucracy became popular heroes and were given gifts on their way into exile or were supported by private charity in their distress. Concomitantly, jurors among the parish priests became especially unpopular and were threatened and derided. Few would receive the sacraments from a juring priest. In sum, the French greatly deceived themselves in believing the Romans to be oppressed and hungry for "liberty"; Miollis remarked that the

power of Pius VII had never been greater than during the period 1809–14. Every March 21, the anniversary of Pope Pius VII's elevation, the people of Rome illuminated the city in the traditional manner.[39] Moreover, ceremonies and circuses intended to bribe the lower classes into supporting the empire failed miserably, and carnival festivities on the Corso were met with shuttered windows and closed shops. And Pasquino, the statue famous for giving us the word "pasquinade," was often festooned with placards condemning the French.

Rome's determined opposition seems to have surprised, unsettled, mystified, and finally enraged Napoleon. He sincerely thought he was granting a great boon to the city by naming it the second capital of the empire and by designating his only legitimate child its king. Massive resistance, almost always passive, was even more surprising since the measures the government had taken to strangle opposition in the former States of the Church were the same as those they had employed in all the conquered and annexed territories: censorship, spies, the violation of the mail, and strict control of the press. Immediately after the deposition of the pope the employees of the postal system were dismissed and replaced by members of the French service. A campaign of wholesale letter opening began, and with it a strict censorship directed by highly placed functionaries of the imperial government. Many who resisted the new government and others who merely complained about it were arrested and usually deported only on the evidence of opened letters.[40] The insecurity of the mail may have obliged Canova to exercise caution in correspondence that was not forwarded by friends. His letters during the occupation evidence a greater reticence, in contrast to those of the late 1790s, which are characterized by frank outrage and anti-French partisanship.

The Roman press was even more hamstrung by censorship than the post, for in Napoleonic Rome it was not enough to be silent about what the government wished suppressed; the press had to glorify and aggrandize the regime and attempt to create a consensus favorable to the new status quo, both in Rome and, perhaps more significant, in France and the other occupied territories. As early as April 1808, over a year before the annexation, Miollis initiated the *Gazzetta romana,* which the next year became the *Giornale del Campidoglio,* a publication that, when united to the *Giornale romano* in April 1810, became the chief propaganda organ of the imperial regime. It published decrees, slanted war news, encouraged "reforms" (that is, whatever the government had decided to enact or decree), and glorified military service in the emperor's armies.[41] Above all, it sullied the name and reputation of Pius VII and of the previous government and its adherents. The papal journal, *Diario di Chracas,* was suppressed. The French newspapers engaged in sophisticated propaganda, trying to create an image of a festive, culturally progressive and contented city, describing glittering parties, receptions, and theatrical performances along with detailed accounts of impressive ecclesiastical ceremonies honoring Napoleon and his family.[42] This fiction, directly contradicted by contemporary diarists and correspondents, has been discounted by almost all Italian scholars. Only the French themselves and the small minority of Roman collaborators frequented the French festivities, opposition in Rome remaining mostly mute but highly tenacious.

Outrage at the treatment of monks and nuns; the spoliation of religious communities; the

suppression of charities; high taxes; seizure of horses, grain, fodder, carriages, and so forth, on an unprecedented level; and epistolary and journalistic censorship—none inspired as much anguish, grief, and loathing as military conscription. The French wars for European dominion that had lasted for over two decades before the fall of Napoleon had turned much of the continent into an abattoir. Hundreds of Romans and over two thousand papal subjects were killed or wounded in Napoleon's wars, many in the ill-fated invasion of Russia and the disastrous retreat that followed. Most of these were conscripts, since very few ever actually volunteered. By 1813, when the loss of the Grande Armée in Russia made Bonaparte especially desperate for troops, the draft age in Rome ranged from nineteen to sixty. The diarist Fortunati recorded a characteristic incident that occurred on January 13, 1813. In front of the Church of Santa Maria sopra Minerva, General Miollis was exhorting a group of reluctant conscripts to martial virtue and eventual glory. They shouted back, "We don't want to go to war!" When he commanded them to shout, "Long live the Emperor!" they whispered instead, "Damn the Emperor!"[43]

In addition to recruiting for the army, the French proposed to remove 212 boys from aristocratic families in Rome and the former Papal States, a scheme they called the Golden Levy. To balance an education considered too religious and insufficiently technical, the children were sent to France to various *écoles* for administrative, military, and scientific training. Many of the assessed families pleaded ill health and sundry other excuses, but to no avail. Besides its benefit in supposedly frenchifying the future leaders of the Roman nobility, removing the boys gave the French excellent hostages, ensuring the good behavior of their families. Some of the children were only eight years old, and victims included members of the Odescalchi, Chigi, Barberini, Santa Croce, Spada, Altieri, Patrizi, Colonna, Ruspoli, Doria, and many other families—in short, almost all the politically important families in the former papal capital.[44] One of these families, the Patrizi, were Canova's friends, to whom he had once given a *Madonna and Child* in relief as a token of esteem. Cunegonda and Giovanni Patrizi were singled out for Napoleon's wrath because they heroically resisted the Golden Levy, Cunegonda accompanying her sons to school in France while her husband languished in prison—among his places of incarceration were the infamous château d'If and Fenestrelle, where he was imprisoned with the emperor's old enemy Cardinal Pacca and other dissidents. Bonaparte singled out the Patrizi for constant harassment. He commanded that some of their property be confiscated, and he read their letters himself, ordering that they be intercepted by the police.[45] The persecution the family suffered on account of their children must have angered their friends, including Canova.

The Golden Levy did much to erode the support for the empire that had existed among a minority of the Roman aristocracy, much as anticlericalism, conscription, and high taxes had alienated the lower and middle classes. Draft dodging and tax evasion were commonplace, especially after the debacle in Russia, and the attendance at Te Deum rituals, military reviews, and Bonapartist celebrations, never high, dwindled to almost nothing.[46] Rome tired of the exactions and the military occupation, and many took hope in the rumors of French defeats and in the nearness of the English fleet.[47] In addition, the continental system and high

tariffs assessed against Italian exports of nonagricultural goods, levied to privilege French industries, had crippled most of Italy economically. Over 20 percent of taxes collected went directly into the imperial treasury, and by 1810 it was obvious that the entire peninsula was to become a source of raw materials for metropolitan France.[48] The French legacy in Italy was social unrest, massive population displacement, lowered living standards, business failure, cultural humiliation, hunger, and death. Like the citizens of the puppet republics of the 1790s, few in Rome regretted the passing of the imperial French hegemony.

Pius VII's tumultuous welcome back to his capital in 1814 far surpassed any display ever afforded the French there. The pontiff's return, however, was not an unmitigated blessing for Canova. Some of his enemies took the opportunity to denounce him as a collaborator, since he had continued his work in the cultural bureaucracy under French rule. Even before the arrival of the pope, Canova ran afoul of the severe interim governor, Monsignor Francesco Cavalchini, who erected a scaffold and a whipping post on the Corso to punish all manner of minor offenses. When Canova intervened on behalf of an artist banished for political offenses (he had worked for the French), Cavalchini accused the sculptor of defending brigands and traitors; the sadistic cleric was among Canova's most influential slanderers, but Cavalchini was removed from office, partly at Canova's urging, as soon as the cardinal secretary of state, Ercole Consalvi, arrived in Rome to prepare for the reception of Pius VII.[49]

The aged monsignor was not the artist's only enemy. Canova's exalted position as artist hero vastly increased the resentment and envy of some of his less successful rivals, who saw an opportunity to injure his reputation by charging him with collaboration. The unsettled times and the virulently Francophobic reaction that ensued in 1814 made the moment seem propitious for such calumnies. Although the pope's and Consalvi's confidence in him never wavered, the attacks continued, and finally, after suffering in silence, Canova defended himself.[50] If the abbate Missirini used his own words in recounting Canova's self-defense, his text doubtless reflects the sculptor's sentiments:

> I am conscious of my zeal for the arts, for Rome, for the adorable prince who governs us. Who dares to dispute it, or to equal these my sentiments? Perhaps it is a demerit in me to have instituted public prizes for the young artists? to give pensions to some Roman student who shows talent and hope in the arts? to have advanced 2,000 scudi of my savings to save, in these recent times, the medal collection of His Holiness? It is probably a grave demerit to have undertaken the statue of Religion, larger than any other marble statue that exists in Rome, which I would not agree to execute for anyone else if they had 40,000 scudi?[51]

Concerned for his reputation and for his place in history, Canova felt that such self-justification was necessary despite continuing government support and the distinct possibility that he had the pope's permission to continue as director of the museums during the occupation, and to do what he could for the pontifical collections. But the criticism stung him deeply, and the ultimate rejection of the colossal *Religion* soon afterward filled Canova with resentment that was assuaged only in the building of the Tempio at Possagno.

FIGURE 35
Antonio Canova, *Pietà,* gesso, 1820.
Possagno, Gipsoteca Canoviana.

Whatever his disappointments in Restoration Rome, Canova remained Francophobic in his attitudes, albeit on a much less engaged level. In July 1815, informed of his election as a citizen of the Republic of San Marino, he replied that he was happy to claim the world's oldest republic as his *patria* and that it would be better to have been born its citizen than that of the greatest empire in the world. In gratitude, he presented San Marino with a suite of engravings of his works. He must have been thinking of the Serene Republic, effaced from the map, and of the ephemeral empire of Napoleon, now also vanished. The antiquity of San Marino's independent republic must have made an ironic comparison to Napoleon's short-lived imperial dreams.[52]

Canova's decisive involvement in the repatriation of the Italian collections from the former Musée Napoléon subjected him to insult and vilification in France, where he had never been popular except with a few artists and with the Bonaparte family. During his sojourn in Paris in 1815 he had discussed with Quatremère de Quincy and others a commission for a *Pietà* for the Church of Saint-Sulpice, religious art being politically correct in Restoration France.[53] Canova made a *bozzetto* for the work (figure 35), but a French detractor, probably

Louis Forbin, had poisoned the waters against the sculptor, and the church was persuaded not to take the work. Canova informed Quatremère that he would not send the work out of Italy, although there had been offers for it from Britain and Russia. The artist did not live long enough to execute the sculpture in marble, and it is not entirely clear why the discussion of it, at least as a commission from Quatremère, was dropped. The failure of the project, however, provided an apposite ending to a long relationship between Canova and France, often marked by bitterness and resentment, that was, at best, cool, suspicious, and aloof.

4

CANOVA, NAPOLEON,

AND THE BONAPARTES

———————————

SHORTLY AFTER THE OVERTHROW OF THE SERENE REPUBLIC OF VENICE in the summer of 1797, General Napoleon Bonaparte wrote the following letter to Antonio Canova in Rome:

> I am informed, Sir, by one of your friends, that you are deprived of the pension that you enjoy from Venice. The French Republic holds in special esteem the great talents that distinguish you. Celebrated artist, you have a very special right to the protection of the army of Italy. I have just given the order that your pension be paid to you punctually, and I pray you to let me know if this order is not executed, and to believe in the pleasure that I have in doing something that may be useful to you.[1]

This flattering and solicitous letter began what was to be the most complex and troubling association of Canova's professional career. Given Bonaparte's appreciation of the sculptor's great fame and his later desire to attract Canova into the court orbit as the chief cultural ornament of the Consulate and, later, the empire, it is a bit surprising that this is the only known letter Napoleon ever wrote to the illustrious Venetian artist. Afterward Napoleon always informed Canova of his wishes and commands (to him they were synonymous) through intermediaries. And while Canova's political attitudes were generally Francophobic, he executed some of his most important commissions for Napoleon and the Bonaparte family.

Part of Canova's involvement with Napoleon was historically determined; Bonaparte controlled most of Europe more or less absolutely during fifteen years of the sculptor's artistic prime, and Canova, as he acknowledged, needed to work during troubled times, when he was effectively inaccessible to the British clients whom he much preferred. But Canova was never a Napoleonic artist in the manner of David and Gros, or even an artist to be identified with the French court.[2] Canova's chief goal in life was to live and work inde-

pendently, and his obsession with this notion led him into an often rocky relationship with Bonaparte, who wanted to monopolize him and enlist his talent in the cause of cultural propaganda. This chapter considers the Canova-Napoleon relationship from both sides, focusing on the highly problematic *Napoleon as Mars the Peacemaker* (see figure 38) that, with the possible exception of *Religion,* was the artist's most singular failure. Moreover, I discuss Canova's activities for other members of the family, including Josephine and Pauline Bonaparte Borghese, and examine closely his portrait of Napoleon's mother, a statue that offers valuable insight into his strategy for dealing with clients with whom he shared little personal sympathy and whose politics he found objectionable. Finally, I discuss some notable women—Juliette Récamier, Cunegonda Patrizi, and Delfina de Custine, among others— whom Canova greatly esteemed and personally liked, and whom Napoleon persecuted for political reasons. Working on the assumption that we resent people who hurt our friends, I believe that Bonaparte's animosity toward these intelligent and culturally enlightened women contributed greatly to Canova's quiet dislike of the French dictator—as if the betrayal of Venice had been insufficient to the purpose.

After the coup that gave dictatorial power to General Bonaparte as first consul, Napoleon again turned his attention to Canova, inspired by the admiration he felt for the recumbent *Cupid and Psyche* (see figure 7), which was in the collection of his brother-in-law Joachim Murat.[3] Much of his favorable response to the statue was doubtless the desire to possess an object, acknowledged to be beautiful, that had been created by the most eminent artist in Europe, for Napoleon's personal aesthetic sensibilities were, by all accounts, extremely limited. The second, standing, version of the theme (figure 36), however, rather than the more famous recumbent version usually cited in this context, may have prompted the praise recorded in a letter sent from Paris to Canova by Ennio Quirinio Visconti on August 18, 1802.[4] It informs the sculptor of Bonaparte's admiration, concluding, "The opinion of a man so extraordinarily great, will, I am sure, be sweet to you; and I wanted therefore to give you notice of it."[5] Visconti, a Roman Bonapartist who had gone to Paris to live, addresses Canova in the formal way, indicating that he did not know the artist very well, and although Canova valued praise only when it came from artists he admired or connoisseurs whose judgment he respected, he must nonetheless have been highly flattered. Earlier in the letter Visconti remonstrates with Canova over his reluctance to abrogate Colonel Campbell's claims to the statue, so Canova must not have been overenthusiastic about sending it to France, although Josephine later acquired a variant based on the *modello* originally made for Campbell.

Less than two months after Visconti wrote to inform Canova of the first consul's high opinion of his work, the sculptor came to Paris and heard it from the original source. He arrived there in October 1802 to begin the heroic portrait demanded by Napoleon, after several difficult weeks spent attempting to avoid the trip and the commission. Napoleon had issued his "summons" to Canova through his ambassador in Rome, François Cacault, all of whose diplomatic abilities were put to the test in persuading the artist to comply. At first Canova, inventing excuses about poor health, bad weather, and impassable roads, asked to be excused. When further pressed, he simply said he could not work for the man who had

destroyed the independence of Venice.[6] Rebuffed, Cacault then put enormous pressure on Pius VII through Cardinal Consalvi, stating that Napoleon was determined to have his way in the matter and that a refusal might have serious diplomatic and political repercussions, especially in regard to the concordat then being negotiated. Canova was also told that by declining the commission he could create serious problems for Rome and the papacy. Pressured from all sides, the sculptor finally capitulated to what was little short of an ultimatum.

Hugh Honour has said that Canova's reluctance to work for the first consul is largely apocryphal, citing as evidence a letter the sculptor wrote to Count Tiberio Roberti, announcing, "Great news! any day now I must leave for Paris where I am summoned by the first consul in order to confer with me." Although Honour's interpretation of this curious letter is certainly plausible,[7] an ironic reading of at least the phrase "Gran nuova!" is possible. Roberti, no admirer of Napoleon (he identified himself with the Austrian interest, as I demonstrate in Chapter 5), would have been the right reader to appreciate such irony. Because Honour's reading has the further drawback of being at odds with the testimony of the early biographers, it is not persuasive. I am inclined to believe that Canova felt distaste for the project and that he began to hope for some advantage from it only once it became unavoidable. In fact, in a letter to Selva in February 1805 after the annexation of Venice to the Kingdom of Italy in the Treaty of Pressburg, Canova wrote, "I would never have gone to Paris had it not been in order to speak of my country."[8]

While Canova was in the consular capital, he received a letter from Selva expressing sympathy for his having had to make the trip and predicting that the portrait would be only the beginning of Napoleon's demands on the artist. Moreover, he wondered how Canova would be able to persist in his disinclination to work for Bonaparte:

> But dear friend, how can you avoid accepting commissions from the first consul? I bet that you will find it impossible not to adapt yourself, because he will give you time, and he will want to increase the glory of France with some monument of yours, as certainly he has augmented his own; since his name by your creations will also be immortal in the annals of the fine arts.[9]

The architect added a personal note, reporting that his mother, doubting that Napoleon would allow Canova to come home, was praying for him. Selva probably had good reason to write to Canova in this vein, understanding the sculptor's aversion to the task at hand. His pessimism reflects the political situation in 1802. Napoleon had signed peace treaties with all his enemies and had a concordat with Pius VII in the offing; as unquestioned military dictator of France, he seemed unassailable. Controlling the Netherlands, the Rhineland, Switzerland, and most of northern Italy, France was more powerful than any state in Europe had been since the empire of Charles V. Given these circumstances, Canova's position stands in even greater relief, and the political courage he manifested during the first consul's sittings is even more remarkable.

When Canova was presented to Napoleon at court, the first consul acknowledged the sculptor's unwillingness to come to Paris and, remembering the pleas of poor health, mocked

him by observing, "But you look very well!"[10] It was not an auspicious start, but Canova overcame his natural timidity and confronted Napoleon on political issues that were potentially explosive. He expressed a resigned bitterness about the fate of Venice and, what was more dangerous, argued against the policy of despoiling Italy that was largely Bonaparte's invention. Canova even cited the controversial "Miranda letters" penned by Quatremère to protest the Directory's cultural policies in Italy, a document that had split the French cultural elite.[11] Moreover, the sculptor had declined an invitation to stay at court while in Paris; he rather pointedly lodged with the papal nuncio to underscore that his sojourn was a pontifical favor to Napoleon and to underplay the humiliation of being summoned—"chiamato," as he expressed it in the letter to Roberti. Napoleon bore it all with apparent good grace, Canova being sufficiently tactful to back away from topics when he saw the first consul beginning to anger. Undoubtedly, Canova's status as an international cultural celebrity gave him greater freedom of speech than almost anyone Bonaparte could have talked to, and knowing this, the artist could take advantage of the ruler's wish to conciliate him. In short, Canova made the best of a bad situation.

In Paris Canova modeled a clay portrait bust of Napoleon from life. This subsequently served as the model for the numerous studio versions in marble and other replicas that began to appear shortly afterward all over Europe; it became the canonical image in sculpture (figure 37). This bust was also the portrait model used for the monumental full-length statue for which Canova was to receive 120,000 francs in three installments, a truly astonishing price that may have been fixed both to bribe Canova and to show Bonaparte to advantage as a Maecenas. Cacault in Rome was to be the liaison for the undertaking, and the peremptory tone the diplomat adopted in his letters (and doubtless in his direct dealings with the artist) concerning Canova's activities may be responsible for the sculptor's marked dislike. For example, Cacault envisioned two statues of Napoleon, one the planned standing figure and the second an equestrian the size of the *Marcus Aurelius.* Regarding the latter Cacault wrote to Talleyrand asking if the idea had been approved, adding that he would instruct Canova to begin work immediately and to "accept no other work before completing the two monuments."[12] The artist did ultimately agree to do an equestrian monument of Napoleon for Naples, but under conditions that did not demean him or put at risk the independence of his practice.

Before considering Canova's controversial statue of Napoleon, it is appropriate to analyze Bonaparte's motives in wanting the work in the first place, besides the obvious political advantage believed to accrue to conspicuous cultural consumption. In his biography of Canova, Quatremère de Quincy confirmed the sculptor's reluctance to go to Paris to execute the first consul's portrait and then says of Napoleon vis-à-vis Europe's most famous artist:

> Time, however, has revealed to us that in him [Napoleon] there was still something other than the desire to entrust the portrait of himself to the most renowned talent of that time. This kind of ambition, since Alexander, has not been lacking in any celebrated man. But with Bonaparte, there was already the expectation of that universal conquest that was the object of his whole

FIGURE 37
Studio of Antonio Canova, *Napoleon as First Consul,* marble, ca. 1803. Florence, Palazzo Pitti.

life. Hence his covetousness of everything there was in each country, whether masterpieces or precious objects, or men of talent and famous subjects. What follows will make better known, in regard to Canova, the extraordinary desire that he had to appropriate him, his works even less than his person.[13]

Canova partly understood Napoleon's determination to possess him body and soul, and he must have deeply feared being the object of desire of one so powerful and selfish. This fear must have been a major reason why Canova struggled so hard and long to distance himself from Paris and to maintain the independence of his sculptural practice in Rome.

Canova began *Napoleon as Mars the Peacemaker* in 1803 and finished it in 1806, although it was destined to arrive in Paris only early in 1811 (figure 38). The conceit of the mixed-genre portrait had a venerable ancien régime pedigree, and I have argued elsewhere that Canova frequently employed this compromise when executing portraits on the scale of life, especially of members of the Bonaparte family. This procedure had two main advantages for the artist. First, it allowed him to "elevate" such works, which he really did not like to make, above

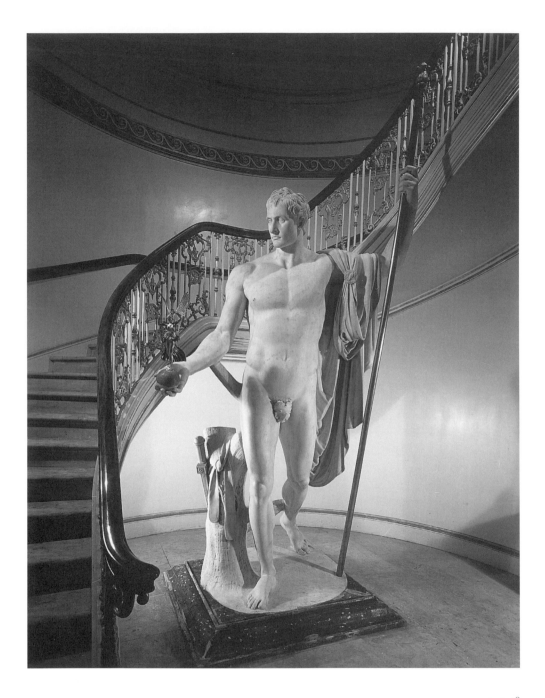

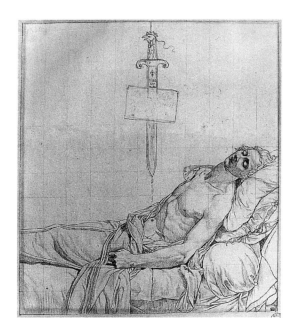

FIGURE 39
Antoine Devosge, after Jacques-Louis
David, *Lepeletier de Saint-Fargeau
on His Deathbed,* pencil drawing,
ca. 1793–94. Dijon, Musée des Beaux-
Arts de Dijon.

mere portraiture, a category of art he considered much inferior to the historical/mythologi-
cal genre. Second, in an era fraught with violence toward works of art, above all public por-
trait sculpture, an artist who mixed contemporary political figures with mythological themes
might partially camouflage the object, so that the work could survive in dramatically altered
political circumstances.[14] The sorry fate of Jacques-Louis David's *Lepeletier de Saint-Fargeau
on His Deathbed* (figure 39),[15] and of statues of Marx and Lenin in more recent times, is a vivid
reminder of the vulnerability of engagé political imagery. "Disguising" the controversial
subjects of his portraits, then, appealed to Canova both personally and professionally: he re-
fused to be co-opted as the cultural propagandist for any particular ideology, even though, as
I hope I have demonstrated, he was far from being politically neutral.

Mixed portraiture, however, had become a highly problematic proposition by the end of
the eighteenth century. Its use in rococo society portraits was commonplace, and the ratio-
nalist, neoclassical critique of the practice found much to deconstruct, beginning with the
contradictory components themselves. Jean-Marc Nattier's *Madame de Caumartin as Hebe*
(figure 40) is a typical example. Suffused with decorative grace, aristocratic chic, and coy ref-
erences to the loves of Jupiter / Louis XV, the portrait testifies elegantly to the perceived su-
periority of both the aristocratic body and the upper-class imagination. And the image's
main purpose was private delectation by the very society it glamorizes, which it imbues
with reassuring magic. But Nattier's portrait is also a victim of its own agenda, given the di-
minished belief in the status quo during the mid eighteenth century, and finally the painting
itself seems only an embellished metaphor, revealing wit and taste, not actual belief.[16]

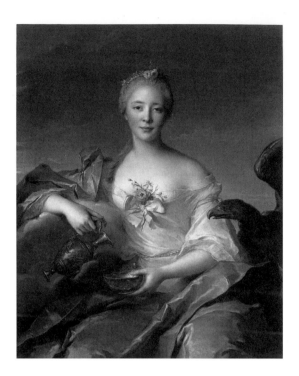

FIGURE 40
Jean-Marc Nattier, *Madame de
Caumartin as Hebe,* oil on canvas,
1753. Washington, National
Gallery of Art.

Given the conceptual problems of the mixed portrait, one wonders why Canova employed it in his major Bonapartist statues. Perhaps he understood that such images had lost the aura of authority they had once possessed and had developed into exercises of the artist's imagination. By moving the power of the image from the subject depicted to the creator, an artist could utterly frustrate the political aims of the patron.

While Canova was working on Napoleon's portrait in the guise of the god of war, Peter Beckford, in his *Familiar Letters from Italy, to a Friend in England,* was repeating, in a different context, the old maxim "It has been said, that if the body were naked, the face would be little regarded."[17] This witticism could very well be applied to Canova's conception of Napoleon's portrait, for I believe that the artist used nudity to defeat any (positive) political purpose the statue might serve. This undermining of political meaning was noteworthy, since the general *concetto* shows Napoleon in a new role, that of peacemaker, even though the general European peace of 1802 lasted only a year.[18] But the most controversial issue surrounding Canova's statue was its "heroic" nudity. The first consul, who had not yet adopted the sumptuous court dress that became one of his neurotic obsessions during the empire, proposed that Canova depict him in his uniform, perhaps manifesting a modernist sensibility and having in mind something like Jean-Antoine Houdon's *George Washington* (figure 41), which makes classical allusion to an edifying ancient theme while maintaining the bourgeois dignity of contemporary dress. Quatremère sagely suggested to Canova that he represent

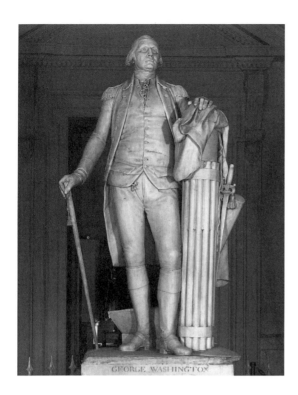

Napoleon as an equestrian Roman emperor in bronze, casting the work in two separate pieces "in case of events."[19] Canova insisted on nudity, following the adage "Graeca res est nihil velare" (The Greek way is to cover nothing) and the ancient example common especially in images of Hellenistic rulers, whose nudity denotes heroic or semidivine status. Quatremère supported the sculptor's decision on philological grounds, unaware of the problems contemporary nudity might present to the French public, which was unfamiliar with art theory and poetic conventions.[20] One of Canova's points of departure was an image like the famous Hellenistic Roman figure in bronze now preserved in the Terme Museum in Rome. As Paul Zanker has pointed out, the pose and conception go back to representations of Alexander the Great and were at variance with the Roman tradition of togaed figures and richly equipped equestrians.[21] Indeed, the shock to Roman republican sensibilities of the nudity of such figures was echoed in early-nineteenth-century France's reaction to *Napoleon as Mars.*

Napoleon, never personally comfortable with the idea of his statue by Canova being au naturel, was slowly persuaded by the arguments of his advisors Ennio Quirinio Visconti and Dominique-Vivant Denon and, finally, by Canova himself. Visconti defended the proposed nudity because of its timelessness; the ancients represented their heroes nude because clothing is subject to variations.[22] D'Este attributes similar reasoning to Canova, who states that a sculptor "consecrates his work to all peoples, to all times, and one calls upon remote posterity for judgment."[23] I would reverse this statement: for Canova, not only was nudity the supreme

state of physical perfection and aesthetic sublimity, but it also prevented a work from being consecrated to any one people, to any one time, as contemporaries could, and did, judge. And as Beckford's quip suggests, the head in the statue of Napoleon as Mars was indeed little regarded in relation to the body. Because the head was a recognizable, if idealized, representation of Napoleon, Canova's strategy of camouflaging the portrait by the use of nudity and the genre of mythology could only have been a mixed success. But he did as much as he could to deflect political scrutiny from a challenging and undesirable commission.

As Horst Janson has noted in regard to *Napoleon as Mars the Peacemaker,* the sublimity of neoclassical nudity may border on the ridiculous; Janson perceived in Bonaparte's posture an attitude of embarrassed hesitancy.[24] Although I think that cannot have been the artist's intention, there was a precedent for hesitancy and embarrassment about nudity in public sculpture in France: the debacle of Claude Dejoux's *Monument to General Desaix* that had been erected in the Place des Victoires in 1810 (figure 42). Napoleon had approved the use of nudity in the statue, perhaps reflecting on the arguments of Visconti, Denon, and Canova eight years earlier. Dejoux's monument was an important test case for the public reception of *Napoleon as Mars,* and its failure augured ill for its more highly anticipated marble counterpart.

The monument to Desaix has much in common with Canova's *Napoleon as Mars the Peacemaker,* and a consideration of it sheds light on Canova's statue. Both works reveal a great deal about the pragmatic, often half-baked cultural initiatives of Bonaparte; both were complete failures as propaganda, and nudity was their downfall. On October 1, 1802, shortly before Canova's arrival in the French capital, the first consul promulgated a decree concerning the Desaix statue. It states that a colossal sculpture of the slain hero of the battle of Marengo was to be erected in the Place des Victoires, a significant political site where a bronze equestrian monument of Louis XIV had stood before the Revolution sent it to the smelters. The captives and chained personifications of provinces on this statue's base led Edme Bouchardon to use caryatid virtues instead on Louis XV's equestrian statue for the Place Louis XV, a device that did not, however, save it from the revolutionary mob. The pedestal of the *Monument to General Desaix* was to be adorned with reliefs related to the conquest of Egypt and the battle of Heliopolis, where Desaix had distinguished himself. The decree named "citoyen Dejoux" as the sculptor and charged the minister of the interior with its realization.[25]

On August 15, 1810, when the empire celebrated the uncanonical "Feast of Saint Napoleon" ordered by the emperor for universal observance, Bonaparte unveiled the nude Desaix monument. It was unanimously judged either indecent or ridiculous, depending on the individual viewer's sensibilities.[26] Dejoux's reputation was partly salvaged by the claim that there had been a problem in the casting of the bronze, but we hear little of him professionally after 1810. The palings around the statue were put back in place and the statue was covered, only to be melted down during the Restoration to make an equestrian statue of Henri IV for the Pont Neuf. Rarely has a much ballyhooed work of art been such a flop. But there was soon to be another.

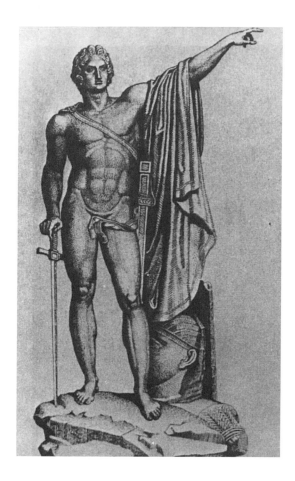

FIGURE 42
Engraving after Claude Dejoux,
Monument to General Desaix, 1805–7;
original bronze statue destroyed 1814.

The unprecedented expectations in France for *Napoleon as Mars* and the long discussion about its ultimate placement in the capital only serve to highlight its failure. Denon was especially eager to have it in his museum. Shortly after the completion of the statue in Rome (but almost five years before it reached Paris), the director of the Musée Napoléon wrote to the emperor: "The whiteness and the purity of the material do not permit that this statue be exposed to the inclemencies of our climate; its nudity has made me think of placing it in the museum among the emperors and in the niche where the Laocoön is, in such a manner that it would be the first object that one sees on entering."[27]

François Cacault, the ambassador in Rome who had done much to bring the commission to fruition, shared Denon's anticipation and opinion of where the statue should be set up, writing in 1803: "The statue must become the most perfect work of this century. It is not a figure to be placed on a public square: it must be placed in the museum in the midst of the ancient masterpieces we owe to the first consul."[28] Even after the arrival of the statue on New Year's Day 1811, Denon was enthusiastic and wrote to Napoleon, stating that it was to be un-

packed and placed in the Salle des Hommes Illustrés to await imperial inspection and permission to be put on public exhibit.[29] As it happened, Bonaparte did not come to see the statue until the following April, and his adverse response to it must have surprised, and perhaps frightened, Denon, who had been one of its primary apologists. I wonder if the director's subsequent hostility to Canova did not begin over the loss of face he suffered with Napoleon's summary banishment of "the most perfect work of this century" to the oblivion of a storage closet.

The elaborate care surrounding the packaging and shipment of Napoleon's statue in Rome, including the extreme precautions taken to prevent its capture by the British Mediterranean fleet (it was judged too risky physically for the statue to be sent over the Apennines and the Alps), indicates, I believe, the emperor's highly ambiguous attitude toward his monumental nude image. The case containing the sculpture was taken from the artist's studio at midnight in great secrecy, carted to the Porto di Ripetta, and then sent down the Tiber by barge to Ostia. The cloak-and-dagger routine was intended to make sure that British spies had no knowledge of when the work was to be shipped, lest the naval squadron patrolling the Italian coast be on the lookout. Bonaparte had already been humiliated when his letters concerning Josephine's alleged adultery were intercepted by the Royal Navy while en route from Egypt to France in 1799. The most curious element of these clandestine arrangements was Napoleon's insistence that the crate be so positioned that it could be jettisoned in case of successful pursuit by an enemy ship. Such a solution to an imagined problem borders on paranoia; had Canova known about it, he would have been deeply angered that a statue on which he had expended so much labor—one he had not really wanted to make in the first place—should be lost forever simply because the emperor feared his nude image might be taken as a war prize. Fortunately for the artist and the object (but perhaps not for Napoleon), the ship reached Genoa on Napoleon's birthday in 1810, the same day the Desaix monument was unveiled in the Place des Victoires, and about two weeks later the crate arrived without incident at the French naval base at Toulon. By mid November it was in Lyon, and on January 1 it arrived in Paris.[30] Rarely has a work of art been the subject of so much military solicitude.

Quatremère de Quincy, in a letter dated May 3, 1811, informed the artist of the emperor's visit to see *Napoleon as Mars*. Quatremère, mocking Napoleon as the "Supremo Signore," relates the unhappy outcome of the august visitation. Bonaparte immediately ordered that the statue be placed apart and public access forbidden. In fact, only a few artists and lucky connoisseurs were able to see it at all. There were many possible reasons for Napoleon's decision to send the work to the storage room, but Quatremère believed, and told Canova, that the current political circumstances made its exhibition to the public impossible.[31] Perhaps a war-weary France was tired of such martial imagery or, as I believe more likely, Napoleon feared scandal, derision, and, above all, laughter. Denon's letter to Canova was much more diplomatic, avoiding discussion of political considerations, but it still put Canova on the defensive.

> I have the honor of informing you, Sir and Dear Colleague, that the emperor has come to see your statue. His Majesty has seen with interest the beautiful execution of this work and its imposing aspect, but he thinks that the forms of it are too athletic and that you may be a bit mistaken about the character that eminently distinguishes him, that is to say the calmness of his movements. . . . His Majesty, my dear colleague, has not yet decided on its destination.[32]

There is one lie in this letter, and one half-truth. Napoleon was anything but calm in his movements, as everyone, including Denon, knew very well. He was especially impatient of sitting for his portrait, as David, Gros, Appiani, and Canova, among many others, could easily attest.[33] The half-truth is that the placement of the statue had not been decided, for the decision not to exhibit it at all had absolutely been made when Napoleon saw how the display of the idealized nude demigod might pose a danger to his personality cult. The shock and mocking laughter recently occasioned by Dejoux's bronze statue of General Desaix may still have been in his mind.

I believe that Napoleon primarily feared the comparison of his present balding, paunchy self to Canova's sublime, heroic creation, unquestionably crowned with his own likeness. The marble portrait, superimposed over the muscular body like a beachgoer's face above the photographic cutout of a strongman, was based, like literally hundreds of others, on the bust Canova made from life in 1802. This image had permeated the public consciousness even more than the photographs of American presidents in the post office do today because Napoleon's features did not age or sag, nor did he grow bald. This bust, in myriad plaster variants, was found even in working-class French homes, as one sees in Louis-Léopold Boilly's *Reading of the XIth and XIIth Bulletins of the Grande Armée* (figure 43), where the image (on the mantel) is the hearth god of the family, benignly looking down on the mother nursing her child. She is able to reproduce (Napoleon's quintessential role for women) and, if necessary, to sacrifice her offspring to *la gloire*.[34] Perhaps Josephine, when no longer empress, put her finger on it when she praised the bronze version of *Napoleon as Mars* that had been executed for her son, the viceroy Eugène de Beauharnais in Milan (figure 44): "Although now the emperor is fat, he still always retains the physiognomic character that you have given him."[35] The emperor knew that the French public in all likelihood would not look on his statue with the indulgence of a fond ex-wife, and not to display it was doubtless the correct decision politically.

But Canova was offended. No work of his had ever been so rudely received, and even though he had been paid most handsomely for it, reputation to him had even greater value. He flatly disallowed the emperor's statement that the forms were too athletic, a criticism picked up by many French connoisseurs, who made a distinction between the athletic and the heroic that the sculptor, on theoretical and historical grounds, would not countenance. In an uncharacteristically peevish letter to Quatremère of November 29, 1806, shortly after he had finished *Napoleon as Mars the Peacemaker*, Canova prophesied a hostile critical reception for the statue. So full of resentment and hurt feelings was the letter that he begged its recip-

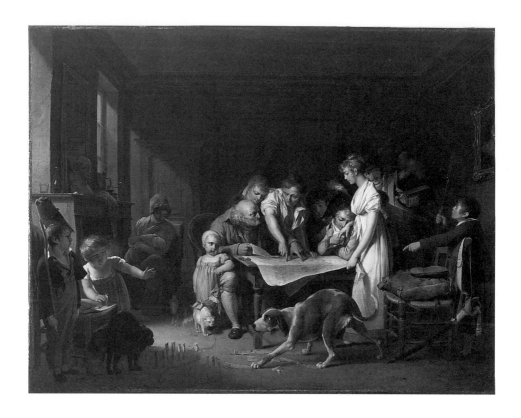

ient to burn it after reading: "One day the statue of the emperor will come to Paris; it will be criticized without pity, and I know it. It will certainly have its defects; above all others it will have the disgrace to be modern and by an Italian."[36] It is clear from this missive that the sculptor did not trust the sincerity of most French criticism, believing it based on the assumption of ancient Greek superiority to any modern art and motivated by nationalistic sour grapes. So marked was the emperor's preference for the Venetian Canova and so equivocal the artist's gratitude that French artists, especially sculptors, grew jealous. David was one of the few exceptions. He wrote to Canova on June 27, 1811, praising the despised statue: "You have made a beautiful figure representing Emperor Napoleon. You have made for posterity all that a mortal can do: the calumny that clings to it, regard it not, allow to mediocrity its habitual little consolation. The work is there, it represents Emperor Napoleon, and it is

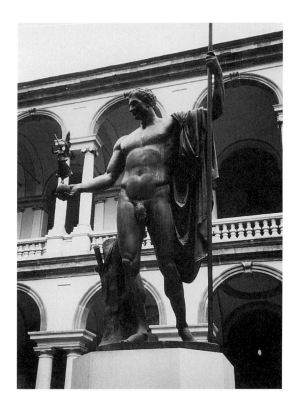

FIGURE 44
Antonio Canova et al., *Napoleon as
Mars the Peacemaker,* 1809, bronze
replica of the marble original of
1803–6. Milan, Museo di Brera.

Canova who made it. That is all that need be said."[37] The sculptor wrote a gracious re-
sponse to the painter on August 8, 1811, thanking him for the praise, but I suspect that his
feelings as an artist exceptionally sensitive to criticism were little mollified.

There must have been some comfort, however, in the knowledge that *Napoleon as Mars*
was politically useless to Napoleon. Criticism of the statue was largely limited to formal
considerations, a response appropriate to the work of an artist who always attempted to
sublimate politics in favor of more pressing aesthetic concerns.[38] Negative political readings
came from non-French viewers, but they were relatively few in number, given the statue's
isolation. British admirers of Canova, who for the most part had not seen the sculpture,
claimed that the work had been done under coercion (which it was) and that his heart was
not in it (which is untrue). Once the commission became inevitable, Canova worked on it
carefully and painstakingly; he knew that the prominence of the sitter would give visibility
to his creation, and he valued his reputation and his place in art history above all other pro-
fessional considerations.[39] In a more subtle vein, the bizarre Frederick Hervey, earl of Bris-
tol and bishop of Derry, supposedly remarked that he could not see England on the globe
held by Napoleon, and the emperor's estranged brother, Lucien, told Canova that his
brother's statue seemed more minatory than pacific and asked the sculptor how he could

have made such an image of the destroyer of his *patria*. The artist responded that his signature, Canova da Venezia, said it all.[40]

Some modern critics have also viewed the statue as an aesthetic problem that reveals Canova's ambiguity toward the subject. Albert Boime, characterizing the "swaying pose and flaccid gestures" as subversive elements that give Napoleon an indecisive air, does not, however, credit Canova with actively promoting subversion in the statue.[41] More perceptive, Giulio Carlo Argan noticed that the idealized head gave the figure an almost supernatural ineffability that was far removed from the heroic mode of the warrior type; he compared its otherworldliness and abstraction to those of Ingres's *Napoleon on His Imperial Throne* (figure 45),[42] which, like Canova's statue, was considered a failure because the figure lacked the active engagement deemed necessary in representing someone popularly called the Man of Destiny. I think Canova's deliberate idealization and abstraction of form were intended to distance the sculpture from the contemporary (political) world. And possibly some subversion of a more traditional type was intentional. The oxymoronic concept of Mars the Peacemaker, which was almost certainly the sculptor's own, must have seemed ironic to some viewers, and the invited comparison between the ideal "athlete" and the pudgy middle-aged dictator must have made more than a few spectators smile. But for Canova himself, *Napoleon as Mars* was first and foremost a work of art, with all other considerations of only secondary importance.

Another problem faced by *Napoleon as Mars* in Paris in 1811 was the general desire for a new image of the emperor as a man of peace (certainly not Mars) and a good father to the people, notions that emerged from war weariness and a general wish for the peace necessary to enjoy fully the fruits of empire won with so much French blood. David's *Napoleon in His Study* (figure 46), although commissioned by Bonaparte's Scottish admirer Alexander Douglas, is the most famous representation of this new image of the ruler in the last years of the empire. The portrait celebrates the Code Napoléon, on which Bonaparte has been laboring most of the night, in a naturalistic style that is light years removed from the idealism of Canova's remote deity. But this painting is also politically problematic, for in lionizing Napoleon the first consul, whom David and his patron Douglas admired, it implicitly criticizes Napoleon the emperor, about whom David was "profoundly ambivalent," to use Dorothy Johnson's phrase.[43] A subversive, anti-imperial subtext has convincingly been argued for David's *Distribution of the Eagles,* which, like *Napoleon as Mars,* relies visually on abstraction and the depiction of the emperor as a removed, aloof figure.[44] Ultimately, both works of art, for similar reasons, were ineffective as political and cultural propaganda.

When Napoleon fell in 1814–15, *Napoleon as Mars,* despite its mythological component, became vulnerable, and Canova was concerned for its fate. Late in 1815, while Canova was in London, Giovanni Battista Sartori-Canova wrote to Quatremère, asking for help and advice about buying back the former emperor's statue:

> Now I must come to another important commission, which I entrust to your acknowledged benevolence. My brother is disposed, having the resources, to take back the statue of Napoleon

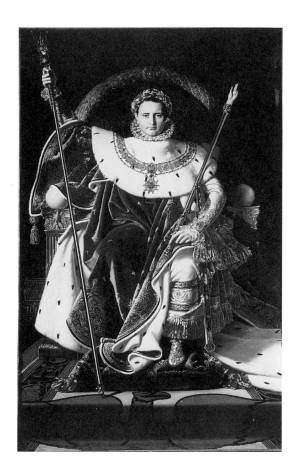

himself and then have it sent back to Rome. I ask whether you in your wisdom think the idea can have any result, and whether the proposition of my brother, when he returns to Rome, merits disclosure. . . . Write and let us know on what terms it would be given back to the author, a work on which he sweated a great deal and that perhaps would be, through the fault of political circumstances, buried in a storage room eternally.[45]

This is a highly curious letter. Why did Canova himself not ask Quatremère about reacquiring the statue while he was in Paris earlier in the fall? The artist's half brother is also very circumspect, as if he were afraid of attracting publicity to the enterprise. Certainly having a work consigned to a storage closet would have been most unsatisfactory to the sculptor, who may also have felt that it would be physically safer discreetly on view in his studio in Rome than in Paris, which was virulently anti-Bonapartist during the early years of the Bourbon Restoration. It has been claimed that Canova wanted the statue back so that it could be erected in the Roman Forum,[46] but this would not have been in keeping with the

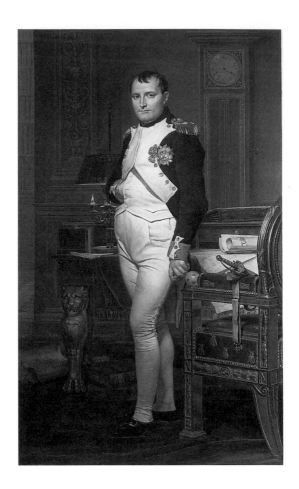

artist's anti-Bonapartist proclivities and would, in any event, have been politically impossible, given the universal detestation of Bonaparte in Restoration Rome. Ultimately, the British government purchased *Napoleon as Mars the Peacemaker* from Louis XVIII and presented it to the duke of Wellington, victor of Waterloo; thus, the statue was politicized in a manner undreamed of by either the artist or the patron. It is still claustrophobically "imprisoned" by the stair balusters near the front entrance of the Iron Duke's London mansion, Apsley House.

The summons of Canova to Paris in 1802 that resulted in *Napoleon as Mars the Peacemaker* was given forcefully, at the instigation of the first consul, but through diplomatic channels. When in 1810 Emperor Napoleon I decided to have Canova execute the portrait of his new consort, Marie-Louise of Austria, the summons was peremptory and absolute, since

Napoleon ruled Rome as emperor of France, and Venice as king of Italy. If it were possible, Canova was even less desirous of going to Paris in 1810 than he had been eight years before, and he feared that he would be forced to move his studio to the imperial capital. As it happened, he almost was. The sculptor was in Florence late in the summer of 1810, installing the *Monument to Vittorio Alfieri,* when he received a letter from Superintendent-General of the Emperor's Household Martial Daru that included two separate proposals:

> His Majesty, Sir, has revealed to me his desire to call you to Paris, either for a time only, or to settle there entirely, and he has asked me to propose to you some measures appropriate to this end. The extraordinary attention he pays to your superior talents and to your knowledge in all the arts of design has made him think that your advice would contribute greatly toward completing the works of art he is having executed that must perpetuate the splendor of his reign.[47]

The letter goes on to say that Napoleon's high opinion and wish to see his subject established in the capital of the empire must be compelling reasons for the sculptor's compliance, and it promises (unspecified) largesse when Canova accedes to the imperial wishes.

The tone of this letter and its firm resistance to excuses to delay his trip to France must have terrified Canova, who responded in a letter to Daru on September 1, 1810. The conciliatory, even obsequious tone indicates, to my mind, a frightened man, but while accepting the unavoidability of going to execute Marie-Louise's portrait, he nonetheless politely but firmly refuses the invitation to transfer his practice to Paris.

> And here I implore Your Excellency to consider the invincible reasons that link me to Italy, and to Rome. It is true to say that this city, mother and ancient seat of the arts, is the only refuge for a sculptor, especially one who has fixed his residence there, now changed by necessity [he was writing from Florence], for very many years. I have given many of these years, however, in service either to His Majesty or to the imperial family, in preference to other very advantageous and honorific commissions, for the dear ambition of ensuring the immortality of my name.[48]

He added that he only wished to be left in peace.

While Canova was in France executing from life the portrait of the empress that was to serve as the model for his full-length *Marie-Louise as Concord* (figure 47), he had a number of conversations with the emperor about politics, history, and the arts. These discussions, which took place at the château of Fontainebleau, were remarkable for the sculptor's candor in speaking to Napoleon on behalf of Pius VII. Canova pleaded for a reconciliation between the two and for the return of the pope to Rome, where there was a severe depression in the arts in the absence of the Curia and the pontifical court. Ironically, Fontainebleau was to be the scene both of Pius's last imprisonment after his removal from Savona and of Bonaparte's first abdication. The artist's diplomatic courage amazed the other auditors, including the empress, for of all subjects the pope was scrupulously avoided by everyone who talked to the em-

peror, including the French episcopate.[49] Napoleon grew angry when Canova pressed hard in defense of Pope Pius, so the sculptor changed tack and beseeched the emperor for munificence to Rome and Florence, for their academies and for the restoration of their monuments; in this endeavor he was successful. Canova knew that an appeal to Bonaparte's vanity was often efficacious, so he underscored Italy's desperate need for a Maecenas and stressed the political advantages of cultural initiatives. In the end, although Napoleon promised much, only a portion was ever forthcoming. But something was better than nothing. Napoleon hoped that if he yielded to the artist's entreaties, Canova would move his studio to Paris. The sculptor, however, persisted in his refusal to live anywhere but Rome. Finally, in frustration, Napoleon bade him go. Very few people had ever been able to get the better of Bonaparte during a negotiation, for that is precisely what was going on at Fontainebleau; Canova was promised a great deal and, in return, only had to spend a few weeks in France and execute the *Marie-Louise as Concord,* for which he was handsomely paid. In fact, the statue was not completed until after the fall of the empire; it was sent to Marie-Louise in Parma, where she was installed as ruler in the general settlement that followed Napoleon's exile to Saint Helena.

Although there appears to be little consistency or continuity in Napoleon's art policies, especially during the empire, there was one essential principle that may be seen throughout his relatively uncoordinated cultural initiatives: that culture be used always as a tool of state control over France and, more important, occupied Europe. Bonaparte knew very little about art per se, but he fully understood the prestige it conferred and its potential for propaganda, above all in legitimizing a regime. This awareness came early to him. In May 1796 Napoleon wrote to Ambassador Guillaume-Charles Faypoult de Maisoncelle in Genoa, asking for a list of the most important art collections in northern Italy, and commissars were assigned to the Army of Italy to select and then confiscate objects in the army's victorious wake, both for the state collections and, more perniciously, as cultural bribes to private individuals back in France who could be of use to an ambitious young general.[50] As consul and emperor Napoleon employed the best artists available to create an aura of splendor, majesty, and legitimacy around what was, in essence, a usurping military dictatorship. He was convinced that the liberal support of the arts could disguise the authoritarian character of his rule, much as Canova believed that a mythological veneer in his Bonapartist portraits could deflect attention from their political raison d'être. In pursuit of cultural respectability Napoleon attempted to bring Canova directly under his influence, but the sculptor believed the ruler had little true taste and, when asked by Bonaparte about the display of antique statues in the Musée Napoléon, the artist supposedly said, "They would certainly be [displayed] better in Italy."[51]

Napoleon's art patronage was highly pragmatic, not aesthetically motivated, and its primary aim was propagandistic. But the emperor also desired to use the arts as an appeal to history. He wanted to imitate Augustus Caesar, who was said to have found Rome a city of brick and left it a city of marble. Napoleon spent enormous sums on the architectural and sculptural embellishment of Paris, and lesser amounts in Rome, usually for victory monuments or memorials to slain generals, works often financed by public subscription. He rarely allowed monuments to himself, preferring posterity (history) to make them for him. The one exception is the equestrian monuments, which Napoleon thought appropriate.[52] Thus *Napoleon as Mars the Peacemaker* was highly exceptional in Bonaparte's patronage.

A copious writer and an indefatigable chronicler of his own life, Napoleon had an obsessive historical sensitivity and a strong desire to impose himself on history. As in his imagery, he wanted to use historical writing to appeal to public opinion.[53] This megalomaniacal propensity led him to manipulate historical writing as a genre of contemporary French scholarship. For example, loyalist historians were petted and honored, often with the Legion of Honor and membership in the Institut de France, and they were well rewarded financially. In many cases the government undertook the publishing and sale of books, with the profits going to the authors. The government prodded slow scholars by withholding payments until publication. It also used teaching positions as rewards for compliance to the government line. Censorship was employed to quash "extreme" books, but even works considered insufficiently laudatory were denied publicity in *Le Moniteur,* making their publication much more difficult and economically risky. The theater and the classics did not escape Bonaparte's censorious scrutiny. Fearing that audiences would interpret traditional

plays as subtle political subversion, he banished many of them from the repertoires of theatrical companies. Voltaire's *Merope* is a case in point. A scene in the play shows the queen mourning two sons, and because Napoleon felt it might be read as France lamenting the absence of the comte d'Artois and the comte de Provence, it was banned. Similarly, most biblical subjects, considered too ambiguous, were officially discouraged.[54] In sum, as in the arts, so in letters; all cultural initiatives were evaluated primarily for their utility to the politics of the regime. And in the final analysis Canova was deemed inadequate to this overarching purpose.

After this brief consideration of Napoleon's agenda for cultural patronage and aid to the arts, I want to return to the promises of support made to Canova at Fontainebleau in 1810. Specifically, the emperor allotted 100,000 francs per annum to the Roman Accademia di San Luca, 25,000 for the institution's expenses and 75,000 for the conservation of ancient monuments. In addition, he earmarked 200,000 for archaeological excavations, giving a clear indication of French priorities. In 1811 Canova had to write to Bonaparte, pleading with him to honor his pledges. It is obvious from the letter that no money had been made available and that officials in Rome were (or pretended to be) completely ignorant of imperial intentions. Canova also wrote to the emperor, describing the inadequacy of the quarters assigned to the Accademia di San Luca and the depression in the local cultural economy.

> You decreed 100,000 francs for the encouragement of the arts. Of this provision, so worthy of you, as opportune and necessary to the ever increasing miseries of the professors, the government seems not yet to have been informed, and everyone in the meanwhile brings their complaints to me, the interpreter of your vows and the herald of your beneficence: everyone stagnates little by little, and even those of uncommon merit are entirely deprived of commissions, and the circumstances of your Rome are much more wretched than what I have already described to you.[55]

He adds a supplication that Napoleon be as good as his word. Eventually some of the money was paid out, but the promises of 1810 were not fulfilled, and of the sums received so much was committed to archaeological initiatives that practicing artists derived only limited benefit from them. The increasingly strained state of imperial finances, especially after the disaster of 1812, made full compliance all but impossible, and after the papers had published the original act of benevolence and the princely sums involved, little more propaganda value could be had for actually enacting the pledges, so there was no incentive, apart from Canova's reproaches, for the emperor to keep his promise.

Although Napoleon was keenly interested in Rome as a cultural talisman and as a historical idea, his cultural dreams for the Eternal City were best served, not through the Accademia di San Luca and the patronage of modern artists, but rather through vigorous, relentless excavation. As Marita Jonsson has stated, Napoleon naively believed that ancient buildings were intact beneath the city's soil, and that their "liberation" was merely a matter of digging.[56] Moreover, the historical process in which the fabric of ancient structures had

been wholly or partly consumed by the fabric of later buildings was, in the emperor's view, a deplorable example of priestly neglect; the ancient must be "freed" from the unworthy accretions allowed during the ages of priestcraft and superstition. The problems presented by the Arch of Titus demonstrate what a dangerous proposition French-style archaeology could be. The approach here was in many ways a metaphor for the French plans to reform Rome—strip away the last fifteen hundred years of Roman history to revivify the splendor of the ancient *caput mundi*, and the people would once again embrace militarist ardor and dreams of world dominion, all, of course, under the aegis of imperial France. Culturally, such a reawakening would engender new Raphaels, new Virgils, and new Vitruviuses to rival those of old. Canova was a vital component of this vision, since Napoleon needed a great artist to be *his* artist in the tradition of Alexander and Apelles, and he believed that the Venetian sculptor could reach unparalleled heights in the new Roman order. Consider what he had already accomplished under the woefully mediocre Pius VII.[57]

The emphasis on archaeology and the courting of Canova were only part of a more complex relationship Napoleon sought to have with Rome. Significantly, his administrators there enjoyed only modest titles, and no member of the imperial family was given an official post. Indeed, there was no prince of Rome or even duke; only the heir to the throne was allowed to assume the lofty title king of Rome. Even Napoleon's stepson, Eugène de Beauharnais, had only been designated prince of Venice, a usurpation of tradition that must have appalled Canova. And while archaeology was a vital ingredient in the recipe of Roman revivification, it was not only the caesars whom Bonaparte wished to blend into his historicist confection. Even more important was the legacy of Charlemagne, assumed by Bonaparte along with the imperial diadem, a fantasy with a profound impact on Rome.

Shortly before the occupation in early 1808 Napoleon wrote to the pope: "I recognize you as my spiritual chief, but I am your emperor."[58] Although the pontiff decried the historical absurdity of the claim with some indignation, it was this idea that ultimately led Bonaparte to depose the bishop of Rome. On May 17, 1809, he revoked the "donation" of Rome to the popes made by his "predecessor" Charlemagne, even though Pius VII rightly pointed out that this donation did not include Rome itself and never had included it. Napoleon's chief ecclesiastical advisor, Monsignor François Amable de Voisins, bishop of Nantes, encouraged the emperor's hard line, and gave lessons both in French Gallican principles and in papal secular obedience to imperial dictates. Bonaparte's suppression of the Holy Roman Empire in 1806 had, he argued, removed the Habsburg pretensions to the imperial dignity and had enabled Napoleon to assert his "true" rights to the succession.[59] The decree annexing the Papal States to France, signed by Bonaparte on the battlefield near Vienna on May 17, 1809, justified the action on the historical grounds "that when Charlemagne, emperor of the French and our august predecessor, made donation of several counties to the bishops of Rome, he gave them only as fiefs, and for the well-being of his states, and by this donation, Rome did not cease to be part of his empire."[60] Pius's response was to excommunicate immediately everyone who participated in the annexation and the usurpation of the secular power of the papacy.

While Bonaparte pursued his Carolingian agenda politically with Rome and the papacy, he promoted it culturally at home. Writing in his own hand on April 29, 1803, he ordered the minister of the interior to prepare a proposal to erect a statue of Charlemagne either in the Place de la Concorde or in the Place Vendôme.[61] By the following October the project had become much more ambitious: the monument, now a column for the Place Vendôme almost twenty-one meters high, modeled on the Column of Trajan, was to be decorated with 108 allegorical figures (representing the departments of the empire) on a semicircular pedestal festooned with olive branches supporting a statue of Charlemagne standing.[62] The column clearly anticipated Napoleon's imperial schemes, and the political resonance of the Frankish conqueror in Paris exceeded that of any Roman emperor. I believe it is significant that none of the French monuments planned for occupied Rome represented Charlemagne. The monument in Paris eventually became the Vendôme Column, and although it did not, as realized, glorify early medieval imperium, that is nonetheless what it was initially conceived to do.

As I have attempted to demonstrate in this chapter, Canova's personal and professional contacts with Napoleon were fraught with conflicting ideas and agendas. The chief artistic fruit of these contacts, *Napoleon as Mars the Peacemaker,* reveals how the sculptor, in holding fast to his own aesthetic concerns, subverted the emperor's expectation of political aggrandizement in the work. Although this foregrounding of aesthetics prevented the emperor from gaining much cultural advantage, Canova's strategy had negative consequences, drawing fresh French criticism to his art and humiliating him as he saw a sculpture on which he had expended much labor relegated to temporary oblivion. The empress's portrait as Concord was less problematic, I believe, because she was a woman and a Habsburg, and she was not viewed as a symbol of violence and oppression in her own right. When Canova worked for other members of the Bonaparte family, however, the conflicts he experienced with the head of the clan reappeared, if in a milder, reduced form. In my discussion of this other work the statues of the emperor's mother, Letizia Ramolino Bonaparte, and his sister Pauline Bonaparte Borghese play a noteworthy part. Among his best-known works, these two representations, in different ways, use history and mythology to create mixed portraits and thereby camouflage a more direct politicization. In addition, I believe both statues have subtle, subversive undercurrents unflattering to the sitters and to the imperial family. The sculptor's activities for Josephine, however, presented none of the political difficulties that accompanied the portrait demands of the other members of the Bonaparte family. She was the only one of them for whom Canova worked willingly.

Letizia Bonaparte, called Madame Mère, commissioned her full-length portrait from Canova while she was in Rome in 1804 (figure 48). Indeed, her affection for Rome and her preference for living there perhaps did much to recommend her to Canova, who seems to have accepted the commission without difficulties. (At about the same time, she also asked for a portrait bust of herself, a work less congenial to the artist that was completed, probably with

considerable studio assistance, in 1806.)[63] Of all the full-length representations of the Bonapartes Canova actually completed, this is the only one without a mythological "disguise." Its formal reliance on a famous ancient statue, however, the Capitoline Agrippina (figure 49), named for the museum that housed the sculpture, gives *Madame Mère* a deeply ambiguous historical referent. Its patron, moreover, failed in her ultimate purpose of placing the work opposite her son's throne in the Tuileries Palace, arguably because it closely resembled the famous antique statue.[64] As a problematic historical metaphor Agrippina deeply compromised the statue, which, like *Napoleon as Mars,* ended up in a British collection, that of the duke of Devonshire at Chatsworth, in Derbyshire.

The trouble was that there were two Agrippinas in the Julio-Claudian dynasty, one a paragon of matronly virtue and the other a monster of ambition who slept with her brother Caligula, married her uncle Claudius, and then poisoned him to achieve power, if we are to believe Suetonius and Tacitus. Thus, Madame Mère had a fifty-fifty chance of being flattered. Not so Napoleon, for the elder Agrippina was the mother of the deranged Caligula while her daughter, Agrippina the Younger, gave birth to the equally insane Nero. The Capitoline Agrippina that was Canova's point of departure had long been the center of a philological debate about which woman the statue represented, and while the majority opinion favored the virtuous mother, a minority held out for the vicious daughter. Either way, Canova made a brilliantly ambiguous choice that allowed him to compete with a canonical masterpiece of ancient sculpture while frustrating any attempt to promote it as a glorification, cultural or otherwise, of the imperial family.[65]

The French antiquarian Quatremère de Quincy seems to have been among the less numerous group of savants who believed the Capitoline Agrippina was a portrait of the depraved mother of Nero, or at least he pretended to believe it after Canova chose it as the source for *Madame Mère.* His opposition to the Bonapartist regime was notorious (and monitored), and he doubtless delighted in an opportunity to use scholarship to discredit the dynasty from the safety of the library. He wrote to Canova: "The statue of Madame Mère is very beautiful, and must make, in the draperies, a beautiful effect, broad and large, which varies a great deal from the Agrippina. The head seems to me a good likeness, and of good character; and altogether would seem a rare work, if it was not that the pose is too similar to that of the Roman empress."[66] Quatremère's references to Agrippina and to the Roman empress are worth considering. The one to Agrippina does not identify her specifically, which seems a strange omission until one reads further to "Roman empress." Agrippina Major, wife of Germanicus, was never empress, but her daughter, Agrippina the Younger, wife of Emperor Claudius, was. In such historical detail an antiquarian scholar as proficient as Quatremère was unlikely to make a mistake, so in his opinion, at least, the *Madame Mère* was "too similar" in its pose to a statue of Nero's mother. To the literate elite, who knew the texts of the ancient historians, the reference would have been clear. In any event, both Agrippinas were mothers of demented emperors, and if Canova intended an ambiguous referent or even direct subversion of the imperial family, he could not lose.

But as with the naked statue of Napoleon, criticism of this work was largely limited to

its formal qualities and the too-close resemblance Quatremère noted to the ancient source of inspiration. The artist predicted this reaction in France even before he had finished the statue. In a letter of November 29, 1806, to Quatremère, he wrote:

> The statue of the mother will come: it will be said immediately that it entirely resembles the Agrippina; and I would say: put them side by side, and then contradict me if there are not very substantial and original differences, in the general movement, in the entirely different legs, in the head, and above all in the drapery, in which I defy anyone to show me a single fold that derives from any figure, ancient or modern.[67]

It is obvious from this defensive statement that Canova understood the criticism he was likely
to provoke if he used the Capitoline Agrippina in relation to *Madame Mère* as he had the
Apollo Belvedere for *Perseus with the Head of Medusa*. Could there have been an iconographic
incentive in addition to the challenge of surpassing an acknowledged antique masterpiece?

Canova moved from the realm of Roman history to Roman mythology in seeking a ref-
erent for the statue of Madame Mère's most interesting daughter, Pauline. She vetoed the
sculptor's original suggestion to depict her in the guise of Diana, the chaste goddess of the
hunt, and insisted on being depicted as the goddess of love. Although *Pauline Borghese as
Venus Victrix* is arguably Canova's most famous statue, it acquired its exalted place in his oeu-

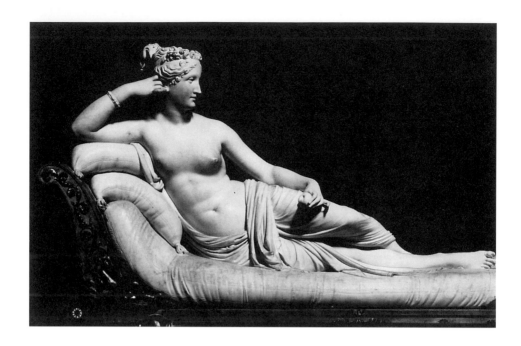

FIGURE 50
Antonio Canova, *Pauline Borghese as
Venus Victrix,* marble, 1804–8. Rome,
Villa Borghese.

vre only posthumously (figure 50). Given Pauline's European reputation for boudoir in-
trigue and adultery (something she shared with her brother the emperor), Canova's initial
choice of Diana may have been ironic. If he had depicted her as Apollo's twin, the represen-
tation would certainly have occasioned derisive comment. Indirectly, it would also have
made Napoleon Apollo, an allusion also full of subversive possibilities. Pauline, however,
wished to be Venus, and it is as the goddess who triumphs in the judgment of Paris, hold-
ing the golden apple and reclining on a divan, that the artist has so elegantly represented her.
This statue is rather unusual for its type in that the portrait is less idealized than one would
expect and the cushions and linens of the couch are rendered with a degree of naturalism
worthy of Bernini, elements due, I believe, to the overt eroticism Canova and Pauline Bor-
ghese wished to convey to the beholder. Even though the ostensible patron was Prince
Camillo Borghese, there can be little doubt that his wife was the force behind the commission.

Napoleon had arranged the marriage of his widowed sister to the heir of the noble Ro-
man Borghese family in 1803 while he was still first consul. Doubtless, as she herself seems
to have realized, he could have done better for her had he waited a year until he became em-

peror. Upon her arrival in Rome her fame and beauty made her popular for a time, but Roman society was put off by her pretensions and repulsed by her constant complaints about her spouse's impotence. From a position as unofficial queen of Rome she soon earned the sobriquet "Messalina of the Empire" because of her notorious affairs, the number of which was exaggerated by her legions of ill-wishers.[68] Less than a year after the marriage, her brother wrote from Paris complaining of her behavior and predicting serious consequences if she continued in her present path: "I was pained to hear that you do not have the good sense to conform to the morality and the customs of the city of Rome; that you expose yourself to the contempt of the inhabitants. . . . Love your husband and his family, be kind, accommodate yourself to the morals of the city."[69] He threatens to repudiate her if she does not mend her ways. Understanding Pauline's deeply compromised reputation, Canova may have meant the statue more as a monument to her brazen disregard for social observances than as a traditional tribute to her beauty. And although the statue was kept under close watch by Prince Camillo and relatively few people were allowed to see it (and then only by torchlight), it still gained great notoriety for both the artist and the subject. Unfortunately for Napoleon's social ambitions, the attention was largely negative.

Of all the members of the Bonaparte family who patronized him, Canova preferred to work for Josephine. Like her second husband, she became interested in the sculptor when she saw the two versions of *Cupid and Psyche* in Murat's collection. Her enthusiasm lasted as long as her life, and Canova executed some of his finest works in the graceful mode for the gallery at the château de Malmaison that she dedicated to his work. One of her earliest requests was for a series of diminutive statues representing either the seasons or the deities of Mount Olympus, but Canova answered that such works were not quite in his professional line.[70] He perhaps forgave her this faux pas because she never asked him for a portrait. Among her early purchases were a version of *Hebe* and a standing *Cupid and Psyche,* both of which were shown with some success at the Salon of 1808.[71] Her two most important commissions, however, were *Paris* (figure 51) and the justly celebrated *Three Graces* (figure 52), a work she did not live to see. Her collection, sold in 1814 by her son Eugène to Czar Alexander of Russia, is still to be seen in the Hermitage in Saint Petersburg.

Canova's letters to Josephine concerning her various commissions reveal his respect for the refinement and elegance of her taste and praise her natural inclination to the "beautiful." Indeed, Malmaison, the residence she kept after the divorce, enjoyed a wide reputation as a center of the arts, literature, and learning.[72] The collection she formed of Canova's sculptures was, for all too brief a time, the best in existence, and Malmaison became a pilgrimage site for the sculptor's admirers, including Stendhal and Quatremère. For Canova's art it was a bastion of aesthetic approbation in a largely hostile critical environment. In particular Josephine's *Dancer* (figure 53) was acclaimed for the novelty of the subject and the gracefulness of the treatment.[73]

One other problematic Bonapartist commission should be considered in the present discussion, the proposed full-length, seated portrait of Napoleon's sister Elisa, grand duchess of Tuscany. The beginnings of the project are somewhat uncertain, but possibly it was com-

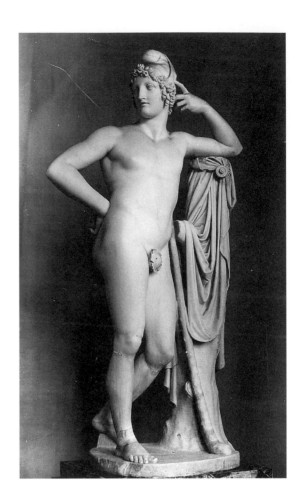

FIGURE 51
Antonio Canova, *Paris,* marble,
1807–12. Saint Petersburg,
Hermitage.

missioned in 1810 when Canova resided in Florence to supervise the installation of the *Monument to Vittorio Alfieri* in Santa Croce. Florence was on the artist's mind during his trip to Paris that year, and he asked for and obtained the promise of aid both for the Florentine Academy and for the much needed restoration of Santa Croce, the latter being a not wholly disinterested request. Quatremère states that Canova made a highly generalized portrait of Elisa in case of a change in political circumstances and that he left it in *modello* form for an exceptionally long time, waiting on events. In all probability he intended the statue as an ideal piece, *Polyhymnia,* for which it was generally recognized when it was finally exhibited (see figure 62).[74] I discuss this work in Chapter 5. The French scholar admits that he does not know why Canova was so hesitant about executing Elisa's commission or why he made it as generic as possible, but I suspect he was following the same logic that led him to execute Napoleon's horse before he made the rider. In each instance he proved to be vatic, for both works ended up in the hands of Bonaparte's enemies, the equestrian monument with the Bourbons and the Elisa portrait with the Habsburgs. *Polyhymnia* constituted Canova's con-

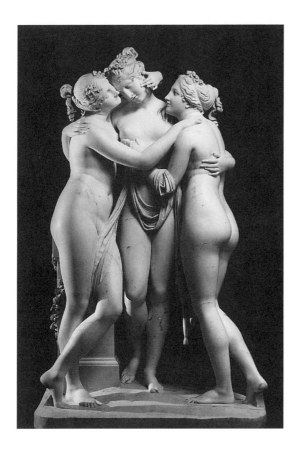

FIGURE 52
Antonio Canova, *The Three Graces,*
1810–14. Saint Petersburg,
Hermitage.

tribution to the Venetian gift of works of art given by members of the academy to Emperor Francis II on the occasion of his fourth marriage. The statue adorned the new empress's apartments in the Hofburg Palace.[75]

Napoleon's siblings, having been placed on thrones all over Europe—Holland, Naples, the Grand Duchy of Tuscany, Spain, and Westphalia—were, in a very short time, thrust into the center of the cultural politics of contemporary Europe. Almost the entire family courted Canova and commissioned portraits and other works from him, including Cardinal Fesch, Madame Mère's stepbrother who became archbishop of Lyon;[76] Letizia; Joseph, king of Naples and later of Spain; Caroline, wife of General Murat and queen of Naples; Elisa, grand duchess of Tuscany; Pauline Borghese; Lucien Bonaparte; and Josephine. Canova's work for the Bonapartes as a group represents a highly significant component of his practice. But the Venetian artist's activities for the dynasty, excepting Josephine, were problematic, often subversive, ambiguous, and unpalatable, especially the portrait busts the family continually demanded and he supplied reluctantly when he could not avoid doing so. And none of the works executed directly for the family, again with the exception of those for Josephine and Pauline, rank among the artist's best productions, probably by his own evaluation. In

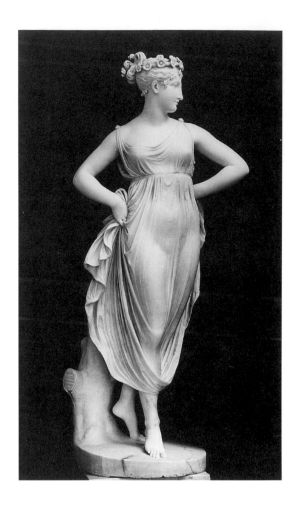

sum, I believe that Canova worked either unwillingly or unenthusiastically for the entire Bonaparte family (save Josephine), and although he always strove for superior achievement, knowing the historical importance of his patrons, in most of his Bonapartist production his reluctance shows.

It may seem surprising that Canova, having been abandoned by his mother at an early age, without sisters, and suffering an unhappy love affair as a struggling young artist in Rome, had many of the closest and most emotionally satisfying relationships of his adult life with women. Widely admired and much sought after as an eligible bachelor, the shy Canova basked in the intimacy occasioned by flirtations with ladies of fashion he met in various salons. With a number of these women he formed true and lasting friendships, but probably of a platonic nature.[77]

He never married. Whatever the attractions that fostered these friendships, they also had a political side: most of his female friends were decidedly anti-Bonapartist, and some were actively persecuted by the French ruler. I believe these facts help to explain Canova's political character, for it is hard to admire or even be neutral toward someone hated by our dearest friends, someone who, in turn, harasses, insults, and even imprisons them solely for their political opinions.

An important member of Canova's circle who was strongly anti-Napoleon was Juliette Récamier, although the artist only met her in early 1813, in Naples. She had been exiled by Bonaparte for her political opposition to the regime, especially in her role as a salon hostess who did much to focus opposition to the imperial government. The fourteen letters from Récamier to Canova that survive indicate warm friendship and sincere mutual admiration. Récamier's plight as an exile moved Canova deeply, since it was motivated by Napoleon's hostility toward learned women. In 1815, when he was in Paris, Canova and his half brother were her houseguests, she having at last returned home after the fall of Bonaparte.[78] In 1849 Récamier presented the terra-cotta *modello* for Josephine's *Three Graces* (figure 54) to the Musée des Beaux-Arts in Lyon, a present she had been given by Canova as a token of affection.[79] One of the last works Canova ever executed was a friendship portrait of Juliette Récamier.[80]

Cunegonda of Saxony, principessa Patrizi, was another of Canova's friends who was persecuted by Bonaparte. Her family's opposition to the Golden Levy is discussed in the preceding chapter; her personal sufferings as a wife and mother deeply impressed everyone in Rome, especially her friends, and her tragic experience of imperial tyranny moved Tournon to pity. When Cunegonda's sons, Xavier, aged twelve, and Filippo, eight, were "conscripted" in the levy and ordered to school in France,[81] Prince Patrizi refused to comply, rousing Rome's admiration and infuriating the emperor, who had him arrested in November 1811. During his imprisonment Cunegonda lived in lodgings near her sons' school, attempting to give them some semblance of family life. Cunegonda had introduced Canova to the Patrizi circle. In her palazzo he met such resolute enemies of Bonaparte as Cardinals Consalvi and Albani and the deposed grand master of the Knights of Saint John of Malta, whose order had suffered greatly at the hands of the French.[82]

One of Canova's nearest friends was Delfina de Custine, who utterly charmed the sculptor when they met in Rome in 1811. She was an accomplished amateur painter and shared Canova's love of art. During the Terror she had been in the Temple prison with Josephine de Beauharnais, and many of her relatives had been guillotined (Josephine's first husband, Alexandre, had also been a victim). Resistance to Napoleon had put her under police surveillance, and, fearing arrest in France, she traveled to Italy.[83] Canova's friend Polissena Turinetti, marchesa di Prié, was also an anti-Bonapartist exile, from her native Piedmont; Canova had been a guest in her palace in Turin on his way from Paris back to Rome in 1802. She was eventually sentenced to prison at Fenestrelle for her opposition to Napoleon.[84] A keen admirer of the celebrated poet Vittorio Alfieri, Turinetti was connected to Louisa von Stolberg, countess of Albany, Alfieri's erstwhile mistress, who commissioned his tomb from Canova. As the leading light of an anti-imperial salon in Florence, Albany was actually in

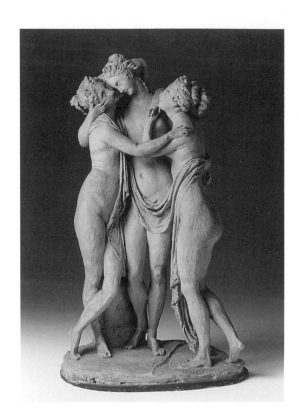

Paris being interrogated by Napoleon's agents when Canova came to install the Alfieri monument's pedestal. To his dismay, even the direct intervention of the grand duchess could not prevent the persecution of the countess.[85] Like Récamier, Custine, and Turinetti, Germaine de Staël was also exiled from France for her salon activities. Napoleon hated her above all the others. As a travel writer, poet, and intellectual who never ceased to criticize the imperial regime, she made herself persona non grata with him, and he banished her on several occasions. Although Canova was only acquainted with de Staël, counting himself among her admirers, she was a close friend of Juliette Récamier's and Louisa von Stolberg's.

That almost all Canova's close friends—Quatremère, Selva, Falier, Rezzonico, D'Este, and the women I have just discussed—were anti-Bonapartists cannot be mere coincidence. I have argued that his troubled relationship with Napoleon and his often unhappy dealings with the rest of the Bonaparte family were caused in part by a Francophobia formed long before the establishment of the empire. The depredations of that empire and the emperor's dogged persecution of Canova's friends did not transform the sculptor into an anti-French activist or a conspirator, but his Francophobic political views did affect his professional practice when Bonapartist patrons employed him—in sharp contrast to his work for the Austrian Habsburgs, as I demonstrate in the chapter that follows.[86]

5

CANOVA AND THE

AUSTRIAN HABSBURGS

THE HABSBURG DYNASTY OF IMPERIAL AUSTRIA, like the Bonapartes of France, eagerly employed the visual arts and culture for the family's glorification, promoting them to fulfill an obligation of rule and to make a political statement. And also like the Bonapartes, the Habsburgs saw Canova as an artist of the highest international reputation whose works could give much cultural splendor to Vienna or at least to Venice, which formed part of their empire from 1797 until 1805 and again from 1814 until the city's absorption by the Kingdom of Italy in 1866. Like Napoleon, Emperor Francis II did much to encourage Canova's entry into the court orbit, asking him to move to Vienna in 1799 and, when Canova declined, offering to build a splendid studio in Venice if the sculptor would agree to live there half the year, a plan that also failed.[1] Despite these rebuffs, however, the imperial family was keen to promote their most famous Italian subject, partly to reconcile their Italian provinces to Viennese rule. Austria had long enjoyed excellent political relations with Venice, and there had been numerous points of artistic contact, so their regard for Canova had a strong traditional basis. As early as 1784 the artist's first Roman masterpiece, *Theseus and the Dead Minotaur* (see figure 22), had come to Vienna after its purchase in Rome by the count von Fries, and the ruling family, while less assiduous art patrons than their French rivals (they were not nearly so rich), commissioned several more works from the Venetian sculptor. Among them was the *Tomb of the Archduchess Maria Christina* (see figure 58), arguably his masterpiece.

This chapter considers the political dimensions of Canova's professional relations with the Habsburg dynasty, focusing on five works with Austrian connections: *Hercules and Lichas,* the *Portrait of Emperor Francis II,* the *Tomb of the Archduchess Maria Christina, Polyhymnia,* and *Theseus and the Centaur.* Scrutiny of these sculptures sheds light on an artist-patron relationship remarkably different from that between Canova and the Bonapartes, although there are also some important similarities. The greater ease between Canova and the Habsburgs was due to the sculptor's political disposition as a conservative Catholic and his

cautious enthusiasm for Austria as a bulwark in Italy against anticlericalism, political radicalism, iconoclasm, cultural spoliation, and mob violence.

The first, unsatisfactory, professional contact between Canova and the Habsburgs, in the spring of 1799, involved the monumental *Hercules and Lichas* (figure 55). A brief history of this remarkable sculpture before 1799 helps to explain the controversy it created in Austrian Italy four years after Canova began to work on it and testifies eloquently to the unsuitability of Canova's works as propagandistic public monuments. Antonio D'Este claimed that the idea for *Hercules and Lichas* originated with Don Onorato Gaetani, a Neapolitan nobleman and minister of the Bourbon government. During a visit by D'Este to Gaetani's palace, conversation turned to Canova's sensitivity to the criticism that although proficient in graceful themes, he was incapable of working in the sublime mode of the *genere forte*.[2] According to D'Este's account, Gaetani then suggested as a theme for the sculptor the moment when Hercules casts Lichas over the citadel walls to the rocks below, an incident from Sophocles' play *Women of Trachis*. D'Este conveyed the offer of this commission to Canova, who accepted. A letter to D'Este from Gaetani dated May 5, 1795, thanked him for his help in the negotiation.[3] *Hercules and Lichas* was the first colossal freestanding group sculpture conceived by Canova, and he spent several months studying the figures in numerous drawings, as in a vigorous early sketch (figure 56).[4] The *modello* was completed by April 2, 1796.[5] Then the difficulties began. The marble block selected for the sculpture in 1798 proved inferior, heightening Canova's anxiety during these months of political catastrophe for Venice, northern Italy, and the Papal States. Canova wrote to Count Daniele degli Oddi in Padua on March 31, 1798: "I am working like a desperate man, and I work more to fling out of my head these thoughts that disturb me. . . . The 'Hercules' is not yet begun in marble, considering that the marble block that came to me is bad, and I want to execute it in another, better one."[6] Unfortunately for the patron Gaetani, the political and military upheavals that were convulsing most of Italy arrived in Naples, where the government was temporarily overthrown and a French puppet Parthenopean Republic was established on the model of the Roman republic. Gaetani followed the Bourbons into exile in Sicily and, with Canova's acquiescence, defaulted on the commission.[7]

Gaetani's political problems left Canova with a major financial difficulty: finding a new patron for a colossal group sculpture in which he had already invested a great deal of time and for which an expensive marble block had already been ordered. The subject was also problematic, being so specifically connected to Gaetani and certainly not to everyone's taste. It must have seemed little short of miraculous to Canova when Count Tiberio Roberti contacted him on behalf of the city of Verona to offer the commission for a sculptural monument honoring Emperor Francis II to be erected in a public square in the city. The sculptor saw a way to sell his *Hercules and Lichas* rather than make a new, more overtly politicized monument. The deeply disturbing narrative of Hercules killing Lichas may be interpreted in a number of ways, providing the ambiguity Canova sought in his public works. He rejected the new commission outright, but mentioned his willingness to make a marble version of the *Hercules and Lichas* for Verona instead. He wrote from Possagno to Roberti on May 7, 1799:

You already know that at Rome I was working on a group representing "The Maddened Hercules who casts Lichas into the Sea," of the dimensions of the celebrated "Farnese Hercules," for a certain Neapolitan gentleman. I do not know whether I have ever told you the little story of some Frenchmen concerning this group sculpture. These [men] said that such a work would have to be set up in Paris, that the "Hercules" would have been [in their interpretation] the "French Hercules," who throws monarchy to the wind. You know very well whether I would ever have adhered to such an idea for all the money in the world. But now could not this "Hercules" perhaps be the inverse of the Frenchmen's proposition? Could not Lichas be licentious liberty? Some of the most interesting deeds then could be sculpted on the pedestal. What do you say about it?[8]

Canova went on to add that he could produce *Hercules and Lichas* much more quickly than a new monument because the *modello* had already been made and the block of marble ordered. The original patron had also given him permission to dispose of the commission as he saw fit, a point on which Canova was always exact.[9] On the surface, the scheme seemed likely to benefit both Canova and the town council of Verona.

Less than two weeks later Roberti notified the sculptor that the Provveditori (town council) had decided that the *Hercules and Lichas* would be erected in the city as a monument to the Austrian emperor. Canova responded:

Viva Verona! One sees that that city always loves the beautiful; and the excellent taste of those gentlemen has made them immediately grasp the moment. They have seen that the group marvelously suits the present circumstances, and that in this way they will also be able to have a work in a style that, if the sculptor does not deceive himself, one will certainly be able to look at with pleasure forever, whereas in the modern taste it would have been very difficult to be able to make a work to merit a continual sympathy.[10]

He concludes by naming the price—3,500 Venetian zecchini—which he claims will be a considerable financial loss.

This letter directly addresses two important elements of Canova's original proposal. Initially, it is pragmatic. The Provveditori are to have a monument that "marvelously suits" their needs, one that can be executed with speed and will also be aesthetically important, a lasting tribute to their good taste and artistic discernment. On a more theoretical level, in alluding to the debate about modern dress and contemporary political monuments, the sculptor comes down firmly on the side of nudity and traditional metaphor. Canova's professional concerns, however, should not be underestimated. The year 1799 was an *annus horribilis* for him; exiled from Rome, separated from his studio, and worried about his finances, he had an especially powerful incentive to sell *Hercules and Lichas* to the Veronesi. Indeed, Canova's *modello,* left behind in Rome, might well suffer violence were it known that the finished work would honor the Austrian Habsburgs. Police had already prevented an assault on Canova's studio by a republican mob that wanted to destroy the model of his *Ferdinand IV with the Attributes of Minerva,* so it was no paranoid fantasy to fear such political violence. All

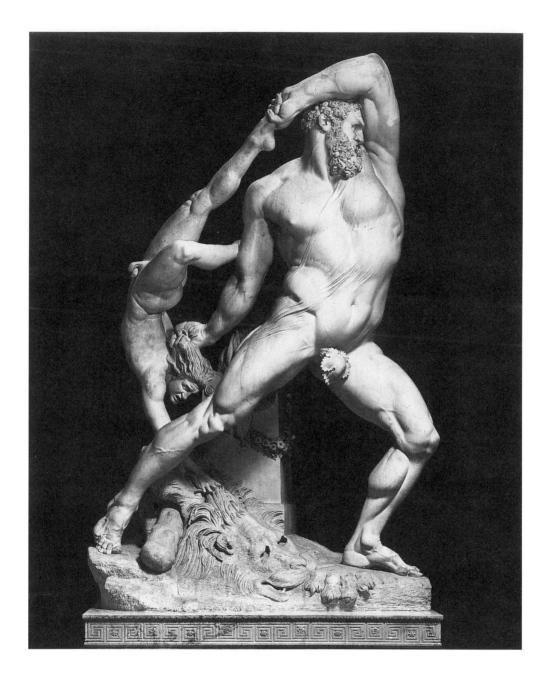

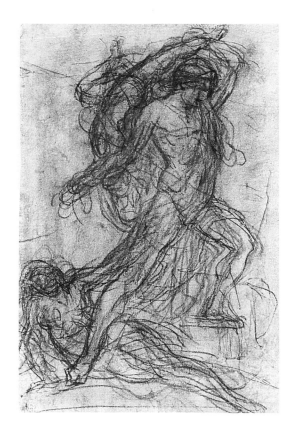

things considered, the commission suited everyone involved admirably, with the exception
of the man being eternalized by the statue. Francis II's rejection of *Hercules and Lichas* for
Verona indicates either insight into the problematic use of mythological metaphor for polit-
ical engagement, rather than a more direct contemporary representation, or a lucky guess.
The immediate circumstances of the commission from Verona help to explain why the em-
peror declined the city's tribute.

Roberti wrote his initial letter offering Canova a commission on behalf of the city of
Verona less than a month after the Austrians had defeated the French (on April 5, 1799) in
the battle of Magnano, fought near the city. So the commission was formulated in the initial
flush of victory. This martial enthusiasm is unsurprising, given the rarity of Austrian victo-
ries, and it indicates the strong anti-French sentiments of the city's leadership. Verona had
been the scene of a nasty guerrilla uprising against General Bonaparte's troops two years ear-
lier, in 1797. According to Malamani, Giovanni de Lazara had first urged the Austrian con-
sul general of the province to consider employing Canova's chisel for an honorific statue, en-
visioning a portrait statue of Francis II on a large base bedizened with trophies and golden
crowns.[11] Small wonder Canova would have nothing to do with this proposition. In the

event, the monument's original purpose was somewhat altered, from a direct tribute to the emperor to a more generic celebration of the victory at Magnano. Field Marshal Peter von Kray, the Austrian commander at the battle, came to share some of the encomium. The statue was to be erected in the Piazza Brà, or the Piazza dell'Armi as it came to be called.[12] The more generalized ideas of commemoration that emerged in the weeks after the battle contributed substantially, I believe, to the emperor's ultimate decision to cancel the project. The ambiguity of both the subject of the work and its celebratory objective proved fatal to Canova's hopes.

Late in the spring of 1799 the Veronesi expressed at court in Vienna their desire to honor their emperor and his triumphant armies with a monument, and Francis II learned of the proposed use of Canova's *Hercules and Lichas*. On June 22, 1799, the imperial minister, Baron Franz de Paula von Thugut, wrote to the Provveditori of Verona, forbidding the commission in the name of the emperor:

> [His Majesty,] while recognizing in such a desire a new indication of the civic attachment that so particularly distinguishes the people of Verona, is, however, too sensible of the damages this province has recently suffered to permit for the present a new burden on these people for the fulfillment of the celebratory project, and . . . [commands] that the execution of such an idea be remitted to other times.[13]

Canova accepted the imperial decree in a gracious letter to Roberti, dated July 20, 1799.

The emperor's decision to nix the cultural tribute of his new Veronesi subjects at a time when he wished to reconcile his Italian provinces to imperial rule cannot have been made unadvisedly. As a testimony of local loyalties, the Verona proposal must have been highly flattering. It had been mentioned by Giovanni de Lazara that the pedestal of the monument was to include reliefs depicting Francis II bringing peace and unity to the region and functioning as the father of the people. But the sticking point was not, as Thugut's letter alleges, the wish to spare a war-ravaged province the expense of a monument but rather an almost instinctive reaction against the subject of Hercules murdering Lichas.[14] Through either Roberti or some other channel the court in Vienna must have learned of the interpretation given *Hercules and Lichas* by the French visitors to the artist's studio; the possibility of diametrically opposed readings had its effect. Moreover, in essence the theme is negative and irrational; however one interprets Lichas, Hercules is still an insane victim of feminine jealousy, not a triumphant general, benevolent father, or omnipotent deity. I suspect Canova played the political card with Roberti primarily to sell the sculpture, although his personal sympathies were clearly Austrian. He knew that such an ambiguous theme was not suited to an overtly political function. As Hugh Honour has sagely stated: "A truly political work of art must necessarily be unambiguous."[15] Francis II, having taken this truth to be self-evident, had decided that the *Hercules and Lichas* simply would not do as a victory monument in Verona.

As with so many other works by Canova that were (or became) to some degree politi-

cized, aesthetic issues fueled critical reactions to *Hercules and Lichas,* lifting it, finally, out of the cultural politics of the era. Its ultimate purchaser, the Roman banker Giovanni Torlonia, had it placed in a specially designed scenographic gallery with apposite decorations and carefully orchestrated lighting, rendering the group sculpture politically neutral in spite of its earlier history.[16] Count Leopoldo Cicognara wrote an almost breathlessly admiring description of the statue in which Canova represented a fearful story with great artistic finesse; it is worth quoting in this context.

> The composition is entirely taken from the *fantasia* of the artist, and in vain does one search there for the pathetic, since the most horrible and fearsome tragic action is offered. The unhappy youth can offer no defense of any kind; he clings to the altar in vain, already taken by a foot and by the hair by the furious tamer of monsters, deaf to the cries of more mortal than frightened pain, who snatches him from every support and throws him inexorably downward. . . . reflect on the immense difficulty of rendering Lichas in that pose, in which no model is able to place himself; it is forced upon the artist to guess it and place him in an instant, rather than imitating nature. Notwithstanding, the most learned artists and the most scrupulous anatomists found Lichas [to be] most correctly executed.[17]

The extent to which ambiguity depoliticized *Hercules and Lichas* and critics such as Cicognara aesthetically fetishized it is evident in a manuscript list that includes many of Canova's works. The list is part of a treatise by Giuseppe Tambroni, entitled "Lo stato delle Belle Arti in Roma nel 1814." It was intended as a present for Prince Klemens Wenzel Lothar von Metternich, from whom Tambroni hoped to secure employment in Rome in the imperial interest, needing no small amount of help to overcome his past as a Bonapartist bureaucrat. Praising the Venetian Phidias as the restorer of ancient perfection, Tambroni goes on to catalogue the sculptor's most important works, significantly omitting all Bonapartist commissions except *Marie-Louise as Concord* (safe enough) and Josephine's *Three Graces,* which now belonged to the czar. The first sculpture mentioned is *Hercules and Lichas.*[18] Its inclusion at the head of the list is especially noteworthy in the ultra-reactionary political atmosphere of the Restoration, above all in Austria, where even a faintly suspected political heterodoxy or subversion was ruthlessly rooted out. Tambroni, who knew Canova well, could have had no notion of a lingering political odor for *Hercules and Lichas* or he would never have given it such prominence. I suspect this was exactly as Canova would have wished it.

Francis II rejected the proposed Canova monument for Verona at the very time when he was also doing a great deal to court and flatter the sculptor, hoping to take advantage of the political turmoil in Rome to attract him to either Vienna or Venice. This strategy centered on continuing the pension that Canova had been granted by the Serene Republic in lieu of payment for the *Monument to Admiral Angelo Emo* (see figure 24). Canova had already re-

fused Bonaparte's offer of help when the payment had ceased with the demise of the republic, but in the summer of 1798 the sculptor went to Vienna with Abbondio Rezzonico to petition the imperial government for its continuation. At the Hofburg Canova was distinguished by Baron von Thugut and by the emperor and was courted by the imperial family. Count Lodovic Cobenzel successfully presented the sculptor's request to the sovereign. Missirini mentions that initially the pension was granted on the condition that Canova transfer his practice to Vienna (for which I think the cleric must have meant Venice), but he received it despite declining to forsake Rome.[19] On August 16 he wrote to Selva, mentioning the restored pension and the imperial invitation to remain in Vienna.[20] He did not consider it any more seriously than he had a similar earlier appeal from Catherine II and a later one from Napoleon. Francis's desire to attract Canova to his capital, or at least to his province, and the restoration of the Venetian annuity indicate how highly the Habsburg ruler estimated Canova's international cachet. Such regard makes the negative verdict on *Hercules and Lichas* assume even greater importance in the scheme of Austrian cultural politics.

In addition to restoring the pension and doubtless offering other gratifying tokens of Habsburg good will, the imperial family, in 1798, gave Canova one of the most significant commissions of his entire career—a monument to the late Archduchess Maria Christina. It was commissioned by her widower, Albert of Saxe-Teschen, the most culturally sophisticated member of the reigning family. This monument, Canova's first large-scale work for a non-Italian patron and site, allowed him to use a conception he had previously modeled for the aborted tomb project for the painter Titian, intended for the church of the Frari but suspended by the political cataclysms of the 1790s. It was doomed by the fall of the republic. Comparison of the sketch for the tomb of Titian (figure 57) to the *Tomb of the Archduchess Maria Christina* (figure 58) clearly indicates the point of origin of the latter monument. That an idea originally visualized to commemorate a Renaissance painter could be reinterpreted for a Habsburg archduchess manifests the essentially aesthetic, rather than directly political, concerns that animated Canova's artistic imagination. The Maria Christina tomb also afforded the sculptor an opportunity to execute a grand multifigured ensemble within an architectural framework for the first time since his completion of the *Tomb of Pope Clement XIII* (see figure 19) for Saint Peter's in 1792. Canova had to make major adaptations of the figural elements in the Titian sketch and in the structurally complex papal tombs; these presented him with an unprecedented problem. Used to working without interference and with relatively little input from his patrons beyond a general agreement on the subject matter and approximate dimensions, Canova was surprised and chagrined when Duke Albert not only took an interest but also intervened heavy-handedly in the identification of the figural elements of his late wife's tomb and in the monument's dynastic associations. The friction that ensued caused Canova considerable trouble and ultimately compelled him to compromise his own views in the matter, something he almost never did. Why did he tolerate the duke's interference? This relation between artist and patron raises many interesting political questions and sheds considerable light on what amounted to a battle between tradition and creative independence. The partial victory of tradition in this special case indicates, I be-

lieve, the sculptor's wish to placate the Habsburg dynasty that ruled his native Venice. In addition, seeing the chance to increase his reputation by creating a masterpiece in a major European capital, the historically ambitious Canova seized the golden opportunity, a patron's injudicious intrusions notwithstanding.

Serious work on the Maria Christina tomb was begun in early 1800 after Canova returned to Rome from the north. The site for the monument had been selected while the sculptor was in Vienna—the church of the Augustinians, because of its historical associations with the dynasty. In a letter of July 5, 1800, to Canova, however, the patron vacillated on the location, entertaining the idea of a public space such as a square or even a fountain. Moreover, he asked that Canova eliminate the lion and genius of death from the design. Canova responded on August 2, questioning, in somewhat undiplomatic terms, how a person of the duke's sophisticated tastes could propose something so absurd as an exterior site for the tomb, which needed to be in a sacred site, protected from the elements. He also overruled the excision of the genius-and-lion group from the composition.[21] Although Albert gave in to the artist's views on these two points, the trouble was just beginning.

The most scabrous issue in the battle to control the monument's meaning concerned the interpretation of the figures, on which Albert had strong views from which he would not budge. Canova intended that the figures, of varying age and both genders, represent humanity's common fate as all approach the tomb's door of death. He wished to avoid associating them in any direct way with the virtues of the deceased archduchess, which to Albert were the point of the tomb. D'Este states unequivocally that the identifications of the figures are a dramatis personae created by the patron over the artist's objections; for example, the lame old man is led forward by a female figure identified as "Beneficence."

> [The presence of] allegorical compositions on sepulchral monuments has provoked several arguments for their exclusion. Leaving aside that the learned patron prescribed to Canova the symbolic figures in the monument to Archduchess Christina, nevertheless, he [Canova] sought to group them in a narrative rather than an allegorical manner, allegory always being a metaphysical argument.[22]

D'Este also recognized that Canova's idea went against traditional iconographies for such monuments, where patrons and public merely wanted to be moved, without having to reflect and exert themselves to learn the deeds and virtues of the deceased person and determine to whom the monument belonged.[23] Part of Canova's problem was the highly radical nature of his conception, a syncretic everyman's death memorial of prescient modernity and profound emotional meaning. More important for the present discussion, the artist's vision ran counter to the traditional beliefs and attitudes of Albert of Saxe-Teschen.

Selma Krasa has observed that Albert was a thorough traditionalist in his ideas about the artist-patron relationship. Steeped in eighteenth-century prejudices in which the commissioner is the ultimate arbiter of form and meaning, the duke found alien both Canova's independence and his insistence on creative and interpretive control. And in the end Albert's

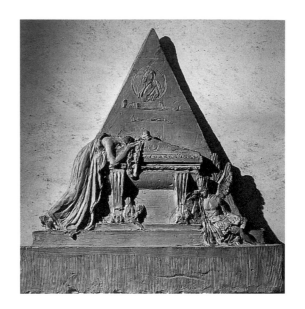

FIGURE 58
Antonio Canova, *Tomb of the
Archduchess Maria Christina of Austria,*
marble, 1798–1805. Vienna,
Augustinerkirche.

FIGURE 59
Antonio Canova, *Genius of Death
with Coat of Arms,* detail of the *Tomb
of the Archduchess Maria Christina
of Austria,* marble, 1798–1805. Vienna,
Augustinerkirche.

persistence, at least publicly, carried the day. Canova's beliefs and protests against the rather
pedestrian allegorical identification of each figure of the death cortege are recorded.[24] Ulti-
mately, the artist stated his case by disavowing the patron's nomenclature, claiming himself sat-
isfied if the viewer understood the group as simply a generalized, all-encompassing funerary
procession. These universalist notions have done much to place the *Tomb of the Archduchess
Maria Christina* firmly in the canon of early modern sculpture. But its true radicalism was not
widely understood at the time. Ironically, the first important discussion of the monument, pub-
lished in the year of its unveiling in the Augustinerkirche, distorted or ignored Canova's aims

in the monument and argued, in traditional fashion, for the absolute necessity of allegory in funerary sculpture. E. C. Van de Vivere called the use of allegory in Maria Christina's tomb "ingenious and clear" and claimed that the obligation to commemorate the deceased made allegory crucial.[25] He incorrectly credited Canova with the taste and sagacity to select the appropriate allusions to the archduchess, begging the question of how widely known it was that Albert had imposed allegory onto Canova's monument. We may never know.

In addition to Canova's debate with his patron over the use of allegory, the sculptor and patron disputed over the need for dynastic symbols—a predictable contest of wills, given the very different ambitions of the two men. Habsburg heraldry, a detailed inscription, and a foregrounded representation of the deceased archduchess, all desired by Albert, undermined Canova's conception of the monument. He acceded to the patron's wishes but reduced the inscription to the phrase "To the Best of Wives" and placed Maria Christina's portrait, borne upward by winged genii, on the periphery of the composition. This left the figural cortege, the darkened door, and the genius with the lion relatively unencumbered. But Albert insisted on the display of the family escutcheons and Canova, obliged to conform, placed the heraldic symbols in a stone of the pyramid behind the lion and genius at lower right (figure 59). Augustus von Kotzebue, who saw the completed figures and the model of the tomb in the sculptor's studio shortly before it was shipped to Vienna, commented on the *concetto* and confirmed Canova's opposition to including the family heraldic devices:

> I am unable to judge the effect of the whole, as I have only seen the figures singly; but I prophesy that it will be great. . . . Perhaps the whole is rather too far-fetched and not sufficiently simple, but the execution is inimitable. The only thing which will certainly injure the group is the arch-ducal arms; by which rank, which is here quite unnecessary, is associated with virtue and benevolence. Such, likewise, was the sentiment of the artist himself, but such were the express orders he received.[26]

The indirectly antiaristocratic sentiment expressed in Kotzebue's objection to the escutcheon may be mere prejudice, but I strongly suspect the artist, rather than his visitor, first noted that its inclusion would detract from the effect of the group. Van de Vivere, in contrast, praised Canova's invention in using the heraldic devices as part of the conceit and fantasized on the role of Duke Albert in the monument's narrative construct:

> The object that first strikes our eyes is Duke Albert of Saxony, symbolized by the genius who is draped in the chlamys, this military mantle of the Greeks, and plunged into the most profound affliction, and seated on the steps of the tomb, . . . contemplating with the most deeply felt expression the arms of the House of Austria, and who, to render the thing even more clearly, holds the escutcheon of Saxony in his left hand.[27]

The author praises the artist's *fantasia* in placing the essential dynastic symbols organically into the composition and then gives them an overt political reading.

The buckler of the Teutons is perfectly suitable for the daughter of the chief of the Germanic empire. The round Etruscan buckler belongs to a prince originally from Italy [Albert] who is symbolized by an allegorical being representing death of the type that played such a great role on the monuments of the peoples of Etruria, whose vast empire formerly included all the states that in subsequent times the House of Este has occupied in Italy.[28]

The historicist fantasy of these interpretations vividly anticipates the atmosphere of the Restoration. References to the chief of the Germans at a moment when Austria was battling France at Austerlitz and Jena to determine the fate of the Holy Roman Empire are especially poignant politically. So, too, is the allusion to the Etrurians and to the D'Este family, whose duchy had earlier passed to the Habsburgs. In this instance remembrance of things lost underscores the present state of affairs; the tomb was being completed and erected at a moment when the Austrian Habsburgs were struggling with Napoleon to maintain their suzerainty in Germany and the imperial title and to reconquer their lost territories in Italy. Essentially out of thin air, then, Van de Vivere politicized the monument for purposes that can only be described as propagandistic. The subtle heraldic devices and the allegorical tributes to the dead archduchess were as far as Canova was willing to go in the direction of ideological engagement. It is significant that Albert, in these years of political crisis for the dynasty, wished to go much further.

Despite the issues of allegory and heraldry raised by Albert during the monument's realization, Canova was eager to have the finished tomb installed and unveiled in the Augustinerkirche. He returned to Vienna in the spring of 1805 to oversee the installation. On June 11 he wrote to Tiberio Roberti (who was always interested in events in Vienna) of his concerns about placement and lighting in the church's nave and expressed his hope that the installation would soon be completed, adding: "What I am most impatient about is the effect the work will produce in the souls of this public."[29] Almost three and a half months later the tomb was still covered, waiting for the return of the emperor from the battlefields of Germany. The public debut was highly successful, and Canova remarked with satisfaction to Roberti that Albert had presented him with a diamond-encrusted snuffbox decorated with the duke's portrait that the sculptor estimated to be worth 1,500 zecchini—a princely tip. But I imagine Canova felt he had earned every sequin.

Canova's concessions to Albert of Saxe-Teschen in the *Tomb of the Archduchess Maria Christina* and his partial compromise with the patron on the work's political agenda stand in sharp contrast to the obstacles he raised to working at all for Napoleon. His refusal to give in on the question of nudity in *Napoleon as Mars the Peacemaker* and his great reluctance to complete the equestrian monument to the French ruler for Naples are notable evidence of favoritism to Austria. The execution of a major work in the imperial capital undoubtedly appealed to Canova's vanity, but I think there must have been more to it. Working for Bonaparte's enemies must have had its own attraction, as a manifesto of his professional independence, if nothing else. The Habsburgs were also now the rulers of Venice, and Canova

much preferred them to the French, who had been there before and were to return again. The Maria Christina tomb, then, is not only a timeless and moving visualization of the inevitability of death, but also a monumental testimony to the artist's willingness to be flexible enough to satisfy his Austrian patron. It is strong proof, moreover, of his determination to construct a professional destiny free from the ideological coercion generally imposed on a court artist.

A second, less ambitious Habsburg cultural initiative that involved Canova was the commission for a bust of Emperor Francis II (figure 60) to be placed in the Biblioteca Marciana in Venice. It was a votive tribute of the imperial government in return for the gift (which the Austrian authorities requested) of six incunabula to the Imperial Library in Vienna. The liaison between Canova and the government was the Marciana librarian Jacopo Morelli, whom the sculptor had advised about the placement of the institution's collection of antiquities in the last years of the republic. Morelli had generally preferred the Austrian rule of Venice to the French, complaining that the French took many books from the library whereas Austrian demands were light. The scholar, as a political realist, was ultimately loyal to the library.[30] Morelli, in conjunction with Canova, decided that the bust should be placed on a plinth in the Marciana's antechamber, a clear marker of the change in proprietorship. The plinth was to be designed by the Venetian architect Gianantonio Selva, Canova's close friend and frequent correspondent. The undertaking offered them a rare opportunity for collaboration. Morelli initiated the project in the spring of 1802, but the exact date of the imperial commission to the sculptor is uncertain. Perhaps it was discussed in the Austrian capital in 1799 or developed naturally from the correspondence involving the Maria Christina tomb. In any event, Canova agreed to make the bust portrait, although he rarely welcomed such commissions. The portrait's destination for a conspicuous public space in an important Venetian cultural institution may have helped reconcile him to the task. He completed the bust early in 1805.[31]

The major problem Canova confronted in this portrait resembled that of nudity in *Napoleon as Mars the Peacemaker:* the imperial government wanted the bust done in contemporary court dress replete with orders and ribbons, while Canova insisted on depicting the emperor in a cuirass and chlamys, both ancient clothing types with decided martial associations. On December 5, 1803, Canova wrote to Selva in Venice, expressing concern over Viennese expectations that the bust be in modern rather than classical dress. The cuirass-chlamys solution had already satisfied Morelli. The sculptor went on to tell the architect that such a bust as the imperial ministers imagined would be only a vulgar bit of buffoonery (*coglioneria*).[32] After a great deal of haggling Canova got his way, and the bust portrait reached Morelli at the Marciana in early 1805. Unfortunately for Venice, the Treaty of Pressburg transferred the Veneto back to France on the day after Christmas of the same year, and the statue was crated up and sent to Vienna. In 1817, after the Austrians returned to the city,

FIGURE 60

Antonio Canova, *Portrait of Emperor Francis II of Austria,* marble, 1803–4. Vienna, Kunsthistorisches Museum.

a portrait of the emperor by Giuseppe Pisani was placed in the library, but Canova's bust of Francis II remained in the imperial collection.

In his other letters to Selva Canova reveals his habitual fears about the safe arrival of the work and its public reception. In a letter of May 1805 Selva allays these anxieties, informing Canova that the bust of Francis II had arrived without damage and also telling him of the portrait's highly favorable reception in his native city. "Yesterday I saw the bust of the sovereign made by you; and at first glance one must say that whoever it is, it is a prince of the House of Austria. All those who know Francis II personally say it to be perfectly similar. You have given spirit to him, and the head is turned with such imposing sweet majesty that it breathes respect and confidence."[33] The architect also informed Canova that the Habsburg viceroy in Venice was delighted with the portrait and that there was still some discussion about its placement; he said he was afraid it might be transferred to Vienna.[34] Possibly the Austrian officials were so impressed by the high quality of the marble bust that they enter-

tained thoughts of sending it to the capital, but in the end it was placed in the entrance hall of the Biblioteca Marciana as Morelli and Canova had planned. Its removal to Vienna a few months later was necessary for political reasons. Jacopo Morelli delivered an oration on the statue's merits at the unveiling ceremony, and Canova must have been gratified to have another of his works receive accolades at home. Selva's enthusiasm led him to compare the bust to an ancient head of Jupiter; Morelli's comments also flattered the emperor, almost to the point of obsequiousness. I cannot help thinking that in commending the emperor's portrait, Selva and Morelli indicate at least a moderate approbation for his government in Venice as the best alternative to the dead republic. In contrast, Selva used guarded language in his letters that describe Napoleon when Venice was under French rule. I believe Canova shared his opinion and that his political views became increasingly pro-Austrian after Venice (in 1805) and Rome (in 1808) again came under Bonapartist dominion.

Although Venice and Austria had long enjoyed excellent diplomatic and cultural relations, those between Vienna and Canova's adoptive city, Rome, had been tense during most of the eighteenth century. The Napoleonic hegemony in Italy, however, made natural allies of the Habsburgs and the papacy, and Pius VII, especially, benefited from Francis II's support, both moral and diplomatic. The indefatigable efforts on Pius's behalf by Cobenzel, Metternich, and the emperor after Napoleon had deposed the pontiff must have made Canova profoundly grateful, since he was also doing all he could for the papal cause.[35]

Similarly timely diplomatic intervention by Austria in 1813 saved the important Roman Church of SS. Nome di Maria from destruction, assisting the hard-pressed Canova, who had been actively trying to save the structure from the French urban planners for an entire year. One of the more ambitious archaeological initiatives of the French in Rome was the proposed isolation of Trajan's column and the creation of an elliptical piazza around it to allow for more scenographic viewing. The Commission des Embellissements, the bureau responsible for the project, selected Giuseppe Valadier, probably the best-known architect then in Rome, to oversee it. He razed the buildings of the (suppressed) convents of Santo Spirito and Santa Eufemia but preserved the two nearby churches, SS. Nome di Maria and Madonna di Loreto. All was well until the imperial commissioner Pierre-François-Léonard Gisors arrived in 1813. He immediately petitioned the Commission des Embellissements to permit the razing of Nome di Maria (figure 61), which he characterized as being "de mauvais style," and the request was granted. Tournon, who supported Gisors, thought the project might be completed before the end of the year under the supervision of Giuseppe Camporese, who had replaced Valadier as architect.[36] Officials of the Accademia di San Luca, led by Principe Canova, who protested what they considered the wanton destruction of the church, were seconded by local opinion. Would not the church adorn the square better than the houses that would partially replace it? The intervention of Austria proved decisive. SS. Nome di Maria had been built in the mid eighteenth century—ironically, by the French architect Antoine Derizet—as a votive sanctuary to the Virgin Mary in thanksgiving for Prince John Sobieski's deliverance of Vienna from the Ottoman siege of 1683. France, now

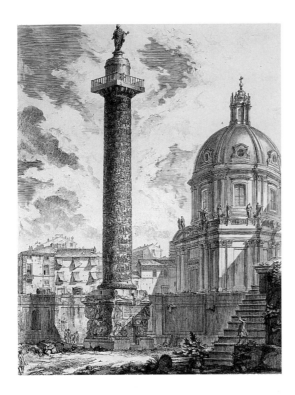

FIGURE 61
Giambattista Piranesi, Column
of Trajan, with Antoine Derizet's
SS. Nome di Maria, Rome, etching
ca. 1748–49. Washington, National
Gallery of Art, Mark J. Millard
Architectural Collection.

allied to the Habsburgs by marriage and wishing to appease Austria in the dark days following the disaster in Russia, yielded the point and the church was saved, Tournon ordering the suspension of the proposed demolition in the summer of 1813. In sum, French destructiveness and disdain of local sentiments contrasted sharply with Austrian policies of conciliation and circumspection, both in Rome and Venice, and Canova would certainly have appreciated the advantages of the Habsburg alternative.

Canova presented his idealized *Polyhymnia* (figure 62), begun as a mixed-genre portrait of Napoleon's sister Elisa, grand duchess of Tuscany, to Francis II in 1817 on the occasion of the emperor's fourth marriage, as part of the wedding tribute assessed the city of Venice.[37] The work's adaptability to a purpose widely different from the original one marks its highly tenuous relationship to the original Bonaparte patron. After the fall of Napoleon *Polyhymnia* had been promised to a rich Bolognese, Cesare Bianchetti, who wrote to Cicognara on January 22, 1817, saying that Canova had asked him to cede the work to the emperor and asking, "How does one say no to Canova?"[38] The sculptor was interested in the cultural gift

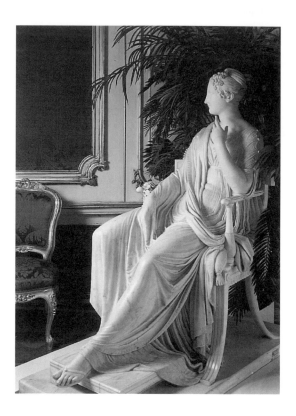

to Francis and Caroline Augusta because it would provide an opportunity to showcase the young artists of the Venetian Academy, directed by Leopoldo Cicognara, in a highly conspicuous venue. Canova was especially eager to publicize the talents of his protégé Francesco Hayez, one of whose paintings had been selected for inclusion in the present. Hayez went on to become one of the most important painters of Ottocento Italy. Part of Canova's motivation was also financial. Even though the *Polyhymnia* was a dead loss, Cicognara's initiative on behalf of the academy and Venetian artists would have foundered if Canova had not contributed, and Venice's wedding "gift" to the bridal couple had been assessed at the rather generous sum of 10,000 zecchini.

When *Polyhymnia* was placed in Caroline Augusta's new imperial apartments, it entered a highly politicized context. The group of paintings executed by the members of the Venetian academy for the wedding gift had carefully censored subjects, monitored by Cicognara. They were to illustrate the benefits of Austrian rule in Venice and to celebrate the Habsburg couple and their marriage. The director gave his nuptial initiative additional publicity by publishing a booklet listing the artists who participated in the scheme and describing the paintings' subjects.[39] Ironically, a Bonapartist portrait transformed into a neutral muse of

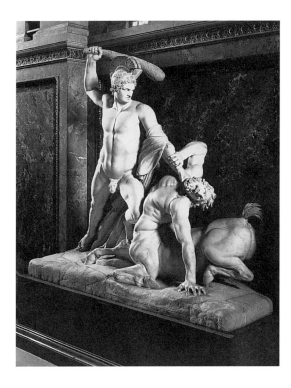

FIGURE 63
Antonio Canova, *Theseus and the Centaur,* marble, 1804–19. Vienna, Kunsthistorisches Museum.

music ended up in one of the most overtly propagandistic settings imaginable. But Canova's past concerns about the safety and viability of politicized art had diminished with the end of the turmoil of the Napoleonic Empire.

The last important link between Canova and the Habsburgs reveals the dramatically altered political circumstances of public and court sculpture after the defeat of Napoleonic France. While in Rome in 1818 the emperor of Austria saw the large group sculpture *Theseus and the Centaur* (figure 63) nearing completion in Canova's studio and asked to buy it. Canova modeled the work in about 1805, basing its composition on an engraving he had seen in Stuart and Revett's celebrated book *Antiquities of Athens.* Serious work on the marble group was not initiated until after the Napoleonic wars; the sculptor was probably inspired to pick it up again after seeing the Parthenon marbles in London, the works "collected" by Lord Elgin in Athens, whose proposed purchase by Parliament fueled one of the great cultural and political controversies of the nineteenth century. Antonio Canova played an important part in the debate, his unqualified admiration for the naturalism of these architectural sculptures,

which he believed to be by Phidias, influencing the parliamentary committee's decision to purchase them for the nation.[40]

Like *Polyhymnia, Theseus and the Centaur* had a Bonapartist past. About the time of Austerlitz and Jena, Canova's friend Giuseppe Bossi, president of the Milanese Accademia di Brera, broached the idea of a Napoleonic victory monument, to be carved by Canova and erected in some public space in the Lombard capital, most likely the Foro Bonaparte. The project had the approval of the Kingdom of Italy's viceroy, Eugène de Beauharnais. Although Canova made a sketch, he did nothing else in this direction. A similar project had been the impetus for *Perseus with the Head of Medusa,* but it, too, came to naught, its export being forbidden by Pius VII, who bought it, much to the sculptor's delight, for the Vatican collections. *Theseus and the Centaur* was, by any definition, an enigmatic theme for a monument to Napoleon or even to his victorious Grande Armée. Fred Licht has correctly attributed the selection to Canova's political tact, but I would add that the thematic ambiguity rendered the work politically safe, in keeping with the sculptor's iconographic inclinations in similar circumstances, above all in *Napoleon as Mars the Peacemaker* and, more appositely in this instance, *Hercules and Lichas. Theseus and the Centaur* makes no overt reference to a Napoleonic triumph or even to France, as Hercules could have, and the government in Milan may have refrained from pressuring Canova to finish the monument because the theme was unsatisfactory for Napoleonic propaganda.[41] The sculptor himself seems not to have been especially interested in the work until the Elgin marbles rekindled his enthusiasm on an artistic rather than a political level.

When *Theseus and the Centaur* was completed in 1819, it was sent to Vienna, although there was some grumbling in Milan, where there had been some hope that the monument could be erected in an entirely new context. The emperor's personal request carried weight with Canova, as it did with the Milanese, since Lombardy was now part of the Habsburg Empire.[42] A Grecian Doric temple had been built in the gardens of the Hofburg Palace to receive what was thereby transformed into a cult statue; the new Theseion in Vienna built to house the sculpture became one of the most important monuments of Romantic Hellenism in Austria. More important, Francis II's acquisition of *Theseus and the Centaur,* which came to be interpreted as a Romantic musing on the lost splendors of ancient Greece, utterly obliterated any trace of a Bonapartist political association that may have lingered around the statue. This could have happened only with the end of the Napoleonic threat to the European status quo that had so radicalized cultural politics that all public art not clearly committed to one side or the other became immediately suspect. Had France been definitively defeated in 1799, *Hercules and Lichas,* like *Theseus and the Centaur* afterward, might have enjoyed a long life in Verona or even in Vienna itself.

The professional contacts between Canova and the Habsburgs were not always unmarred by disagreements and conflicting agendas, as both the rejection of *Hercules and Lichas* for

Verona and the disputes between the artist and Albert of Saxe-Teschen over the iconography and allegory of the *Tomb of the Archduchess Maria Christina* in the Augustinerkirche demonstrate. The question of ancient or contemporary court dress for the portrait bust of Francis II executed for the Biblioteca Marciana also created friction that in this instance was resolved in favor of the sculptor. *Theseus and the Centaur* was an untroubled transaction because it was negotiated in relatively untroubled times. Despite some differences, however, there is little evidence to suggest that Canova worked unwillingly for the House of Austria, a phenomenon that stands in dramatic relief to his dealings with Napoleon Bonaparte. Generally speaking, the lighter hand of Habsburg rule in Venice (at least during the artist's lifetime) and the less peremptory manner in which the Habsburgs treated him as a professional artist did much to conciliate Canova—a view I realize will not be welcomed by those who see Canova as a proto-Risorgimento hero. Austria and the Habsburgs were to become the deadly repressive enemies of Italian unification, but this was a conflict still in incubation when Canova died in Venice in 1822.

It is worth noting some instances of Habsburg consideration for Canova the artist that contrast with his treatment by Napoleon. For example, in 1802 the first consul pressured the sculptor to come to Paris to make his portrait; the artist's bust of Francis II required no such ostentatious visit. It was done in the manner traditional where long distances were involved: Canova simply used other portraits and a life mask for the emperor's likeness. Similarly, Gianlorenzo Bernini had used Anthony Van Dyck's portrait *Charles I in Three Views* when he executed his own portrait of the Stuart monarch in Rome. Fortunately, Canova had met the emperor in 1798, so he could weigh images against memory for the portrait features of the bust.

From a professional point of view Canova appreciated the practical attentions of the imperial government in Vienna, as when the Austrian authorities exempted his funerary *Monument to Faustino Tadini* from import duties when it entered Lombardy on its way to the town of Lovere. The gesture, besides its financial advantages, indicated the government's willingness to give up revenue to encourage important works of art in its dominions.[43] Canova respected Austria and the imperial family as conservative guardians of the peaceful status quo, as relatively clement governors of Venice, as papalists, and as enthusiasts for his art—to the extent that in some instances he made concessions to accommodate their opinions in matters of great personal importance. The enthusiastic reception of his works in Vienna, in contrast to the captious critiques that usually greeted them in Paris, must also have been gratifying.[44] Unfortunately, for both political and financial reasons the Habsburgs were not able to offer enough work to keep Canova in the continuous activity he deemed necessary, so he accepted commissions from France. By executing statues for the Bonapartes, moreover, the artist also maintained a cultural balance of power that helped to ensure his independence. Doubtless he considered his fame and reputation when he made works for Napoleon, although he was much less willing than with the Habsburgs to make compromises in the process, as his obstinacy in the question of nudity for *Napoleon as Mars* indicates. His works for both the Habsburgs and the Bonapartes took on

additional professional importance for Canova because war and geography had all but closed him off from British patrons from the late 1790s until 1814. The chapter that follows considers the personal, political, and professional connections between Canova and the British, from whom, as a group, Canova received the most pleasurable and rewarding commissions he ever executed.

6

"THAT ILLUSTRIOUS

AND GENEROUS NATION":

CANOVA AND THE BRITISH

━━━━━━━━━━━━━━━━

IN 1817 COUNT LEOPOLDO CICOGNARA WROTE TO CANOVA describing the revolution in taste that had banished a decadent, lingering baroque and engendered the classical "gusto" of which Canova was the ultimate and best exemplar. According to Cicognara, one of the chief reasons for the rebirth of art created in the true spirit of the ancients was the enthusiasm of wealthy and cultivated Briton grand tourists for antiquities and for knowledge of all things ancient.[1] Indeed, the presence of a relatively large group of British collectors, connoisseurs, antiquarians, diplomats, dealers, and artists was of seminal importance to Canova's aesthetic and professional development, for the British, with their advice and patronage, did more to establish him in a highly competitive market than any other national group. Except for the virtual hiatus in the sculptor's dealings with the United Kingdom during the revolutionary and Napoleonic wars, there was a personal and professional exchange between Canova and the British that was, by all accounts, mutually beneficial and satisfying. The artist was sentimentally more attracted to the British than to other groups of foreigners, in part, I believe, because they valued and encouraged his independence from creative constraint and only wanted to possess his sculptures, in almost all cases, for predominantly aesthetic reasons.[2]

The mutual admiration also had an ideological motivation. An ardent Anglophile, Canova was also a philosophical relativist, having an eclectic taste and love of aesthetic mixing that enabled him to combine the linear purity of ancient reliefs with the smoldering eroticism of the Venetian Renaissance. The principles of classical conformity and logical unity at the heart of the French classical tradition were antithetical to him, and he preferred the less exclusivist, and hence more cosmopolitan and cultivated, tastes of the British.[3] Intellectual and artistic sympathies, along with his grateful remembrance of early help and encouragement, greatly prejudiced Canova in Britain's favor and, by extension, helped disincline him to work for the French. This chapter examines the political dimensions of the Venetian

sculptor's work for clients in the United Kingdom, focusing on the proposed monument to Admiral Lord Horatio Nelson, the *Cenotaph of the Last Stuarts,* and *Venus and Mars* (see figures 68, 71, and 73). The politicization of these monuments reveals Canova's Anglophile political views and demonstrates his enduring admiration of British culture, society, and art.

Chapter 1 briefly discusses Canova's association with the British colony in Rome during the 1780s. I want to return to that topic, examining other, different, aspects of this formative relationship. Without question Canova's art changed profoundly during his initial visit to Rome in 1779–80, when he was under the protection of the Venetian ambassador Girolamo Zulian. The close political and diplomatic ties between Great Britain and the Serene Republic ensured that the young Venetian would meet many British in the Palazzo Venezia, and such was the case. By far his most significant contact was with the Scottish painter and antiquarian Gavin Hamilton, whose severe, restrained painting style and *exemplum virtutis* subject matter made him a leading light of the neoclassical reform movement in Rome. The transformation of Canova's style from a Venetian rococo naturalism into a Winckelmannian self-contained, idealized classicism owes an enormous debt to Hamilton. Had the Scottish artist, the doyen of progressive artists in the papal capital, not supported Canova unconditionally, the fledgling sculptor would have found his path to success and fame much more difficult in the world of cultural rivalry, *campanilismo,* and intrigue whose capital was Rome.[4]

Only a few days after his arrival Canova wrote in his diary of a visit to Hamilton's studio, reporting that the painter had impressed him extremely well and that he had seen *The Oath of Brutus* (figure 64), whose invention and proper antique character he praised highly, faulting only the color.[5] A combination of praise and avuncular advice from Hamilton turned Canova into an outright enthusiast when the painter visited Zulian's palace to see the cast of *Daedalus and Icarus* that had been sent from Venice for evaluation by Roman artists and cognoscenti. Hamilton paired praise with criticism and helped turn Canova away from naturalism in a psychologically effective way. Hamilton's opinion on the group, which had made Canova's reputation in Venice, was what the sculptor most wanted to hear, and the painter's advice to Canova on redirecting his style led the sculptor to praise Hamilton effusively as a "very sincere man most intent on the proper course and an excellent painter."[6] In this comment the young provincial artist demonstrates all the fervor of a convert. For a time Canova trusted Hamilton's judgment more than his own, as when he showed him two proposals, one an active combat and the other a contemplative reflection on victory, for the Zulian commission *Theseus and the Dead Minotaur* (see figure 22).[7] Hamilton's verdict in favor of calm repose for the victorious Athenian hero changed the history of modern sculpture.

Canova's friendship with Hamilton led him to ever closer links with the British artistic community in Rome. The impressive number of friends and patrons he found in this group stands in strong contrast to his few and distant relationships with the French artists at the Villa Medici. Anglophilia helped to form both Canova's art and his political views, it being reasonable to assume that he felt some sympathy with the opinions of those whom he liked and respected professionally and personally. John Flaxman was an important member of this

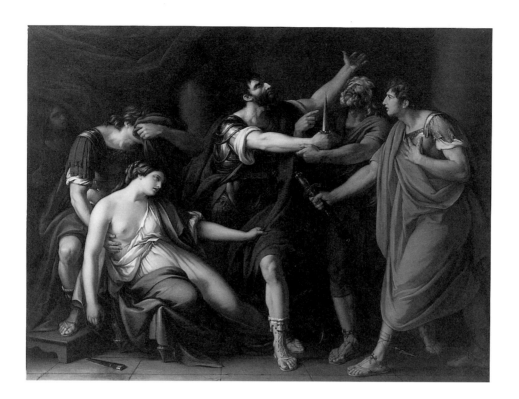

FIGURE 64
Gavin Hamilton, *The Oath of Brutus,*
oil on canvas, ca. 1763. New Haven,
Connecticut, Yale Center for British
Art, Paul Mellon Collection.

cohort. Arriving in Rome from Florence late in 1787, the English artist made a sketch of
Canova's *Tomb of Pope Clement XIV* (figure 65) in the Church of the Holy Apostles, a work
that transformed monumental funerary sculpture just as *Theseus and the Dead Minotaur*
had radicalized figural sculpture. Flaxman probably visited Canova in his studio sometime
in 1788, for by 1790 they were on good enough terms for Canova to recommend the En-
glishman to the truly strange patron Frederick Hervey, earl of Bristol and bishop of Derry,
an introduction that resulted in Flaxman's masterpiece, *The Fury of Athamas* (figure 66).[8]
This large marble group sculpture eventually made its way (after the French had confiscated
it) to the Hervey mansion in Suffolk, Ickworth, an architectural marvel as bizarre as its ini-
tial builder. Flaxman took his theme from Ovid's *Metamorphoses,* which tells how Athamas,
a mortal, guilty of hubris, was driven mad by the gods. In Flaxman's narrative Athamas
seizes his son, Learchus, from his wife, Ino, and is about to bash his head onto the unseen
rocks. Hugh Honour has argued that Canova may have suggested the pose of Athamas

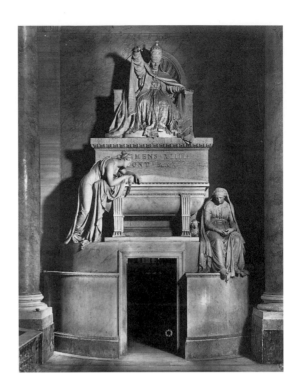

and Learchus to Flaxman, for *Hercules and Lichas* and Hervey's group have notable compositional similarities, although Flaxman's sculpture was executed before *Hercules and Lichas* was begun.[9] It is possible that the older sculptor was prompted by the younger, but this seems unlikely, given the serious professional investment Canova had in making a reputation in the sublime mode with the *Hercules and Lichas.* Moreover, the Venetian artist's detractors and rivals would surely have accused him of plagiarism, as they did on other occasions, had it not been generally known that the invention was Canova's. The elder sculptor became a lifelong admirer of Flaxman, whom he often recommended to patrons and whose relative neglect in Britain caused Canova to scold his hosts during his visit to London in 1815.

Another artist Canova admired was Christopher Hewetson, an Irish portrait sculptor of considerable reputation when the Venetian artist met him in 1780. Unlike most other established sculptors in Rome, Hewetson was enthusiastic about the *Tomb of Pope Clement XIV* and later came to see the *modello* for the genius of death figure for the *Tomb of Pope Clement XIII* (see figure 19) in the artist's studio, even though he had hoped to receive the commission for the Ganganelli tomb himself. Hewetson offered extravagant praise of this daring figure, so abstractly classicizing and novel in papal tomb imagery. It is said that in the late 1790s Hewetson was extremely distressed to hear of the sufferings of war-ravaged Italy, a sorrow he shared with Canova.[10] The Irish painter Hugh Douglas Hamilton, a pastel

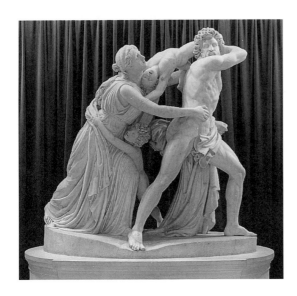

FIGURE 66
John Flaxman, *The Fury of Athamas,*
marble, 1790–94. Ickworth, Suffolk,
England.

portraitist whom Hewetson probably introduced to Canova, also became a friend. Hamilton's side of a correspondence with Canova mentions the painter's anxiety about the French threat to Italy and especially to Rome. Canova seems to have exercised a strong influence on the young Irishman, who purportedly turned from pastel to oil on Canova's advice and whose style subsequently became more restrained and less decorative.[11] A late pastel of 1788–89 by Hamilton, now in a private collection, testifies to his admiration. *Antonio Canova and Henry Tresham with a Model for Cupid and Psyche* shows the sculptor with his friend Tresham, an Irish painter who was also Hamilton's friend, looking at a *modello* for the recumbent version of *Cupid and Psyche,* commissioned by John Campbell. The Irish painter's frank admiration of Canova and his statue, seen by torchlight, and his friendly tribute in the picture document Canova's important role in the British and Irish artistic circle in Rome in the last two decades of the eighteenth century.

In a youthful diary he kept during his first sojourn in Rome, Canova commented favorably on a painting representing a female saint by "un inglese" who has been identified as John Parker, a pupil of Marco Benefial. Parker became the director of the first British Academy in Rome, established in 1752.[12] More enthusiastically, Canova praised the classicizing landscapes of the Scottish painter Jacob More, whose restrained, lyrical interpretations of the Roman Campagna, peopled with dignified, self-possessed figures in simple draperies, must have appealed to the creator of *Theseus and the Dead Minotaur* and the admirer of the history paintings of Gavin Hamilton. *Classical Landscape with Figures* (figure 67) is typical of the essentially decorative paintings bought avidly by British grand tourists to adorn their country houses. Jacob More was also a close friend of the Roman sculptor Vincenzo Pacetti, whose manuscript diary is such an invaluable source for our knowledge of the Roman art world

during this era.[13] In addition to More, Canova was also well acquainted with the sculptors John Deare and Richard Westmacott, the connoisseurs and collectors Charles Tatham, Thomas Jenkins, Sir Richard Worsley, John Disney-ffytche, John Thorpe, and especially Colonel John Campbell. In sum, Canova was a fully integrated and influential member of the British set and was so identified at the time. Given these connections, it is no surprise that he believed the British would play the leading role in his professional career, a view that was altered dramatically until 1814 by political circumstances beyond the control of both the artist and the British.

To judge by the avidity of British collectors in Rome in the late 1780s and early 1790s to possess sculptures by Canova, the sculptor was right to believe they would form the majority of his clients in the future. Prominent among many was Colonel John Campbell, later Baron Cawdor, whose enthusiasm for Canova often went beyond his ability to pay for commissioned works, as in the case of the recumbent *Cupid and Psyche* (see figure 7) that eventually entered the collection of General Joachim Murat. The *modello* for this sculpture that

appears in Hugh Douglas Hamilton's pastel portrait of Canova and Henry Tresham may be an allusion to Campbell, who certainly was a most adulatory promoter of Canova in the artist's early Roman years. The sculptor executed the *Cupid* now at Anglesey Abbey in Cambridgeshire on commission from Campbell. In typical British fashion the aristocrat bought ancient sculptural fragments and vases to augment the contemporary works he commissioned.[14] Probably on the advice of his agent John Thorpe, Campbell's contemporary Henry Blundell commissioned a standing *Psyche* from Canova for his expanded collection at Ince Blundell Hall. The wealthy collector Thomas Hope also was interested in works by Canova at an early date, but his *Venus* was not completed until 1820.[15] After the Napoleonic wars a whole new wave of British commissions flowed the Venetian artist's way. Thus in the 1780s and early 1790s, when Canova's cultural and political formation was being established, his most numerous and sympathetic patrons and colleagues were decidedly British.[16] I believe that this circumstance partly explains the almost complete absence of French patrons and connections and that it helped to shape Canova's political and professional attitudes in the troubled years ahead.

But Canova did not accept all proffered commissions from the British. He refused to work for Frederick Hervey because of the eccentricities of that patron, who had also offended him by questioning the prices for his work. More important, he declined a group of highly politicized monument commissions, offered to him during the tumultuous 1790s, partly because he felt no sympathy with such undertakings but also because of increasingly problematic sea and land transport, occasioned by the Anglo-French wars. He refused at least three portrait commissions: a statue of Lord Dundas proposed without any limitations on the price by Lord Ferguson; a portrait statue of Charles James Fox, the radical politician, for the duke of Bedford; and a monument to William Pitt for the University of Cambridge. By 1800 Canova was so fully occupied that he felt free to decline uncongenial work, and his dislike of portraiture and overt political agendas made the decision in these cases easy.[17] He refused the commission offered by Cardinal de Bernis for a monument to the chevalier Bayard, and one should not underestimate his aversion to all monuments of this type, regardless of the nationality or politics of the patron.

The decision not to execute the political portrait monuments to Dundas, Fox, and Pitt did not diminish Canova's Anglophilia. In a broader context, British influence and admiration for things British characterized progressive intellectual culture in eighteenth-century Italy at least as much as French influence and admiration of things French. British science and literature were especially potent in Italy; the works of Newton, Burke, Richardson, and Johnson, to name only a few, were widely read in Italian translation or, in the case of Newton, in the original Latin. The obvious and widespread fascination with the ancient Roman past and the Italian Renaissance tradition on the part of the British created much sympathy for them in Italy, and the presence of large numbers of artists and grand tourists with ready praise and open purses was a source of pride for the politically enervated Italian states.[18] The establishment of the exiled Stuart court in Rome gave the city an additional British luster, although the relative religious tolerance and liberalism of Italy, even the Papal States, made it

an attractive destination for British Protestant travelers and residents. It is telling in this context that Canova studied the English language, a rather surprising effort for a Settecento Italian, artist or otherwise, and that he gained at least a passive understanding of it. Lady Holland claimed in 1815 that he was fluent, and his rebuke to the Earl-Bishop's complaint in English about his prices indicates that he understood much of what was being said. In all probability, he understood spoken English well enough, spoke it a little, and could write it scarcely at all.[19] My point here is that even making the attempt was remarkable in an age when French was the lingua franca of polite society and when most of Canova's British friends spoke French and at least some Italian. There must have been more to this desire to learn English than the obvious business advantages of knowing his clients' native tongue.

The British offered a highly flattering critical appraisal of Canova's art, according it all but complete equality with the great antiquities of the Graeco-Roman past. Not even in Italy was he venerated, sought after, and adored as he was in Britain. Such adulation could not but have influenced the sculptor's general attitudes and prejudices. The sculpture collection at Syon provides an interesting illustration of this phenomenon. The celebrated entrance hall, designed by Robert Adam, contains a bronze copy by Valadier of the Dying Gladiator and a plaster cast of the Apollo Belvedere. In an adjacent room are copies of the Belvedere Antinoüs and the Borghese Silenus. Twelve gilt bronze casts after antique statues were placed on a dozen verd antique columns in the anteroom. At some later point, one of the ancient copies was removed from its column pedestal, and a bronze replica of Canova's *Hebe* took its place.[20] The Venetian sculptor was thus apotheosized appropriately on this English Olympus.

Canova and many Italians learned of Admiral Nelson's stunning and decisive victory over the combined French and Spanish fleets at Trafalgar in Milan's *Giornale Italiano* several weeks after the momentous engagement in the Bay of Biscay. The "Nuove Politiche" section of December 8, 1805, told readers of the admiral on the deck of his flagship HMS *Victory,* mortally wounded, ordering that he not be buried at sea but taken home for interment at his native town of Burnham-Thorpe, "if His Majesty does not order differently."[21] The Lombard journal's anticipation that some conspicuous memorial to Great Britain's most celebrated war hero was in the offing was thus communicated to the finest funerary sculptor of the age. Canova executed a detailed and complex *modello* for a highly ambitious monument to Nelson the very next year (figure 68). Several early biographers, including Countess Isabella Teotochi Albrizzi, claimed that the sculptor made the *modello* spontaneously and for his own amusement.[22] It is difficult to imagine how he could have actually accepted a commission for such a memorial without immigrating to England, at no little peril to himself. But if he executed it in Rome, he would have had to trust fate in shipping it to London through Gibraltar and the stormy Atlantic. And that course would still have left open the question of overseeing its installation in the English capital. The commission could have posed far greater political problems for Rome and the papacy than, say, the *Tomb of the*

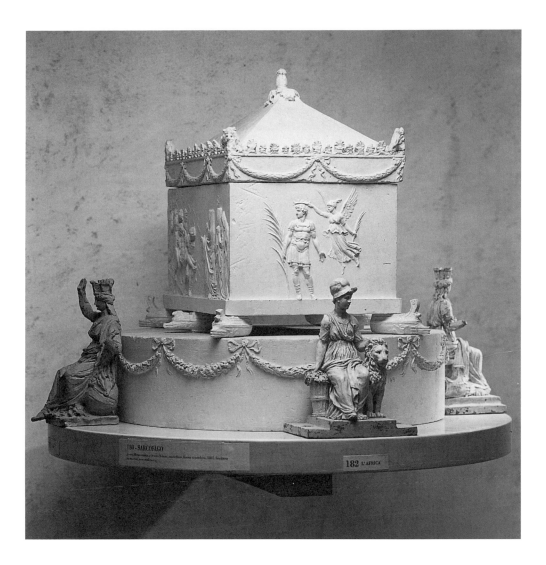

FIGURE 68
Antonio Canova, *Monument to
Admiral Horatio Nelson,* plaster, wax,
and terra-cotta, 1806–7. Possagno,
Gipsoteca Canoviana.

Archduchess Maria Christina (see figure 58), which caused only complaints from France. The many obstacles notwithstanding, considerable evidence suggests that Canova anticipated a major sculptural competition for a monument to Nelson and that British admirers had approached him discreetly about the project. The tomb envisioned in the *modello* is remarkable, whether he made the model for his own delectation or, as I believe, in anticipation of a commission. It is still an open question.

Canova designed Nelson's tomb on a colossal scale; nothing so grand had been planned in the genre since Michelangelo's *Tomb of Julius II.* With a lidded sarcophagus as the central feature, the structure was to be surrounded by ornate, classicizing candelabra, and seated female allegories representing the four continents were to be placed on each face of the sarcophagus, accompanied by inscriptions relating to Nelson's naval victories. On the platform with the marble sarcophagus were to be rostral columns, and three sides of the tomb were to feature figural reliefs, the fourth an inscription.[23] The narrative focal point of the design is the relief showing the body of Nelson being received in England by female personifications of the three kingdoms—England, Scotland, and Ireland—for a burial befitting the hero. The relief on the opposite side features Minerva, Mars, and Neptune entrusting the infant Nelson to the United Kingdom, and end panels bear a victor's laurel with the inscription and a scene of apotheosis in which Nelson is crowned by Nike. As Ottorino Stefani has pointed out, *Nelson's Remains Received by the Three Kingdoms* is the most allusive and politically important component. The sailors who bear Nelson's body call to mind scenes of the Deposition, while the three female nations, in veiled sorrow, recall the Three Marys at the Sepulcher, giving a sense of Christian profundity to a scene of allegorized contemporary history.[24] Antonio D'Este described the *modello* most eloquently as a majestic combination of Greek elegance and Roman magnificence.[25]

Canova's admiration for Horatio Nelson and his wish to execute his funerary monument were partly motivated by his association of the hero of Trafalgar with the fifteenth-century Venetian admiral Carlo Zeno, and there are some remarkable parallels in the biographies of the two commanders. Like Admiral Nelson, Zeno had been blinded in one eye by enemy fire and died in battle. Moreover, each man became a legend in his country, Zeno being commemorated in numerous verses and biographies, the most recent, a work Canova quite possibly knew, having been written by the celebrated historian Lodovico Antonio Muratori in 1731.[26] Even if the sculptor was unaware of Muratori's text, it is difficult to imagine that he was ignorant of such an important Venetian patriot's celebrated deeds, given his deep pride in the *patria,* and it is probable that the Zeno-Nelson coincidences encouraged Canova to pursue his ambitions to execute Nelson's tomb.

The sculptor may actually have met Horatio Nelson in Naples sometime in the mid-1790s, but such an encounter, while likely, is undocumented. Canova did know Sir William Hamilton and his wife, Lady Emma, quite well.[27] Emma Hamilton's illicit love affair with Nelson both scandalized and intrigued Europe. Moreover, the encouragement of Canova's British friends, coupled with the enticing professional and aesthetic challenges such a monument could provide, led the artist to persevere. Nelson's well-known antipathy to every-

thing French would only have increased the admiral's favor so far as the sculptor was concerned.[28] Charles Francis Greville, William Hamilton's nephew, was the chief promoter of Canova's name for the proposed monument to Nelson in Saint Paul's. His undisguised favoritism and lack of tact did much harm to whatever chance Canova may have had to receive the commission. In a pamphlet published in 1807 announcing plans for the monument, Greville championed the Venetian Phidias as the only sculptor capable of doing justice to Nelson and defended the artist's work for Napoleon as having been done under duress. He added that the sculptor's sympathies were English and that Canova wished to enhance his reputation by making the monument. Unfortunately, Greville also attacked the Royal Academy and disparaged British sculptors, insults that roused vigorous protests and turned the commission into a highly politicized and nationalist issue that rode a wave of xenophobia.[29] Canova was not the first Italian artist to suffer from this phenomenon in Great Britain. Thus, it is not surprising that his aspirations were frustrated at this juncture, and the commission was eventually given to John Flaxman.

Canova manifested his interest in the Nelson monument in more than the making of the *modello;* works of art based on the *modello* indicate its centrality for the sculptor's ambitions during a considerable period of time. An engraving by Pietro Fontana, made after a painting of the *modello* by Bernardino Nocchi, is dated 1806, evidence that the sculptor wished to publicize the design immediately, although the intended audience is somewhat uncertain, and it would have been difficult to circulate such a politically charged object outside the Papal States, which were then still independent of France. In 1810 Nocchi was engaged in another painting of the monument for engraving; the resulting prints were not distributed until 1814.[30] The much trumpeted tomb of Nelson was originally to be placed under the dome of Saint Paul's;[31] after the commission was awarded to Flaxman, its location was changed. Was some other commemoration on a different site planned, or did Canova wish only to show what he would have made had he been selected for the commission? He also executed small grisaille paintings of the three figural reliefs from the *modello* that are still preserved at Bassano del Grappa, and a second version of the focal story, *Nelson's Remains Received by the Three Kingdoms,* executed in 1807, is in the Museo Correr in Venice.[32] Why all this activity for a commission he was unlikely to receive, given the political and logistical difficulties, one that would have been exceptionally difficult to execute had he been employed? It is hard to avoid concluding that the project genuinely engaged him and that his unusual involvement in such a politicized monument reveals something of his own political inclinations. There can be little doubt that the papacy hoped the Royal Navy could help ensure the survival of the secular power of the papacy and the independence of the States of the Church, but this hope was shortly to be dashed by the French occupation of Rome and the annexation of the Papal States to France. Nevertheless, Nelson's victory at Trafalgar had ended any serious French threat to the British Isles, and with Austria defeated and vulnerable, Canova looked to the United Kingdom as the last best hope against Napoleonic hegemony in Europe.

Canova's protracted engagement in the proposed monument to Admiral Nelson helped to keep him in at least nominal contact with the British art world in which his interest continued despite the formidable obstacles to communication posed by the war and Napoleon's continental blockade. In 1815, however, a few months after the Man of Destiny's second abdication and exile to Saint Helena, the Italian sculptor visited London in the role of an international celebrity, initiating the last, most brilliant phase of his career. British commissions occupied him from 1815 until his death in 1822, as if to make up for lost time, the only serious competition to them being the Tempio at Possagno after 1818. Indeed, Canova executed at least thirteen statues for British clients during this period as well as several ideal heads. His long-standing zeal to promote Italian art, especially sculpture, found a highly sympathetic patron in William George Spencer Cavendish (1790–1858), the sixth duke of Devonshire. In addition to *Endymion,* which he commissioned directly, the duke owned five other sculptures by Canova, including *Madame Mère.* At Chatsworth, his country house in Derbyshire, the duke displayed modern sculpture in a collection notable for its quantity and quality. With Canova's six works as centerpiece, the patron collected numerous marble sculptures by Roman artists and others associated with Canova, John Gibson and Adamo Tadolini prominent among them. Nor did the duke neglect the competing aesthetic of Bertel Thorvaldsen, purchasing works by the Danish master, his students, and imitators, including Johann Gottfried Schadow and Pietro Tenerani. The best-known Florentine sculptor of the century, Lorenzo Bartolini, was also included. The recently controversial *Three Graces* (figure 69), commissioned by the sixth duke of Bedford for his country house, Woburn, should also be considered in this context.[33] In sum, Canova's triumphant visit to England coincided with, and helped further, the exalted reputation he enjoyed there.

Canova's most public political act during his visit to London was to intervene in the debate over the Elgin marbles taken from Turkish-occupied Athens. The sculptor had seen a small part of the collection in 1803, and he rendered, as Elgin had believed he would, a highly favorable opinion before the parliamentary committee debating the purchase. The sculptor John Charles Rossi, the antiquarian Ennio Quirinio Visconti, and William Hamilton all shared Canova's high opinion of the classical Greek sculptures, and their judgment probably reinforced his own. In testimony before the committee, Canova estimated the worth of the Elgin marbles at £100,000. He based this estimate on a lower one—£15,000— given for the Phigalian marbles by Richard Payne Knight and the Society of the Dilettanti, who championed those works to the disparagement of Lord Elgin's Greek masterpieces.[34] He ascribed a greater empirical naturalism to the sculptures from the Acropolis than to more schematized Graeco-Roman copies, and his reputation, never higher in Britain than it was in 1815, did much to sway the politicians in favor of purchasing the Elgin marbles for the nation.

The invitation to testify on behalf of the Acropolis sculptures was the most public manifestation of official British admiration for Canova, but the dinner given in his honor by the Royal Academy was the most gratifying professional distinction he received in the English capital. Joseph Farington's diary entry of December 1, 1815, describes the event and lists the

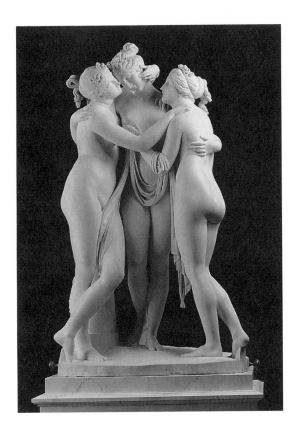

academicians present, a distinguished group that included almost every British artist of note with the exception of John Constable. The sculptors Joseph Nollekens, Richard Westmacott, and John Flaxman, all of whom already knew Canova, were present, along with such influential painters as the president of the Royal Academy, Benjamin West; James Northcote; David Wilkie; Henry Fuseli; J. M. W. Turner; and the future president of the institution Thomas Lawrence.[35] Four days later, Farington commented in his diary that Lawrence knew a good deal about Canova's background and thought him "a pattern for an artist," and he recorded Robert Smirke's observation that "what English He does speak is remarkably pure and correct."[36] Canova's high estimation of British art is also a theme in Farington's diary entries for the period, and years later the sculptor wrote to the portraitist Marianna Pascoli Angeli in Venice, recommending Lawrence as an artistic model: "Mr. Lawrence is a very great man in making portraits. He has the judgment to know how to choose each person at the best moment; a difficult task! Then he paints with a beautiful sense of color. He is enchanted by the beautiful works of our Venetian masters."[37] An excellent example of this discerning appraisal is seen in Lawrence's *Portrait of Antonio Canova* (figure 70), which exists in at least two versions, one of which was a present from the painter to the sculptor. The

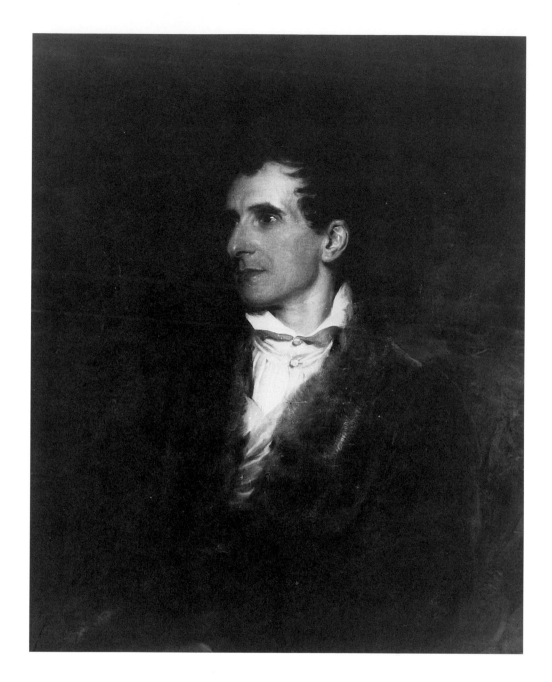

FIGURE 70
Thomas Lawrence, *Portrait of Antonio*
Canova, oil on canvas, 1818. Possagno,
Casa di Canova.

immediacy of the pose and the smoldering chromatism of the red velvet cloak certainly recall the traditions of Titian and Tintoretto. Thomas Lawrence and Canova were to meet again when the Royal Academician, newly knighted, was sent to Rome to paint the portraits of Pius VII and Cardinal Consalvi for the Prince Regent that were to form part of a highly politicized cultural initiative for Windsor Castle, of which more is said later in this chapter.

Canova's constant refrain during his English visit, recorded by Farington, the newspapers, and many who met him, was his sincere, effusive gratitude to the duke of Wellington; Robert Stewart, Viscount Castlereagh, later Lord (Earl) Londonderry; Richard William Hamilton; and the Prince Regent George for their political intervention to restore the papal art collections from the former Musée Napoléon. A sincere admirer of the pope, the Prince Regent provided 200,000 francs for the costs of packing and shipping the art objects to Rome, a timely consideration given the papal treasury's state of near bankruptcy.[38] The Prince Regent had shown his favorable attitude toward Rome and the papacy the previous year by affording almost full diplomatic ceremonial honors to Cardinal Secretary of State Consalvi during his visit to London—the first member of the Sacred College to visit England since Cardinal Pole during the reign of Queen Mary I. This gesture marked a new departure in Anglo-papal relations and may have helped to accelerate the movement for Catholic emancipation.[39] Canova also brought official letters from Rome for the Prince Regent and took letters back for the pontiff and Consalvi, serving as an unofficial diplomatic courier. His presence in London must have had a positive political influence on the liberalization of attitudes toward the Catholic Church and the pope in the heady days following the triumph over Napoleon, a phenomenon much encouraged by the Prince Regent, who, as a younger man, had illegally married a Roman Catholic.

The future George IV was much taken with Canova when they met in London, and his admiration led to the two most significant and politicized commissions the sculptor ever executed for a British patron: the Stuart cenotaph (see figure 71) for Saint Peter's and the *Venus and Mars* (see figure 73) for the Prince Regent's private collection. At an audience in December 1815 George lavished praise on the sculptor and offered numerous commissions; Canova accepted *Venus and Mars* "for sentiments of recognition and veneration," a reference to the invaluable assistance given him in recovering the looted Italian collections. When Canova had his final audience with George, he was handed a diamond-studded snuffbox by the Prince Regent himself, a mark of high distinction. D'Este relates that George asked Canova if he took snuff, and when he replied that it was not his habit, his patron told him to try it and he might like it. The box contained a note for £500, a princely sum indeed.[40] Canova described his royal reception in a letter to Cicognara in Milan dated January 17, 1816, with a great deal of understandable pride:

> I would have been able to receive commissions without number from the English if those that I have did not already keep me occupied for many more years. But I shall make [a work] only for the Prince Regent, an ideal group of Venus and Mars, symbolizing Peace and War. The honors rendered me by that illustrious and generous nation were many and great. The Royal

Prince presented me with a superb snuffbox with diamonds, and it contained a magnificent gift.[41]

Although *Venus and Mars* was not quite the only commission Canova accepted in London, it is remarkable that he readily agreed to execute such an unabashedly political allegory. Although I cannot prove it, I suspect George had the sculpture in mind as a component of an artistic ensemble that was only partly realized in the Waterloo Chamber at Windsor Castle. With its strong monarchical associations, this site seems appropriate for the Prince Regent's large group of portraits of the allied political and military leaders who together had defeated Bonaparte, all painted by the leading portraitist of the age, Sir Thomas Lawrence. The central images are those of George III and the Prince Regent, who conducts this "Concert of Europe" and culturally supports his claim to consideration as the senior statesman of Restoration Europe. Would not Canova's allegorical group sculpture have admirably served this status quo agenda?

The Italian sculptor was also highly gratified, not only by the Prince Regent's personal attentions and patronage but also by his munificence toward Italian artists, especially students. He provided plaster casts of the Elgin marbles to the Roman and Venetian Academies, a gift prompted by Pius VII's present of several plaster casts of the famous antiquities from the Pio-Clementino and Capitoline Museums that had been taken under Canova's supervision. He also added some casts of his own works, including *Marie-Louise as Concord, Venus Italica,* and *Madame Mère.* The presentation of the casts to Great Britain was partially motivated by the pope's desire, heartily seconded by Canova, to express gratitude for the Prince Regent's diplomatic and financial support in 1815. In 1818 George had become the patron of the Cork Society for Promoting the Fine Arts, which was renamed Royal Cork Society of Arts in his honor, and he presented the papal casts and the Canovas to Cork for the benefit of the students.[42] Because the Catholic majority in Ireland had long concerned the papacy in its political relations with Britain, this gesture must have impressed the pontiff. Canova, who had Irish friends, must also have been pleased with the arrangement. The *Diario di Roma* of November 18, 1820, gave notice that King George IV's present of the Elgin marbles casts had arrived: "By means of these plaster casts we finally have a true idea of the works of that most renowned prince of the Greek sculptors [Phidias], by which to assure ourselves also of the merit of the works of the Greek chisel, of which we have in Rome several undoubted masterpieces, although in another style."[43]

Even in this innocent news item, one senses the beginnings of the loss of absolute confidence in such venerable canonical Graeco-Roman sculptures as the Apollo Belvedere, the Laocoön, and the Medici Venus. In December 1819 Canova wrote to Cicognara in Venice, expressing satisfaction that the largesse of George IV had been extended to the Venetian Academy, apparently at the request of its president, Cicognara. In fact, the casts destined for Venice arrived before those dispatched to Rome.[44] Obliging Cicognara and especially Canova by presenting the plaster casts to the Venetians was doubtless important to the British monarch, but the political compliment to the emperor of Austria should also be con-

sidered. The United Kingdom was Austria's chief ally in maintaining the restored status quo in Europe, and growing liberal unrest in Spain, the German states, and elsewhere made their old alliance more necessary than ever.

The firm commission for *Venus and Mars,* negotiated during Canova's visit to England, was accompanied by a discussion of a monument to be erected in Saint Peter's to honor the recently extinguished line of Stuart pretenders to the throne, Cardinal Henry, duke of York, styled Henry IX, having died in 1807. Originally the executor of his estate, Monsignor Angelo Cesarini, the cleric's secretary and close friend, had approached Canova in 1810 to commission a funerary monument to the last Stuart pretender. This initiative resulted only in a preliminary payment and a sketch for the tomb. In 1815 the Prince Regent gave Canova a considerable sum of money to return to the project on a more ambitious scale, including in the monument the dead cardinal's brother and father.[45] Ercole Consalvi was the liaison between the patron and the artist. Serious work began in 1817, the cenotaph being unveiled in the Vatican basilica two years later.

Composed of bust portraits of the so-called James III, the Old Pretender; and his two sons, Charles Edward, the Young Pretender (also known as Bonnie Prince Charlie), and Henry Benedict, cardinal-duke of York, above a tomb door flanked by nude genii of death with downturned torches, the *Cenotaph of the Last Stuarts* (figure 71) is a composite of ideas borrowed from Canova's earlier tomb ensembles, especially the *Tomb of Pope Clement XIII* and the *Tomb of the Archduchess Maria Christina of Austria.* The rather cramped position of the monument in the left side aisle owes to its siting near the *Monument to Queen Maria Clementina Sobieski,* dating from the middle of the Settecento. A Polish princess whose marriage to the Old Pretender had been arranged early in the eighteenth century by Pope Clement XI, Sobieski was the mother of the Young Pretender and of Cardinal Henry, duke of York. Despite the somewhat narrow, claustrophobic location, its presence in the mother church of the Roman Catholic religion gave it a public visibility that created both political and moral controversy when it was unveiled.

Cardinal Henry, pretender duke of York and the last Stuart claimant to the British throne, was also bishop of Frascati. By all accounts he was an excellent administrator and a pious pastor in addition to being a discerning patron of the arts, especially poetry. Unlike the rest of his family he was favorably disposed toward his Hanoverian relatives and even accepted a pension from the Prince Regent when the French occupation of Rome eliminated the sources of his income. Only his fondness for rank and his refusal to abjure his pretended title of King Henry IX after Charles Edward's death prevented a full reconciliation.[46] The Prince Regent's wish to commemorate his deceased Stuart rivals was inspired partly by family piety but also by a desire to conciliate the remaining Jacobites in his realm and to give a sense of closure to one of the bloodiest and most divisive struggles in British history. Although the battle of Culloden in 1746 effectively ended the Jacobite military threat, the

severity with which George's uncle, the duke of Cumberland, suppressed the rebellion had left a bitter legacy in the northern kingdom and had alienated a considerable number of English Tories. After the death of "Henry IX," George could afford to be generous. Still, the strong feelings against the Catholic Stuarts on the part of many in the British Protestant majority necessitated a careful political balance on the part of the Prince Regent; this in turn affected Canova's realization of the cenotaph, above all its inscription. After the Prince Regent had read its initial wording, he instructed Castlereagh to inform Canova that George's name was not to appear on the monument, doubtless a political concession to those who believed him too soft on the Stuart legacy and too tolerant generally of Roman Catholicism and the papacy. George and the British government wanted a monument to Hanoverian-Jacobite reconciliation, but public opinion at home demanded that it not be too overt.[47]

In a letter Canova wrote on New Year's Day 1818 to the countess of Albany one sees that his motive for making the Stuart cenotaph for Saint Peter's was a desire to oblige the Prince Regent. As the estranged wife and then widow of the Young Pretender, Albany had a dynastic interest in the monument. After informing her that he had completed the *modello* and had begun to work on the marble figures, he added:

> In this monument undertaken by me to favor the kindnesses of the Prince Regent who has wanted to share in the expenses with a sum that must suffice me for the price of everything, I have studied and I am studying to engage all my zeal to give with this work some demonstration of grateful homage to His Royal Highness the Prince Regent to whom I owe so much, to you, and to our Cardinal Consalvi.[48]

I am not sufficiently cynical to doubt the sincerity of this claim, and I sense Canova's genuine attachment to the patron of the cenotaph, to the last surviving member of the immediate Stuart family, and to the cardinal secretary of state who helped facilitate the execution of the monument. Canova's *Cenotaph of the Last Stuarts* symbolizes the closing of the book on a long and tragic era, and no matter how flawed the Prince Regent may have been as a moral exemplar and party politician, his inflection of cultural politics to conciliate the disaffected in his now undisputed kingdoms, manifested in Canova's cenotaph in Rome, shows a highly developed awareness of the political power of images.

The end of dynastic and religious conflict and the dawn of a new era of unity and greater spiritual tolerance in Great Britain were not the only political dimensions of the *Cenotaph of the Last Stuarts*. It also provoked a storm of moral protest in the upper echelons of the Church, a prudish brouhaha that revealed the deep rift between progressives and reactionaries in the early Restoration Curia. Canova had already run afoul of the traditionalists in the chapter of Saint Peter's with his proposal for the colossal *Religion,* whose dimensions and placement were sufficiently innovative to cause suspicion among reactionaries, who ultimately frustrated the plan. Soon after the unveiling of the Stuart cenotaph, their calumnies became vocal enough to reach the ears of the pope. At issue were the bare flanks of the two profiled genii on either side of the fictive door (figure 72); the only slightly more strategically

draped genius at the base of the *Tomb of Pope Clement XIII* (see figure 19) at the opposite end of the basilica seems to have elicited similar, if less vituperative, comment. In late November 1819, not long after the cenotaph was revealed to public scrutiny, Canova received a letter from the papal *Maggiordomo,* Antonio Frosini, that I believe is a significant document in the history of art censorship. Coming immediately to the point, Frosini wrote:

> No one is more persuaded than Our Holy Lord that the two genii on the mausoleum of the last remains of the illustrious Stuart family do not have that which promotes scandal and animadversion in the souls of the well intentioned; and therefore no one is more moved to make the eulogies that are due to them than His Holiness. . . . But not everyone wants to submit themselves to the proper way of seeing of wise men. . . . I cannot be excused from asking for a measure to be taken about these same genii. . . . The Holy Father defers everything to you, to the knowledge of your superior ability and to your high sense of morality and religion that are well known to him and of which you daily give proof.[49]

Monsignor Frosini played the "heavy" in asking the artist to modify the seminude figures, strongly hinting that such a compromise would help the pope mollify the opposition. The letter underscores the increasingly difficult situation of Pius VII, whose tolerance and progressive cultural interests were viewed with hostility by the dogmatists rapidly gaining control of the Church hierarchy. Similarly, it suggests that the cosmopolitan syncretism characteristic of Canova's neoclassical aesthetic was less desirable in a world that valued medieval theocratic historicism more than the outmoded grandeur of the ancient civilizations so beloved of the eighteenth century. The pontiff ultimately left the matter in the artist's hands. Canova responded that he would not cover the offending flanks for reasons that might now be labeled artistic freedom.[50] He and his genii were left in peace while he (and Pius VII) lived, but the figures were partially draped afterward and remained so until the present century.

Although the tribute to the Stuart pretenders was a public cenotaph in Christianity's most famous church and the better informed among the viewers knew who had paid for the work, the Prince Regent, for political reasons that had little to do with Rome and everything to do with public opinion at home, distanced himself from the monument. The future George IV was less constrained by public opinion and freer to promote a personal political agenda in the other major sculpture he commissioned from Canova—*Venus and Mars* (figure 73). I return to this group sculpture to examine its role in the Prince Regent's cultural politics, as well as the sculptor's process of conceptualizing this decidedly political allegory. More than any other work executed for the British, *Venus and Mars* reveals a happy confluence of the patron's public wishes and the artist's private desires. It is, moreover, a work that underscores the strengths and the weaknesses of mythology as political allegory, one that stands as a monument to royal egotism and the discharge of the sculptor's personal sense of obligation.

Commissioned in the same year as Wellington's definitive victory over Napoleon at Waterloo, *Venus and Mars* manifests the new spirit of nationalistic pride and martial self-confidence sweeping Britain, which had emerged from the ruins of Europe as the world's most powerful nation. I have already mentioned the possibility that the sculpture may have formed part of George's "Concert of Europe" theme envisioned for Windsor Castle, but Canova's statue, even if not linked directly to Lawrence's portraits, was certainly intended to visualize and even exaggerate the Prince Regent's role in the defeat of imperial France. Possession of an important work by Canova would also put him into the same league, culturally speaking, as Bonaparte, the czar, and Francis II. Moreover, the austere, rhetorical character of *Venus and Mars* as an allegory of war and peace trumpets the notion of public duty on the part of both deities, metaphorically speaking. Rather than focus attention on the intimate sorrow of an imminent separation or stress the essentially irreconcilable natures that Venus and Mars represent, Canova gives them an air of resigned constraint that subdues individual desire for a greater good.[51] Sculpture teaches a moral lesson with a political subtext.

George wished to recall to Europe's attention the usefulness of sculpture as a symbol of the cultural achievements of Western civilization. In Thomas Lawrence's *Portrait of Pope Pius VII* (figure 74), painted for the Waterloo Chamber where *Venus and Mars* could possibly have been placed, the Laocoön and other antiquities returned to Rome partially through

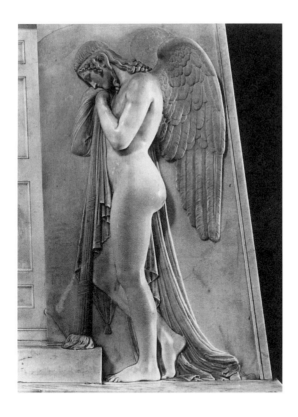

FIGURE 72
Antonio Canova, *Genius of Death*,
from *Cenotaph of the Last Stuarts*,
marble, 1817–19. Vatican City,
Saint Peter's.

the Prince Regent's efforts, and largely through his financial support, are visible in the distance behind the seated pontiff.[52] It had been rumored, when the issue of repatriating the looted art in the Musée Napoléon was first raised, that the Prince Regent hoped to acquire all or part of it, given Pius's probable inability to pay for the transport back to Rome, and George did entertain the idea. But persuaded that there was more to be gained politically through benevolent disinterestedness, he instead agreed to pay the freight. The objects in question in Lawrence's papal portrait give eloquent testimony, as does the benign and grateful pope, to George's noble actions. That Canova was the papal negotiator for the return of the pontifical collections, as well as the sculptor of *Venus and Mars,* further indicates a focused program of cultural politics on George's part. Alas, his plans were probably never made concrete, and even the arrangement of the Waterloo Chamber portraits has been altered; the room was never fully realized according to its ambitious patron's admittedly vague desires. It was a brilliant opportunity missed.

Canova's conceptualization of *Venus and Mars* as an unambiguous allegory of peace and war, so contrary to his usual practice, also sheds light on his creative process and acceptance of the patron's agenda for the sculpture. He had already executed an allegorical sculpture of

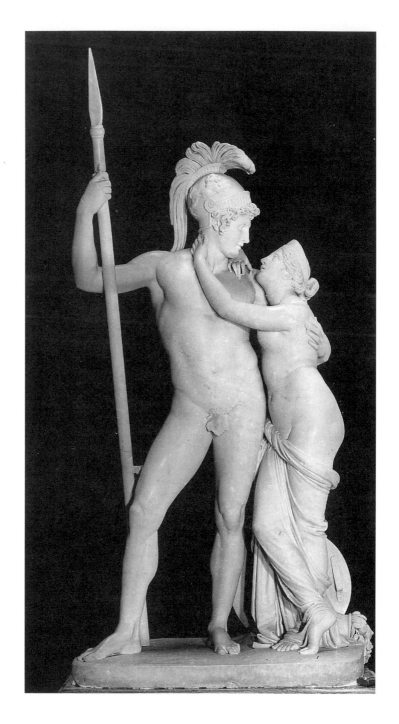

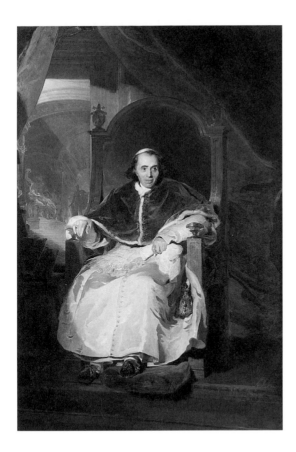

Peace before negotiating the commission for *Venus and Mars.* In about 1811 the sculptor accepted a proposal by Count Michael Paul Romanzov, chancellor to Czar Alexander I, to execute the work. In the sculpture a winged woman wears a diadem and holds a scepter while treading on a serpent representing war. Inscribed on a truncated column are the names of important Russian peace treaties negotiated by Romanzov's grandfather (Åbo, 1743), his father (Kuchuk Kainarji, 1774), and himself (Fredrikshamn, 1809). Although completed in 1814, the year of Napoleon's first abdication, *Peace* concerns only the history of the Romanzov family and their contributions to Russian diplomacy.[53] As an overtly political allegory, however, it served as a useful prototype for *Venus and Mars,* the wholly unobjectionable concept represented notwithstanding. It should also be noted that the patron's diplomatic activities helped to make the statue possible: at the time it was commissioned Russia was at peace with France (including Rome), partly through the chancellor's efforts. In a state of war it would have been difficult to arrange the commission for the work, which, as it happened, was not sent to Saint Petersburg until 1816, after the Franco-Russian war of 1812–14.

Even more significant for the Prince Regent's *Venus and Mars* was a celebrated painting

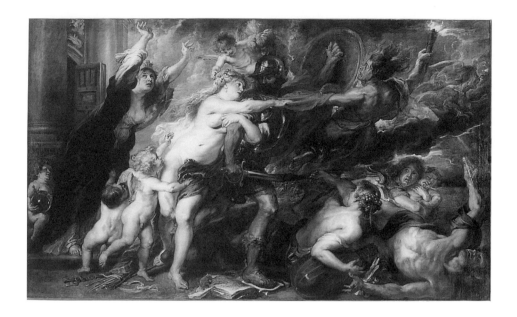

FIGURE 75
Peter Paul Rubens, *Peace Halting
War,* oil on canvas, 1637–38. Florence,
Palazzo Pitti.

by Peter Paul Rubens, *Peace Halting War* (figure 75), a large picture Canova probably saw in the grand duke's collection in Florence. The baroque masterpiece shows a fleshy Venus holding back an irate armored Mars, who is trying to wreak havoc on the entire continent. Countess Albrizzi, in her discussion of Canova's marble group sculpture, refers at length to the Rubens, underscoring the appositeness of the allegory for Europe at the end of the French wars: in the painting "one sees a majestic woman surrounded by recent massacres, all covered by mourning crepe, symbolizing Europe nearly torn asunder by new wars, who desperately rises and stretches out toward the furious god of war, to stop him."[54] While Rubens's painting made a visual plea to maintain peace and the Prince Regent George's statue was intended as a monument to peace after military victory, it is tempting to think that Canova had the Pitti painting in mind when he selected the (admittedly obvious) theme of *Venus and Mars* for the patron's purposes. In the Rubens the mythological narrative of the deities of war and love is largely overpowered by the allegorical message, while in Canova's work the mythological specificity of the topos is a salient feature. In embodying the Prince Regent's self-proclaimed role as restorer of European equanimity and tranquillity after a generation of conflict, *Venus and Mars* marks the zenith of George's using the visual arts for his own aggrandizement, a process that began ambitiously when he helped negotiate the return of confiscated and looted art from Paris. His association with Canova made him an art

patron of European, and not just British, importance. The Prince Regent's generosity and material help in dismantling the Musée Napoléon earned him the Venetian sculptor's gratitude and esteem, for without the British government's concentrated effort, Canova's art diplomacy would probably have been fruitless. The chapter that follows looks at Antonio Canova's efforts in the cause of Italian art and the decisive help he received from his British friends and admirers.

7

"THIS GREAT CAVERN OF STOLEN GOODS":

CANOVA AND THE REPATRIATION OF THE

PAPAL COLLECTIONS FROM PARIS IN 1815

═══════════════

HAD CANOVA NOT GONE TO PARIS IN 1815 to negotiate for the return of works of art taken by the French from Italian churches, religious and civic establishments, private collections, museums, and a wide variety of other venues from 1796 until the fall of the Bonapartist empire, the cultural complexion of both Paris and most of Italy would be dramatically different today. With the fall of Napoleon and the convening of the European nations at Vienna to reconfigure as far as possible the ancien régime, there was hope in Italy that its stolen cultural patrimony might somehow be restored. Any attempt at repatriation would face enormous legal, logistical, and, above all, political problems, but the choice of Antonio Canova gave Italy a decisive advantage; his artistic preeminence and reputation for personal integrity and disinterestedness made him the perfect cultural diplomat. His selection for the onerous task was especially inspired because the pope and the central Italian princes lacked the mili-

The quotation in the chapter title comes from an English translation of a letter Canova wrote to an English friend. It was published in the *London Courier* on October 16, 1815. The passage reads: "The cause of the Fine Arts is at length safe in port; and it is to the generous and unremited exertions of the British Minister, that Rome will be indebted for this triumphing in the demands I came hither to make in her name. We are at last beginning to drag forth from this great cavern of stolen goods the precious objects of art taken from Rome." The partisan pithiness of the language suggests a loose paraphrase rather than an exact translation, but these were certainly Canova's personal sentiments. The British painter Andrew Robertson attached a similar version of this text to a diary entry for October 6, 1815, as a statement from Canova. Robertson was an eyewitness to the removal of works from the Louvre, but his diary entries seem curiously uninformed about the political machinations and Canova's role in the repatriation of the Italian art. He says that Lawrence told him that it was a pity the collections were to be dismantled and that the *Transfiguration* looked fine to him, even after a reputedly brutal restoration by the Louvre conservation laboratory, a reaction quite different from that of Henry Fuseli. For the pertinent diary entries by Robertson, see Francis Henry Taylor, *The Taste of Angels: A History of Art Collecting from Rameses to Napoleon* (Boston, 1948), pp. 574–87. The quotation from the *London Courier* comes from Dorothy MacKay Quynn, "The Art Confiscations of the Napoleonic Wars," *American Historical Review* 50 (1945): 455–56.

tary ability to press their claims, a problem the German petty princes and the Dutch also faced; thus, Canova could argue from the moral high ground the just cause of the weak and the cause of the arts. Although the sculptor was reluctant to undertake the delicate assignment with its potential pitfalls, he was persuaded by Cardinal Consalvi and Pius VII. Canova knew that failure would indelibly mark his reputation and his place in history, whatever subsequent masterpieces he might produce. Once he agreed to accept the responsibilities, however, he employed all his patience and tact and all his charm and cunning to achieve success.[1] Some compromises notwithstanding, Rome and Italy are infinitely richer for his efforts.

The greatest obstacle to the repatriation of works of art taken from the Holy See was the Treaty of Tolentino, forced upon Pope Pius VI in 1797. This document, which affirmed the clauses of the Armistice of Bologna that had been signed the previous year, called for the cession of one hundred works of art to the French Republic, to be selected by their own commissioners, who swarmed through the States of the Church compiling lists of objects to be extracted. In the final reckoning, far more than a hundred works were taken. After the first abdication of Napoleon in 1814 and the restoration of Louis XVIII, the principle of legitimacy reigned supreme, and overturning a treaty, however unjust and immoral it might be, would have set a highly dangerous precedent. In addition, the victorious allies wanted to appease the French public into accepting the Bourbon monarchy, and a restoration of art would have damaged this political goal, for it would have looked like a foreign oppressor's humiliation of a puppet king. In addition, the allied leadership had enormous military and political problems to address in the aftermath of the empire, and questions of the repatriation of cultural properties had very low priority. The return of Bonaparte from Elba, the Hundred Days, and the battle of Waterloo, however, dramatically altered the victors' attitude from persuasion to vindictiveness—above all that of the British and the Prussians, who had borne the brunt of a temporarily revitalized France on the fields of Flemish Brabant. Waterloo did much to increase the odds of success for Canova's cultural diplomacy.

Even before the Congress of Vienna the idea of the restitution of the papal archives and art collections was suggested by Antonio Gabriele Severoli, papal nuncio in Vienna, who urged that pontifical claims be linked to those of the allies. Initially, the representatives of Great Britain, Austria, Prussia, and Russia agreed in principle, and Severoli wrote to Consalvi urging him to press Pius VII's demands for the return of annexed territories in conjunction with claims for the restoration of the archives and cultural properties.[2] A memorandum warmly supporting restitution resulted from Severoli's advice, but territorial disputes and the animus of the Treaty of Tolentino made the outlook for success in 1814 rather bleak. In July 1815, less than a month after Waterloo, Crown Prince Ludwig of Bavaria, a former forced ally who had subsequently become a bitter opponent of Napoleon, wrote to Consalvi, recommending that a distinguished diplomat with remarkable artistic knowledge and sensibilities be sent to Paris to negotiate; given the prince's sincere admiration for Canova, I wonder if he had the sculptor in mind. Consalvi wrote back on August 12 that Canova had been chosen for the task, and Ludwig subsequently did all he could to aid the artist's cause.[3] Thus, encouraged by Severoli (who argued for the restitution of the col-

lections—because of their vital importance to the arts and to the students in Rome—and challenged the morality of the Treaty of Tolentino) as well as by Crown Prince Ludwig of Bavaria (who urged the selection of a famous connoisseur), Consalvi initiated a process that led to the recovery of the most important works taken by the French. It could be argued that the cardinal's diplomatic skill and finesse in persuading the reluctant sculptor to accept the mission were as vital to its ultimate success as Canova's own considerable abilities.

To aid the artist, Pius VII awarded him the Cross of the Order of Jesus Christ, the highest papal distinction, which would enhance his status in the ultra-aristocratic world of early Restoration diplomacy. Before departing for Paris, the sculptor did three things; he had Quatremère de Quincy's *Lettres à Général Miranda* of 1796, deploring the cultural and artistic spoliation of Italy, reprinted at his own expense; he asked the illustrious librarian and antiquarian Marino Marini to accompany him; and he made his will.[4] The first two acts proved enormously helpful and the third, unnecessary. In particular Quatremère's controversial *Lettres,* with their appended artists' petition in favor of Italy that was signed by no less an artist than David, were influential in gradually undermining allied acceptance of the Treaty of Tolentino.

Pius VII sent Canova to Paris amply furnished with letters to the sovereigns and their ministers arguing against the moral force and legality of this treaty. The pontiff cited his predecessor's constant attempts to keep the peace and his extravagant appeasement of the Directory. In addition, the popes had fed and sheltered several thousand dispossessed and exiled French clergy while offering a refuge in Rome to Louis XVIII's own aunts, the princesses Victoire and Adelaide. Pius VII argued that France's goal had always been to seize the wealth of the patrimony of Peter and to humble the papacy forever. To this end, the French invaded and sacked the States of the Church, occupied Rome, and deposed Pius VI; thus French aggression had violated the terms of a treaty that France had entered in bad faith, making that treaty null and void.[5] Canova's diplomatic credentials, addressed by Pius VII to the allied ministers Metternich of Austria, Alexander von Humboldt of Prussia, Castlereagh of Great Britain, and Karl Robert von Nesselrode of Russia, among others, both made clear the pope's moral claims and formed the basis of Canova's argument against the validity of the treaty:

> The regicide troops of the French Republic, having immersed Italy in horrors, invaded without provocation the peaceful States of the Church and constrained His Holiness Pius VI to repurchase peace and political existence with the grievous sacrifice of the most celebrated monuments of the arts of painting and sculpture. The same French troops returned without provocation and again invaded the states of the Holy See, dethroning and imprisoning that same pontiff, whom they had just forced to cede all that they had wanted. And in this second invasion they completed the spoliation of the chief works of art.[6]

The brief concludes with an appeal for help in reformulating Rome as the seat of the arts and the tutor of artists and argues, as Canova and Quatremère did, that the works in Paris could be fully understood and appreciated only in Rome. Even though Pius's argument against the

treaty was at first met with sympathetic shrugs or outright resistance, it began to make headway with many of the allied diplomats when strongly supported by Europe's most famous artist.

In August 1815 the British minister, Lord Castlereagh, received from thirty-nine artists of several nationalities living in Rome a petition begging for restitution of the confiscated and looted works of art. With Canova's mild but determined presence and the aid of William Richard Hamilton, whom Dominique-Vivant Denon and many others in Paris believed the "evil genius" of the dismantling of the museum, the allied opinions that mattered came to accept the Roman view that the 1797 pact was invalid. Castlereagh summed it up when he wrote: "Buonaparte's treaties, as, for instance, that of Tolentino, were not inferior in immorality to his wars."[7] Thus, Tolentino came to occupy a position of infamy in the recent history of French diplomacy, ensuring Canova's success in Paris in 1815.

While in the French capital in the autumn of 1815, Canova stayed with his old friend Quatremère de Quincy, and although it was mostly a private arrangement, it nonetheless had political advantages in publicizing the amiable relationship between the Venetian artist and the French antiquarian, widely known as a supporter of cultural restitution. In 1802 Canova had lodged with the papal nuncio while in Paris to execute the first consul's portrait, a move calculated to indicate that the sculptor was there as a favor to Napoleon from Pope Pius VII. Presumably the same option was open to him in 1815, but being the guest of France's most famous scholar doubtless had a strong appeal, given the delicate nature of his mission. As Quatremère's houseguest he frequented the intimate soirees of the archaeologist's widowed sister-in-law, Madame Pia Quatremère, an elite circle characterized by religious sensibility and conservative politics. Madame Pia was a great admirer of Canova, as was her clerical friend the abbé de Pierre, a scholar and clergyman attached to the Church of Saint-Sulpice who encouraged Canova in the ill-fated *Pietà* group originally planned for the church (see figure 35).[8] One of the chief topics of discussion at these evening parties was the restitution. Similarly, the dismantling of the Museum of French Monuments was promoted, Quatremère being a violent opponent of Alexandre Lenoir's cultural initiative during the Revolution that had saved numerous works of sacred art from popular and state-supported iconoclasm. Indeed, Quatremère's antipathy to museums was so pronounced that he must have influenced Canova's thinking on this thorny issue. Although Quatremère's attitudes are beyond the scope of the present discussion, their importance to the development of modern museology and the increasingly negative critique of museums in postmodern culture have drawn to them such scholars as Sylvia Lavin, Daniel Sherman, Édouard Pommier, and many others. The consensus in Pia Quatremère's salon was that the objects in the museum should be returned either to the churches from which they had been removed (whenever possible) or to the original owners.[9] Undoubtedly Canova also supported the recontextualization of these works of art.

My point in dwelling on the Quatremère circle is to underscore the support of many French conservatives for repatriation as a vital principle of the general restoration with long-term benefits for France and Europe. Melchior Missirini, in his biography of Canova, mentions an item in a Parisian paper that appeared amid the turmoil of packing the papal works. The author of the article paraphrased by Missirini claimed that losing the works of art wounded only the nation's sensibilities, not its interests, unlike the loss of a province or a financial indemnity. Moreover, Rome, Florence, and other countries would always be hostile to France when reminded of their cultural losses by empty frames and barren niches. Indeed, the duke of Parma had placed a black mourning cloth where Correggio's *Madonna and Child with Saint Jerome* (figure 76) had been, as a remembrance. Because the original spoliation had outraged those of moderate political views and almost all artists throughout Europe, a general restitution was both a political expedient and a true service to the arts, since Italy was widely believed to be their proper setting. Finally, there was an appeal to simple justice—Napoleon's policy of beggaring the genius of other nations from a sense of vainglory was wrong, and Rome should be restored to its legitimate place as the capital of the arts.[10]

Canova, on the eve of his appearance at the renamed Musée Royal, the ci-devant Musée Napoléon, on the first day of October, wrote a letter that betrays his anxiety and apprehensions about the events of the next day. Removing works of art surrounded by hostile crowds, with the support of only the soldiers of an occupying power, was an unenviable task. Aided by his half brother Giovanni Battista Sartori-Canova, he was also ably assisted by a fluent French speaker, the Italian republican exile Luigi Angeloni from Frosinone.[11] Angeloni had been a tribune of the Roman republic in 1798–99 and had fled to France after the brief Neapolitan occupation of Rome in 1799. In Paris he had been involved in several anti-Bonapartist plots, including the "infernal machine" affair of the Italian sculptor Giuseppe Ceracchi (a plot to blow up the first consul's carriage as he left the opera), and had spent a number of years in prison. While Canova did not share his republican opinions, they did agree on the importance of the restitution, and Angeloni worked tirelessly on its behalf. For his efforts he received a gold snuffbox from Pius VII, and Canova later appealed for an end to his exile, but Angeloni's increasing involvement in the rhetoric of Italian unification and his subsequent estrangement from the sculptor undermined these efforts at reconciliation.[12] Thus the Canova brothers and Angeloni began packing up the works of art that would arrive in Rome three months later.

Before discussing the problems of the removal, I want to look at the diplomatic process that made it possible and at Canova's role in it. This negotiation brought his diplomatic abilities to the fore; his cosmopolitan sculptural practice had been an excellent school for the wholly unexpected role of cultural negotiator. His many contacts in the aristocratic circles of the major European powers also greatly aided his mission. He had to deal differently with each foreign ministry, depending on his familiarity with each nation's views and agenda vis-à-vis France as well as the overall policy of restitution. With the Treaty of Tolentino rendered suspect and vulnerable, Canova needed only to win over those still hesitant to humiliate the new king of France.

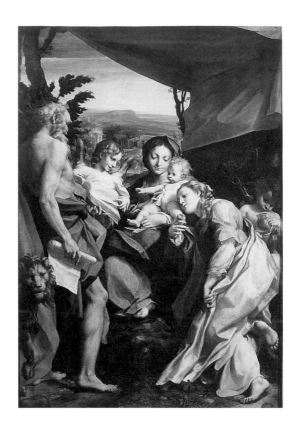

FIGURE 76

Correggio, *Madonna and Child with Saint Jerome,* oil on panel, ca. 1524. Parma, Galleria Nazionale.

By far the most important and material aid Canova received in Paris came from the United Kingdom, above all from William Richard Hamilton, Castlereagh, the duke of Wellington, and the Prince Regent, George. Fortunately, the British role is especially well documented. British diplomatic efforts on behalf of the papacy might have caused more political controversy at home had not French attempts to keep the spoils of war roused public indignation. Pius VII's reputation as a long-suffering victim of Napoleonic tyranny also made it easier for the overwhelmingly Protestant nation to support Canova's endeavors.[13] An extract from an article published in the *London Courier* on October 15, 1815, captures the public mood in Britain. With the many veterans of the Grande Armée stirring up the French people by criticizing official acquiescence to the restitution and loudly proclaiming France's right to the trophies in the Louvre, the *London Courier* asked rhetorically, "Do they persist in enforcing that right? Then why do not now the Allies plunder France of every article worth removing which she possessed before Buonaparte's time? They are entitled to do this by the example of Buonaparte's practice, now so eagerly sanctioned by the Parisians."[14] Ultimately, as upholders of a pre-1789 status quo, the allies could not either allow the looted works of art to remain in Paris or remove cultural objects from defeated France. Frederick

the Great of Prussia became the moral exemplar on the issue of art spoliation during war. When his armies had twice occupied the Saxon capital at Dresden, the king had contented himself with admiring his beaten enemy's celebrated gallery of masterpieces. In comparison, what Bonaparte had done (and the Republic before him) was considered a barbarous aberration and an affront to civilized society.

William Richard Hamilton had been friendly with Canova for many years when the two met in Paris in 1815. He was Lord Elgin's secretary during the negotiations with the Sublime Porte for the removal of the ancient Greek marbles from the Acropolis in Turkish-occupied Athens, and in 1815, as Castlereagh's undersecretary of state for foreign affairs, was in an excellent position to aid Canova's mission. Denon especially feared Hamilton's influence, believing he wished to destroy the reputation of the Louvre so that the United Kingdom could assume the museological (and thus cultural and artistic) leadership of Europe, forming a national collection in London around the Elgin marbles, contributions from the British royal and private collections, and some prized objects obtained from the Italian collections Hamilton hoped to remove from the former Musée Napoléon. A paranoid Denon declared: "What is most certain is that Mon. Hamilton has behaved in this matter like a maniac, that he has set on the entire destruction of the Museum and that he has got the support of Lord [*sic*] Wellington in the execution of his project."[15] Hamilton tenaciously opposed the spoliation of the occupied territories by the French, and whatever his dreams in 1815 about a British national collection, he strongly supported the return of the works of art plundered from Italy to their original places and owners. In a letter to the earl of Bathurst responding to the Prince Regent's proposal to acquire some of the works belonging to Rome as a price for helping to return the rest, Hamilton outlined the wise and diplomatic course the British soon adopted for the entire undertaking, saying of George's rather cynical proposal: "It would throw an odium upon our exertions to receive stolen goods.... If accompanied with any proposal to our own benefit the whole will fall to the ground, and the French will remain undisturbed proprietors of what they are now afraid they are to lose; and they will have the additional gratification of owing it to our mismanagement."[16] This letter struck just the right note with the British leadership, who wished to do justice to Rome but also wanted to wound French pride, and Hamilton's argument appears clearly to have been followed in official documents and correspondence on the subject generated by Castlereagh, Wellington, and even the Prince Regent.

In addition to William Richard Hamilton's urgings that the British government take a disinterested approach to the Italian collections in the Musée Royal, Joseph Planta, the principal librarian of the fledgling British Museum, entreated Castlereagh and the duke of Wellington to support Canova's mission. Planta had gone to Paris to see the museum late in the summer of 1815, and he had an introduction to Castlereagh through his son, who was one of the minister's secretaries. Planta drew up a document urging governmental support for a general restitution, an endeavor in which he was greatly helped by Lord Clancarty. Joseph Farington wrote that Wellington and Castlereagh were much influenced by Planta's arguments and that a general restitution would soon occur. The diarist also noted that the

impoverished pontiff would probably wish to sell at least part of the collection to the British government, a course of action Planta may have supported on behalf of the British Museum. Hamilton's diplomatic disinterest, however, carried the day.[17]

The possibility that Pius VII might sell some of the papal works of art to Britain was still being mooted when Canova finally met Castlereagh in Paris in late September. The artist informed him that since Pope Pius had only a life interest in the patrimony, he could not, under normal conditions, sell anything, but Canova had been authorized by the pope, in this unprecedented emergency, to auction some of the lesser objects to pay for the transportation of the most important works back to Rome. Castlereagh then informed the prime minister, Lord Liverpool, who told the Prince Regent. Under the circumstances, and probably at Hamilton's suggestion, Castlereagh recommended that the altruistic position would gain His Majesty's government greater international credit,[18] and I suspect that at this point in the discussion George determined to pay the shipping costs himself. He could certainly have used some good press for a change. A letter from Consalvi to Castlereagh whose contents were intended primarily for the Prince Regent may also have helped George decide to assist Canova and Pius VII so generously. The cardinal, noting the Prince Regent's personal regard for the pope, asked the secretary to beseech that George help in the repatriation, "employing his valuable offices in a restitution that will be recalled with everlasting recognition by Rome, and ecstatically applauded by all Europe."[19] The Prince Regent, who wished to play the grand old man in the early Restoration era, relished the opportunity to assist the lionized and highly sympathetic Pius VII.

The ultimate decision to support the restitution came from the duke of Wellington, the man of the year in 1815. His intervention was decisive, and his opposition would have brought down the entire undertaking, whatever the government's opinion. In all probability Wellington saw the restitution almost exclusively as another way to punish France for its Bonapartism. Like Castlereagh and many others, he was disgusted by the speed with which the French people turned on Louis XVIII and supported the empire, and he believed that the presence of military trophies in Paris in the form of works of art could only be a stimulus to *la gloire* in the future. In the final analysis, I believe Napoleon's return from exile on Elba not only ended his military career but also spelled the death sentence for his unparalleled museum in the Louvre. Writing to Castlereagh in the aftermath of the Hundred Days, on September 23, 1815, the Iron Duke summarized his views on the subject of restitution:

> But the circumstances now are entirely different. The army disappointed the reasonable expectation of the world, and seized the earliest opportunity of rebelling against their Sovereign, and of giving their services to the common enemy of mankind, with a view to the revival of the disastrous period which had passed, and of the scenes of plunder which the world had made such gigantic efforts to get rid of. This army having been defeated by the armies of Europe, they have been disbanded by the United Counsel of the Sovereigns, and no reason can exist why the powers of Europe should do injustice to their own subjects with a view to conciliate them again. Neither has it ever appeared to me to be necessary that the Allied Sover-

eigns should omit this opportunity to do justice and to gratify their own subjects in order to gratify the people of France. The feeling of the people of France upon this subject must be one of national vanity only. It must be a desire to retain these specimens of the arts, not because Paris is the fittest depository for them, as, upon that subject, artists, connoisseurs, and all who have written upon it, agree that the whole ought to be removed to their ancient seat, but because they were obtained by military concessions, of which they are the trophies. The same feelings which induce the people of France to wish to retain the pictures and statues of other nations would naturally induce other nations to wish, now that success is on their side, that the property should be returned to their rightful owners, and the Allied Sovereigns must feel a desire to gratify them. It is, besides, on many accounts, desirable, as well for their own happiness as for that of the world, that the people of France, if they do not already feel that Europe is too strong for them, should be made sensible of it; and that, whatever may be the extent, at any time, of their momentary and partial success against any one, or any number of individual powers in Europe, the day of retribution must come.[20]

This famous letter underscores arguments that perhaps should be more seriously considered: that the presence of the "trophies of conquest" in Paris was a constant grievance to the countries deprived of a significant part of their most cherished artistic heritage and that the French could also use the objects as propaganda to incite aggression and to glorify war. Seen in this light, one wonders how Wellington reacted when Louis XVIII stoutly opposed the return of the works of art to their countries of origin even though their strongly Bonapartist associations could have endangered his own regime.

Although the duke of Wellington's support for restitution was crucial, enabling Canova to complete his mission successfully, the Prince Regent received the lion's share of the credit for it. George intervened at an opportune moment when he paid the large cost of transporting the papal works (and some others) back to Italy. Pius VII, touched by this kind gesture from a Protestant ruler, expressed through Cardinal Consalvi his "lasting sentiment of infinite gratitude" toward Britain.[21] Never one to pass up an opportunity for favorable publicity, George decided to include Pius's portrait by Lawrence conspicuously among the full-length representations to be placed in the Waterloo Chamber (see figure 74). Michael Levey claims that Lawrence made the decision to place the pontiff before his restored masterpieces, but even so, it clearly served the Prince Regent's agenda for the portrait.[22] What may be more closely linked to Lawrence, I believe, is the letter Pius holds, labeled "Per Ant.o Canova," quite probably the sculptor's patent of nobility as marchese d'Ischia, conferred by the pope in return for Canova's services in Paris.

Like the pontiff, Canova was highly sensible of the Prince Regent's help in both negotiations in Paris and financial arrangements for the removal of the works of art to Rome. He wrote from Paris to Cicognara in Venice on October 8, 1815, that he had secured the bulk of the celebrated papal antiquities and that Britain was paying for the transportation, adding, "Bella Cosa!"[23] In addition to accepting George's commission for the *Venus and Mars,* Canova also honored the Prince Regent by having one of his favorite painters, the president of the Royal Academy, Benjamin West, elected an amateur member (*accademico di merito*) of the

Academy of Saint Luke, a distinction shortly afterward extended to John Flaxman, Henry Fuseli, and Thomas Lawrence. As an additional sign of his gratitude, Canova engineered the nomination of William Richard Hamilton as an honorary member (*accademico di onore*) of the Accademia, and proposed him for membership in the Roman Academy of Archaeology in 1816.[24] The artist, the cardinal, and the pope all fully appreciated that without British help, the restitution of the papal collections, and probably many others in Italy, would never have taken place.

But the role of some of the other allied powers in the success of Canova's mission was also important, above all that of Prussia and Austria. Shortly after the allies persuaded the French to return the papal archives, which had been neglected and exposed to the elements while in Paris, Prussia negotiated for the works taken from their royal and German princely collections that were not on display in the Louvre. The restitution of the archive, occasioned by Pius VII's complaint that he could not reestablish papal rule in Rome without it, was an important precedent. The restoration of unexhibited paintings confiscated from several Spanish nobles who had resisted Joseph Bonaparte's regime in Madrid soon followed. The restitution of such symbols of papal authority as the archives and the fisherman's ring as well as the Prussian and Spanish paintings tentatively established the principle of restoration, but this was as far as the French were willing to go in 1814. A few weeks after the battle of Waterloo, however, Prussian General August Wilhelm Karl Georg von Ribbentrop wrote to Denon, reclaiming the displayed works seized from Berlin and also demanding many other works of art from other German collections, including Dresden, Kassel, and Braunschweig. In speaking here for the German states, the Prussian general assumed a role similar to that of Canova vis-à-vis many of the Italian states, including Venice, Tuscany, and the central Italian duchies. On July 11, eight days after Ribbentrop's ultimatum, in the face of determined opposition from the museum's director, Prussian troops occupied the Louvre and removed their works of art and those of the German states.[25] The use of force added a new dimension to the restitution; in the end Canova himself would have to rely on foreign troops to enforce the pope's claims to his works of art. After Great Britain, the Prussians were the most stalwart supporters of the papal claims. Ironically, the two Roman Catholic powers, Austria and France, either prevaricated or directly opposed the pope on this issue.

King Frederick William III of Prussia, however, wanted something for his support of the pope. While Canova was negotiating with France and the allies in Paris, the University of Heidelberg, through a representative at the Congress of Vienna, requested the return of the Palatine codices of Maximilian of Bavaria, which had been given to Pope Gregory XV early in the seventeenth century. The Prussian monarch enthusiastically endorsed the university's plea. Pope Pius, to show his gratitude for Prussian support and to placate a powerful ally, gladly returned the manuscripts, which were then in Paris, to Heidelberg, sending from Rome about eight hundred additional manuscripts in the German language culled from various Roman sources, especially church archives.[26] King Frederick William III was shrewd enough to know that Pius VII could hardly refuse Heidelberg's request to repatriate Maximilian's codices, even though they had left Germany under dramatically different

circumstances than the works of art the pontiff was trying to recover, with Prussian help, in the French capital.

The Pope's return of a famous manuscript to the University of Heidelberg, along with the spontaneous gift of a great many others, was a small price to pay for the support of Prussia, but initially it looked as if the price for the active aid of Habsburg Austria would be too high. At the end of the Napoleonic Kingdom of Italy, some British but mostly Austrian troops controlled northern and central Italy, including the papal Legations in the Romagna and the Adriatic port of Ancona. Ever since the War of the Spanish Succession at the beginning of the eighteenth century, when the Austrians occupied the papal town of Comacchio north of Ravenna and refused to give it back, an act that poisoned Austro-papal relations for the rest of the century, the Habsburgs had coveted this region. And when after the defeat of Napoleon it looked as if the Austrians would keep both the Veneto and Lombardy while also controlling Parma and Tuscany as family sinecures, the Legations were even more strategically appealing. Pius VII needed them too, for they were the most economically viable of all his territories, and Bologna was second only to Rome in prestige and importance in the States of the Church. Realizing that he could not use force, Francis II pressured Pius in every way possible to relinquish his claims, including withholding support for cultural restitution, although his Italian possessions, especially Venice and Milan, also had a great deal to lose if a general restitution did not take place. Finally, self-interest brought Great Britain to the rescue. Lord Liverpool needed Austria as a balance against France and potentially Russia, but he had no wish to make the Habsburgs any more powerful in Italy than they already were. Facing determined opposition, Austria gave up on the Legations. With that scabrous issue out of the way, the emperor jumped on the bandwagon of restitution, realizing that the enormous cultural boon would enrich his new Italian provinces. Canova wrote to Consalvi on October 10, 1815, just as he was completing the packing of the papal works in the Louvre, of the importance of Austrian support:

> Prince Metternich agrees that I may profit by his courier to send the present letter to Your Eminence. This is a new act of bounty toward me and for the cause of the arts sustained by the particular protection of the emperor and of His Highness. I would not be able to describe to you succinctly the particulars of this affair, which finally, through the good and authoritative offices of the prince, so zealous for our good, succeeded in the much desired effect of having the other powers . . . also enable Rome to retrieve the objects of art it had lost.[27]

Canova wrote to Cicognara, in a letter I have cited previously, that it would have been scandalous if the allied powers regained their lost works of art and Rome alone remain unrequited. He also mentioned that Austrian pressure had secured the liberation of the Venetian objects, including the lion of Saint Mark and the four horses from the facade of the saint's basilica, except that Veronese's massive *Marriage at Cana* (figure 77), considered too large and fragile for safe transport, was allowed to remain behind. The masterpieces of Graeco-Roman sculpture, he added, were then (October 8) in an Austrian barracks, guarded by imperial

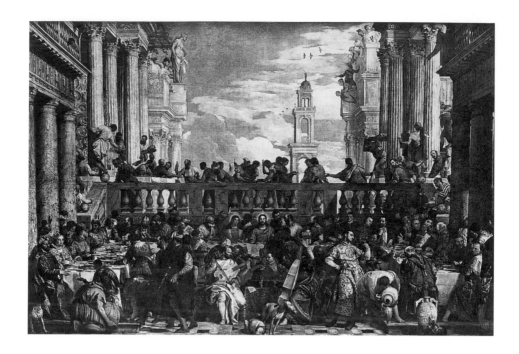

soldiers.[28] Moreover, the emperor's dragoons had helped in the packing and had escorted
the objects through Parisian streets filled with angry, abusive crowds. Canova's high repu-
tation in Vienna must have been an important factor in the Austrian show of strength in the
Louvre during the sculptor's difficult business there.

By far the most unpredictable allied player in the restitution drama, however, was Czar
Alexander I of Russia. Of all the European monarchs allied against imperial France, he was
the one who most admired Napoleon personally and who was the least embittered and vin-
dictive toward the defeated nation. At Alexander's command, the Russian diplomats firmly
and consistently opposed any move toward restoring works of art confiscated or looted by
the French. Indulging from time to time in an inconvenient and annoying mysticism he
thought quintessentially Russian, Alexander believed, or pretended to believe, that the works
of art and other cultural properties had been given to France by a higher authority he refused
to dispute. After reading some of Canova's letters from the 1815 mission to Paris, Pietro
Giordani, a noted liberal poet, wrote in 1817 to his friend Gaetano Dodici about what he con-
sidered the czar's hypocrisy and insincerity:

He always affects a mysticism, and one always wonders whether it is sincere or scenic. Nor did he depart from his custom on this occasion. He was most resolutely steadfast against the recovery of the monuments. And he did not wish to receive the envoy of the pope. . . . It is gracious, then, that a schismatic observed to the father of the Catholics that he must not reclaim them, because the Gospel commands us to give the tunic to him who has taken the cloak. The papal envoy replied to His Majesty that therefore he would have to have given Saint Petersburg to him who had burned Moscow: And therefore one may leave the Gospel aside.[29]

The spirited Roman response to Alexander's mockery about the tunic and the cloak perhaps reveals Giordani's awareness of the true reason the czar opposed restitution—a high degree of self-interest. Many works of art the French obtained in their various conquests ended up, not in museums or even churches, but in private collections. Napoleon's marshals were especially rapacious, and Josephine was a major beneficiary. She acquired almost a score of paintings purloined from the elector of Hesse's gallery at Kassel, and when the Hessian representatives appeared at Malmaison a year after her death to reclaim their works of art, they learned that the heir to her estate, Eugène de Beauharnais, had sold them to none other than the czar of all the Russias. This sale, which included Josephine's collection of statues by Canova, posed an insurmountable problem to repatriation.[30] Thus Alexander's feigned mystical view that the French were entitled to their trophies of conquest was little more than a cloak for his desire to enhance his own collections. Doubtless he entertained designs on some of the Italian works in Paris to augment his German spoils. Fortunately, Russian opposition alone could not stand up to the unified front of Great Britain, Prussia, and Austria, seconded by Spain, Piedmont, and the Italian states.

Russian antagonism aside, the most determined adversaries Canova faced in Paris were the French themselves, especially King Louis XVIII, Prime Minister Talleyrand, and the Louvre's fiercely possessive director, Dominique-Vivant Denon. The French were almost as dangerous an enemy to Italian art and culture in defeat as in victory. Many French scholars have argued that the repatriation of works of art was a spoliation of their museum; they contend that all the sculptures and paintings taken from the Papal States under the Directory and the Consulate were extracted by contract or treaty or as the result of an administrative decision.[31] In 1815 the French believed that the works of art were inviolable because only a new treaty could overturn their original cession or seizure. The speciousness of this argument is obvious, for no allied nation recognized the annexation of the Papal States to France, and many works of art in the Louvre had been removed during the occupation from churches and religious communities that the French had suppressed or looted spontaneously from churches and palaces, and objects had been confiscated from such Roman families as the Braschi and the Albani.

The military convention signed on April 23, 1814, in Paris between the allies and the

newly restored Louis XVIII made no mention of restitution for fear of inciting a volatile public. It was left to Louis XVIII to determine what, if anything, would be returned. Although he made some minor concessions to Prussia and Spain, he clearly saw how the former Musée Napoléon could be a strong rallying point for his regime. Addressing the reconstituted Chamber of Deputies on June 4, 1814, he proclaimed: "The glory of the French armies has not received any injury. The monuments of their valor live and the masterworks of art belong to us from now on by rights more permanent and sacred than those of victory."[32] Understanding their political value and their symbolic association with military triumph, a feature of the museum that became especially poignant when it seemed evident that all the conquered and annexed territories would have to be handed back, Louis was loathe to relinquish the art, and Canova's hope of winning Bourbon support to his cause was lost from the outset. When the artist presented his diplomatic credentials and requests for help to the king, Louis claimed that by not specifically mentioning art and cultural properties, the armistice of 1814 protected the museum, an interpretation Canova vigorously disputed. Louis XVIII's claim, however, was only a last-ditch effort in a cause he knew he had lost in the atmosphere of allied vindictiveness after Waterloo.[33]

Louis's chief minister, Prince Talleyrand, who had managed to remain in positions of power and influence from the Revolution to the Restoration, received Canova even more coldly than the king and threw a new wrench into the proceedings by claiming that the controversial concordat of 1814 between Napoleon and his prisoner Pius VII validated the Treaty of Tolentino. The papal position since the day after Pius signed the document had been that he had done so under duress while a captive, ill, and unadvised by the Sacred College, which Napoleon had dispersed. In short, force invalidated the agreement, and Pope Pius himself had repudiated it before the ink was dry. Contrary to the new French argument, the "concordat" did not specifically mention Tolentino, and many hundreds of objects then in Paris and elsewhere in France were not "protected" by the notorious treaty. Talleyrand wrote to Castlereagh on September 15, 1815, stating France's increasingly unpopular position: "The allies, it is said, were also during the Hundred Days the allies of Louis XVIII; can they now take his collections from him? Why pretend that works of art cannot be acquired by conquest as well as provinces and peoples?"[34] Such cynicism was typical of the former bishop of Autun, and Canova clearly could expect no help from him. Events, however, were outflanking the recalcitrant Louis and Talleyrand, for the king of the Netherlands had been given allied troops to force the restitution of works of art plundered from Belgium and Holland. On September 30, 1815, Marshals Karl Philipp von Schwarzenberg, Gebhard Leberecht Blücher von Wahlstatt, and Arthur Wellesley, duke of Wellington, ordered General Frederick Ferdinand Karl Müffling to give the same armed assistance to Antonio Canova.

Even after Canova received assurance of allied support for the recuperation of the works of art taken from the Papal States, he still faced difficult problems. Lacking an inventory,

which was absolutely essential, the sculptor had to send to Rome for one posthaste. With the exception of celebrated objects, most of the things taken were described too generically for quick identification. Denon's intransigence added to the difficulties; the director of the museum opposed Canova at every turn, and his cunning assistant Athenase Lavallée did much to obscure the origins of works and encouraged evasion and passive resistance on the part of the provincial museums. Lavallée continually warned of the fragility of the objects considered for return, although few French voices had been raised on that account when the works were taken from Italy.[35] Denon who had previously courted and flattered Canova, now treated him with great contempt, calling him *emballeur* (packer) instead of *ambassadeur,* and did much to whip up popular antagonism against him. Indeed, one of myriad obstacles the sculptor faced was that few French workers were willing to assist in the packing, and he had to enlist Austrian and British soldiers in the operation.[36] Vilified and threatened by the mob, Canova became an object of derision and a subject of popular lampoons, although none of them reveals the wound to French amour propre more tellingly than a political print showing a disconsolate man witnessing the removal of the Italian masterpieces (figure 78). It forms an ironic counterpart to the print made to celebrate the triumphal procession of the spoils of Italy into Paris in 1798 (figure 79).[37]

Denon's hostility and obstructionism were so virulent that it may be useful to examine his role in the restitution in more detail. His efforts, while on the whole unsuccessful, did help to keep a number of important works in the French national collections. Denon's monomania regarding the museum was a more intense form of the national, emotional, and especially political investment in the collection the king, the government, and most of the people, above all the Bonapartists, shared. The director's goal from the beginning had been to transform the Louvre into the permanent headquarters of the Western visual tradition, an idée fixe that was greatly facilitated by Napoleon's policies of spoliation. Denon even went on a "shopping trip" to Italy in 1811–12 to gather important works of the early Renaissance from recently suppressed churches, convents, and monasteries to augment the Louvre's collection of this period in the history of art, which began to accrue greater value in the early years of the nineteenth century. Cimabue's *Madonna and Child Enthroned with Angels* (figure 80), which is still in Paris, exemplifies Denon's eye for quality and suggests his ruthlessness in violating Italy's cultural heritage. Such was his cupidity that he even endorsed plans to remove Correggio's frescoes from the Benedictine refectory in Parma and Danielle da Volterra's *Deposition* from the Church of SS. Trinità dei Monti in Rome, proposed acts of vandalism that in the end proved impracticable.[38] Josephine's depredations to the museum to enhance her gallery and the wish to expand provincial collections in France increased Denon's bitter resistance to Canova's 1815 mission. Moreover, Denon found Napoleon occasionally uncooperative, as when he rejected Canova's *Napoleon as Mars the Peacemaker* for the Hall of Antiquities and peremptorily ordered that the fragile *Marriage at Cana* by Veronese, among other paintings, be moved from the Grand Galerie for the festivities surrounding his wedding to Marie-Louise. After Denon cited the danger of such an undertaking because of the painting's colossal dimensions, the emperor responded that if it could not be moved, it could be burned.

Denon, as hostile toward Canova as he was apparently ill-informed about his diplomatic movements, libeled the sculptor in a letter of September 15, 1815, to Talleyrand, a document in which bitterness only thinly camouflages despair:

> This artist has come to France under the pretext of executing the bust of the Emperor Alexander, but with the secret mission of interesting Russia in the claims of the court of Rome, and of promising, in recognition of such support, some ancient masterpiece. This negotiation having failed, Mr. Canova has left for England, where he hopes to find better disposed sympathizers. I will not relate all the bad arguments that Mr. Canova amasses in order to have it believed that the interests of the arts themselves require the restitution of the objects ceded by the Treaty of Tolentino. . . . The overscrupulous conscience of Mr. Canova is very unreliable. He does not recognize that his works are much more remarkable for voluptuousness than for the purity of the forms. But it is not a question here of the talent or morality of Mr. Canova. I have only wanted to recall to Your Highness all the importance that the museum has for the prosperity of the French school and the glory of France.[39]

What was Denon's state of mind in writing such a letter? His information that Canova ostensibly came to Paris to execute a bust of the czar and would depart for England in mid Sep-

ENTRÉE TRIOMPHALE DES MONUMENTS DES SCIENCES ET ARTS EN FRANCE; FÊTE À CE SUJET.
les 9 et 10 Thermidor, An 6me de la République.

FIGURE 79
Fête de la Liberté, engraving, 1798.

tember to rally support for restitution was patently false, existing only as a rumor or a para-
noid imagining. While it is true that the czar was then in Paris, there is no evidence that he
had any contact with Canova about a possible portrait commission. In criticizing Canova's
work for its voluptuousness and claiming that his forms lack purity, he hypocritically re-
verses the praise he had consistently offered Canova during the Consulate and the empire,
when a positive response had been politically and professionally expedient. Like so many
others in France, even Denon could not understand the museum except in relation to "la
gloire de la France."

Part of his hostility toward Canova may be attributed to jealousy, since his position as di-
rector of the Musée Napoléon had once been offered as an incentive to the Italian sculptor
to move his practice to Paris. But to many French scholars, Denon has been the hero who
tried to save the museum and was betrayed by Talleyrand and Louis XVIII. According to
Eugène Müntz, the director was activated by "the most ardent patriotism" in wishing to pre-
serve "the treasures bought at the price of our blood," and while Louis XVIII was initially
firm with Canova in refusing to negotiate the return of the papal works of art, he ultimately

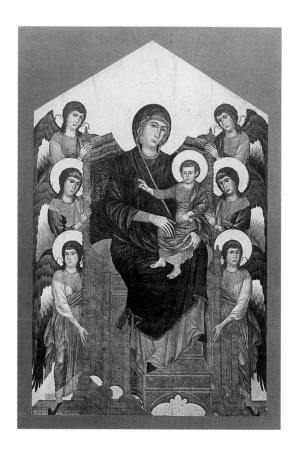

FIGURE 80
Cimabue, *Madonna and Child
Enthroned with Angels,* tempera on
panel, ca. 1280–90. Paris, Musée
du Louvre.

realized he would have to compromise and secretly instructed Denon to use delaying tactics and passive opposition to the allied demands.[40] In implementing the royal order, the director resorted to every deception, chicanery, outright misrepresentation, and mendacity to preserve as much as possible of the collection he had spent over a decade assembling.

Two instances of Denon's duplicity and passive resistance to the repatriation of works of art to their countries of origin can serve as illustration. The first involved an altarpiece by Giulio Romano, *The Martyrdom of Saint Stephen* (figure 81), which had been taken from the Louvre in 1815 by the king of Piedmont's commissioner, Giuseppe Enrico Costa de Beauregard, on behalf of the city of Genoa. Denon said that the painting had been "offered in homage to the French government by the city council of Genoa" and that transport would be risky to the large, fragile altarpiece. In a letter of October 1, 1815, to the comte Jules-Jean-Baptiste-François de Pradel, secretary of the interior, Denon asks that it be seized by customs as French property and retained for the museum.[41] He does not mention the physical perils faced by the painting when it was originally sent to Paris from Genoa, nor does he question the legitimacy of the Genoese government when it originally made the gift "in homage" to France. Denon was well aware that the altarpiece had essentially been confiscated as a part

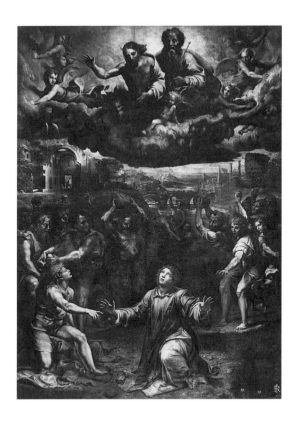

FIGURE 81
Giulio Romano, *The Martyrdom of Saint Stephen,* oil on panel, ca. 1521–23. Genoa, Santo Stefano.

of the city's cultural tribute. The director used a similar argument about an unspecified work by Bartolomé Esteban Murillo supposedly given by the city of Seville to Marshal Nicolas-Jean Soult, who had, in turn, donated it to the Louvre. The Spanish ambassador Miguel Ricardo de Alava, responding to an insolent letter from Denon claiming the Murillo as French property, pointed out that the city of Seville could not give away a painting it did not then, and had never, owned. The picture had been too familiar to him since his childhood for him not to know its rightful owners. He reminded Denon, moreover, that many works had been extorted from puppet authorities during the Bonapartist occupation. Alava eloquently concluded: "I would be able, Sir, to add several reflections in response to your letter, but I shall content myself by saying to you that in this unpleasant affair I have employed all the delicacy of a man of honor, and to reclaim that which belongs to the Spanish nation by justice and by right, I have employed more respect than the agents of Bonaparte used in Spain to rob us of our objects."[42] It is hard to escape the conclusion that Denon was being deliberately untruthful about the Giulio Romano and the Murillo to keep them for the museum. I doubt that he fully understood the irony of Alava's reference to Napoleon's agents in Spain, which implicated Denon in these controversial cultural policies.

However immoral and dishonest Denon's tactics, his actions during the dismantling of

the collection saved many of the ill-gotten gains for France and for the Louvre. His hostility led Canova to compromise on a number of significant works. In the final analysis, only about half the works of art taken from the States of the Church found their way home. (The percentage returned to other places in Italy was considerably larger.) It was a fifty-percent solution. Canova agreed to leave behind all the paintings that had been assigned to the provincial museums or to churches in Paris, and he exempted from restitution all objects that had been transferred to the king's private collection, many of them less important than the sculptures and paintings still in the Louvre. But among the great works exempted, the finest was Annibale Carracci's *Pietà* (figure 82), which had been taken from the Church of San Francesco a Ripa in Rome and ended up in Louis XVIII's private collection. Canova agreed in the name of the pope, moreover, to have most of the objects returned to a pontifical museum rather than replace them in the churches and palaces from which they had been taken. The centralizing tendency in early modern museology first symbolized by the Louvre ultimately carried the day, so that the original context of many masterworks of religious art was lost forever. It should be kept in mind that Canova promised the allied powers who supported the restitution a papal gallery open to the students and cognoscenti of all nations.[43] Ironically, his promise echoes arguments put forth by Denon and the French in their tenacious attempts to keep the art in the Louvre.

Although Canova made the decision not to include provincial, ecclesiastical, and royal acquisitions in the restitution to placate the king and assuage the feelings of the public, it also spared him the trouble of collecting these objects from disparate locations in a deeply hostile environment. Possibly he had papal approval to leave certain works behind, but I believe he had all but complete freedom to act as he saw fit. Some works of art were left in Paris, such as the ancient sculptures *Tiber* and *Melpomene,* since variants existed in Rome and they were extremely heavy. Indeed, any delay of several days during the move from the museum to the Austrian barracks for forwarding to Italy could well have occasioned popular violence. Canova also agreed, in conjunction with the Austrian representatives in Paris, to leave Veronese's *Marriage at Cana,* taken from Venice in 1797, behind, its size and precarious condition making its transfer dangerous.[44] Putting the best political face on an ad hoc policy that had both artistic and pragmatic features, Canova presented the king with the works left behind as a present from Pope Pius VII. During the Second Empire Adolphe de Bouclon claimed that Canova gave works of art to France (the pontiff's "Eldest Son") because of his "generous heart" in the face of British, Prussian, and Austrian "brutality."[45] Motives, often suspect, may easily fall prey to historical interpretation, but surely generosity toward France was the least of the sculptor's reasons for settling the question of restitution in the reasonable way he did.[46]

From the point of view of Pius VII and Cardinal Consalvi Canova had worked marvels in cultural diplomacy in the French capital, and the restitution far surpassed what either had

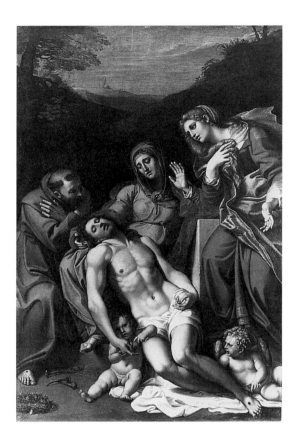

hoped for. As a reward for his services the sculptor was named marchese d'Ischia with an emolument of 3,000 scudi a year. In typical fashion, Canova assigned the income to various Roman cultural institutions, including the Accademia di San Luca. Although Pius gave the artist a pontifical welcome, he received the repatriated works of art discreetly when they reached the outskirts of Rome early in January 1816. The pope, probably advised by the cardinal secretary of state, ordered that the carts enter the city at night and by the Porta Angelica rather than the more public and ceremonial Porta del Popolo. This route put the workers to considerable trouble, but the government wanted to avoid turning the event into a triumph along the lines of the Fête de la Liberté held in Paris under similar circumstances in 1798. Having obtained their political goal, the pope and Consalvi wished to wound French pride as little as possible. Even so, several hundred people turned up at the Porta Angelica to acclaim Canova and the pope until the Swiss Guards closed the gates against them.[47] The extreme delicacy manifested on this occasion indicates an awareness that the Church in France, despite the loss of the trophies of conquest, would probably gain advantages in the general spiritual and cultural climate of the Restoration.

The circumspect Pius may have underexpressed his gratitude to those chiefly responsi-

ble: Wellington, Castlereagh, and Hamilton. At least Canova thought so, and he determined to redeem his personal obligations in his own way. In a letter of January 12, 1817, he told Luigi Angeloni, who had helped as an interpreter during the negotiations in 1815, of his intention to present gifts to the British benefactors. He was especially eager to thank Wellington, whose decisive influence had so aided the papal cause. Wellington, Castlereagh, and Hamilton all received marble busts of ideal figures by Canova like the Iron Duke's *Muse* (figure 83), still at Apsley House. He also presented Hamilton with "a beautiful and very well-preserved painting by Titian," a work that I have been unable to trace.[48]

The calumnies leveled against Canova in 1814 by ultraconservatives, who accused him of collaborating with the French, had an interesting parallel in 1816 when the works recovered from Paris reached Rome. Enemies immediately accused the sculptor of corruption and malfeasance, and others were dismayed at the large number of objects left in France: 248 paintings, some 20 sculptures, and 9 other works that could not be located.[49] Although no one who mattered took the charges seriously, the criticism nonetheless stung him. The predictable claims that half the works of art left behind were masterpieces only exacerbated Canova's chagrin. Pius offered unswerving support, especially since he understood the problems involved—French obstinacy and evasion, the absence of an authoritative inventory, and British pressure to compromise. The captiousness of Canova's enemies, however, combined with the failure to find a site for his proposed statue *Religion,* increased the artist's sense of disappointment and encouraged him to throw his remaining energies into the construction of the Tempio at Possagno.

Surprisingly, Canova's bitterest critic on the question of the fifty-percent solution in Paris was actually there and should have known better—Luigi Angeloni. In Paris in 1818 the Italian patriot published the two-volume work *Dell'Italia uscente il settembre 1818, Ragionamenti IV,* which became a Risorgimento classic. On New Year's Eve in 1818 Canova, to whom the author had (perhaps mockingly) presented a copy, wrote a letter praising Angeloni's zeal but expressing the wish that the author had consulted him before writing about the restitution of 1815.[50] Angeloni attributed Canova's compromise to his timidity, lack of bitterness toward Italy's despoilers, and courtly politesse, blaming the sculptor alone for the loss of so much of the Italian patrimony. Moreover he castigated Canova and Marini for allowing about five hundred papal medals and numerous manuscripts to remain in France.[51] The artist informed Angeloni that he could not be aware of all the reasons for the decisions Canova had made and basically did not know enough about the restitution to draw such extreme conclusions.[52] Angeloni had also sent a copy of his book to Cardinal Consalvi, whose reaction, unfortunately, is not recorded. Canova must have been deeply offended, for apparently there was no further correspondence with Angeloni.

Having examined the political and diplomatic particularities of Canova's activities in Paris in 1815, some more general considerations of the event may help to clarify its historical im-

FIGURE 83
Antonio Canova, *Muse,* marble,
ca. 1815–16. London, Apsley House

portance. I believe it was a defining moment in the history of museums, in the relationship
between cultural properties and military conquest, and in the role of museums in a (now)
postmodern society. Quatremère de Quincy, a central figure in the debate about the nature
of works of art at the time, helped give the papal position moral authority as a French
scholar and antiquarian who had, seemingly, much to gain if the Roman works of art re-
mained in France. Quatremère's opposition to the spoliation of Italy by the armies of the Di-
rectory produced an extremely valuable document for the history of art in context—the so-
called *Lettres à Miranda.* The antiquarian's argument against removing art from its original
setting owed much to Winckelmann,[53] but Quatremère added that the understanding and
interpretation of antiquities was not limited to discreet works of art but included the entire
environment that had created them. Works of art derived their essential meaning, not from
their formal, aesthetic qualities alone, but also from such important factors as placement, es-
pecially in the urban context; local customs and traditions; ruins; geology; and even meteor-
ology. As Giuseppe Pucci has appositely observed, Quatremère's *Lettres* are the first mani-
festo of material, as opposed to aesthetic, culture.

Although the championship of art in context was inimical to Denon's undertaking in the Louvre, Quatremère was not opposed to museums in principle, as is sometimes claimed. Rather, he encouraged them for works that had already lost their original context, such as ancient sculptures and frescoes detached from razed churches and palaces. The best contemporary museum for Quatremère was the Pio-Clementino in the Vatican. His rancor was reserved for the Louvre and the notion of an encyclopedic display of the history of art based solely on formal, aesthetic development, a system in which objects lost their own "history" in order to enter art history. To Quatremère, the creation of such institutions for didactic purposes and public benefit was ill-conceived.[54] In *Considérations morales sur la destination des ouvrages de l'art,* published in 1815, he suggested the novel idea that the city of Rome itself was a museum, and he proposed that decontextualized works be recontextualized whenever possible. Canova fully agreed. As late as 1836 Quatremère derided Denon's approach to museology as both ahistorical and immoral and delighted in his own contribution to dismantling much of Denon's museum.[55] But as the encyclopedic museum became the rule in the nineteenth century, it helped promote the spoliation of art from its original context while altering the actual creation of art in a modernist world.

Despite some carping about Canova's having left many important works in France in 1815, most of his contemporaries in Rome and elsewhere in Italy were delighted with the repatriation of the bulk of their looted collections, and the sculptor became a cultural hero. In 1816 an oration read in Canova's honor before the Roman Academy of Archaeology said that the restitution had prevented the loss of Italy's creative genius, which for so long had glorified the peninsula; the recuperation of the works of art would bless and glorify the restored pope, Pius VII.[56] Thus the restitution assumed a specifically papal political dimension once the problems of highly complex European politics had been overcome. By 1829 Antonio Meneghelli could characterize Canova's achievement in Paris in terms that suggest a specifically Italian, as opposed to a Roman or Venetian, cultural and political triumph.[57] Antonio Canova was well on the way to becoming a cult figure of the Risorgimento.

CONCLUSION:

CANOVA'S POLITICAL AFTERLIFE

By the time Canova died in Venice on October 13, 1822, the *carbonari,* a semi-secret pan-Italian nationalist organization that originated during the resistance to Napoleon, were a growing force in Italian political life. The *carbonari* and many other groups were organizing all over Italy, hoping to end foreign domination of much of the peninsula and establish a truly Italian government. The Risorgimento, which culminated in 1870 when Italian troops occupied and annexed Rome to the Kingdom of Italy, had begun. But what political form a united or independent Italy would take was still very much an open question. Many favored a monarchy based on the dynasty of Savoy in Piedmont-Sardinia, a coalition that ultimately carried the day under the shrewd guidance of Camille de Cavour. Others preferred a republican Italy and an erosion of aristocratic and clerical power, the alternative to monarchy whose chief proponent was Giuseppe Mazzini. Still others wanted a loose federation of states under the aegis of the pope in Rome, a solution that would preserve local autonomy and respect the geographical, linguistic, and cultural distinctions among the Italian states. Despite these differences, however, most Italians, above all the young who came of age during the Napoleonic wars, probably thought that foreign occupation was the primary obstacle to the *patria.*[1] Canova, as both a cultural hero unparalleled in Italy since Michelangelo and the most politically potent artist ever produced there, became a rallying point for antiforeign feeling. Given his conservative, papalist, and pro-Venetian opinions and his distinctly cosmopolitan sculptural practice, his co-option by the Risorgimento is ironic and rather surprising. Indeed, his political afterlife as a symbol of opposition to the political status quo and his prominent role as a leader of a redefined *italianità* began at his funeral.

For sentimental, not political, reasons Canova may have been pleased to die in his beloved Venice, but he certainly did not go there intending to die. In declining health when he visited the city in the autumn of 1822 for medical attention, he nonetheless died suddenly and unexpectedly. Politically speaking, however, his death in Venice had a greater impact than it would have had in papal Rome or remote Possagno. Even though it made the Austrian authorities extremely nervous, they could not deny the last truly famous son of the Serene Republic a state funeral (as opposed to a commemorative ceremony, had the actual obsequies taken place in Rome). Count Cicognara was in charge of the arrangements. He had worked in harmony with the government as president of the Venetian Accademia di Belle Arti but had a suspect liberal past as a member of the government of the Cisalpine Republic. His brother, moreover, was a well-known dissident. A further complication clouded

the event politically: a Piedmontese *carbonaro,* the actor and playwright Angelo Canova (no relation to the Venetian sculptor), had been tried and condemned to prison a few months before for high treason. Shouts of "Viva Canova!" in the streets during the funeral procession, ambiguous and minatory, did much to unsettle the Austrian police.[2]

Cardinal Ladislao Pyrcher, patriarch of Venice, presided at the funeral in the Basilica of San Marco. In typically repressive fashion, the Austrian authorities forbade the mourners following the hearse to wear black, because of its *carbonari* associations; they chose to wear green in protest, green being associated with the House of Savoy.[3] Sartori-Canova and the senior members of the academy were the chief mourners, but the Austrian governor and all the members of the upper echelons of the administration were present, as a sign of both respect for the deceased artist and solidarity in the face of anti-imperial sentiment. The route of the cortege was carefully prescribed, with no deviations permitted. All governmental and constabulary edicts notwithstanding, Cicognara was able to have Canova's remains brought into the academy for a brief eulogy, something the Austrians had especially wanted to prevent. Equally ineffective was the attempt of the imperial censors to suppress the patriotic flavor of the scores of encomia and sonnets published in Venice and elsewhere to commemorate the event.[4] Canova's flame was safely in the keeping of the Venetian resistance to Austria.

While Canova's death and funeral occasioned spectacular displays of anti-imperial feeling, some of his works were already beginning to be interpreted patriotically, although initially the readings were Venetian rather than Italian in their political implications. Countess Isabella Teotochi Albrizzi's *Opere di scultura e di plastica di Antonio Canova,* published in Pisa in 1821, claimed that the artist's early masterpiece *Theseus and the Dead Minotaur* (see figure 22) was an allegory of the *patria* defeating an enemy, Habsburg Austria. Hugh Honour has rightly claimed that the sculpture, executed in 1781–83, carried no such nationalist intention,[5] but I believe it may have had a subtle relation to the Serene Republic's centuries-long struggle with the Ottoman Empire. Theseus and the Minotaur, as a myth set in Crete, the Venetian island colony of Candia lost to the Muslims less than a century before, was certainly open to a political reading. The interpretation by Albrizzi suggests how the political inflection of a work of art can change with historical circumstances.

Canova, described in Lord Byron's *Childe Harold* as the modern equivalent of an ancient worthy—"Such as the great of yore, Canova is today"[6]—was paired off with other humanistic celebrities in the pantheon of *italianità,* to the political advantage of the Risorgimento. One of the most frequently encountered couplings was with the Francophobic poet Vittorio Alfieri, whose tomb by Canova in the Florentine mortuary temple of dead heroes of the humanities, also known as the Church of Santa Croce, became an Italianist shrine of the first order, linked to the cult of both the writer and the artist. No matter how different their actual opinions during their lives, in death they were united in the cause of Italy. Again, Albrizzi expressed it best in her *Opere di Canova:* "Pray! May these precious names, so dear to the 'patria,' of Alfieri and Canova, united forever and respected by Time the destroyer, uphold and witness to remote posterity the glory and the splendor of Italy!" She then asks that

Santa Croce be protected from sacrilegious hands in the future, probably meaning those of Austria, calling the venerable Franciscan basilica a "sublime monument of Italian glory."[7]

During the early years of the Venetian struggle for liberation from Austria, an enormous cenotaph for Canova was erected in the prominent Church of Santa Maria gloriosa dei Frari, opposite a similar shrine to Titian. Ironically, the form of the cenotaph was based on that of the *Tomb of the Archduchess Maria Christina of Austria* in Vienna, originally invented for the dean of the Venetian school of Renaissance painting in the Frari.

Marking the death of Europe's greatest artist in papal Rome, his city of adoption, was an undertaking quite different from what it had been in the highly politicized and patriotic atmosphere of his native Venice. But in Rome, as in Venice, politics intruded, although the issues were those important to the Restoration Church rather than to the nascent Risorgimento. At first the Accademia di San Luca planned a memorial service for Canova at the Church of Ss. Martina e Luca, the traditional site for the academy's liturgical functions. On November 2, 1822, Cardinal Bartolomeo Pacca, who was also the protector of the academy, wrote to the institution's leadership, stating that the church by the Arch of Septimius Severus was not sufficiently grand for such an important ceremony and ordering the service moved to SS. Apostoli, the mother church of the Franciscan order, where Canova's first major public work, the *Tomb of Pope Clement XIV Ganganelli* (see figure 65), was located.[8] The catafalque, designed by Giuseppe Valadier, was placed before the high altar in the transept of the basilica, adorned and surrounded with models of various statues borrowed from the deceased artist's studio for the occasion. Cardinal Pacca, a conservative cleric who objected to nudity in art, insisted that the model of the *Pietà* (see figure 35), originally designed for Saint-Sulpice, be placed prominently before the catafalque, imitating the use of the *Transfiguration* (see figure 3) at the papal funeral of Raphael in 1520.[9] In addition, Pacca intended to take advantage of the opportunity to promote religious sculpture rather than the mythological themes with which Canova was so closely identified. The impressive ceremony in the Basilica of the Holy Apostles was attended by most of the Sacred College and the Curia and by the diplomatic corps accredited to the Holy See. None of the *carbonari* political overtones distracted from the dignity of the event in Rome as they had in Venice.

Antonio Canova's last will and testament called for the burial of his remains in the Tempio in Possagno, and except for his heart, which remained in the academy in Venice, and a hand, which went to Rome, his remains were interred in the village in the Dolomites according to his wishes. But both Venice and Rome wished to erect monuments to his memory, and these undertakings were fraught with political difficulties and funding problems, especially the proposal for a cenotaph in the Pantheon promoted by Canova's friend and admirer Elizabeth Hervey, widow of the fifth duke of Devonshire, in 1823. The duchess proposed the monument to an enthusiastic Accademia di San Luca, hoping for a large number of submissions from which to choose. An anonymous design in the Thorvaldsens Mu-

FIGURE 84
Bertel Thorvaldsen (?), *Design for a Cenotaph of Antonio Canova,* pencil on paper, ca. 1823. Copenhagen, Thorvaldsens Museum.

seum in Copenhagen (figure 84) envisioned a reclining Canova with flanking seminude genii of sculpture and painting, all on a pedestal adorned with three relief sculptures. I believe the design has strong affinities with the Danish sculptor's own work. The narrative subjects chosen for the reliefs are Pius VII Admiring "Perseus with the Head of Medusa," Canova Offered the Principate for Life by the Accademia di San Luca, and Canova Holding the Plans for the Tempio at Possagno. The academy suggested changes, including tunics for the genii, added in the atmosphere of controversy surrounding similar figures in the artist's *Cenotaph of the Last Stuarts* in Saint Peter's, and put Bertel Thorvaldsen in charge of the project. At some point in the discussion the site was changed from the Church of Santa Maria ad Martyres to the Church of Santa Maria degli Angeli, exchanging propinquity in death to Raphael, entombed in the Pantheon, for nearness to Carlo Maratti and Salvator Rosa, whose funerary monuments were in the basilica built into the Baths of Diocletian. But the cardinal titular of the church, Giuseppe Morozzo, and Cardinal Pacca halted the proposed monument, objecting to the nudity of the figure of Perseus in the relief and the generally secular air of the monument.[10] The indefatigable Devonshire, who had already enlisted the aid of King George IV and a number of other rulers, continued to promote the idea until her death in 1824, when the project was abandoned.[11]

The dreams of a suitable monument to Canova died with the duchess of Devonshire, and what finally emerged from the numerous proposals was the modest *Cenotaph of Antonio*

FIGURE 85
Giuseppe de Fabris, *Cenotaph of
Antonio Canova,* marble, ca. 1826–32.
Rome, Protomoteca Capitolina.

Canova by Giuseppe de Fabris (figure 85). This scaled-down initiative was sponsored by Count Cicognara. Curiously, Thorvaldsen, who had been in charge of the Devonshire project, refused to contribute money for the more modest cenotaph of Cicognara, possibly because he would not be the sculptor to execute it.[12] Always jealous of Canova's greater fame, Thorvaldsen contented himself with helping to ensure that no noteworthy memorial to his more successful rival ever saw the light of day in the city that Canova had done so much to enrich, promote, and protect.

Cicognara's efforts on behalf of the Frari cenotaph were singularly more successful than his attempts to promote a similarly impressive monument in Rome; the modesty and banality of the sculptural group by De Fabris are evident, and however bombastic and derivative the cenotaph in Venice may be, at least it is grand, impressive, and conspicuously placed. The count was successful in enlisting the aid of Prince Camillo Borghese, then living in Florence, in a subscription for the cenotaph. Borghese made a handsome contribution and spearheaded the subscription list in Tuscany, perhaps as a cultural gesture of atonement for his Bonapartist past. Others were much less generous. The countess of Albany and her lover, the painter François-Xavier Fabre, gave nothing at all, perhaps considering payment for the Alfieri monument a sufficient tribute.[13] The most politically motivated refusal to subscribe to Cicognara's monument came from Louis-Philippe d'Orléans, the future citizen-king of the French. He wrote his reasons to the count in a letter dated April 12, 1824:

> But unfortunately it is public knowledge that in 1815 Canova abandoned his chisel to come to Paris, charged with the destruction of this museum of which France deplores the loss, and of which the friends of the fine arts of all countries must, in my opinion, regret the dispersal. This sad page in his history prohibits any Frenchman from adding his name to the list of those who are raising a monument to him.[14]

Even in death Canova could not escape the political dissension that plagued him during his career. During one of the most turbulent eras in European history his immediate political afterlife proved almost as difficult as his professional life.

NOTES

INTRODUCTION

1. "Occupé tout à la fois de tous les genres de gloire, le héros de nôtre siècle, pendant la tourmente de la guerre, a exigé de nos ennemis les trophées de la paix, et a veillé à leur conservation." Quoted in Jean Chatelain, *Dominique Vivant Denon et le Louvre de Napoléon* (Paris, 1973), pp. 317–26.

2. The Louvre restoration of the Raphael painting is discussed in greater detail in Andrew McClellan, "The Responsible Republic: Art, Conservation, and the Museum during the French Revolution," *Apollo* 130 (1989): 5–8.

3. Quoted and translated in ibid., p. 8.

4. Alessandro D'Este, ed., *Memorie di Antonio Canova scritte da Antonio D'Este* (Florence, 1864), p. 242.

5. Works restored in the Louvre were said to have been given a brownish tone, and the surface was regularized in a highly academic fashion that removed original paint and ignored individual artistic variation. See Alessandro Conti, "Vicende e cultura del restauro," in Federico Zeri, ed., *Storia dell'arte italiana* (Turin, 1981), 3:73–74; and Orietta Rossi Pinelli, "Artisti, falsari o filologi? Da Cavaceppi a Canova, il restauro della scultura tra arte e scienza," *Ricerche di storia dell'arte* 8 (1978–79): 46. The works returned to Florence were similarly criticized for radical overcleaning. See Gabriella Incerpi, "I restauri sui quadri fiorentini portati a Parigi," in *Florence et la France: Rapports sous la Révolution et l'Empire* (Florence and Paris, 1979), pp. 215–49.

6. "... voi siete una vera potenza in questo mondo, e non conoscete però la forza che avete, che forse potresti intuonar molto più d'alto. Null'ostante avete una gloria comune alle potenze straordinarie, quella cioè d'aver fatta una rivoluzione nelle arti, come le potenze militare le fanno nella politica." Quoted in Leopoldo Cicognara, *Lettere ad Antonio Canova,* ed. Gianni Venturi (Urbino, 1973), p. 22.

7. Among the Spanish detainees were Antonio Solà and Raimondo Barbi, both of whom became artists of considerable reputation in post-Napoleonic Spain. See D'Este, pp. 179–82, and especially Giorgio Gambinossi, "Antonio Canova e Napoleone," *L'Italia moderna* 3 (1905): 17–18.

8. Quoted in Carolyn Springer, *The Marble Wilderness: Ruins and Representation in Italian Romanticism, 1775–1850* (Cambridge and New York, 1987), pp. 81–82. The aesthetic, literary underpinning of the conjunction of ancient culture and contemporary social utopian notions owes much to Vincenzo Monti's justly celebrated "Prosopopea di Pericle." See Carmela Falco, *Iconologia neoclassica fra il Monte e l'Appiani* (Rome, 1979), with additional bibliography.

9. The relationship between Canova's subject matter and his psychological state in the late 1790s is discussed in Ottorino Stefani, *I rilievi del Canova: Una nuova concezione del tempo e dello spazio* (Milan, 1990), pp. 64–65, who extends the moral metaphor of a stricken Italy to the Socrates reliefs. As a hero

of the revolutionaries, Socrates was a problematic choice of subject for an anti-French allegory, and their conception by Canova largely predates the problems posed to the peninsula by the French Revolution.

10. The letter to Giuseppe Falier of March 28, 1794, is quoted in part in Giuseppe Pavanello and Mario Praz, *L'opera completa del Canova* (Milan, 1976), p. 84.

11. Carla Nardi, *Napoleone e Roma: La politica della Consulta Romana,* Collection de l'École Française de Rome, vol. 115 (Rome, 1989), pp. 155–57.

12. I say much more about this impact in Chapter 3.

13. Quoted and translated by Springer, p. 53.

14. Napoleon's cultural policies and Quatremère's opinion are discussed in reference to battle paintings in Susan Locke Siegfried, "Naked History: The Rhetoric of Military Painting in Postrevolutionary France," *Art Bulletin* 75 (1993): 235–36.

15. Paolo Sica, *Storia dell'urbanistica: Il Settecento* (Rome, 1976), pp. 336–37. These general comments are further analyzed in Chapter 3.

16. John S. Memes, *Memoirs of Antonio Canova with a Critical Analysis of His Works, and an Historical View of Modern Sculpture* (Edinburgh, 1825), pp. 393–94.

17. Jacques Perot, "Canova et les diplomates français à Rome: François Cacault et Alexis de Montor," *Bulletin de la Société de l'histoire de l'art français* (1980): 228.

18. "Monsieur Daru, je viens de voir le portrait qu'a fait de moi David. C'est un portrait si mauvais, tellement rempli de défauts, que je ne l'accepte point et ne veux l'envoyer dans aucune ville, surtout en Italie, où ce serait donner une bien mauvaise idée de notre école." *Correspondance de Napoléon Ier publiée par ordre de l'Empereur Napoléon III* (Paris, 1858–70), 12:504, item 10,432. See also Dorothy Johnson, *Jacques-Louis David: Art in Metamorphosis* (Princeton, N.J., 1993), pp. 204–6.

19. Supporting Denon's position was the Italian Carlo Fea, while Ennio Quirinio Visconti upheld the traditional attribution. Canova's reasoning was based on convincing technical arguments, and perhaps the opinion of a sculptor carried greater weight for the pragmatic Napoleon. See Ferdinand Boyer, "Les offres de Napoléon pour l'achat de la statue antique de Pompée," *Bulletin de la Société nationale des antiquaires de France* (1943–44): 260.

20. Denon's bitter hostility and obstructionism are discussed in Chapter 7.

21. Corrado Maltese, *Storia dell'arte in Italia, 1785–1943* (Turin, 1960), p. 49.

22. Fred Licht, *Canova* (New York, 1983), p. 155.

23. Albert Boime, *Art in an Age of Bonapartism, 1800–1815* (Chicago, 1990), p. 642.

CHAPTER 1

1. Canova's journal is discussed in greater detail in Elena Bassi, "Due diari del 1780," in *Arte neoclassica: Atti del convegno 12–14 ottobre 1957,* pp. 34–37, Civiltà Veneziana Studi, vol. 17 (Venice and Rome, 1957). Canova's entire diary has been transcribed by idem, *I quaderni di viaggio (1779–1780)* (Venice and Rome, 1959).

2. Many of Canova's biographers discuss his self-improvement. See especially Melchior Missirini, *Della vita di Antonio Canova* (Prato, 1824), pp. 75–76. The cleric Bonaiuti, whose first name is never given in the sources, is possibly to be identified with the engraver Ignazio di Paolo Bonaiuti, who worked in Rome in the 1770s and 1780s, although Canova's friend's status as an abbate makes this identification problematic.

3. John Moore, *A View of Society and Manners in Italy with Anecdotes relating to some Eminent Characters,* 4th ed. (Dublin, 1792), 1:176–78.

4. Licht, pp. 224–25. One of the central themes of Licht's excellent text is the modernity of Canova's working procedures, which in fact initiated patterns that held sway well into the twentieth century.

5. Even if the story is partly or even totally apocryphal, there are others sufficiently similar to give it conviction. See D'Este, pp. 91–92. D'Este figures large in most of this biography's incidents, not surprising given the desire of his son Alessandro to lionize his father while discrediting the latter's detractor, Missirini. Juliot is an elusive figure. His surname is given in the early biographies, and he is sometimes called a diplomat accredited to the Cisalpine Republic, another reason Canova might not have liked him, his antipathy to that French creation in northern and central Italy being well documented. It is possible that Juliot is a mistake for Pierre-Louis-Pascal Jullian, a French diplomat, former Jacobin, and friend of Lucien Bonaparte's who was active in Italy during the Directory, but I have not been able to find out if he was a diplomat or other official of the Cisalpine Republic in Milan.

6. Alessandro D'Ambra, "Canova e le vicende politiche del suo tempo," *La cultura moderna natura ed arte* 31 (1922): 506. Emperor Francis II of Austria and the Holy Roman Empire attempted unsuccessfully to attract Canova to Vienna or even to his new province of Venice. More is said about this in Chapter 5.

7. See my "Portrait Mythology: Antonio Canova's Representations of the Bonapartes," *Eighteenth-Century Studies* 28 (1994): 119–21.

8. Ferdinand Boyer, "Autour de Canova et de Napoléon," *Revue des études italiennes* (1937): 208–9.

9. This resistance is a major concern of Chapter 4.

10. This triumphant journey is described in D'Este, pp. 129–30.

11. The letter, dated July 7, 1804, from Milan, is quoted in full in Fortunato Federici, ed., *Lettere di Giuseppe Bossi ad Antonio Canova* (Padua, 1839), p. 9.

12. These honors and others are conveniently listed in Giuseppe Falier, *Memorie per servire alla vita del marchese Antonio Canova* (Venice, 1823).

13. D'Este, pp. 88–89.

14. These and other acts of munificence are recorded in Antoine-Chrysostome Quatremère de Quincy, *Canova et ses ouvrages; ou, Mémoires historiques sur la vie et les travaux de ce célèbre artiste* (Paris, 1834), pp. 184–86.

15. A convenient translation in English exists in *Napoleon and Canova: Eight Conversations held at the château of the Tuileries in 1810* (London, 1825).

16. While in Paris, Canova spent much time with Quatremère, an anti-Bonapartist savant who was Canova's friend and chief French apologist. This contact makes Quatremère's comments more reliable than they might otherwise have been. See Quatremère de Quincy, *Canova et ses ouvrages,* pp. 197–201.

17. The letter is quoted in A. Valmarana, ed., *Lettere scelte dell'inedito epistolario di Antonio Canova* (Vicenza, 1854), pp. 53–54. It is unclear why Quatremère disregarded his friend's request that he burn the letter.

18. The reply is given in full in ibid., p. 55.

19. This is the date given by Antonio Munoz, *Antonio Canova: Le opere* (Rome, 1957), pp. 53–54, although an inscription on the back reads "Canova, Rome 1790," but perhaps 1796 was intended. See also Giuseppe Pavanello and Giandomenico Romanelli, eds., *Canova* (Venice, 1992), pp. 254–56.

20. The *Mercure de France,* on the other hand, was unstinting in its praise. See Missirini, *Della vita di Antonio Canova* (Prato, 1824), p. 112.

21. Count Sommariva patronized all these contemporary painters. See Fernando Mazzocca, "G. B. Sommariva o il borghese mecenate: Il 'cabinet' neoclassico di Parigi, la galleria romantica di Tremezzo," *Itinerari* 2 (1981): 173–74.

22. Boyer, "Autour de Canova," pp. 213–14.

23. See Gérard Hubert, "Josephine, a Discerning Collector of Sculpture," *Apollo* 106 (1977): 34–43. As the widow of an ancien régime aristocrat, she was perhaps a more sympathetic figure to Canova than was her husband. Canova, after initially refusing to execute a series of allegories for Malmaison, accepted important commissions for her gallery; until its dispersal in 1814, it was the best collection of his sculpture outside Rome. I believe it is significant that she never asked him for a portrait, possibly appreciating his aversion to the genre.

24. Quoted in Francis Haskell, *An Italian Patron of French Neoclassical Art* (Oxford, 1972), p. 16.

25. This question is examined fully in Chapter 3.

26. Cicognara wrote an extensive history of Italian sculpture from the Renaissance to Canova that purposefully celebrates the modern sculptor as the ultimate realization of the Italian pursuit of ideal Beauty and Truth. Leopoldo Cicognara, *Storia della scultura dal suo risorgimento in Italia sino al secolo XIX per servire di continuazione alle opere di Winckelmann e di d'Agincourt,* 3 vols. (Venice, 1813–18). In a procedure many today would find problematic, Cicognara asked Canova to approve his manuscript before publication.

27. This idea, central to my understanding of Canova, was first suggested to me by Francesca Fedi, *L'ideologia del bello: Leopoldo Cicognara e il classicismo fra Settecento e Ottocento* (Milan, 1990), pp. 199–200, which is also the source for the Foscolo quotation.

28. Augustus von Kotzebue, *Travels through Italy, in the Years 1804 and 1805* (London, 1806), 3:147–48. The denigration of Canova to Thorvaldsen's advantage was largely the result of a book published by Carl Ludwig Fernow, *Über den Bildhauer Antonio Canova und dessen Werke* (Zurich, 1806).

29. This judgment appeared in the first extensive consideration of Canova's work published in America: [Edward Everett], "Canova and His Works," *North American Review,* n.s. 1 (1820): 372–74.

30. Some of these prices are quoted in Maria Sofia Lilli, *Aspetti dell'arte neoclassica: Sculture nelle chiese romane 1780–1845* (Rome, 1991), pp. 27–29.

31. Alberigo Agnoletto, *Canova e l'arte sacra* (Rome, 1922), pp. 7–8, which has its own pro-Catholic revisionist agenda. The prominence of religious themes in Canova's art during the Restoration has been cited as evidence of the sculptor's fervent Catholicism by Luigi Coletti, *Mostra Canoviana* (Treviso, 1957), pp. 92–93.

32. Missirini, *Vita di Canova,* pp. 468–69.

33. D'Este, p. 290, writes: "Il Canova era religioso, ma di quella religione senza ostentazione, né ipocrisia; credeva fermamente tutto ciò che gli era stato insegnato fino dall'infanzia e nulla esaminava per non turbare lo spirito, e metterlo in contradizione coi principj che avea succhiato col latte." In fact, it sounds rather like the typical popular Catholicism a young peasant might practice even in a much higher sphere of life than that to which he was born.

34. Falier, p. 27.

35. Canova's assertion to Napoleon was picked up by Pius's biographer, Gaetano Giucci, *Storia della vita e del pontificato di Pio VII* (Rome, 1857), 2:19–22.

36. Bassi, *Quaderni di viaggio,* p. 13.

37. Pietro Caliari, *Il Canova a Verona* (Verona and Padua, 1896), p. 15. The incident is described in a manuscript by della Rosa then in the author's possession.

38. Emmanuele Cicogna, *Lettera di Antonio Canova intorno ad una Madonnina in basso rilievo di marmo prima scolpita da lui circa l'anno 1770* (Venice, 1854), pp. 7–11. Canova comments to Gaspari that he did execute the relief, even though it does not look like his work, and that Cardinal Consalvi was interested in knowing the sculpture's whereabouts.

39. Quoted in Vittorio Malamani, *Canova* (Milan, 1911), p. 337.

40. Bassi, *Quaderni di viaggio,* p. 39. The entry is for November 21, 1779.

41. The sketch and the damaged painting are discussed and illustrated in Gian Lorenzo Mellini, "Presenza dell'antico nella pittura di Antonio Canova," in *Congresso internazionale Venezia e l'archeologia: Un importante capitolo nella storia del gusto dell'antico nella cultura artistica veneziana,* ed. Gustavo Traversari, pp. 216–17, supp. to *Rivista di Archeologia* 7 (Rome, 1990). Mellini interests himself in the ancient precedents for the chariot, protome, and angel—not in Canova's possible Jesuit sympathies.

42. Quoted in Vanni Zanella, *Giacomo Quarenghi architetto a Pietroburgo: Lettere e altri scritti* (Venice, 1988), pp. 318–19.

43. For French opposition to the tolerance of the Jesuits and its effect on the negotiations for the concordat, see Ilario Rinieri, *La diplomazia pontificia nel secolo XIX: Il concordato tra Pio VII e il Primo Console* (Rome, 1902), pp. 84–86.

44. Mario Rosa, "Introduzione all'Aufklärung cattolica in Italia," in *Cattolicesimo e lumi nel Settecento italiano,* ed. Mario Rosa, pp. 1–47, Italia Sacra, vol. 33 (Rome, 1981).

45. Quoted in D'Este, pp. 383–84. Canova would soon come to Venice to install the *Monument to Angelo Emo* that had been commissioned by the Serene Republic.

46. For the Restoration cult of Pope Pius, see Roberta J. M. Olson, "Representations of Pope Pius VII: The First Risorgimento Hero," *Art Bulletin* 68 (1986): 77–93.

47. Philipp H. Fehl, "Canova's Tomb and the Cult of Genius," *Labyrinthos* 1–2 (1982): 49–51.

48. This interesting painting, unfortunately lost, is discussed in Anna Maria Corbo, "L'insegnamento artistico a Roma nei primi anni della Restorazione," *Rassegna degli archivi di stato* 30 (1970): 100–101, who cites a document from the Archivio del Camerlengato in the Archivio di Stato di Roma.

49. Canova's frustrating attempts to find a church willing to accept as a gift a monumental sculpture from the world's most famous artist is recounted in D'Este, pp. 258–65.

50. Canova's letter of October 22, 1814, written from Rome to Cicognara at Ferrara, is quoted in Giovanni Bottari and Stefano Ticozzi, eds., *Raccolta di lettere sulla pittura, scultura ed architettura scritte da' più celebri personaggi dei secoli XV, XVI, e XVII pubblicata da M. Gio. Bottari e continuata fino ai nostri giorni da Stefano Ticozzi* (Milan, 1822–25), 8:202–3.

51. For the portrait, see *Venezia nell'età di Canova,* ed. Elena Bassi et al., exhibition catalogue (Venice, 1978), pp. 256–57.

52. Quoted in Valmarana, ed., pp. 8–9. This letter is dated October 1, 1813, when the French still controlled Rome and a return of the pope, still a prisoner in France, was uncertain, though Napoleon's armies had suffered crippling setbacks in Russia and Germany. Canova certainly could have envisaged a monument to religion, but if it was also to honor the pontiff, it adds evidence of Canova's strong anti-French bias, which certainly seems in character. Or—another possibility—if the letter is dated erroneously and was written in 1814 instead of 1813, it would date from only three weeks before the letter on the same subject to Cicognara, cited in note 50. It is an intriguing question. Bossi's original text reads: ". . . se tu vuoi fare un monumento a Pio VII, fallo altrove. . . ."

53. These models are discussed in Elena Bassi, *La gipsoteca di Possagno: Sculture e dipinti di Antonio Canova,* Cataloghi di raccolte d'arte, vol. 3 (Venice, 1957), pp. 218–20.

54. Zurla left this model to Gregory XVI, who gave it to the Pontificio Seminario Romano Maggiore, and it entered the Vatican collections in 1985. See Andrea Zanella, *Canova e Roma* (Rome, 1991), pp. 25–26.

55. Missirini, *Vita di Canova,* pp. 431–32. The French journal borrowed the account of the Tempio from the *Diario di Roma* of August 8, 1821. The French antagonism to Canova after the museum debacle of 1815 is discussed fully in Chapter 7.

56. Franco Barbieri, "Il tempio canoviano di Possagno: Fede e ragione," *Arte lombarda* 110–11 (1994): 22–23; for superb photographs and a floor plan of the church, see idem, *Canova: Scultore, pittore, architetto a Possagno* (Padua, 1990).

57. Pavanello and Romanelli, eds., pp. 382–83. The idea of the altarpiece as a metaphor for the Church's suffering (along with a relief *Lamentation* that Canova executed after his return to Rome in 1800) has been posited by Ottorino Stefani, *I rilievi di Canova,* pp. 70–71.

58. For the importance of the Farsetti collection, see especially the exhibition catalogue *Alle origini di Canova: Le terrecotte della collezione Farsetti* (Rome, 1991), especially pp. 15–21. The collection is now in the Hermitage in Saint Petersburg.

59. Irene Favaretto, *Arte antica e cultura antiquaria nelle collezioni venete al tempo della Serenissima* (Rome, 1990), p. 63.

60. Emilio Lavagnino, "Il momento della 'conversione' del Canova," in *Arte neoclassica: Atti del convegno 12–14 ottobre 1957,* pp. 180–83, Civiltà Veneziana Studi, vol. 17 (Venice and Rome, 1957).

61. Favaretto, p. 198.

62. Ibid., p. 64.

63. Quoted in Luigi Rizzoli, "Alcune lettere di Antonio Canova al marchese Tommaso degli Obizzi e la musa Melpomene del R. Museo Archeologico di Venezia," *Atti del Reale Istituto Veneto di Scienze, Lettere ed Arti* 82 (1922–23): 408–12.

64. For the most famous of Rome's restorers, see especially Seymour Howard, "Bartolomeo Cavaceppi and the Origins of Neo-Classic Sculpture," *Art Quarterly* 33 (1970): 120–33, with additional bibliography.

65. This incident is recounted in a highly informative article by Orietta Rosa Pinelli, "Artisti, falsari o filologi?" pp. 48–49.

66. A nearly contemporary account is given in James Dallaway, *Of Statuary and Sculpture among the Antients, with Some Account of Specimens Preserved in England* (London, 1816), pp. 292–93.

67. Antoine-Chrysostome Quatremère de Quincy, *Lettres sur l'enlèvement . . .* (Paris, 1796), pp. 233–35. The English collections are discussed in the fifth letter. These "letters" were republished in 1815 when Canova came to Paris to seek the repatriation of the Italian works of art.

68. *Napoleon and Canova,* pp. 2–4.

69. For the Pacca Law, see Andrea Emiliani, *Leggi, bandi, e provvedimenti per la tutela dei beni artistici e culturali negli antichi stati italiani, 1571–1860* (Bologna, 1978), pp. 110–25.

70. Anna Maria Corbo, "L'esportazione delle opere d'arte dallo Stato Pontificio tra il 1814 e il 1823," *L'arte* 4 (1971): 84–85.

71. Lilli, pp. 16–17.

72. This information, from Bacciarelli's papers in the Biblioteka Narodowa in Warsaw, was published by Hugh Honour, "Canova's Studio Practice II: 1792–1822," *Burlington Magazine* 114 (1972): 221 n. 54.

73. William St. Clair, *Lord Elgin and the Marbles* (London, 1967), pp. 152–53.

74. Anton Raphael Mengs first championed the Greek cause by arguing the unpopular position that most of the canonical works of the Italian collections were either Hellenistic originals or Roman copies. His analyses, largely empirical, were based on style and especially on quality of execution, an element of sculptural production that also was an obsession for Canova. See A. D. Potts, "Greek Sculpture and Roman Copies I: Anton Raphael Mengs and the Eighteenth Century," *Journal of the Warburg and Courtauld Institutes* 43 (1980): 150–73.

75. Missirini, *Vita di Canova,* pp. 308–9.

76. Antoine-Chrysostome Quatremère de Quincy, "Notice sur M. Canova, sur sa réputation, ses ouvrages et sa statue du Pugilateur," *Mélanges de litterature, d'histoire et de philosophie* 3 (1804): 4–6. Quatremère's text reads: "[Sculpture] fut l'art nécessaire, l'art politique, l'art dominant des anciens. Je suis persuadé qu'il donna constamment le ton à la peinture. Un description de tableau antique ressemble trop à la description d'un bas-relief, pour qu'on en puisse douter."

CHAPTER 2

1. Cultural nationalism is discussed in terms of Herderian *Weltgeist* in H. G. Schenk, *The Mind of the European Romantics* (Oxford and New York, 1979), pp. 15–18, with additional bibliography. I thank Barbara Stafford for an illuminating discussion of Herder's ideas. For his expressivist theory of culture, see especially Vicki Spencer, "Towards an Ontology of Holistic Individualism: Herder's Theory of Identity, Culture, and Community," *History of European Ideas* 22 (1996): 245–60, also with additional bibliography.

2. Quatremère de Quincy, *Lettres sur l'enlèvement,* pp. 185–87, from the second letter to General Miranda.

3. It has been argued that Canova actively promoted political unity; see Jean Henry, "Antonio Canova and Early Italian Nationalism," in *La scultura nel XIX secolo,* ed. Horst W. Janson, pp. 9–16, Atti del XXIV congresso internazionale della storia dell'arte, vol. 6 (Bologna, 1984). Henry's argument, which centers on the *Monument to Vittorio Alfieri* in Florence, is, in my view, overstated and contrary to the evidence.

4. "L'article de l'armistice avec Rome, qui stipule que les cent plus beaux morceaux de peinture et sculpture nous seront livrés, fait grand mal coeur du peuple romain et de tout l'Italie. . . . L'Italie nous verrait céder sans regret par le Pape toutes les terres domaniales appartenantes à la Chambre Apostolique, si nous voulions les prendres en échange des monuments." Quoted in Jules Guiffrey, "L'Académie de France à Rome de 1793 à 1803," *Journal des Savants* (1908): 659–60.

5. Springer, pp. 80–81. The author appositely mentions that as the Canova myth grew, progressives and even antipapalists laid claim to his achievement as a regenerator of Italian culture and as a paradigm for political regeneration.

6. Pietro Giordani, *Per l'aspettato arrivo di Canova in Bologna: Poesie* (Bologna, 1810), pp. 10–12.

7. ". . . che la nostra infelice Italia in tempi sì difficili possa ancor primeggiare nelle bell'arti. . . ." Quarenghi's letter from Saint Petersburg is dated April 28, 1803. Curiously, the two artists never met, but both were close friends of Gianantonio Selva's. See Vanni Zanella, p. 310.

8. See Ulrich Hiesinger, "The Paintings of Vincenzo Camuccini, 1771–1844," *Art Bulletin* 60 (1978): 306.

9. This difference between Italian and French responses to public art is discussed briefly in René

Schneider, "L'art de Canova et la France impériale," *Revue des études napoléoniennes* 1 (1912): 42–43. Once the Paris museum was dismantled, the stipulation that the works returned to Rome be consolidated in a single museum anticipates the ultimate triumph of the French view.

10. The story of the smelters is recounted in several places in the contemporary account by Richard Duppa, *A Journal of the Most Remarkable Occurrences that took Place in Rome, upon the Subversion of the Ecclesiastical Government, in 1798* (London, 1799).

11. The negotiations and execution of the monument are carefully documented in L. G. Pélissier, "Canova, la comtesse d'Albany, et le tombeau d'Alfieri," *Nuovo archivio veneto* 3 (1902): 147–88 and 394–427; 4 (1902): 214–45.

12. Licht, p. 75. For the argument that the figure of Italica on the tomb unites Alfieri's and Canova's aspirations into a monumental plea for political action, with strong pan-Italian memories of the Roman Empire, see Jean Henry, "Antonio Canova and the Tomb to Vittorio Alfieri," Ph.D. diss., Florida State University, 1978, pp. 142–43. The untenability of this suggestion will soon become evident.

13. Jean Henry has made this claim in "Antonio Canova, the French Imperium, and Emerging Nationalism in Italy," *Proceedings of the Consortium on Revolutionary Europe, 1750–1850* 2 (1980): 87–88.

14. The identification of the Ariccia figure is based on the inscription "Italia Nova" on a drawing by Cades for the Sala di Ariosto commission now in the Chigi Archives of the Vatican Library. In an album in Lisbon, a drawing by Cades dated 1788 has a similar figure labeled "Roma Papale." See Maria Teresa Caracciolo, *Giuseppe Cades, 1750–1799, et la Rome de son temps* (Paris, 1992), pp. 310–24.

15. ". . . un bassorilievo rappresentante le fedeli Provincie che giurano fedeltà al loro leggittimo Principe. Cosa sarà questo bassorilievo, e di qual merito, lascio a voi il considerarlo. Amore, gratitudine, è che muove il nostro Amico." The letter is quoted in A. Segarizzi, "La Biblioteca Querini Stampalia nel sessennio 1910–1915," *L'ateneo veneto* 38 (1915): 198–99. To subdue the Venetian state more easily, the French instigated revolts against Venice on the mainland, but had success only in Bergamo and Brescia. Canova was especially grieved by the ceremonial destruction of the bust portraits of the *podestà* of Bergamo. Almost all the Terra Ferma remained loyal, however, with the cities of Vicenza, Verona, Treviso, Padua, Valpolicella, and Breganze and the provinces of the Fruili, Istria, and Dalmatia swearing oaths to Venice, despite the catastrophic political situation. See Ricciotti Bratti, "Antonio Canova nella sua vita artistica privata (da un carteggio inedito)," *Nuovo archivio veneto* 33 (1917): 348–49. Ironically, Venice was again threatened with foreign conquest at the time of both Segarizzi's and Bratti's publications, this time by Austria-Hungary.

16. From a letter quoted in Vanni Zanella, pp. 311–12. The Italian *cittadino,* literally citizen, has the same Jacobin association as the French *citoyen* and thus would not have been favored by Canova.

17. The abbate Farsetti commissioned two of Canova's earliest works, simple sculpted baskets of fruit and flowers, for the staircase of Palazzo Farsetti. For the progressive cultural tendencies of Farsetti and his friends, see Albert Boime, *Art in an Age of Revolution, 1750–1800* (Chicago and London, 1987), pp. 138–39.

18. For Cades's ties to the Venetian contingent in Rome, see Caracciolo, p. 69. The competition between Canova and Angelini made possible by Abbondio Rezzonico is discussed in Giuseppe Pavanello, "Una scheda per 'l'Apollo che si corona' di Antonio Canova," *Antologia di belle arti* 35–38 (1990): 10. The *Apollo Crowning Himself* was praised by Gian Gherardo de' Rossi, director of the Portuguese Academy in Rome, who saw in it a new direction for modern sculpture. See his "Sopra il gruppo del Teseo vincitore del minotauro," in *Memorie per servire alla storia letteraria e civile* (Venice, 1796), p. 56.

19. Canova initially refused in a letter written from Possagno on May 7, 1799, less than a month after Pesaro's death. See Bottari and Ticozzi, eds., 8:182–83.

20. See Stefani, *I rilievi di Canova,* p. 98, with additional bibliography.

21. The failure of the subscribers to follow through on the commission is discussed in Canova's letter to Priuli of June 5, 1802, quoted briefly in Pavanello and Romanelli, eds., p. 174.

22. *Venezia nell'età di Canova,* p. 67.

23. Quoted in Giuseppe Pavanello, "The Venetian Canova," in Pavanello and Romanelli, eds., p. 49.

24. The political underpinnings of Venice's support for Canova have been discussed by Giulio Carlo Argan, *Da Hogarth a Picasso: L'arte moderna in Europa* (Milan, 1983), 2:211–12.

25. Boime, *Art in an Age of Revolution,* p. 141.

26. The details of the Turkish war and the Austrian alliance are examined in John Julius Norwich, *A History of Venice* (New York, 1989), pp. 580–82, with additional bibliography.

27. Quoted from an original document by Memes, pp. 291–92.

28. See Missirini, *Vita di Canova,* pp. 96–101; and Boime, *Art in an Age of Revolution,* pp. 141–42.

29. Giuseppe Consolo, *Memorie relative al monumento Emo esistente nell'Arsenale di Venezia opera dell'immortale Antonio Canova,* Nozze Treves-Todros (Padua, 1844), pp. 11–14.

30. Bratti, 33:293–99.

31. This letter is quoted in Giovanni Correr, *Documenti sul monumento ad Angelo Emo di Antonio Canova, e sulla medaglia d'oro donata al Canova dal Senato Veneziano,* Nozze Emo–Capodilista-Venier (Venice, 1867), pp. 14–15. The first discussion of an annuity in lieu of a fixed sum is found in the letter Canova addressed to Francesco Battaja in Venice of April 18, 1795, so apparently the idea was the artist's solution. In not stipulating a price at the outset (an unusual procedure for the sculptor), Canova may have had an annuity in mind all along. Bratti states that the annuity had been the wish of Girolamo Zulian, and although he gives no source for the claim, it does sound reasonable, given the patrician's understanding of an annuity's political implications.

32. Quoted in Pavanello, "Venetian Canova," in Pavanello and Romanelli, cds., p. 49.

33. Canova's request is discussed in G. Vinco da Sesso and Paolo Marton, *Antonio Canova: Opere a Possagno e nel Veneto: Works in Possagno and the Veneto Region* (Bassano del Grappa, 1992), pp. 31–32, with additional bibliography.

34. Quoted in Angelo Geatti, *Napoleone Bonaparte e il trattato di Campoformido del 1797* (Udine, 1989), pp. 198–99.

35. Giovanni De Castro, *Storia d'Italia del 1799 al 1814* (Milan, 1907), pp. 285–88.

36. Napoleon blamed the Venetian patriciate and clergy, above all the bishop of Verona, for the bloody insurrections. In a letter to the Directory of May 3, 1797, written from Palmanova, he vilifies the Venetians: "Après une trahison aussi horrible, je ne vois plus d'autre parti que celui d'effacer le nom vénetien de dessus la surface du globe. Il faut le sang de tous les nobles vénetiens pour apaiser les mânes des Français qu'ils ont fait égorger." Quoted in *Correspondance de Napoléon,* 3:20–21, item 1,766.

37. Francesco Lazzari, *Della seconda Psiche scolpita da Canova,* Nozze Bigaglia-Bertolini (Venice, 1858), pp. 32–33.

38. Quoted in Munoz, *Canova,* p. 59.

39. For the secret clauses and a summary of the massive territorial exchanges occasioned by the Leoben armistice (April 1797) and the Treaty of Campoformio (October 1797), see Robert A. Kann, *A History of the Habsburg Empire, 1526–1918* (Berkeley, Los Angeles, and London, 1974), pp. 215–16.

40. Quoted in Paolo Guerrini, "Il carteggio canoviano della Queriniana di Brescia," *Archivio veneto-tridentino* 2 (1922): 171.

41. E. E. Y. Hales, *Revolution and Papacy, 1769–1846* (New York, 1960), pp. 170–71. Napoleon also announced in the newspapers that Pius was to be given two state coaches, and while the first consul got the favorable press, Pius never got the presents. Similarly, during tours at Gobelins and Sèvres, the pope expressed admiration for several works in tapestry and porcelain, and his entourage mentioned that they had last seen these objects in Rome.

42. The return of the Italian collections from France is the subject of Chapter 7.

43. Quoted in Bottari and Ticozzi, eds., 8:206–7.

44. Cicognara's views, in unusual variance to Canova's, are discussed in Fedi, pp. 85–86.

45. The return of the San Marco horses is fully described in Massimiliano Pavan, "Canova e il problema dei cavalli di San Marco," *L'ateneo veneto,* n.s. 12 (1974): 83–111, especially 96–99.

46. For Pius VI's art patronage, see Jeffrey Laird Collins, "Arsenals of Art: The Patronage of Pope Pius VI and the End of the Ancien Régime," Ph.D. diss., Yale University, 1994, with an excellent bibliography. Professor Collins is preparing a book on the subject.

47. Owen Chadwick, *The Popes and European Revolution* (Oxford, 1981), p. 482.

48. The goal of the mission is suggested in Hugh Honour, ed., *Edizione nazionale delle opere di Antonio Canova: Scritti, I* (Rome, 1994), p. 259. For the drawings Canova made on the trip, see Hans Ost, *Ein Skizzenbuch Antonio Canovas, 1796–1799,* Römische Forschungen der Bibliotheca Hertziana, vol. 19 (Tübingen, 1970).

49. E. E. Y. Hales, *The Emperor and the Pope: The Story of Napoleon and Pius VII* (1961; reprint, New York, 1978), pp. 70–71.

50. On the sympathy for Pius VII and the clerics, in marked contrast to the subversive representation of the gaudy entourage and the posturing Napoleon, see Johnson, pp. 198–204.

51. For more particulars of the dismemberment, see Owen Connelly, *Napoleon's Satellite Kingdoms* (New York and London, 1965), pp. 32–33.

52. Margaret M. O'Dwyer, *The Papacy in the Age of Napoleon and the Restoration: Pius VII, 1800–1823* (Lanham, Md., New York, and London, 1985), pp. 93–94.

53. Hales, *Emperor and Pope,* pp. 86–87.

54. For the process of political alienation between Napoleon and Pius VII, see Chadwick, pp. 510–14; and Roger Aubert et al., *The Church between Revolution and Restoration,* vol. 7 of *History of the Church,* ed. Hubert Jedin and John Dolan, trans. Peter Becker (New York, 1981), pp. 72–73, both with additional bibliography.

55. Henri Daniel-Rops, *The Church in an Age of Revolution, 1789–1870,* trans. John Warrington (Garden City, N.Y., 1967), p. 97.

56. De Castro, 2:215–16.

57. For Lebzelten's protest, see Robert A. Graham, *Vatican Diplomacy: A Study of Church and State on the International Plane* (Princeton, N.J., 1959), pp. 133–34.

58. "Je suis fâché qu'on ait arrêté le Pape; c'est une grande folie. Il fallait arrêter le cardinal Pacca et laisser le Pape tranquille à Rome. Mais enfin, il n'y a point de remède; ce qui est fait est fait." Regarding Pacca, the emperor added ". . . s'il y a un Français assassiné par l'effet de ses instigations, il sera le premier qui payera de sa tête." *Correspondance de Napoléon,* 19:265–66.

59. D'Este, pp. 157–58. Canova formulated two dancers during this troubled period. The fin-

ished version, whose gesso was marked with the artist's anguished graffito, is now in the Galleria Nazionale d'Arte Antica in Palazzo Corsini, Rome.

60. Aubert et al., pp. 73–74.

61. Ibid., pp. 74–76.

62. Leopold M. Kantner, "Die französischen Besatzungen in Rom 1798–1800 und 1807–1814 im Blickwinkel des Zeremonialdiaristen von S. Pietro," *Römische Historische Mitteilungen* 15 (1973): 86–87. See also Jacques Moulard, *Le comte Camille de Tournon auditeur au Conseil d'Etat, Intendant de Bayreuth, Préfet de Rome, de Bordeaux, de Lyon, pair de France (1778–1833)* (Paris, 1927–32), 2:536. A great favorite of Pius VII, Zingarelli was best known for his oratorio *Jerusalem Destroyed.* The emperor had quashed a French proposal for 12,000 livres for a new choir school at Saint Peter's, possibly because of Zingarelli's resistance to the regime.

63. Pier-Alessandro Paravia, *Notizie intorno alla vita di Antonio Canova giuntovi il catalogo cronologico di tutte le sue opere* (Venice, 1822), p. 57.

64. Giovanni Rosini, *Saggio sulla vita e sulle opere di Antonio Canova,* 2d ed. (Pisa, 1830), pp. 36–37.

65. "Sa Saintété a fait appeler il y a quelques jours dans ses appartements M. Canova, célèbre sculpteur vénitien établi à Rome. Elle l'a entretenu avec affection et lui a attaché à sa boutonnière l'ordre de l'Eperon; ensuite elle l'a embrassé et l'a déclaré cavaliere de cet ordre. Le brevet qui a été remis à cet effet à M. Canova renferme l'éloge le plus distingué de son talent et de sa singulière modestie." The letter bears the revolutionary calendar date 7 pluviôse An X. Quoted in Anatole de Montaiglon and Jules Guiffrey, eds., *Correspondance des Directeurs de l'Académie de France à Rome avec les Surintendants des Bâtiments publiée d'après les manuscrits des Archives Nationales* (Paris, 1887–1912), 17:349–50.

66. D'Este, pp. 141–43.

67. "Non posso spiegarvi quanto è voluto bene qui il vostro buon Papa." Quoted in Valmarana, ed., p. 36.

68. "Voglia il Cielo conservarlo degli anni molti per veder lungamente nella cattedra di S. Pietro un ministro sì prezioso alla religione ed all'arte. Oh quanto S. S. è ancor qui venerato e stimato! Credo che pochi siano quelli che non preghino per lui; e voi dovete esser più tranquillo ora che possedete sì gran tesoro." Quoted in Domenico Selva, *Lettere familiari inedite di Antonio Canova e di Gianantonio Selva,* Nozze Persico-Papadopoli (Venice, 1835), p. 84.

69. D'Este, pp. 195–97.

70. Marita Jonsson, *La cura dei monumenti alle origini: Restauro e scavo di monumenti antichi a Roma 1800–1830,* Skrifter Utgivna av Svenska Institutet i Rom, vol. 14 (Stockholm, 1986), pp. 18–19. This excellent study is a good antidote to Ronald T. Ridley, *The Eagle and the Spade: The Archaeology of Rome during the Napoleonic Era, 1809–1814* (Cambridge, 1992), which gives far too much credit to the novelty of the French projects, constantly underplaying the pre-French accomplishments, and also uncritically buys into the notion that fully excavated monuments seen in absolute isolation from the surrounding fabric of the city are an improvement on the Settecento's picturesque idea of monuments of all periods integrated into a living environment. Mussolini certainly favored such isolation, as the destruction of the Vatican *borghi* (the old residential districts around the Vatican) and the isolation of Saint Peter's, among other Fascist era urbanistic initiatives, documents.

71. Attilio La Padula, *Roma 1809–1814: Contributo alla storia dell'urbanistica* (Rome, 1958), pp. 23–25.

72. Springer, pp. 8–10.

1. The offer and Canova's refusal are described in Honour, ed., *Scritti, I,* pp. 216–20, transcribed from the original document. In an undated letter to Giuseppe Falier in Venice, Canova wrote, "Al Card. de Bernis, ministro di Francia a Roma, si sono scritti tre fogli di carte acciocchè mi volesse persuadere di fare per non so quale provincia di Francia un Mausoleo alla memoria del Cav. Baiardo, uomo già celebre nella storia...." I suspect Canova took no little pride in having refused such a spectacular commission. For the letter, see Bottari and Ticozzi, eds., 8:172–74.

2. In September 1792 the sculptor Joseph Chinard was arrested and imprisoned at Castel Sant'Angelo for Masonic activities, along with the lesser-known artist Ildephonse Rater.

3. For the Roman reaction, see especially Vittorio E. Giuntella, *Roma nel Settecento,* Storia di Roma, vol. 15 (Bologna, 1971), pp. 193–94. The overturned throne was replaced by a plaster cast of the celebrated bust of Brutus in the Capitoline Museum, which was later to figure so importantly in the spoliation of the Roman museums, it being the only work specifically named as one of the hundred works of art demanded by the Treaty of Tolentino.

4. "... sa che a quest'ora il povero Re di Francia non abbia finito di vivere. O quanto è meglio di essere Pittori...." The letter, dated December 18, 1792, is preserved in the Canova archive at Bassano del Grappa. Quoted in Giuseppe Maria Pilo, "Due ritratti di Alvise Pisani di Domenico Pellegrini: Lettere di Domenico Pellegrini ad Antonio Canova," *Paragone* 16, no. 185 (1965): 51–52. Louis XVI, Citizen Capet, was guillotined on January 21, 1793.

5. Giuntella, *Roma nel Settecento,* pp. 192–95.

6. Italian scholarship has long defended a more balanced view of the late Settecento in Italy. See Eugenio Battisti, "Ragioni politiche e religiose della 'Querelle' fra neoclassici e romantici," in *Arte neoclassica: Atti del convegno 12–14 ottobre 1957,* p. 47, Civiltà Veneziana Studi, vol. 17 (Venice and Rome, 1957), who specifically cites Goethe's anti-French views.

7. "Mi avete fatto un vero piacere dandomi la nuova che i Francesi abbiano abbandonato Verona, il cielo voglia che non vi ritornino mai più...." Quoted in Bratti, 33:336.

8. "Se il Diavolo fa che partino questi 100 pezzi, Roma resta desolata, ma speriamo bene giachè pare che le cose vadino predendo buona piega." Quoted in ibid., p. 337. Canova refers to the temporary lifting of the French siege of Mantua by the Austrian General Würmser. A strong fortress city, Mantua was the key to northern and eastern Italy, and its fall assured the victory of Bonaparte. The sculptor had earlier expressed his anxiety over the fate of Mantua, telling Selva that he hoped it would never surrender. In the same letter, he wrote that he had many offers of patronage from the French but had too many things to do to accept them. In this instance I believe his politics influenced his sculptural practice. The letter, dated October 15, 1796, is quoted in ibid., pp. 340–41.

9. "... ho ricusato di valermi del favore che a tal fine mi fu offerto appresso il supremo Comandante Buonaparte...." The letter, dated October 28, 1797, is quoted in ibid., 34:87–88.

10. In a letter of March 28, 1797, to Giuseppe Falier in Venice, Canova wrote: "Veggo l'Italia tutta, anzi l'Europa tutta talmente ruinosa che se non fossi trattenuto da tante cose che mi incatanano qui, sarei tentato di andare in America perché mi sento morire per il povero nostro stato che tanto amo." This and similar letters are quoted in Munoz, *Canova,* pp. 58–59. For Canova's escape from his troubles in hard work, see his letter to Falier written in January 1797: "I have been working desperately hard recently ... because if my mind had not been—or I had not kept it—busy with such things I fear

I would not have been able to bear the heart-rending events now devastating the world." Quoted and translated in Hugh Honour, "Canova's Studio Practice II," pp. 214–15.

11. The text of the letter is quoted in Bratti, 33:318–19.

12. After Duphot's death Pius did all he could to prevent the occupation, even signing a decree making it a capital offense to injure, insult, or even be rude to a French citizen. Penitential processions, in which the higher clergy and nobility, barefoot and in sackcloth, followed important relics, proved ineffective. In fact, Napoleon had already decided that the virtually undefended wealth of Rome was too tempting a prize to overlook, and Duphot's murder simply gave a (rather paltry) excuse for the French army to occupy and sack the city. See Duppa, pp. 17–20.

13. French attempts to rally popular support by staging races during carnival were also unsuccessful. See ibid., pp. 27–30.

14. He left Antonio D'Este in charge of the studio and gave instructions for rendering aid to needy artists in the grim days he saw coming. See D'Este, pp. 93–94.

15. Vittorio Malamani, *Canova* (Milan, 1911), pp. 61–64. For the unusual iconography of the statue of King Ferdinand, see Detlev Kreikenbom, "Canovas Ferdinand IV. von Neapel: Minerva, Imperator oder Griechischer Staatslenker?" *Städel-Jahrbuch* 13 (1991): 227–44.

16. Ottorino Stefani, *Canova pittore: Tra Eros e Thanatos* (Milan, 1992), pp. 58–61.

17. Hugh Honour, "The Rome of Vincenzo Pacetti: Leaves from a Sculptor's Diary," *Apollo* 78 (1963): 374–76.

18. "Le passage de la révolution est déjà oublié, mais Rome diminue et se dépeuple. Cette ville a perdu toutes les sources étrangères de sa grandeur et le Pape la moitié de son État. . . . Les pauvres et les malheureux y surpassent toute proportion." The letter bears the revolutionary calendar date 11 nivôse An X. Quoted in Montaiglon and Guiffrey, eds., 17:341.

19. The figures are given by Nardi, p. 47. For the dramatic decrease in population during the Jacobin ascendancy, see especially Vittorio E. Giuntella, "La giacobina repubblica romana (1798–1799): Aspetti e momenti," *Archivio della società romana di storia patria* 73 (1950): *passim.*

20. Quatremère de Quincy, *Canova et ses ouvrages,* p. 186.

21. The Roman Senate is described by Louis Madelin, *La Rome de Napoléon: La domination française à Rome de 1809 à 1814,* 2d ed. (Paris, 1906), pp. 256–57.

22. Quatremère de Quincy, *Canova et ses ouvrages,* p. 186; Malamani, *Canova,* pp. 156–57; and Luigi Rava, "Antonio Canova ambasciatore," *L'archiginnasio* 18 (1923): 27–28.

23. Boyer, "Autour de Canova," pp. 219–20; León Lanzac de Laborie, *Paris sous Napoléon* (Paris, 1905–13), 8:420 n. 1. Boyer, for many years the director of the Institute for Napoleonic Studies, consistently characterized Canova as a Napoleonic court artist and willing collaborator, albeit with a few annoying idiosyncrasies.

24. Sommariva passes along David's compliments to Canova and adds: "J'ai vu avec plaisir, Monsieur, dans les papiers publics que vous êtes au nombre des personnages distingués de Rome qui ont été nommés senateurs. Je vous prie d'agréer mes félicitations." Whether or not Canova assumed his seat, the government still had the advantage of using his name in the announcement, a form of press propaganda frequently utilized by the imperial administration. The letter is quoted in Mazzocca, "Sommariva o il borghese mecenate," pp. 242–43.

25. This episode is mentioned in most of the early biographies and is summarized by Malamani, *Canova,* pp. 156–57.

26. *Correspondance de Napoléon,* 22:234, item 41,763. The letter, dated June 3, 1811, was written at Chartres.

27. Madelin, pp. 452–53, states that Canova took the modified oath only in early 1813, but sometime the previous year seems more likely.

28. Ridley, pp. 48–49. Gaetano Marini, director of the Vatican Library, and Vincenzo Camuccini also declined to serve on the committee, which proved ineffective and was eventually scrapped.

29. Sica, pp. 236–37.

30. Tournon's apologia for the failure of the 1810 restoration laid the blame on previous pontifical neglect, but the arch was not put in danger until the French attempted to isolate it from its surroundings. For more on this failed initiative, see Ridley, pp. 96–97, with additional bibliography.

31. André Fugier, *Napoléon et l'Italie* (Paris, 1947), pp. 275–77. Fugier is one of the few French scholars to recognize Canova's aversion to France. For a positive view of Denon's activities in Italy, see Marie-Louise Blumer, "La mission de Denon en Italie (1811)," *Revue des études napoléoniennes* 36 (1934): 237–57.

32. For Ingres's activities in Rome during the empire, see Franco Borsi, ed., *Arte a Roma dal neoclassico al romanticismo* (Rome, 1979), p. 58. See also Hugh Honour, "La decorazione scultorea nel Quirinale napoleonico, 1811–1814," in *Il palazzo del Quirinale: Il mondo artistico a Roma nel periodo napoleonico,* pp. 167–69 (Rome, 1989). For Canova's activities as an art patron, see Ulrich Hiesinger, "Canova and the Frescoes of the Galleria Chiaramonti," *Burlington Magazine* 120 (1978): 655–65, although these paintings date from the Restoration.

33. Characterizations of the Romans as lazy, superstitious, ignorant, and priest-driven were commonplace, even in official government documents. A total lack of sympathy on the part of the French with the Roman way of doing things also embittered the people. See Moulard, 2:5–6.

34. Chadwick, pp. 514–15.

35. ". . . ces courageuses victimes d'une absurde persécution." Moulard, 2:69–73. Tournon did all he could to mitigate the severe penalties for nonjurors but encountered increasing difficulties after 1811, when Bonaparte began to adopt a harder line toward the recusants.

36. The diary entry is discussed in Ilario Rinieri, *Napoleone e Pio VII (1804–1813): Relazioni storiche su documenti inediti dell'archivio vaticano* (Turin, 1906), 2:291–99.

37. Moulard, 2:59–60.

38. Ibid., pp. 167–68.

39. Maurice Andrieux, *Les Français à Rome* (Paris, 1968), pp. 236–38.

40. Carlo Botta, *Storia d'Italia dal 1789 al 1814* (Paris, 1837), 4:280–81.

41. Nardi, pp. 32–34.

42. Gustavo Brigante Colonna, *Roma napoleonica: Interpretazioni* (Florence, 1929), pp. 95–96. The writer refers to the *Giornale romano* as the *Giornale di Roma*. A *Monitore romano,* an imitation of the *Moniteur universel,* had been the official journal of the Roman republic.

43. "Viva l'Imperatore!" and "Accidente all'Imperatore!" The incident is related in Rinieri, *Napoleone e Pio,* 2:299–302.

44. Moulard, 2:191–94. The author states that Tournon, thinking the program "unjust and arbitrary," distanced himself from it. His temperance in dealing with passive resistance in Rome, seen to advantage in his delicate handling of the problem of Canova and the oath, suggests that sensitivity and restraint were constituents of Tournon's character.

45. Maddalena Patrizi, *The Patrizi Memoirs: A Roman Family under Napoleon, 1796–1815,* trans.

Mrs. Hugh Fraser (London, 1915), pp. 178–79. Napoleon may have hated the Patrizi because Cunegonda of Saxony, the countess Patrizi, was Louis XVIII's first cousin.

46. Andrieux, pp. 252–53.

47. Fiorella Bartoccini, *Roma nell'Ottocento: Il tramonto della 'Città Santa,' nascita di una capitale,* Storia di Roma, vol. 16 (Bologna, 1985), pp. 20–24.

48. Reuben John Rath, *The Fall of the Napoleonic Kingdom of Italy* (New York, 1941), pp. 22–29. The problems faced by the Italian kingdom under Napoleon and the bitter legacy of his rule there were similar to those in the parts of Italy that had been annexed directly to France.

49. Francesco Hayez, *Le mie memorie* (Milan, 1890), pp. 36–37. The adjectives *severe* and *sadistic* that I use to describe Cavalchini are those used by Hayez himself.

50. Quatremère de Quincy, *Canova et ses ouvrages,* pp. 274–75.

51. Missirini, *Vita di Canova,* pp. 305–6.

52. Ibid., pp. 360–61. "... e quella onestò e distinse singolarmente in faccia al mondo coll'intitolare il simulacro per esso effigiato di Napoleone, estimando che un uomo per molti titoli singolari dovea ad una repubblica consacrarsi."

53. Francesco Paolo Luiso, "L'ultima dimora a Parigi di A. Canova e l'ultima sua grande opera di scultura," *Atti e memorie della società istriana di archeologia e storia patria* 43 (1931): 430–31. The bronze version of the *Pietà,* executed after Canova's death from the master's original *bozzetto,* is placed opposite the tomb of the artist and his half brother in the Tempio at Possagno. A related marble group, also executed after Canova's death, is in the Church of SS. Salvatore in Terracina.

CHAPTER 4

1. "J'apprends, Monsieur, par un de vos amis, que vous êtes privé de la pension dont vous jouissiez à Venise. La République française fait un cas particulier des grands talents qui vous distinguent. Artiste célèbre, vous avez un droit plus particulier à la protection de l'armée d'Italie. Je viens de donner l'ordre que votre pension vous soit exactement payée, et je vous prie de me faire savoir si cet ordre n'est point exécuté, et de croire au plaisir que j'ai de faire quelque chose qui vous soit utile." *Correspondance de Napoléon,* 3:224, item 2,079. The letter, dictated at Milan on August 6, 1797, bears the revolutionary calendar date 19 thermidor An V. Napoleon's informant was Giovanni Gherardo de' Rossi, according to Malamani, *Canova,* p. 62. The order had no effect, and later Canova refused to avail himself of Bonaparte's help in the matter.

2. Some writers have portrayed Canova either as a Bonapartist court artist de facto or as an artist so indifferent to the contemporary political situation that he cynically worked for anyone. Neither portrait characterizes him accurately, nor is it true that Canova was genuinely flattered enough to work for Napoleon, despite some trivial misgivings about the betrayal of Venice and the spoliation of Rome. This is not to say that Canova was wholly indifferent to the praise and attention of the man whose name was on everyone's lips. For the traditional view, see Andrea Busiri Vici, "La situazione romana durante l'occupazione napoleonica," *L'urbe* 198 (1980): 4–5; Carlo Zaghi, *L'Italia di Napoleone dalla Cisalpina al Regno* (Turin, 1986), pp. 509–11; and Gérard Hubert, *Les sculpteurs italiens en France sous la Révolution, l'Empire et la Restauration, 1790–1830* (Paris, 1964), pp. 37–39, who says Canova simply did not have the will to resist being petted. Even more curious is the assertion that Canova's profound admiration for Napoleon was the only political enthusiasm he had, that he was otherwise utterly apo-

litical. For this fantasy, see Arduino Colasanti, "Spirito e forme dell'arte di Antonio Canova," *Nuovo antologia* (1923): 8–11. This is certainly the most extreme evaluation of Canova's politics I have encountered.

3. *Cupid and Psyche* had been commissioned in 1787 by Colonel John Campbell, later Baron Cawdor, one of Canova's earliest and most enthusiastic admirers. Although a payment had been made, the work could not be delivered in 1793, when it was completed, and Canova kept it, probably granting Campbell some future consideration. In 1800 he sold it to a Dutch collector, who then sold it to Murat for 2,000 zecchini.

4. I suggest that the Visconti letter refers to the standing version because Canova had already sold the recumbent *Cupid and Psyche* to "Enrico Hoppe." Since the letter from Visconti dates from 1802, it seems unlikely that he would chide Canova about sticking to an agreement with Campbell for a work already sold. But Napoleon's praise, which Visconti cites later in this missive, does not specify which group Bonaparte liked. Murat exhibited both versions at the château Villiers-la-Garenne at a ceremony honoring the first consul in 1802, so it could be either or both. If the favorable response was to both works, then the remonstrance of Visconti against Colonel Campbell's claims must refer to the second version, which for financial reasons the British patron relinquished to Josephine. It may be significant that 1802 was the only year in which the statue could have been sent to Great Britain in relative safety. See Pavanello and Romanelli, eds., pp. 234–36, 260.

5. "L'opinione d'un uomo si straordinariamente grande, son sicuro che Le [*sic*] sarà dolce; ed io ho voluto perciò darLene [*sic*] notizia." The letter is quoted in Ferdinand Boyer, *Le monde des arts en Italie et la France de la Révolution et de l'Empire: Études et recherches,* Biblioteca di Studi Francesi, vol. 4 (Turin, 1969), p. 127.

6. Malamani, *Canova,* pp. 86–88.

7. Hugh Honour quotes the letter from Bassano MSS 271: "Gran nuova! da un giorno all'altro devo partire per Parigi dove sono chiamato dal Primo Console per conferire meco. . . ." "Canova's 'Napoleon,'" *Apollo* 98 (1973): 84 n. 9. This is one of the few instances in which I disagree with Honour's interpretations.

8. ". . . io non sarei mai andato a Parigi, se non fosse stato per parlare del mio paese. . . ." Quoted in Bratti, 35:214–15.

9. "Ma, caro amico, come dispensarvi dall'accettare commissioni del Primo Console? Scommetto che non potrete sostenere l'impossibilità di non prestarvi, perchè egli vi darà tempo, e vorrà accrescer la gloria della Francia con un qualche vostro Monumento, come di certo ha aumentata la sua; poichè il di lui nome pel vostro fatto sarà immortale anche nei fasti delle Belle Arti." Quoted in Selva, pp. 25–26.

10. "Mais vous avez très bonne mine!" Quoted in Boyer, *Monde des arts en Italie,* p. 132.

11. For Canova's use of the "Miranda letters" against cultural spoliation, see the excellent article by Antonio Pinelli, "Storia dell'arte e cultura della tutela: Le 'Lettres à Miranda' di Quatremère de Quincy," *Ricerche di storia dell'arte* 8 (1978–79): 47–48.

12. ". . . M. Canova n'accepte aucun autre ouvrage avant la fin des deux monuments." Quoted in J. J. Champollion-Figeac, "Canova et ses ouvrages pour Napoléon, Consul et Empereur," *Revue universelle des arts* 1 (1855): 353, where other letters of Cacault concerning Canova are published. The sense of imperial self-importance in the ambassador's correspondence would have seemed unexceptionable during the Second Empire.

13. "Cependant le temps nous a révélé, qu'il y avoit chez lui [Napoléon] autre chose encore, que le

désir de confier le portrait de sa personne au talent le plus renommé d'alors. Cette sorte d'ambition, depuis Alexandre, n'a manqué à aucun homme célèbre. Mais chez Bonaparte, il y avoit déjà la prévision de cette conquête universelle, et en tout genre, qui fut le point de mire de toute sa vie. De là cette convoitise anticipée de tout ce qu'il y avoit en chaque pays, soit de chef-d'oeuvre ou d'objets précieux, soit d'hommes de talent et de sujets renommés. C'est ce que la suite fera mieux connoître, à l'égard de Canova, dans l'extraordinaire désir qu'il eut de s'approprier, moins ses ouvrages encore que sa personne." Quatremère de Quincy, *Canova et ses ouvrages,* pp. 115–16.

14. Johns, "Portrait Mythology," especially pp. 117–21.

15. The painting's composition survives only in a damaged engraving and in the drawing I illustrate in the text. The picture was acquired by the slain legislator's daughter, who, being an ardent Royalist, destroyed it. See Johnson, pp. 95–100.

16. The most intelligent analysis of this problem in eighteenth-century visual culture is still Edgar Wind, "Studies in Allegorical Portraiture, I," *Journal of the Warburg and Courtauld Institutes* 1 (1937–38): 138–62.

17. Peter Beckford, *Familiar Letters from Italy, to a Friend in England* (London, 1805), 2:276.

18. I believe the work refers to the peace treaties of Lunéville (1801) and Amiens (1802) and is linked thematically to Girodet's *Dream of Ossian,* painted for Malmaison in the same year.

19. ". . . en cas d'événements." Quatremère de Quincy, *Canova et ses ouvrages,* pp. 123–24. This is precisely what Canova did with the commission given him by King Joseph Bonaparte of Naples. He cast the horse first and never executed the rider, later placing a statue of Charles III, king of Naples, on his French counterpart's horse. The monument now stands in the piazza San Francesco de Paolo in Naples.

20. Ibid., p. 125.

21. Paul Zanker, *The Power of Images in the Age of Augustus,* trans. Alan Shapiro (Ann Arbor, Mich., 1990), pp. 4–6. The bronze nude sculpture is illustrated as figure 1.

22. Ferdinand Boyer, "L'histoire du 'Napoléon colossal' de Canova," *Revue des études napoléoniennes* 42 (1940): 193–94.

23. ". . . consacra la sua opera a tutti i popoli, a tutti i secoli, e si appella alla tarda posterità per esser giudicato." Quoted in D'Este, p. 321. D'Este, probably motivated by loyalty to Canova, whom Denon had badly abused in 1815 over the repatriation of Italian art from the Louvre, claimed that Denon attacked the notion of nudity, saying that it violated decorum. This is untrue.

24. Horst W. Janson, "Observations on Nudity in Neoclassical Art," in *16 Studies* (New York, 1973), pp. 191–92.

25. *Correspondance de Napoléon,* 8:56, item 6,355. Before the Desaix monument, there had been a pyramid erected in honor of the slain regicide Lepeletier on the site, but it was unpopular and a political liability after the coup of 19 brumaire. About 1800, a decree was promulgated to raze it and build a monument to the Italian campaigns incorporating the San Marco horses, but this work never materialized. See Lanzac de Laborie, 2:233–34. At one point in its formulation Desaix was to be co-honored with General Jean-Baptiste Kléber, but the latter's Jacobinism led Napoleon to drop him from the project. For the politics of public sculpture in ancien régime France, see especially Jeffrey Merrick, "Politics on Pedestals: Royal Monuments in Eighteenth-Century France," *French History* 5 (1991): 234–64.

26. Lanzac de Laborie, 2:235.

27. "La blancheur et la pureté de la matière ne permettent pas que cette statue soit exposée à l'in-

tempérie de notre climat; sa nudité m'avait fait penser de la placer au Musée parmi les Empereurs et dans la niche où est le Laocoön, de manière à ce qu'elle fût le premier objet qu'on verrait en entrant...." The letter is dated December 11, 1806. Quoted in Boyer, *Monde des arts en Italie,* p. 136.

28. "La statue doit devenir l'ouvrage le plus parfait de ce siècle. Ce ne sera point une figure à mettre sur une place publique: elle doit être placée dans le Muséum au milieu des chefs-d'oeuvre antiques que nous devons au Premier Consul." The letter bears the revolutionary calendar date 9 germinal An XI. Quoted in Champollion-Figeac, p. 355.

29. For Denon's enthusiasm for Canova's recently arrived statue, see Chatelain, pp. 143–44.

30. The packaging, which was exceptionally expensive, and the statue's journey to Paris are described in Marie-Louise Biver, "Le 'Napoléon' de Canova," *La revue des deux mondes* (April 1, 1963): 427. Shortly before its consignment to France the statue, which had been exhibited in Canova's studio, was the subject of a short puff in Giuseppe Antonio Guattani, *Memorie enciclopediche romane sulle belle arti, antichità, etc.* (Rome, 1806–19), 2:85–86.

31. The letter, dated from Passy près Paris, is quoted in Valmarana, ed., p. 69.

32. Denon's letter is dated April 15; thus, he lost no time in writing to Canova after the emperor's visitation. "J'ai l'honneur de vous prévenir, Monsieur et Cher Collègue, que l'Empereur est venu voir votre statue. Sa Majesté a vu avec intérêt la belle exécution de cet ouvrage et son aspect imposant, mais Elle pense que les formes en sont trop athlétiques et que vous vous êtes un peu méprise sur la caractère qui le distingue éminemment, c'est-à-dire le calme de ses mouvements.... Sa Majesté, mon Cher Collègue, n'a encore rien prononcé sur la destination...." Quoted in Ferdinand Boyer, "Il y a deux cents ans naissait Canova," *Revue des études italiennes* (1957): 233.

33. Walter Markov, *Die Napoleon-Zeit: Geschichte und Kultur des Grand Empire* (Leipzig, 1985), p. 271.

34. For an incisive political interpretation of this genre painting, see Albert Boime, "Louis Boilly's 'Reading of the XIth and XIIth Bulletins of the Grande Armée,'" *Zeitschrift für Kunstgeschichte* 54 (1991): 374–87.

35. "... sebben ora l'Imperatore sia ingrassato, pure sempre ritiene del carattere di fisonomia, che tu gli hai dato...." Quoted from a letter dated August 26, 1812, from Giuseppe Bossi, celebrated painter and president of the Accademia di Brera in Milan, to Canova in Rome, in Federici, ed., p. 50.

36. "Verrà un giorno a Parigi la statua dell'Imperatore; sarà criticata senza pietà, e lo so: avrà i suoi difetti certamente, sopra gli altri avrà la disgrazia di essere moderna e di un Italiano." Quoted in Boyer, "Autour de Canova," p. 230.

37. Quoted in Canova's *Lettere inedite tratte dagli autografi Canoviani nel Museo Civico di Bassano,* Nozze Chiminelli-Bonuzzi (Bassano, 1891), pp. 7–8. "Vous avez fait une belle figure représentant l'Empereur Napoléon. Vous avez fait pour la postérité tout ce qu'un mortel parvoit faire: la calomnie s'y accroche, cela ne Vous regarde plus, laissez à la médiocrité sa petite consolation habituelle. L'ouvrage est là, il représente l'Empereur Napoléon, et c'est Canova qui l'a fait. C'est tout dire."

38. This point about formal criticism of the work has been made by Gianni Carlo Sciolla, *Canova: La trilogia dell'amore, della morte, dell'eroismo* (Novara, 1983), pp. 13–14.

39. For the negative British evaluation, see Honour, "Canova's 'Napoleon,'" p. 180.

40. Boyer, "L'histoire du 'Napoléon colossal,'" pp. 193–94.

41. Boime, *Art in an Age of Bonapartism,* pp. 640–41.

42. Argan, *Da Hogarth a Picasso,* 1:247.

43. Johnson, pp. 219–20.

44. Ibid., pp. 206–16. In the *Distribution of the Eagles* the figure of the emperor is small, almost swallowed in his robes and marginalized with the women at left, a feature of the painting that minimizes Napoleon's role in the ceremony. In a similar way, Canova all but neutralizes Napoleon's persona by idealizing the body. I thank Professor Johnson for discussing David's painting with me.

45. The letter, dated November 13, 1815, is quoted in Quatremère de Quincy, *Canova et ses ouvrages*, p. 392. "Ora deggio venire ad un'altra importante commissione, che affido alla di lei conosciuta benevolenza. Mio fratello sarebbe nella disposizione di ripigliare, potendo, la statua di Napoleone, a suo conto, e farla trasportar poi a Roma. Ella pensi nella sua prudenza, se l'idea può aver alcun effetto, e se la proposizione di mio fratello, quando egli sarà ritornato a Roma, merita d'essere esternata. [In caso ch'ella trovi luogo a procedere secondo il di lui desiderio,] ci scriva e ci faccia conoscere a qual patto si renderebbe all'autore, un'opera nella quale ha sudato molto, e che forse sarebbe, per colpa della circostanze politiche sepolta in un magazzino eternamente." Canova also tried to buy back *Madame Mère*. See Quatremère de Quincy, *Canova et ses ouvrages*, pp. 400–401; and Ferdinand Boyer, "Le sort de la 'Madame Mère' de Canova et de la table des maréchaux sous la Restauration," *Bulletin de la Société de l'histoire de l'art français* (1940): 207–12.

46. See Horst W. Janson, *Nineteenth-Century Sculpture* (New York, 1985), p. 54. Janson gives no documentation for this assertion, and I have found no corroborating evidence, but the idea is so bizarre that I suspect he must have had some reason for stating it. He also says that Canova admired Bonaparte for unifying Italy and modernizing its institutions, which is not the case.

47. "Sa Majesté, Monsieur, m'a témoigné le désir de vous appeler à Paris, soit pour quelque temps seulement, soit pour vous y fixer tout-à-fait, et Elle m'a chargé de lui proposer des mesures convenables à cet effet. Le cas particulier qu'Elle fait de vos talents supérieurs et de vos connaissances dans tous les arts qui dépendent du dessin, lui a fait penser que vos avis pourraient contribuer puissamment à porter vers la perfection les travaux d'art qu'Elle fait exécuter et qui doivent perpétuer la splendeur de son règne." Quoted in D'Este, pp. 439–40. The letter is dated August 22, 1810, and was written in Amsterdam. D'Este writes Maréschal Duroc for Martial Daru.

48. "E qui supplico l'E.V. di poter osservare le ragioni invincibili, che m'incatenano in Italia, e a Roma. A dir vero codesta Città, madre e sede antica delle arti, è il solo unico asilo per uno scultore, e specialmente per me che vi ho fissato la mia dimora, oramai cangiata in necessità, da moltissimi anni. E molti però di questi anni gli ho spesi in servigio o di S. M. o della famiglia Imperiale, a preferenza di altre commissioni vantaggiose, et onorifiche, per la cara ambizione di assicurare la immortalità al mio nome. . . ." Quoted in Valmarana, ed., pp. 66–68.

49. Henri Welschinger, "Canova et Napoléon," *Revue d'histoire diplomatique* 27 (1913): 354–56.

50. Paul Wescher, *Kunstraub unter Napoleon* (Berlin, 1976), pp. 56–57.

51. Memes, pp. 398–99.

52. R. B. Holtman, *Napoleonic Propaganda* (Baton Rouge, La., 1950), p. 164.

53. Andrew Martin, "Three Representations of Napoleon," *French Studies* 43 (1989): 34.

54. June K. Burton, *Napoleon and Clio: Historical Writing, Teaching, and Thinking during the First Empire* (Durham, N.C., 1979), pp. 49–51. See also J. M. Thompson, *Napoleon Bonaparte*, 2d ed. (London, 1988; reprint, New York, 1996), pp. 219–20.

55. "[Sire] Voi decretaste 100,000 franchi per incoraggiamento dell'Arte. Di questo provvedimento così degno di Voi, come opportuno e necessario alle sempre crescenti miserie dei professori, il Governo sembra non essere ancora informato, e tutti frattanto portano le loro querele a me, che fui l'interprete dei loro voti, e l'annunziatore delle Vostre beneficenze: e tutti a mano a mano languiscono, e quelli pure

di merito non comune, sono privi di commissioni, e la situazione della Vostra Roma è assai più miserabile di quello, che io già vi dipinsi." Quoted in Michelangelo Gualandi, ed., *Dodici lettere inedite di Antonio Canova scritte a diversi,* Nozze Zambrini–Della Volpe (Bologna, 1868), pp. 31–32.

56. Jonsson, pp. 43–44.

57. Madelin, pp. 371–72.

58. Quoted in Vittorio E. Giuntella, "Rome nell'età napoleonica," in *Atti del convegno sul tema: Napoleone e l'Italia* (Rome, 1973), 1:358–59. Pius's response is best seen in a letter written in March 1806 refuting an earlier claim of papal secular obedience to the heir of Charlemagne. For the text, see Rinieri, *Napoleone e Pio,* 1:253–54. See also Daniel-Rops, trans. Warrington, pp. 93–94.

59. For the bishop of Nantes's encouragement of Napoleon's pretensions to the dignities of Charlemagne in ecclesiastical matters, see Umberto Beseghi, *I tredici cardinali neri* (Florence, 1944), pp. 12–13. Napoleon's desire to have Pius VII at his coronation, an ironic variant on the ceremony in which Charlemagne was crowned by the pope in Saint Peter's on Christmas Day, 800, indicates that his Carolingian aspirations predated even his assumption of the imperial dignity.

60. "... considérant que, lorsque Charlemagne Empereur des Français et notre Auguste prédécesseur, fit donation de plurieurs [*sic*] comtes aux evêques de Rome, il ne les leur donna qu'à titre de fiefs, et pour le bien de ses Etats, et que, par cette donation, Rome ne cessa pas de faire partie de son Empire." Quoted in *I francesi a Roma: Residenti e viaggiatori nella città eterna dal Rinascimento agli inizi del romanticismo,* exhibition catalogue (Rome, 1961), p. 340.

61. *Correspondance de Napoléon,* 8:300, item 6,717.

62. Ibid., 9:10–11, item 7,145. The later proposal is dated October 1, 1803.

63. Illustrated in Pavanello and Praz, p. 110.

64. For more information and additional bibliography concerning the commission, the ancient prototype, the patron, and the critical response, see my "Subversion through Historical Association: Canova's 'Madame Mère' and the Politics of Napoleonic Portraiture," *Word and Image* 13 (1997): 43–57.

65. For the Capitoline Agrippina's role in philological debate, see Francis Haskell and Nicholas Penny, *Taste and the Antique: The Lure of Classical Sculpture, 1500–1900* (New Haven, Conn., 1981), pp. 132–34.

66. Quoted in Valmarana, ed., pp. 46–47.

67. "... Verrà la statua della Madre: si dirà subito che rassomiglia affatto all 'Agrippina'; ed io direi: ponetela accanto, e poi mi si nieghi che non vi sieno delle diferenze sostanzialissime e originali, nel movimento generale, nelle gambe affatto diverse, nella testa e sopratutto nel panneggiamento, in cui sfido chiunque ad indicarmi una piega sola che ritragga di alcuna figura antica o moderna...." Quoted in Boyer, "Autour de Canova," p. 220. The French connoisseurs, including Quatremère, based their comparisons on plaster casts and engravings. The ancient statue itself was one of the most important antiquities left in Rome after the sack of the museums.

68. Andrieux, pp. 286–89.

69. "... j'ai appris avec peine que vous n'aviez pas le bon esprit de vous conformer aux moeurs et aux habitudes de la ville de Rome; que vous montriez du mépris aux habitants.... Aimez votre mari et sa famille, soyez prévenante, accommodez-vous des moeurs de la ville de Rome...." For the letter, which dates from April 6, 1804, see *Correspondance de Napoléon,* 9:319–20, item 7,674. See also Johns, "Portrait Mythology," pp. 126–28.

70. Boyer, *Monde des arts en Italie,* p. 123.

71. Ibid.

72. For a brief introduction to Josephine's cultural activities, see Hubert, "Josephine," pp. 34–43, with additional bibliography. Her support for botanical research was also noteworthy, and she gave her name to the Josephine rose. Malmaison became a repository for large numbers of exotic flora. See also Memes, pp. 399–400.

73. See Hugh Honour, "Canova's Statue of a Dancer," *National Gallery of Canada Bulletin* 6 (1968): 2–14. See also Quatremère de Quincy, *Canova et ses ouvrages,* pp. 162–65.

74. Quatremère de Quincy, ibid., pp. 240–42.

75. *Venezia nell'età di Canova,* pp. 247–51. More is said about the circumstances of the Venetian gift to the emperor in chapter 5.

76. Fesch was an avid art collector and patron of contemporary artists, including Jean-Baptiste Wicar, Joseph-Benoît Suvée, Francesco Massimiliano Laboureur, and Canova. His taste, however, was highly cautious, and he patronized only major artists with established reputations. This habit must have frustrated Canova during Fesch's tenure as ambassador of France to the Holy See, since the sculptor was continually promoting talented young painters and sculptors who were having trouble attracting patrons in Rome's diminished circumstances. See André Latreille, *Napoléon et le Saint-Siège (1801–1808): L'ambassade du Cardinal Fesch à Rome* (Paris, 1935), p. 418.

77. The romantic intensity of his letters to various women was, in my view, a part of the game and the custom of the period. His frank admiration of feminine beauty made attractive women enjoy his company, although he could certainly show love and tenderness to such women as Luigia Giuli, his housekeeper, a fellow artist, and mother figure. Some writers have ignored the passionate epistolary style of the era and have claimed that the letters show Canova as a bit of a roué. See Antonio Munoz, "Gli amori di Antonio Canova," *L'urbe* 20 (1957): 8–19, for a characteristic example.

78. Ennio Francia, *Delfina de Custine, Luisa Stolberg, Giulietta Récamier a Canova: Lettere inedite* (Rome, 1972), pp. 134–57, with additional bibliography.

79. Madeleine Rocher-Jauneau, "Les Trois Graces d'Antonio Canova au Musée des Beaux-Arts de Lyon," *Bulletin des musées lyonnais* 8 (1959): 180.

80. This problematic bust is discussed by Luigi Coletti, "Unknown Works of Antonio Canova," *Art in America* 16 (1928): 83.

81. Moulard, 2:195–98.

82. Patrizi, trans. Fraser, pp. 46–48.

83. Francia, pp. 29–45, records her correspondence with Canova.

84. Honour, ed., *Scritti, I,* pp. 317–18.

85. Pélissier, 3:413–17.

86. Canova's friends Giuseppe Bossi and Count Leopoldo Cicognara, however, while hardly Bonapartist partisans, were more politically progressive than Canova and were less negative toward Napoleonic France than most of the sculptor's friends. Cicognara had even held office under the Cisalpine Republic. Both men, however, changed their political tune at the fall of the empire, especially Cicognara, who became a cultural bureaucrat for the Habsburgs in Austrian Venice.

CHAPTER 5

1. Francis II was emperor of the Austrian crown lands, king of Hungary and Holy Roman Emperor until Napoleon's dissolution of that venerable institution in 1806. Francis was the second of the

name to be Holy Roman Emperor, but the first Franz to be emperor of Austria, so he became simply Francis I in 1806. I use the original form, Francis II, to avoid confusion.

2. D'Este, p. 81.

3. Ibid., p. 82. It should be recalled that D'Este's biography, published in 1864, gives its author a greater role in Canova's affairs outside the studio than he probably played. It also lionizes the studio chief at the expense of his enemy, Sartori-Canova, the sculptor's half brother, who is one of the heroes of Missirini's biography.

4. For Canova's design process for *Hercules and Lichas* in 1795–96, see my article "Antonio Canova's Drawings for 'Hercules and Lichas,'" *Master Drawings* 27 (1989): 358–67.

5. Elena Bassi, *La gipsoteca di Possagno,* pp. 107–9; see also idem, *II Museo Civico di Bassano: I disegni di Antonio Canova* (Venice, 1959), pp. 71–94.

6. The letter is quoted in E. Arrigoni degli Oddi, "Sul carteggio fra Antonio Canova e Daniele degli Oddi," *Atti del Reale Istituto Veneto di Scienze, Lettere ed Arti* 81 (1921–22): 538. "lo lavoro come un disperato, e lavoro ancora per trarmi dal capo quei pensieri che mi molestarebbero. . . . L'Ercole' non è per anco incominciato nel marmo attesochè il masso che mi è arrivato è cattivo, ed'io voglio farlo un'altro migliore. . . ."

7. Gaetani's problems in relation to the commission for *Hercules and Lichas* are summarized in Pavanello and Praz, pp. 106–7.

8. "Voi già sapete che a Roma io stavo lavorando per certo signore di Napoli un gruppo rappresentante 'Ercole furioso che getta lica nel mare,' e questo della grandezza del celebre 'Ercole Farnese.' Non so poi se io v'abbia mai raccontata la storiella di certi Francesi sopra di quel gruppo. Questi dicevano che tal'opera avrebbesi dovuto collocarla a Parigi, che l'"Ercole' sarebbe stato l'"Ercole francese,' che gettava la Monarchia al vento. Voi ben sapete ancora se io per tutto l'oro del mondo avessi mai aderito a tale idea. Ma ora questo 'Ercole' non potrebb'egli forse essere inverso della proposizione dei Francesi? Non potrebb'essere Lica la licenziosa libertà? Nel piedestallo poi del gruppo vi si potrebbe scolpire qualche fatto dei più interessanti. Cosa ne dite?" Quoted in Giuseppe Consolo, *Ercole e Lica di Antonio Canova che Verona acquistava per eternare la memoria della battaglia dei 5 aprile 1799* (Padua, 1839), pp. 13–14.

9. "In questo modo il monumento sarebbe di gia avanzato, giacchè il signore di Napoli, attese le accadute circostanze, mi lascia in libertà il lavoro. . . ." This part of the letter is quoted in Ottorino Stefani, *La poetica e l'arte del Canova* (Treviso, 1984), p. 79 n. 6.

10. Quoted in Consolo, pp. 16–17. "Viva Verona! si vede che quella Città ama sempre il bello; ed il gusto fino di que' signori ha lor fatto cogliere subito il punto. Essi hanno veduto che il gruppo calza a meraviglia con le circonstanze presenti, e che in questo modo potranno avere anche un'opera di uno stile che, se lo scultore non ismentisce, essa si potrà certamente vedere con piacere anche da qui a secoli; quando nel gusto moderno sarebbe stato assai difficile il poter fare un lavoro da meritarsi un solido compatimento."

11. Malamani, *Canova,* pp. 68–70.

12. Paravia, pp. 31–32.

13. ". . . mentre riconosce in una tal brama un nuovo contrassegno di quel suddito attacamento che in sì particolar modo distingue i veronesi, è però troppo sensibile ai danni sofferti appunto in questi ultimi tempi da codesta Provincia onde permettere per ora un nuovo aggravio a codesti abitanti per la verificazione del progettato trofeo, e [per non bramare] che l'esecuzione di tale idea venga rimessa ad altri tempi." Quoted in Consolo, pp. 29–31.

14. The political nature of Francis II's rejection of the statue is discussed in my "Antonio Canova and Austrian Art Policy," in *Austria in the Age of the French Revolution,* ed. Kinley Brauer and William E. Wright, pp. 83–90 (Minneapolis, 1990); see also Philipp H. Fehl, "Canova's 'Hercules and Lichas,'" *North Carolina Museum of Art Bulletin* 8 (1968): 24–25 n. 49.

15. Quoted in Hugh Honour, *Neoclassicism* (Harmondsworth, Middlesex, 1968), p. 78.

16. For Torlonia's gallery and the *Hercules and Lichas,* see especially Jörgen Birkedal Hartmann, *La vicenda di una dimora principesca romana* (Rome, 1967), pp. 28–34, with illustrations of the now razed Braccio di Canova. The Palazzo Torlonia, in Piazza Venezia, was destroyed to make way for the colossal monument to Victor Emmanuel II.

17. "Questa composizione è interamente tratta dalla fantasia dell'artista, e invano vi si cerca al patetico, giacchè egli si propose l'azione tragica la più orribile, e la più spaventosa. L'infelice giovane non può oppore schermo o difesa d'alcuna sorte, invano si attiene all'altare, che già il furibondo domatore dei mostri lo ha preso per un piede e per i capegli, e sordo alle grida del dolor più mortale e dello spavento, lo strappa da ogni ritengo e lo precipita inesoratamente. [Chi conosce le arti non avrà di mestieri che lo storico lo conduca a] riflettere sull'immensa difficoltà di esprimere il Lica in quell'atteggiamento, nel quale nessun modello potendo prestarsi, è forza all'artista indovinarlo o coglierlo in un batta d'occhio, piuttosto che imitar la natura. Non ostante gli artisti più dotti e i più scrupolosi anatomici trovavano il Lica giustissimo." Quoted in Leopoldo Cicognara, *Storia della scultura del suo risorgimento in Italia fino al secolo di Canova,* 2d ed. (Prato, 1824), 7:180–81.

18. This document is discussed in Stella Rudolph, *Giuseppe Tambroni e lo stato delle belle arti in Roma nel 1814* (Rome, 1982), pp. 46–48, with additional bibliography.

19. Missirini, *Vita di Canova,* pp. 132–33.

20. Selva, pp. 19–20. See also D'Este, pp. 103–4.

21. The most informative study of the tomb of Archduchess Maria Christina is Selma Krasa, "Antonio Canovas Denkmal der Erzherzogin Marie Christine," *Albertina Studien* 5–6 (1967–68): 67–134. The exchange of letters in the summer of 1800 is discussed on pp. 83–84. For an inspired description of the tomb's eloquent pathos and profound appeal, see Licht, *Canova,* pp. 65–75.

22. "Le composizioni allegoriche sui monumenti sepolcrali han suscitato varie riflessioni per escluderle. Lasciamo da canto che al Canova dal dotto committente gli venner prescritte le figure simboliche nel monumento dell'arciduchessa Cristina; tuttavia egli cercò d'aggrupparle in maniera, che avvessero un'azione piuttosto che un'allegoria, essendo l'allegoria sempre argomento metafisico." D'Este, pp. 322–24.

23. Ibid., p. 224.

24. The details of the opposed positions on allegory are discussed in Krasa, pp. 73–76, with additional bibliography. For a broader contextual treatment, see Fred Licht, "Canovas Monumentalplastik," in *Ideal und Wirklichkeit der bildenden Kunst im späten 18. Jahrhundert,* ed. Herbert Beck, Peter C. Bol, and Eva Maek-Gérard, pp. 163–75 (Berlin, 1984).

25. E. C. J. Van de Vivere, *Le mausolée de S. A. R. Marie-Christine d'Autriche exécuté par le chev. Antoine Canova et expliqué* (Rome, 1805), pp. 66–67.

26. Kotzebue, 3:151–52.

27. "L'objet qui frappe d'abord nos yeux, c'est le Duc Albert de Saxe symbolisé par le génie qui drapé de la chlamyde, ce manteau militaire des Grecs, et plongé dans la plus profonde affliction, et assis sur les marches [s'appuyant sur le type de courage et] contemplant avec l'expression la plus ressentie les armes de la Maison d'Autriche, et qui, pour rendre la chose encore plus claire, tient de la main

gauche, l'ecusson de Saxe." Quoted in Van de Vivere, pp. 69–70. The sculptor would have found absurd such an encomiastic reading of the figure of the winged genius of death as a mourning Albert.

28. "Le bouclier des Teutons convient parfaitement à la fille du Chef de l'Empire Germanique. Un bouclier de forme ronde et étrusque, appartient à un Prince originaire d'Italie et symbolysé par un de ces êtres allegoriques, qui jouent un si grande rôle sur les monuments des peuples de l'Etrurie, dont le vaste empire comprenoit jadis tous les états, que dans le suite des temps, la Maison d'Este a occupés en Italie." Quoted in ibid., pp. 70–71. Maria Christina was the sister of both Marie-Antoinette and Queen Caroline of Naples and was the aunt of Francis II. Albert of Saxe-Teschen was a member of the Habsburg cadet branch that had ruled the old D'Este duchy of Mantua until it was suppressed and absorbed by Napoleon into the Cisalpine Republic and, subsequently, into the Kingdom of Italy. It returned to Habsburg rule in 1814.

29. "Di ciò appunto sono impazientissimo, come dell'effetto che produrrà l'opera negli animi di questo Pubblico." Quoted in Luigi Chiminelli and Marco Pedoni, eds., *Lettere di Antonio Canova al conte Tiberio Roberti,* Nozze Roberti-Chemin (Bassano, 1864), pp. 10–11.

30. Giulio Coggiola, "Della libreria del Sansovino al Palazzo Ducale: Un episodio della vita della Marciana 1797–1812," *Rivista delle Biblioteche e degli Archivi* 16 (1905): 46.

31. Pavanello and Romanelli, eds., pp. 304–6.

32. This letter is quoted in Antonio Bertoldi, ed., *Sei lettere autografe di Antonio Canova tratte dal Museo Civico e Raccolta Correr di Venezia,* Nozze Martinati-Pigorini (Venice, 1879), pp. 14–16.

33. "Ieri ho veduto il busto da voi fatto del Sovrano; ed al primo colpo d'occhio si deve dire da chiunque ch'è un principe della Casa d'Austria. Tutti poi quelli che conoscono personalmente Francesco II, dicono essere perfettamente somigliante. Gli avete infusa l'anima, e la testa è girata con tal imponente dolce maestà che spira rispetto e confidenze. . . ." Selva, pp. 45–46.

34. Ibid., p. 46.

35. The imperial seizure of the papal town of Comacchio in the Legation of Ravenna during the War of the Spanish Succession (1701–13) did much to sour Austro-papal relations, which had reached a zenith in the heady days of the siege of Vienna. Josephinism and Austrian territorial ambitions in the Legations continued this negative trend for the rest of the eighteenth century, even though Austria and Rome were often on the same side in European political and religious conflicts. For Pius VII and Austria, see Alan J. Reinerman, *Austria and the Papacy in the Age of Metternich: Between Conflict and Cooperation* (Washington, D.C., 1979), pp. 1–7, with additional bibliography.

36. This is discussed briefly in Ferdinand Boyer, "Les embellissements de Rome au temps de Napoléon," *Revue des études napoléoniennes* 34 (1932): 228–29.

37. See Chapter 4 for the discussion of Venice's wedding gift to Francis II.

38. "Come si fa a dire 'no' a Canova?" Quoted in Vittorio Malamani, *Memorie del conte Leopoldo Cicognara tratte dai documenti originali* (Venice, 1888), 2:171–72.

39. Leopoldo Cicognara, *Omaggio delle provincie venete alla maestà di Carolina Augusta Imperatrice d'Austria* (Venice, 1818). Before *Polyhymnia* was sent to Vienna, it was exhibited in Venice among the masterpieces of Venetian painting restored to the city through Canova's offices with the help of Francis II. The exhibition, created by Cicognara, became a paean to the very concept of "restoration," artistic as well as political. See Leopoldo Cicognara, *Lettera sulla statua rappresentante la musa Polinnia scolpita dal M. Antonio Canova* (Venice, 1817), especially pp. 20–21.

40. For this still controversial acquisition and the history of the removal and purchase of the Athenian sculptures, see J. Rothenberg, *"Descensus ad Terram": The Acquisition and Reception of the El-*

gin Marbles (New York and London, 1977), with additional bibliography. See also William St. Clair, *Lord Elgin and the Marbles* (London, 1967).

41. The problem of a monument to Napoleon on the rather generic theme of Theseus slaying a centaur was first recognized by Licht, *Canova,* p. 198, whose discussion of the sculpture prompted my own interest in it as an almost antipolitical (not apolitical) statement in its Austrian context.

42. Milanese complaints about ceding the statue to the emperor were more vocal because a mosaic copy of Leonardo's *Last Supper* had been transferred from the Brera to Vienna. See Memes, pp. 416–17.

43. The exemption of the work from import duties as a mark of imperial financial favor is recorded in Adorno Bazzani and Marco Banzolini, *Erettosi nell'oratorio del nobile conte Luigi Tadini in Lovere in memoria dell'estinto suo figlio Faustino un monumento in marmo opera del sommo scultore marchese commendatore Antonio Canova la populazione di Lovere provincia di Bergamo dedica allo stesso celebre scultore alcune poesie* (Bergamo, 1821), pp. 5–6.

44. One further Austrian commission should be mentioned here—the seated portrait *Princess Leopoldina Esterhazy Leichtenstein* that was commissioned by her father. Although not a member of the immediate imperial family, Leopoldina had elevated social connections in Vienna and was a member of two of the most cultivated and aristocratic families in the empire, the Hungarian Esterhazys and the Austrian Leichtensteins. These families both had art collections of enormous prestige, second in quality only to the imperial collections. The princess's reputation as an amateur landscape painter perhaps attracted Canova to the commission. He shows her poised to begin sketching a landscape in preparation for making a painting. Canova was highly supportive of many women artists, both amateurs like Leopoldina Leichtenstein and professionals like Teresa Benincampi and Marianna Pascoli. See Bottari and Ticozzi, eds., 8:209, for a letter of encouragement to Pascoli dated August 14, 1816(?). For the successful exposition of *Princess Leopoldina Esterhazy Leichtenstein* in the sculptor's studio, see Guattani, 4:83–84.

CHAPTER 6

1. Cicognara wrote the letter in Venice on March 8, 1817, in reference to his continuing work on the monumental *Storia della scultura.* According to the president of the Venetian Academy, other factors that led to the rise of what we now, somewhat uncomfortably, label neoclassicism were the massive archaeological excavations of the eighteenth century, the rediscovery of Herculaneum, the books with engraved illustrations of ancient monuments and Greek vases, the excavations and published drawings of the imperial bath complexes, the publication of the illustrations of the restored Vatican Stanze with frescoes by Raphael, the enlargement of the Pio-Clementino Museum, the publication of engravings after the works of ancient sculpture in the Capitoline Museum, the works of Piranesi, the restoration of ancient monuments in Rome and elsewhere, and the promotion of scholarship. This is the most comprehensive and insightful listing I have encountered. The letter is quoted in Luigi Rusconi, ed., *Lettere inedite di Leopoldo Cicognara ad Antonio Canova* (Padua, 1839), p. 29.

2. This opinion was also stated by Claudia Refice, "Antonio Canova e gli inglesi," *English Miscellany* 3 (1952): 224–25. The disruption of trade in the fine and decorative arts in time of war deserves more attention. For an intelligent discussion of the issue in a different contemporaneous context, see Maurie D. McInnis and Robert A. Leath, "Beautiful Specimens, Elegant Patterns: New York Furniture for the Charleston Market, 1810–1840," *American Furniture* 4 (1996): 139–42. This text discusses

the cessation of British furniture imports into the American South resulting from the 1808 Embargo Act and the War of 1812. In this instance, the old pattern of patronage never revived, and Charlestonians turned to other sources. I thank Professor McInnis for a stimulating discussion of this issue.

3. The philosophical implications of this observation are discussed briefly by Carlo Del Bravo, "'Idee' del Canova," *Intersezioni* 7 (1987): 78–80.

4. Refice, pp. 221–24. The author states, however, that Canova's relationships with the British (save Hamilton) were generally superficial, a judgment with which I strongly disagree.

5. "Pasassimo poi da Monsieur Hamilton Pittore eccellente, che mi piaque all'estremo, vidi un Quadro rapresentante la morte di Lugrezia, così bene inventato e di bel carattere secondo l'uso antico il colorito poi non mi parve tanto eccellente. . . ." The entry is dated January 5, 1780. Quoted in Bassi, *Quaderni di viaggio,* p. 59. For Hamilton's activities in Rome, see especially David Irwin, "Gavin Hamilton: Archaeologist, Painter, and Art Dealer," *Art Bulletin* 44 (1962): 87–102.

6. ". . . uomo molto ingienuo, e intendentissimo della buona strada e eccellente pittore. . . ." Quoted in Bassi, ibid., p. 137. The entry is dated June 4, 1780. With Hamilton at the viewing were Zulian, the abbate Puccini, the sculptor Giuseppe Angelini, and the painter Giuseppe Cades, among others.

7. Hamilton's view is given in greater detail in Hugh Honour, "Theseus and the Minotaur," *Victoria and Albert Museum Yearbook* 1 (1969): 4–5.

8. Canova's intervention on Flaxman's behalf is discussed in David Irwin, "Flaxman: Italian Journals and Correspondence," *Burlington Magazine* 101 (1959): 216–17. For an introduction to Hervey's patronage, see especially Brinsley Ford, "The Earl-Bishop: An Eccentric and Capricious Patron of the Arts," *Apollo* 99 (1974): 426–34. Hervey's misfortune in his dealings with Canova was to complain of the sculptor's prices in his hearing, a miscalculation that caused Canova always to refuse to work for him despite apologies and entreaties. A similar circumstance caused a great deal of embarrassment to Giovanni Torlonia about the price of *Hercules and Lichas.* Although the sculptor usually left the financial aspects of his business to Antonio D'Este, he was sensitive about the worth of his creations.

9. Hugh Honour, "Canova and the Anglo-Romans, II," *Connoisseur* 144 (1960): 230–31.

10. For Hewetson's activities in the papal city, see Terence Hodgkinson, "Christopher Hewetson, an Irish Sculptor in Rome," *Walpole Society* 34 (1952–54): 42–54. Among their mutual connections were Don José Nicola d'Azara, the Spanish ambassador to Rome whom Canova admired and whose portrait bust Hewetson made, and Cardinal Giambattista Rezzonico, who patronized Hewetson and whose family was very close to the Venetian artist.

11. Fintan Cullen, "Hugh Douglas Hamilton in Rome, 1779–1792," *Apollo* 115 (1982): 87–89; for his letters to Canova see idem, "Hugh Douglas Hamilton's Letters to Canova," *Irish Arts Review* 1 (1984): 31–35.

12. For this identification see Hugh Honour, "Canova's Diary (1779–1780)," *Arte veneta* 13–14 (1959–60): 254–55.

13. The Anglo-Roman artists' community is discussed in greater detail in Honour, "Rome of Pacetti," pp. 372–73. The author based his observations on the original diary "Giornale di Vincenzo Pacetti dall'anno 1773 fino all'anno 1803," MS 321 in the Biblioteca Alessandrina, Rome.

14. Francis Russell, "A Distinguished Generation," *Country Life* 175, no. 4530 (June 14, 1984): 1746–47.

15. Sándor Baumgarten, *Le crépuscule néo-classique: Thomas Hope* (Paris, 1958), pp. 87–89. See also David Watkin, *Thomas Hope, 1769–1831, and the Neo-Classical Idea* (London, 1968), pp. 39–40.

16. The enmity of many local artists; the death of Pompeo Batoni, who had encouraged Canova;

and his not being made a member of the Accademia di San Luca until 1800 all prompted the sculptor to find inspiration and support among the more progressive, classicizing artists and patrons of the British community. Their affluence and urge to collect also helped orient the ambitious young sculptor in their direction.

17. D'Este, p. 322. See also R. W. Liscombe, "Canova, Aberdeen, and the Pitt Monument," *Burlington Magazine* 119 (1977): 700–705.

18. For an extended discussion of Settecento Anglophilia in Italy, see especially Arturo Graf, *L'anglomania e l'influsso inglese in Italia nel secolo XVIII* (Turin, 1911), especially pp. 391–412. Wedgwood porcelain is a good example of this healthy reciprocity. Flaxman's designs were inspired by "Etruscan" vases found in Italy and widely collected by the British. Products of Wedgwood's Etruria factory influenced by the ancient Italian past became very popular in Italy.

19. This question has been addressed by Honour, ed., *Scritti, I,* pp. 231–34, who discusses a small book in the Canova archives at Bassano del Grappa with handwriting in English by the sculptor that indicates it was a lesson book. One page bears the date September 14, 1792.

20. Haskell and Penny, pp. 87–88, with an illustration and bibliography.

21. P. O. Verrua, *Nelson nel pensiero e nell'arte del Foscolo e del Canova* (Padua, 1919), pp. 8–11: ". . . se S. M. non ordinava diversamente. . . ."

22. Isabella Teotochi Albrizzi, *Opere di scultura e di plastica di Antonio Canova* (Pisa, 1821–24), 2:129–40.

23. Quatremère praised it as ". . . une conception grande et propre à recevoir toutes les magnificences de la sculpture." Quatremère de Quincy, *Canova et ses ouvrages,* pp. 97–98.

24. Stefani, *I rilievi di Canova,* p. 108.

25. D'Este, p. 333.

26. Muratori's biography of Zeno forms part of volume 19 of the *Rerum Italicarum Scriptures* of 1731. See Verrua, pp. 18–23, for this tantalizing historical connection.

27. Hugh Honour, "An Italian Monument to Nelson," *Country Life Annual* (1962): 137.

28. Albrizzi, *Opere di Canova,* 3:129–30.

29. Honour, "Monument to Nelson," pp. 137–38.

30. Verrua, pp. 16–17, mentions Fontana's engraving after a Nocchi design of 1806. This could be a drawing but, given Nocchi's other work for Canova, it was probably based on a painting. A letter of April 1810 by Nocchi complains of the labor involved in painting the *modello* he was then executing. Nocchi, from Lucca, had been making paintings after Canova's sculptures for the engravers since 1803. See Roberto Giovanelli, "Nuovi contributi per Bernardino Nocchi," *Labyrinthos* 7–8 (1985): 150. There may have been two paintings by Nocchi, one of 1806, the other, 1810. Another possibility is that Verrua was mistaken about the 1806 dating; I have been unable to trace that particular engraving. In 1810 Canova was a French subject, and the engraving made after the painting about which Nocchi was complaining in 1810 was not published until 1814, shortly after Bonaparte's Fontainebleau abdication. See Hugh Honour, "Canova e l'incisione," in *Canova e l'incisione,* ed. Grazia Pezzini Bernini and Fabio Fiorani (Bassano del Grappa, 1993), p. 17.

31. *The Age of Neoclassicism,* exhibition catalogue (London, 1972), p. 206, under entry 319.

32. Da Sesso and Marton, pp. 89–90.

33. For the patronage of Italian sculpture by Britons in the immediate post-Napoleonic period, see especially John Kenworthy-Browne, "British Patrons of Sculpture in Italy, 1814–1830," in *La scultura nel XIX secolo,* ed. Horst W. Janson, Atti del XXIV congresso internazionale di storia dell'arte, vol. 6

(Bologna, 1979), pp. 45–48. For the history and vicissitudes of Bedford's *Three Graces,* see *The Three Graces: Antonio Canova,* ed. Hugh Honour et al., exhibition catalogue (Edinburgh, 1995), especially pp. 19–60, with additional bibliography. The duke of Bedford's attempt to sell the statue to the J. Paul Getty Museum touched off one of the most spectacular legal controversies in recent memory. The group sculpture remains in Britain.

34. See St. Clair, pp. 227–28; and Rothenberg, pp. 366–75. Although Rothenberg questions the sincerity of Canova's enthusiasm, I believe his skepticism unwarranted.

35. Joseph Farington, *The Diary of Joseph Farington* (New Haven, Conn., and London, 1978–84), 13:4,743–44, December 1, 1815.

36. Ibid., entry 4,746, December 5, 1815. An earlier entry dated November 22, 1815, that indicates Canova's high opinion of the Elgin marbles and his admiration of the Raphael tapestry cartoons he saw at Hampton Court Palace also mentions that he was then a guest of the duke of Bedford at "Wooburn," advising him on the installation of *The Three Graces.*

37. "Il signor Lawrence è un uomo grande assai nel fare ritratti. Egli ha la bravura di saper coglier ognuno nel miglior momento; cosa molto difficile! Dipinge poi con un bel gusto di colorito. Egli è incantato delle belle opere de' nostri maestri veneziani." Quoted in Bottari and Ticozzi, eds., 8:229–30. In 1819 Canova wrote to Cicognara in Venice, introducing Lawrence as "this learned and amiable artist." Quoted in Malamani, *Un'amicizia di Canova,* p. 174.

38. Canova's activities as a cultural diplomat in Paris in 1815 are the subject of Chapter 7.

39. For the broader context of this thaw in diplomatic relations between London and Rome, see Gary Mooney, "British Diplomatic Relations with the Holy See, 1793–1830," *Recusant History* 14 (1978); 200–202. On his way back to Rome from captivity, Pius celebrated Easter Mass at Imola cathedral, where he had previously been bishop. Lord Bentinck, commander of the British forces in Italy, approached the pontiff there on behalf of the Prince Regent and gave him 50,000 francs for the expenses of his return from France (the source says 50,000 zecchini, an astonishing sum for the purpose; francs must have been meant). He added George's best wishes for a safe journey and the return of peace to the Papal States and to Italy. This is recorded in Giucci, 2:95.

40. D'Este, pp. 220–21.

41. "Commissioni senza numero avrei potuto ricevere dagl'Inglesi, se quelle che ho non mi tenessero già occupato per molti anni ancora. Solamente per il Principe Reggente farò un gruppo ideale di Venere e Marte, simboleggiante la Pace e la Guerra. Gli onori fattimi da quella illustre e generosa nazione, fur molti e grandi. Il principe Reale mi presentò d'una superba tabacchiera brillantata, e conteneva un magnifico dono." Quoted in Malamani, *Un'amicizia di Canova,* p. 62.

42. For a discussion of the Cork academy and the papal casts, see William Carey, *Some Memoirs of the Patronage and Progress of the Fine Arts, in England and Ireland, during the Reigns of George the Second, George the Third, and his Present Majesty; with Anecdotes of Lord de Tabley, of other Patrons, and of Eminent Artists, and Occasional Critical References to British Works of Art* (London, 1826), pp. 253–57.

43. "Per mezzo di questi gessi abbiamo finalmente una vera idea dei lavori di quel rinomatissimo principe dei Greci scultori, onde assicurarsi anche del merito dei lavori di Greco scalpello, de' quali abbiamo in Roma varj indubitati capi d'opera, sebbene in altro stile." Quoted in Massimiliano Pavan, "Antonio Canova e la discussione sugli 'Elgin Marbles,'" *Rivista dell'Istituto Nazionale d'Archeologia e Storia dell'Arte* 21–22 (1974–75): 292.

44. Canova's letter is quoted in Malamani, *Un'amicizia di Canova,* pp. 174–75.

45. Stella Rudolph puts the amount at 50,000 francs; see "Il monumento Stuart del Canova: Un

committente dimenticato e il primo pensiero ritrovato," *Antologia di belle arti* 4 (1980): 44–45. A much lower estimate of 5,000 francs is made by Lilli, p. 63.

46. For a brief eulogy of Cardinal York, see Nicholas Patrick Stephen Wiseman, *Recollections of the Last Four Popes and of Rome in Their Times* (London, 1858), pp. 101–2. Cardinal Wiseman called Canova's Stuart cenotaph "not the happiest production of his chisel." As a young English Catholic priest in Rome when the monument was unveiled, he would probably have taken a particular interest in it. See also James Lees-Milne, *The Last Stuarts: British Royalty in Exile* (New York, 1984), especially pp. 143–78.

47. Rudolph, "Il monumento Stuart del Canova," pp. 45–46; and Andrea Zanella, pp. 31–32.

48. "In questo monumento da me intrapreso per assecondar le premure del Principe Reggente il quale ha voluto cooperare alle spese, con una somma che mi deve alla fine bastare per il prezzo del tutto, ho studiato e studio di porre ogni mio zelo per dare con questa opera una qualche prova di grato omaggio a S. A. R. il Principe Reggente a cui debbo tanto, a Lei ed al nostro Card. Consalvi." Quoted in Francia, *Canova: Lettere inedite,* p. 100 n. 2.

49. "Niuno è più persuaso di Nostra Santità, che i due Genj scolpiti con una estrema eleganza e verità, al mausoleo degli ultimi avanzi dell'illustre famiglia Stuart, non hanno di che portare scandalo ed animadversione negli animi ben intenzionati; e niuno quindi è più animato della Santità Sua a farne i dovuti elogi. . . . Ma non tutti vogliono rassegnarsi al giusto modo di vedere degli uomini savi. [D'altronde in certe materie il Santo Padre per istituto e per uso è lontano di far forza all'istanze, e specialmente se le vede patrocinate da soggetti forse in equivoco, ma rispettabili giacchè la condizione umana pur troppo espone agli equivoci. Tutto ciò posto,] non posso dispensarmi del pregarla d'un provvedimento circa gli stessi Genj, [del modo che di mia commissione le ha parlato il Sig. Alessandro D'Este]. Il S. Padre tutto rimette a lei, alla conosciuta di lei superiore abilità, ed alle di lei massime di morale e di religione, che gli son ben note, e di cui giornalmente dà prova." Quoted in D'Este, p. 459.

50. Ibid., pp. 270–72. D'Este compared the proposal to the covering of the nude passages in Michelangelo's *Last Judgment* by Danielle da Volterra under Pope Pius IV.

51. Licht, *Canova,* p. 219.

52. For the Lawrence portrait, see especially Michael Levey, "Lawrence's Portrait of Pope Pius VII," *Burlington Magazine* 117 (1975): 194–204, with additional bibliography.

53. Quatremère de Quincy, *Canova et ses ouvrages,* pp. 252–60, states that the Romanzov *Peace* celebrated the defeat of Napoleon and the return of Pius VII to Rome, but he was wrong. The error was corrected by Malamani, *Canova,* pp. 186–87. I thank my colleague Robert Geraci for help in sorting out the Russian treaties and their political implications. This sculpture and the circumstances of its creation are discussed in *Canova all'Ermitage: Le sculture del museo di San Pietroburgo,* exhibition catalogue (Rome, 1991), pp. 43–44. I have been unable to obtain a photograph of the work, which is in the Museum of Western and Oriental Art, Kiev, Republic of Ukraine.

54. "Vedesi ivi maestosa una donna da recenti stragi circondata, tutta coperta di gramaglie, simboleggiante l'Europa vicina ad essere lacerata da novelle guerre, la quale disperatamente alzando e stendendo verso il furibondo Nume della guerra, per arrestarlo. . . ." Albrizzi, *Opere di Canova,* 2:39–42.

CHAPTER 7

1. Consalvi was the central player in the decision to send Canova to Paris, having done much to overcome the artist's initial reluctance. See John Martin Robinson, *Cardinal Consalvi, 1757–1824* (Lon-

don, 1987), pp. 120–21. A French scholar during the Second Empire divined a curious reason for the sculptor's refusal to undertake the task. He wrote, "Il n'oubliait pas la belle hospitalité qu'il avait reçue en France, les honneurs et les applaudissements dont il y avait été comblé," adding that Canova had seen Paris in its glory and, as with Venice, he had no wish to see its humiliation. Such absurd reasoning runs counter to an enormous amount of historical evidence. It exemplifies how the historian's beliefs and context influence the writing of history, something that always occurs, but not always so egregiously as in Adolphe de Bouclon, *Canova et Napoléon* (Paris, 1865), pp. 78–79. The most recent investigation of Canova's travels to Paris and London in 1815 is Katharine Eustace, "'Questa scabrosa missione': Canova in Paris and London in 1815," in *Canova: Ideal Heads* (Oxford, 1997), pp. 9–38. This excellent publication includes important new documents, especially those relating to the sculptor's English sojourn.

2. Luigi Berra, "Opere d'arte asportate dai Francesi da Roma e dallo stato pontificio e restituite nel 1815 dopo il Congresso di Vienna," *Rendiconti della Pontificia Accademia Romana di Archeologia* 27 (1951–54): 239–40.

3. Angela Zucconi, "Antonio Canova e Luigi I di Baviera," *Nuova antologia* (October 1, 1941): 223–25. Crown Prince Ludwig had commissioned versions of *Venus* and *Paris,* both of which are still in Munich. He and Canova had an open break over the export of the Barberini Faun from Rome. The sculptor's dogged resistance and opposition caused Ludwig many problems; he obtained an export license only after putting intense political pressure on the pontifical government.

4. These activities are conveniently summarized by Massimiliano Pavan, s.v. "Canova, Antonio," in *Dizionario biografico degli Italiani,* 18:212–13.

5. The diplomatic difficulties presented in 1815 by the Treaty of Tolentino are discussed in relation to Canova's third trip to Paris in Missirini, *Vita di Canova,* pp. 377–80.

6. "Le truppe regicide della Repubblica Francese dopo aver immerso negli orrori l'Italia, invasero senza essere provocate i pacifici Stati della Chiesa e constrinsero la S. M. di Pio VI a ricomprarsi la pace e l'esistenza politica anche col sacrificio doloroso dei più celebri monumenti delle arti in pittura e scultura. Le stesse truppe francesi tornarono senza essere provocate ad invadere nuovamente gli Stati della S. Sede, detronizzarono e imprigionarono quello stesso Pontefice che avevano poco prima forzato a cedere tutto quello che avevano voluto. Ed in questa seconda invasione compirono lo spoglio dei Capi d'opera dell'arte. [Roma che per la riunione di tanti insigni monumenti e per la stessa qualità del suo clima pare destinata dalla natura ad essere la Sede delle arti, la maestra e l'educatrice della gioventù studiosa, ne pianse e ne piange ancora la perdita e con Roma la piangono allievi di tutte le Nazioni che qui si portano ad istruirsi]." This passage from Canova's credentials has often been discussed; I have used the text quoted in Ennio Francia, *Pinacoteca Vaticana* (Milan, 1960), p. 21.

7. Quoted in Cecil Gould, *Trophy of Conquest: The Musée Napoléon and the Creation of the Louvre* (London, 1965), pp. 120–21.

8. An especially interesting description of this problematic group sculpture is found in Isabella Teotochi Albrizzi, *La Deposizione di Cristo tavola da altare di Antonio Canova* (Treviso, 1822), which is mostly devoted to the painting, which Canova had begun in 1798–99. It had originally stood in the parish church but eventually was placed on the high altar of the Tempio at Possagno.

9. For a glimpse into Canova's private life during the difficult weeks in Paris, see Luiso, pp. 424–25.

10. Missirini, *Vita di Canova,* pp. 392–93.

11. Canova's letter states that the packing was to begin at seven A.M., aided by Prussian troops under the command of General Müffling, the military governor of Paris. He also wrote that Sartori-

Canova enlisted Luigi Angeloni's assistance. See Annibale Campani, "Nuovi documenti sull'opera di Antonio Canova pel ricupero dei monumenti d'arte italiani a Parigi (Corrispondenza Canova-Angeloni)," *Archivio storico dell'arte* 5 (1892): 189–90.

12. Rava, pp. 37–39.

13. For the general popularity enjoyed by the pope in the years after the Restoration, see especially Olson, pp. 77–93.

14. Quoted in Quynn, p. 446.

15. Quoted in Ian Jenkins, *Archaeologists and Aesthetes in the Sculpture Galleries of the British Museum, 1800–1939* (London, 1992), p. 15, with additional bibliography.

16. Quoted in Quynn, pp. 448–49, who gives the original citation to the published papers of the Historical Manuscripts Commission.

17. For Farington's belief that the pope would sell some of his collection that might be purchased for the British Museum, see the entry for September 16, 1815, in Farington, 13:4,707.

18. John Tracy Ellis, *Cardinal Consalvi and Anglo-Papal Relations, 1814–1824* (Washington, D.C., 1942), pp. 168–69.

19. "... impiegando i suoi valevoli ufficj in una restituzione che sarà rammentata con eterna riconoscenza da Roma, e applaudita con trasporto da tutta Europa. ..." Quoted in Francesco Lemmi, "Documenti sulla restituzione delle opere d'arte e di antichità trasportate in Francia durante la Repubblica francese e l'Impero," *Revue napoléonienne* 7 (1902): 267.

20. Quoted in Gould, p. 134. It should be mentioned that the duke was an admirer of Pius VII. At his London residence, Apsley House, where he displayed Canova's *Napoleon as Mars the Peacemaker,* he hung Pius's portrait between portraits of Pauline Bonaparte Borghese and the dancer La Grassini, prompting the future Charles X of France to observe that Pius's portrait was "like Our Lord between the Two Thieves." This anecdote is recorded in Levey, p. 199.

21. Quoted in Levey, p. 199. British help in rescuing the Legations of Bologna, Ravenna, and Ferrara from the covetous grasp of Austria must also have pleased the pope.

22. Ibid., p. 202.

23. Malamani, *Un'amicizia di Canova,* pp. 59–60, quotes the entire letter.

24. Massimiliano Pavan, "La visita a Londra del Canova nel 'Diary' del pittore Joseph Farington," *Atti Istituto Veneto di Scienze, Lettere ed Arti* 135 (1976–77): 269–72. Canova was Principe of the Accademia di San Luca and had been president, since 1812, of the Accademia Romana di Archeologia.

25. Gould, pp. 116–18.

26. This interesting tit for tat is related in Giucci, 2:162–63.

27. "Il signor principe Metternich acconsente che io profitti di un suo corriere per mandare la presente a Vostra Eminenza [then at the Congress in Vienna]. È questo un nuovo atto di bontà per me e per la causa delle arti sostenute dalla particolare protezione dell'Imperatore e dell'A. I. Io non Le potrei descrivere con brevità il dettaglio di questo affare, il quale finalmente, mediante li buoni ed autorevoli uffizi del principe, così zelante al nostro bene, riescii al'effetto tanto desiderato, avendo le altre potenze risoluto [nel congresso del 30 p.p.] di porre anche Roma nel diritto di riavere gli oggetti d'arte da essa perduti." In Alessandro Ferraioli, ed., *Lettere inedite di Antonio Canova al Cardinale Ercole Consalvi* (Rome, 1888), p. 12. The glowing references to Metternich may have been due partly to the sending of Canova's letter to Consalvi in the Austrian diplomatic pouch; the wily minister was not above reading other people's mail.

28. Canova's letter is quoted in Malamani, *Un'amicizia di Canova,* pp. 59–60.

29. "Vi sarete accorti ch'egli affetta sempre un misticismo, del quale sì dubita pur sempre se sia scenico o sincero. Nè sì dipartì del consueto anche in quella occasione. Egli era fermissimamente contrario al ripigliare i monumenti: e non volle ricevere l'inviato del Papa, [che li reclamava, e gli fece dire da Capo d'Istria che nol riceveva, perchè non poteva dargli una repulsa, e darla non voleva a un tale uomo]. Bello è poi che un scismatico faceva osservare al padre de cattolici che non li doveva reclamare, perchè l'Evangelio commanda di dare la tonaca a chi ha rapito il mantello. L'inviato papale faceva replicare a S. M. che dunque ella avrebbe dovuto dar Pietroburgo a chi gli aveva bruciato Mosca: e però si lasciasse l'Evangelio da parte. [Nota che i Romani erano stati accorti di domandare le cose loro non solo in onore del Papa, come principe, ma anche in onore del *Senato e popolo Romano*.]" Quoted in Massimiliano Pavan, "Luigi Angeloni, Antonio Canova e Pietro Giordani," *Studi romani* 20 (1974): 468–69.

30. Quynn, pp. 459–60.

31. Typical views opposing restitution on legal grounds are those of Ferdinand Boyer, "A propos de Canova et de la restitution en 1815 des oeuvres d'art de Rome," *Rivista italiana di studi napoleonici* 4 (1965):18–24; and of Eugène Müntz, "Les invasions de 1814–1815 et la spoliation de nos musées," *La nouvelle revue* 115 (1897): 703–16; 117 (1897): 193–207 and 420–39. Boyer explains that Napoleon merely applied the art policies of the Directory and did not invent them. The cession of art by treaty seems, however, to have been General Bonaparte's idea; it continued, in Italy and elsewhere, during the Consulate and the empire. For a general discussion of Denon's role in the attempt to keep the collections intact, see Taylor, pp. 571–74, a spirited and partisan account that has several glaring factual errors.

32. "La gloire des armées françaises n'a reçu aucune atteinte: les monuments de leur valeur subsistent et les chefs-d'oeuvre des arts nous appartiennent désormais par les droits plus stables et plus sacrés que ceux de la victoire." Quoted in Ferdinand Boyer, "Louis XVIII et la restitution des oeuvres d'art confisquées sous la Révolution et l'Empire," *Bulletin de la Société de l'histoire de l'art français* (1965): 202–3.

33. Malamani, *Canova,* pp. 197–98. Canova also reminded Louis of the countless acts of kindness showed the Bourbons by Pius VII, but to no avail.

34. "Les Alliés, dit-il, étaient aussi pendant les Cent Jours les alliés de Louis XVIII; pouvaient-ils lui prendre ses collections? Pourquoi prétendre que des objets d'art ne pouvaient être acquis par la conquête aussi bien que des provinces et des peuples?" Quoted in Boyer, "A propos de Canova et de la restitution," p. 21.

35. Gould, pp. 124–26. France's retention of Rubens's *Madonna with Saints,* the first version of the Chiesa Nuova altarpiece, which had been looted by the French from the artist's mother's tomb and squirreled away in Grenoble (where it remains) is a case in point. The large number of paintings on view today in French provincial museums, above all those at Dijon, Lyon, Tours, Arras, and Bordeaux, often marked "saisi" by the French armies in Italy, is remarkable.

36. Rava, pp. 34–35. Rava calls Denon "Denau."

37. For the procession, see the excellent article by Patricia Mainardi, "Assuring the Empire of the Future: The 1798 'Fête de la Liberté,'" *Art Journal* 48 (1989): 155–63.

38. Bruno Molajoli, "Le benemerenze di Antonio Canova nella salvaguardia del patrimonio artistico," in *Da Antonio Canova alla convenzione dell'Aja: la protezione delle opere d'arte in caso di conflitto armato,* ed. Stefano Rosso-Mazzinghi, pp. 23–25, *Quaderni di San Giorgio* 35 (Florence, 1975). The French attempt to detach Correggio's famous frescoes in Parma and Canova's letter warning of the peril to the paintings the process would entail are described in Antonio Musiari, *Neoclassicismo senza modelli: L'Ac-*

cademia di Belle Arti di Parma tra il periodo napoleonico e la Restaurazione (1796–1820) (Parma, 1986). Pietro De Lama, the academy's president, had written to Canova and the Accademia di San Luca for an expert opinion he hoped would stop the French authorities from removing the frescoes.

39. "Cet artiste est venu en France sous prétexte de faire le buste de l'empereur Alexandre, mais avec la mission secrète d'interesser la Russie dans les prétensions de la cour de Rome, et de promettre, pour reconnaissance d'un tel appui, quelque chef-d'oeuvre d'antiquité. Cette négociation ayant été sans succès, M. Canova est parti pour l'Angleterre où il se flatte de trouver des esprits mieux disposés. Je ne rapporterai pas tous les mauvais raisonnements que M. Canova accumule pour faire croire que l'intérêt même des arts exige la restitution des objets cédés par le traité de Tolentino. [Un des plus forts, selon lui, peut donner la mesure des autres: il prétend que le Musée étant placé si près du Palais Royal, l'École française ne saurait jamais apprécier la pureté des objets qu'il renferme!] La conscience timorée de M. Canova est bien ingrate. Il ne sait donc pas que ses productions sont bien plus remarquables par la volupté que par la pureté des formes. Mais il ne s'agit point ici du talent ni de la moralité de M. Canova. J'ai voulu seulement rappeler à Votre Altesse toute l'importance dont le Musée est pour la prospérité de l'École française et la gloire de la France." Quoted in Müntz, "Les invasions," pp. 423–24.

40. Ibid., p. 195. See also Molajoli, pp. 37–38.

41. Denon's letter is worth quoting: "J'ai l'honneur de vous adresser le procès-verbal de la scène scandaleuse qui s'est passée hier au Musée; vous y verrez qu'un tableau de Jules Romain, le chef-d'oeuvre de ce maître, offert en hommage au gouvernement français par le corps municipal de la ville de Gênes, a été enlevé avec la plus extrême violence par le sieur Costa, commissaire du roi de Sardaigne. Cet article important mérite de fixer toute votre attention. . . . Ce tableau, par ses dimensions, n'est point d'un transport très facile. Il est peint sur bois et a 12 pieds 3 pouces de haut sur 9 pieds de large. Il sera probablement encaissé et embarqué sur la Seine. Ne serait-il pas possible de le faire arrêter par les douanes comme propriété française?" Quoted in Charles Saunier, *Les conquêtes artistiques de la Révolution et de l'Empire reprises et abandons des Alliés en 1815 leurs conséquences sur les musées d'Europe* (Paris, 1902), p. 142.

42. The ambassador's letter is dated September 24, 1815, only a week before Canova began removing the Italian works from the Louvre. "La ville de Séville ne pouvait pas donner à M. le maréchal Soult ce qui ne lui appartenait pas, ce qui . . . lui a jamais appartenu; et je connais trop bien le tableau en question depuis ma jeunesse pour ne pas savoir quel est son véritable propriétaire. L'existence de ce tableau au Museum dépend d'une origine aussi vicieuse que bien d'autres, et nous avons appris à nos dépens de quelle manière on faisait en Espagne ces donations pendant l'invasion de Buonaparte. Je pourrais, Monsieur, ajouter quelques réflexions en réponse à votre lettre, mais je me contenterai de vous dire que, dans cette affaire désagréable, j'ai employé toute la delicatesse d'un homme d'honneur, et que, pour réclamer ce qui appartient à la nation espagnole de justice et de droit, j'ai mis plus d'égards que les agents de Buonaparte en ont mis en Espagne pour nous dépouiller de ces objets. . . ." Quoted in Müntz, "Les invasions," p. 203.

43. Canova's letter to Consalvi concerning the agreement to centralize most of the works of art returned to the Papal States is dated October 2, 1815; it is quoted in D'Este, pp. 206–7.

44. Müntz, "Les invasions," pp. 429–30.

45. Bouclon, pp. 86–87.

46. While Canova was busy repacking the papal works in the museum, Marino Marini, the Vatican librarian, faced similar problems in the Royal Library. Pius VII had ordered Marini to oversee the restitutions with as much grace and tact as possible, but the French librarians responded that they

would only accede to force. With the aid of the Austrian commissioner, the baron d'Offenfels, and Prussian soldiers, Marini recovered hundreds of manuscripts and incunabula taken from papal institutions from 1796 to 1813. In addition, he returned the polylingual printing blocks that had been stolen from the Propaganda Fide, the Aldrovandi natural history collection, several important jewels, jasper vases, and a large number of objects looted in 1797 from the treasury of the shrine of the Madonna di Loreto in the Marches by General Bonaparte's troops. For more on Marini in Paris, see Müntz, "Les invasions," pp. 436–40.

47. Malamani, *Canova,* pp. 215–18.

48. ". . . un bello e conservatissimo quadro di Tiziano." Quoted in Campani, p. 193. Charles Long, a British diplomat who had also assisted Canova in a more modest way, received a variant of the ideal bust *Helen,* of which the original had been made in 1812 as a present for Countess Isabella Teotochi Albrizzi. See Eustace, ed., pp. 81–83.

49. These figures are cited in Francia, *Pinacoteca Vaticana,* p. 26.

50. Pavan, "Angeloni, Canova e Giordani," pp. 456–60.

51. Ibid., pp. 463–64.

52. Campani, pp. 195–96.

53. Both Quatremère and Winckelmann recognized the crucial link between art and a wider cultural context. Quatremère, however, avoided an essential contradiction in the Saxon scholar's ideas first observed by Herder: that if there is an organic connection between art and society, the imitation of Greek sculpture in a modern German (or Roman) artistic context seems doomed to failure. Quatremère posited a highly specific link between objects and cultural context, claiming that imitation could improve a local tradition if the proper models were followed and could even surpass the originals in excellence. But once the work was created, then its context gave it full meaning. For more on Quatremère's ideology of context, see Giuseppe Pucci, *Il passato prossimo: La scienza dell'antichità alle origini della cultura moderna* (Rome, 1993), pp. 26–28; for Winckelmannian contradictions observed by Herder and Lessing, among others, see the succinct summary in Michael A. B. Degenhardt, "Winckelmann as Art Educator," *Journal of Aesthetic Education* 20 (1986): 65–68. Both sources have additional bibliographic references, and both reflect the vast literature on Winckelmann and Quatremère de Quincy. See also Jeffrey Morrison, *Winckelmann and the Notion of Aesthetic Education* (Oxford, 1996), especially pp. 34–68.

54. For more on this argument, and for a discussion of the critique of modern museums that Quatremère helped begin, see especially Daniel J. Sherman, "Quatremère / Benjamin / Marx: Art Museums, Aura, and Commodity Fetishism," in *Museum Culture: Histories, Discourses, Spectacles,* ed. Daniel J. Sherman and Irit Rogoff (Minneapolis, 1994), pp. 123–43, with additional bibliography.

55. René Schneider, *Quatremère de Quincy et son intervention dans les arts (1788–1830)* (Paris, 1910), p. 175.

56. "Prolusione alla nuova apertura dell'accademia del Signor Cavaliere Antonio Canova Marchese d'Ischia presidente nell'anno 1816 letta il 4 luglio dello stesso anno," *Atti dell'Accademia Romana di Archeologia* 1 (1821): 33.

57. Meneghelli made his remarks at the awards ceremonies of the Accademia di Belle Arti in Venice. For his text, see Antonio Meneghelli, *Del Canova discorso letto nell'I. R. Accademia di Belle Arti in Venezia per la distribuzione de' premi nell'anno MDCCCXXVIII* (Padua, 1829), especially pp. 31–32.

1. The Risorgimento literature is vast, and a survey of it here would serve no useful purpose. A good general English introduction to the era is Stuart Woolf, *A History of Italy, 1700–1860: The Social Constraints of Political Change* (London, 1979), with additional bibliography. The chronological organization of the book is useful, but it concludes six years before the Austrians surrendered the Veneto to the Kingdom of Italy in 1866.

2. Malamani, *Canova,* pp. 271–72.

3. The details of the funeral are recorded in the memoirs of a Venetian named Giustina Michiel, quoted in Philipp H. Fehl, "Canova's Tomb," pp. 52–53.

4. There are far too many of these (often rare) commemorative publications to list here, but the events surrounding the funeral and its immediate aftermath are discussed in the major biographies, especially in Quatremère and D'Este.

5. Honour, "Theseus and the Minotaur," p. 12.

6. "Childe Harold," 4. 55, quoted in ibid., p. 15.

7. Albrizzi, *Opere di Canova,* 1:113–16.

8. The portico of SS. Apostoli also houses Canova's most famous funerary stele, the *Monument to Giovanni Volpato,* a notable engraver who helped the young Venetian artist secure the commission for the Ganganelli tomb. A female figure labeled "Amicizia" sits pensively before a pedestal on which rests the large and highly naturalistic bust portrait of Volpato.

9. *Nel centenario della morte di Antonio Canova la R. Accademia di San Luca,* exhibition catalogue (Rome, 1922), pp. 10–13.

10. For more on this failed initiative, see Carlo Pietrangeli, "Storia di un monumento sfortunato," *Strenna dei Romanisti* 23 (1962): 271–75.

11. Elizabeth Hervey, duchess of Devonshire, was an active patron and promoter of the arts in both England and Italy. She was a friend of Canova's, belonged to his circle, and was especially intimate with Cardinal Ercole Consalvi. She was a brilliant society hostess of enormous influence whose evenings in the Palazzo Roccagiovine were called the Salon of Europe by no less a personage than Germaine de Staël.

12. Elisa Debenedetti, "Il ruolo di Thorvaldsen nell'ambito delle istituzioni culturali a Roma," in *Thorvaldsen: L'ambiente, l'influsso, il mito,* ed. Patrick Kragelund and Morgens Nykjaer (Rome, 1991), pp. 45–47.

13. For Prince Camillo Borghese's and the countess of Abany's correspondence with Cicognara on the Frari cenotaph, see Gino Corti, "Canova's Funeral Monument and the Galleria Borghese: Letters from Leopoldo Cicognara and the Countess of Albany," *Burlington Magazine* 119 (1977): 500–503. Interestingly, Prince Metternich was an important supporter of the project and, among Austrian worthies, headed the subscription list.

14. ". . . mais malheureusement il est notoire qu'en 1815 Canova a quitté son ciseau pour venir à Paris se charger de la dévastation de ce Musée, dont la France déplore la perte, et dont les amis des beaux arts des tous les pays doivent, selon moi, regretter la dissemination. Cette triste page de son histoire interdit à tout français d'ajouter son nom à la liste de ceux qui lui élèvent un monument, [et ne me laisse que des regrets de ne pouvoir pas mieux repondre à la lettre que vous n'avez adressée]." Quoted in Malamani, *Memorie,* 2:324.

SELECTED BIBLIOGRAPHY

The Age of Neo-Classicism. Catalogue of an exhibition held at the Royal Academy and the Victoria and Albert Museum, September 9–November 19, 1972. London, 1972.

Agnoletto, Alberigo. *Canova e l'arte sacra.* Rome, 1922.

Albrizzi, Isabella Teotochi. *La Deposizione di Cristo tavola da altare di Antonio Canova.* Treviso, 1822.

———. *Opere di scultura e di plastica di Antonio Canova.* 4 vols. Pisa, 1821–24.

———. *La testa d'Elena scolpita in marmo dall'impareggiabile Canova e da esso relegata ad Isabella Albrizzi nata Teotochi.* 2d ed. Nozze Di Villabruna-Bernardo. Pisa, 1812.

Alle origini di Canova: Le terrecotte della collezione Farsetti. Catalogue of an exhibition held at the Palazzo Ruspoli, December 12, 1991–February 29, 1992, and at the Galleria Giorgio Franchetti alla Ca' d'Oro, Venice, March 20–September 30, 1992. Rome, 1991.

Andrieux, Maurice. *Les français à Rome.* Paris, 1968.

Antonio Canova: Tegninger fra museet: Bassano. Catalogue of an exhibition held at the Thorvaldsens Museum, Copenhagen, October 8–November 9, 1969. Copenhagen, 1969.

Argan, Giulio Carlo. *Da Hogarth a Picasso: L'arte moderna in Europa.* 2 vols. Milan, 1983.

———. "Studi sul neoclassico." *Storia dell'Arte* 7–8 (1970): 249–76.

Argan, Giulio Carlo, and Elisa Debenedetti. *Antonio Canova.* Rome, 1969.

Argan, Giulio Carlo, Giandomenico Romanelli, and Giovanni Scarabello. *Canova, Cicognara, Foscolo.* Venice, 1979.

Arrigoni degli Oddi, E. "Sul carteggio fra Antonio Canova e Daniele degli Oddi." *Atti del Reale Istituto Veneto di Scienze, Lettere ed Arti* 81 (1921–22): 523–39.

Ashby, Thomas. "Thomas Jenkins in Rome." *Papers of the British School at Rome* 6 (1913): 487–511.

Assunto, Rosario. *L'antichità come futuro: Studio sull'estetica del neoclassicismo europeo.* Milan, 1963.

———. *Verità e bellezza nelle estetiche e nelle poetiche dell'Italia neoclassica e primoromantica.* Rome, 1984.

Aubert, Roger, et al. *The Church between Revolution and Restoration.* Vol. 7 of *History of the Church,* edited by Hubert Jedin and John Dolan, translated by Peter Becker. New York, 1981.

Barbieri, Franco. *Canova: Scultore, pittore, architetto a Possagno.* Padua, 1990.

———. "Il tempio canoviano di Possagno: Fede e ragione." *Arte lombarda* 110–11 (1994): 21–23.

Bartoccini, Fiorella. *Roma nell'Ottocento: Il tramonto della "Città Santa," nascita di una capitale.* Storia di Roma, vol. 16. Bologna, 1985.

Barzoni, Vittorio. *L'Ebe di Antonio Canova ordinata e posseduta del conte Giuseppe Albrizzi.* Venice, 1803.

Bassano del Grappa. Museo Civico. *Disegni di Canova del Museo di Bassano.* Milan, 1982.

Bassi, Elena. *Antonio Canova a Possagno.* Treviso, n.d.

———. "Canova e Venere." *Arte veneta* 32 (1978): 464–68.

———. "Due diari del 1780." In *Arte neoclassica: Atti del convegno 12–14 ottobre 1957,* pp. 29–37. Civiltà Veneziana Studi, vol. 17. Venice and Rome, 1957.

———. *La gipsoteca di Possagno: Sculture e dipinti di Antonio Canova.* Cataloghi di raccolte d'arte, vol. 3. Venice, 1957.

———. *Il Museo Civico di Bassano: I disegni di Antonio Canova.* Venice, 1959.

———. *I quaderni di viaggio (1779–1780).* Venice and Rome, 1959.

Bassi, Elena, and Lina Urban Padoan. *Canova e gli Albrizzi: Tra ridotti e dimore di campagna del tempo.* Milan, 1989.

Batiffol, P., ed. "Breve indicazione dell'operato dall'Ab. Marini nell'assenza di N. S. da Roma in servizio della Santa Sede, e della causa publica, e di quanto esiste affidato alla di lui custodia, diligenza, ed onoratezza." *Bulletin de la Société nationale des antiquaires de France* (1989): 106–13.

Battisti, Eugenio. "Ragioni politiche e religiose della "Querelle" fra neoclassici e romantici." In *Arte neoclassica: Atti del convegno 12–14 ottobre 1957,* pp. 39–66. Civiltà Veneziana Studi, vol. 17. Venice and Rome, 1957.

Baumgarten, Sándor. *Le crépuscule neo-classique: Thomas Hope.* Paris, 1958.

Bazzini, Adorno, and Marco Banzolini. *Erettosi nell'oratorio del nobile conte Luigi Tadini in Lovere in memoria dell'estinto suo figlio Faustino un monumento in marmo opera del sommo scultore marchese commendatore Antonio Canova la populazione di Lovere provincia di Bergamo dedica allo stesso celebre scultore alcune poesie.* Bergamo, 1821.

[B. C.]. *Alcune lettere inedite di donne illustri a Canova.* Nozze Andretta-Mazzoni. Bassano, 1852.

Beauvelot, Yves. "Deux bas-reliefs de Canova." *Revue de l'art* 9 (1970): 68.

Beckford, Peter. *Familiar Letters from Italy, to a Friend in England.* 2 vols. London, 1805.

Beguin, Sylvie. "Tableaux provenant de Naples et de Rome en 1802 restés en France." *Bulletin de la Société de l'histoire de l'art français* (1959): 177–98.

Benocci, Carla. "Antonio Canova collezionista: Una raccolta di terracotte e sculture antiche passate ai Musei Vaticani." *L'urbe* 46 (1983): 27–36.

———. "Un documento inedito sullo studio di Antonio Canova." *Alma Roma* 31 (1990): 115–19.

Bergeron, Louis. *France under Napoleon,* translated by R. R. Palmer. Princeton, N.J., 1981; originally published Paris, 1972.

Bernard-Griffiths, Simone, Marie Claude Chemin, and Jean Ehrard. *Révolution française et "vandalisme" révolutionaire: Actes du colloque international de Clermont-Ferrand, 15–17 décembre 1988.* Paris, 1988.

Bernini, Grazia Pezzini. "Canova e il progetto di un catalogo illustrato delle sue opere sculturee." In *Canova e l'incisione,* edited by Grazia Pezzini Bernini and Fabio Fiorani, pp. 31–36. Bassano del Grappa, 1993.

Berra, Luigi. "Opere d'arte asportate dai Francesi da Roma e dallo stato pontificio e restituite nel 1815 dopo il Congresso di Vienna." *Rendiconti della Pontificia Accademia Romana di Archeologia* 27 (1951–54): 239–46.

Bertoldi, Antonio, ed. *Sei lettere autografe di Antonio Canova tratte dal Museo Civico e Raccolta Correr di Venezia,* Nozze Martinati-Pigorini. Venice, 1879.

Bertolotto, Claudio. "Noterella canoviana." *Labyrinthos* 21–24 (1992–93): 305–11.

Beseghi, Umberto. *I tredici cardinali neri.* Florence, 1944.

Bianchi, Arturo. "Le vicende urbanistiche della Roma napoleonica." *L'urbe* 2 (1937): 18–29.

Biver, Marie-Louise. "Le 'Napoléon' de Canova." *La revue des deux mondes* (April 1, 1963): 424–29.

———. "Rome, seconde capitale de l'Empire: Aquila Redux." *Revue de l'Institut Napoléon* 109 (1968): 145–54.

Blumer, Marie-Louise. "Catalogue des Peintures transportées d'Italie en France de 1796 à 1814." *Bulletin de la Société de l'histoire de l'art français* (1936): 244–348.

———. "La commission pour la recherche des objets de sciences et arts en Italie (1796–1797)." *La révolution française* 87 (1934): 62–88, 124–50, and 222–59.

———. "La mission de Denon en Italie (1811)." *Revue des études napoléoniennes* 36 (1934): 237–57.

Boggero, Franco. "Una rilettura critica del Canova: La 'Maddalena penitente.'" *Arte lombarda* 55–57 (1980): 386–92.

Boime, Albert. *Art in an Age of Bonapartism, 1800–1815.* Chicago, 1990.

———. *Art in an Age of Revolution, 1750–1800.* Chicago and London, 1987.

———. "Louis Boilly's 'Reading of the XIth and XIIth Bulletins of the Grande Armée.'" *Zeitschrift für Kunstgeschichte* 54 (1991): 374–87.

Borsi, Franco, ed. *Arte a Roma dal neoclassico al romanticismo.* Rome, 1979.

Borzelli, Angelo. *Le relazioni del Canova con Napoli al tempo di Ferdinando I e di Gioacchino Murat: Memoria con documenti inediti.* Naples, 1901.

Bossi, Giuseppe. *Le memorie, con una lettera a Luigi Milani di Giorgio Nicodemi.* Busto Arsizio, 1925.

Botta, Carlo. *Storia d'Italia del 1789 al 1814.* 4 vols. Paris, 1837.

Bottari, Giovanni, and Stefano Ticozzi, eds. *Raccolta di lettere sulla pittura, scultura ed architettura scritte da' più celebri personaggi dei secoli XV, XVI, e XVII pubblicata da M. Gio. Bottari e continuata fino ai nostri giorni da Stefano Ticozzi.* 8 vols. Milan, 1822–25.

Bouclon, Adolphe de. *Canova et Napoléon.* Paris, 1865.

Bowron, Edgar Peters. "Academic Life Drawing in Rome, 1750–1790." In *Visions of Antiquity: Neoclassical Figure Drawings,* pp. 75–85. Catalogue of an exhibition held at the Los Angeles County Museum of Art and the Minneapolis Institute of Arts, July 1993–April 1994. Los Angeles, 1993.

Boyer, Ferdinand. "L'achat d'antiques à Rome et l'offre des 'Noces Aldobrandines' pour le Musée Napoléon." *Bulletin de la Société nationale des antiquaires de France* (1942): 230–43.

———. "L'achat des antiques Borghèse par Napoléon." *Comptes rendus de l'Académie des Inscriptions et Belles-Lettres* (1937): 405–15.

———. "A propos de Canova et de la restitution en 1815 des oeuvres d'art de Rome." *Rivista italiana di studi napoleonici* 4 (1965): 18–24.

———. "Autour de Canova et de Napoléon." *Revue des études italiennes* (1937): 202–32.

———. "Une conquête de la diplomatie du Premier Consul: La Vénus de Médicis." *Revue d'histoire diplomatique* 70–71 (1956–57): 22–36.

———. "Les embellisements de Rome au temps de Napoléon." *Revue des études napoléoniennes* 34 (1932): 216–29.

———. "L'histoire du 'Napoléon Colossal' de Canova." *Revue des études napoléoniennes* 42 (1940): 189–99.

———. "Il y a deux cents ans naissait Canova." *Revue des études italiennes* (1957): 230–35.

———. "Louis XVIII et la restitution des oeuvres d'art confisquées sous la Révolution et l'Empire." *Bulletin de la Société de l'histoire de l'art français* (1965): 201–7.

———. *Le monde des arts en Italie et la France de la Révolution et de l'Empire: Études et recherches.* Biblioteca di Studi Francesi, vol. 4. Turin, 1969.

———. "Napoléon et l'attribution des grands prix décennaux 1810–1811." *Bulletin de la Société de l'histoire de l'art français* (1947–48): 66–72.

———. "Napoléon et les monuments à sa gloire en France et en Italie (1804–1815)." *Revue de l'Institut Napoléon* 66 (1958): 21–25.

———. "Napoléon, Vivant Denon et les promenades publiques à Rome." *Revue de l'Institut Napoléon* 67 (1960): 249–52.

———. "Nouveau documents sur Canova et Napoléon." In *A travers l'art italien du XVe au XXe siècle: Publications de la Société des études italiennes 1941–1948,* pp. 202–32. Paris, 1949.

———. "Les offres de Napoléon pour l'achat de la statue antique de Pompée." *Bulletin de la Société nationale des antiquaires de France* (1943–44): 251–62.

———. "Le Panthéon et la fontana de Trevi dans les projets de Napoléon." *Revue des études italiennes* (1931): 210–16.

———. "Les projets d'achat pour le Musée Napoléon des Antiques Giustiniani à Rome." *Bulletin de l'Institut Napoléon* (1953): 9–19.

———. "Projets napoléoniens pour le Mausolée d'Auguste et le pont d'Horatius Cocles." *Strenna dei Romanisti* 24 (1963): 96–102.

———. "Projetti per la villa Napoleone a Roma." *Bollettino dei musei comunali di Roma* 4 (1957): 15–19.

———. "Quelques considérations sur les conquêtes artistiques de Napoléon." *Rivista italiana di studi napoleonici* 7–8 (1968–69): 190–204.

———. "Quentin Craufurd et la statue de Laetitia Bonaparte par Canova." *Revue de l'Institut Napoléon* 107 (1968): 77–80.

———. "Les responsabilités de Napoléon dans le transfert à Paris des oeuvres d'art de l'étranger." *Revue d'histoire moderne et contemporaine* (1964): 241–62.

———. "Rome sous Napoléon: Le projet d'un jardin du Capitole." *Bulletin de la Société de l'histoire de l'art français* (1932): 201–15.

———. "Le sort de la 'Madame Mère' de Canova et de la table des maréchaux sous la Restauration." *Bulletin de la Société de l'histoire de l'art français* (1940): 207–12.

Bratti, Ricciotti. "Antonio Canova nella sua vita artistica privata (da un carteggio inedito)." *Nuovo archivio veneto* 33 (1917): 281–350; 34 (1917): 75–94; 35 (1918): 206–46.

Brigidi, Sebastiano. *La vita di Antonio Canova raccontata da Sebastiano Brigidi ad un giovanetto.* Florence, 1866.

Brües, E. "Raffaele Stern: Ein Beitrag zur Architekturgeschichte in Rom zwischen 1790 und 1830." Ph.D. diss., University of Bonn, 1958.

[B. T.]. *Intorno alla scoperta d'un busto del Doge Paolo Renier modellato da Antonio Canova ora di proprietà del signor Nicolò Bottacin.* Trieste, 1864.

Burton, June K. *Napoleon and Clio: Historical Writing, Teaching, and Thinking during the First Empire.* Durham, N.C., 1979.

Busti, Carlo. *Sopra alcune opere di sculture e di plastica di Antonio Canova.* Milan, 1842.

Caliari, Pietro. *Il Canova a Verona.* Verona and Padua, 1896.

Campani, Annibale. "Nuovi documenti sull'opera di Antonio Canova pel ricupero dei monumenti d'arte italiani a Parigi (Corrispondenza Canova-Angeloni)." *Archivio storico dell'arte* 5 (1892): 186–96.

Cancellieri, Francesco. *Memorie istoriche delle sacre teste de' Santi Apostoli Pietro e Paolo e della loro solenne ricognizione nella Basilica Lateranense con un'appendice di documenti.* Rome, 1806.

Canova, Antonio. *Lettere inedite di Antonio Canova.* Padua, 1833.

———. *Lettere inedite tratte dagli autografi Canoviani nel Museo Civico di Bassano.* Nozze Chiminelli-Bonuzzi. Bassano, 1891.

———. *Napoleon and Canova: Eight Conversations held at the Château of the Tuileries in 1810.* London, 1825.

Canova all'Ermitage: Le sculture del museo di San Pietroburgo. Edited by Giulio Carlo Argan et al. Catalogue of an exhibition held at the Palazzo Ruspoli, Rome, December 12, 1991–February 19, 1992. Rome, 1991.

Canova e l'incisione. Edited by Grazia Pezzini Bernini and Fabio Fiorani. Catalogue of an exhibition held at the Istituto Nazionale per la Grafica, Calcografia, Rome, November 11, 1993–January 6, 1994, and at the Museo Biblioteca Archivio, Bassano del Grappa, January 19–April 24, 1994. Bassano del Grappa, 1993.

Caracciolo, Maria Teresa. *Giuseppe Cades, 1750–1799, et la Rome de son temps.* Paris, 1992.

Carcano, Giulio. *Per l'inaugurazione della statua colossale di Napoleone I opera di Canova in Milano il giorno XIV. agosto MDCCCLIX.* Milan, 1859.

Carey, William. *Some Memoirs of the Patronage and Progress of the Fine Arts, in England and Ireland, during the Reigns of George the Second, George the Third, and His Present Majesty; with Anecdotes of Lord de Tabley, of Other Patrons, and of Eminent Artists, and Occasional Critical References to British Works of Art.* London, 1826.

Cartago, Gabriella. "Lo studio delle lingue per Antonio Canova: L'italiano e l'inglese." *Rassegna della letteratura italiana* 91 (1987): 269–81.

Carutti, Domenico. "Antonio Canova e l'Accademia dei Lincei." *Atti della Reale Accademia dei Lincei* 4 (1880): 3–8.

Cassi, Gellio. "Chiarimenti e nuove notizie sulla corrispondenza Canova-Consalvi." *Roma* 10 (1932): 307–20.

Castelnuovo, Enrico. "Arti e rivoluzione: Ideologie e politiche artistiche nella Francia rivoluzionaria." *Ricerche di storia dell'arte* 13–14 (1981): 520.

Catello, Elio. "Cinque lettere inedite di Antonio Canova." *Antologia di belle arti* 3 (1979): 196–97.

Ceci, Giuseppe. "La chiesa di S. Francesco di Paola e le statue equestri di Carlo III e Ferdinando I." *Napoli nobilissima* 5 (1896): 102–5.

Chadwick, Owen. *The Popes and European Revolution.* Oxford, 1981.

Champollion-Figeac, J. J. "Canova et ses ouvrages pour Napoléon, Consul et Empereur." *Revue universelle des arts* 1 (1855): 351–57.

Chatelain, Jean. *Dominique Vivant Denon et le Louvre de Napoléon.* Paris, 1973.

Chiminelli, Luigi, and Marco Pedoni, eds. *Lettere di Antonio Canova al conte Tiberio Roberti.* Nozze Roberti-Chemin. Bassano, 1864.

Chini, Sofia. "Un bozzetto inedito di Antonio Canova." *Dedalo* 3 (1922): 66–71.

Chiti, Alfredo. "Tommaso Puccini e Antonio Canova." *Rivista d'arte* 5 (1907): 1–11.

Cicogna, Emmanuele. *Lettera di Antonio Canova intorno ad una Madonnina in basso rilievo di marmo opera prima scolpita da lui circa l'anno 1770.* Venice, 1854.

Cicognara, Leopoldo. *Biografia di Antonio Canova.* Venice, 1823.

———. "Gruppo di marte e venere scolpito da Canova." *Antologia* 5 (1822): 567–69.

———. *Lettera sulla statua rappresentante la musa Polinnia scolpita dal M. Antonio Canova.* Venice, 1817.

———. *Lettere ad Antonio Canova.* Edited by Gianni Venturi. Urbino, 1973.

———. *Omaggio delle provincie venete alla maestà di Carolina Augusta imperatrice d'Austria.* Venice, 1818.

———. *Storia della scultura dal suo risorgimento in Italia fino al secolo di Canova.* 2d ed. 7 vols. Prato, 1824.

———. *Storia della scultura dal suo risorgimento in Italia sino al secolo XIX per servire di continuazione alle opere di Winckelmann e di d'Agincourt.* 3 vols. Venice, 1813–18.

Cittadella-Vigodarzere, Luisa. *Vita di Canova.* Milan, 1923.

Coggiola, Giulio. "Della libreria del Sansovino al Palazzo Ducale: Un episodio della vita della Marciana 1797–1812." *Rivista delle Biblioteche e degli Archivi* 16 (1905): 33–74.

Colasanti, Arduino. "Spirito e forme dell'arte di Antonio Canova." *Nuovo antologia* (1923): 3–14.

Coletti, Luigi. "La fortuna di Canova." *Bollettino del Reale Istituto di Archeologia e Storia dell'Arte di Roma* 1 (1927): 21–96.

———. *Inediti canoviani.* Treviso, 1937.

———. *Mostra canoviana.* Treviso, 1957.

———. "Unknown Works of Antonio Canova." *Art in America* 16 (1928): 78–91.

Collins, Jeffrey Laird. "Arsenals of Art: The Patronage of Pope Pius VI and the End of the Ancien Régime." Ph.D. diss., Yale University, 1994.

Colonna, Gustavo Brigante. *Roma napoleonica: Interpretazioni.* Florence, 1929.

Connelly, Owen. *Napoleon's Satellite Kingdoms.* New York and London, 1965.

Connor, R. D. W. "Canova's Statue of Washington." *North Carolina Historical Commission Bulletin* 8 (1910): 5–96.

Consolo, Giuseppe. *Ercole e Lica di Antonio Canova che Verona acquistava per eternare la memoria della battaglia del 5 aprile 1799.* Padua, 1839.

———. *Memorie relative al monumento Emo esistente nell'Arsenale di Venezia opera dell'immortale Antonio Canova.* Nozze Treves-Todros. Padua, 1844.

Conti, Alessandro. "Vicende e cultura del restauro." In *Storia dell'arte italiana,* edited by Federico Zeri, 3:37–112. Turin, 1981.

Corbett, Patricia. "'Imbued with a Sort of Infinity': The Sculpture of Canova." *Apollo* 136 (1992): 120–22.

Corbo, Anna Maria. "L'esportazione delle opere d'arte dallo Stato Pontificio tra il 1814 e il 1823." *L'arte* 3 (1970): 82–113; 4 (1971): 82–103.

———. "L'insegnamento artistico a Roma nei primi anni della Restaurazione." *Rassegna degli archivi di stato* 30 (1970): 91–119.

———. "Il restauro delle pitture a Roma del 1814 al 1823." *Commentari* 20 (1969): 237–43.

Corboz, André. "Guardare Canova oggi." *Arte veneta* 47 (1995): 78–83.

Correr, Giovanni. *Documenti sul monumento ad Angelo Emo di Antonio Canova, e sulla medaglia d'oro donata al Canova dal Senato Veneziano.* Nozze Emo–Capodilista-Venier. Venice, 1867.

Corti, Gino. "Canova's Funeral Monument and the Galleria Borghese: Letters from Leopoldo Cicognara and the Countess of Albany." *Burlington Magazine* 119 (1977): 500–503.

Costantini, Celso. "Nel centenario della morte di Antonio Canova." *Arte Cristiana* 10 (1922): 289–305.

Cullen, Fintan. "Hugh Douglas Hamilton in Rome, 1779–1792." *Apollo* 115 (1982): 86–91.

———. "Hugh Douglas Hamilton's Letters to Canova." *Irish Arts Review* 1 (1984): 31–35.

———. "The Oil Paintings of Hugh Douglas Hamilton." *Walpole Society* 50 (1984): 165–208.

Cummings, Frederick. "The Selection of 'Style' in Neo-Classical Art as Exemplified in Antonio Canova's 'Hercules and Lichas.'" In *Stil und Überlieferung in der Kunst des Abendlandes: Akten des 21. Internationalen Kongress für Kunstgeschichte in Bonn.* 3 vols. Berlin, 1964, 1:232–35.

Cunial, Giancarlo, and Gianna Ghizzoni Rattazzi. *La Gipsoteca Canoviana di Possagno.* Asolo, 1992.

Cuozzo, Assunta. "Due bassorilievi inediti del Canova." *Venezia arti* 3 (1989): 173–74.

Cusatelli, Giorgio. "Canova als 'Kunsttheoretiker.'" In *Kunstliteratur Italienerfahrung,* edited by Helmut Pfotenhauer, pp. 197–204. Tübingen, 1991.

Dallaway, James. *Of Statuary and Sculpture among the Antients, with Some Account of Specimens Preserved in England.* London, 1816.

Daltrop, Georg. "The Collections of Greek and Roman Antiquities in the Nineteenth and Twentieth Centuries." In *The Vatican Collections: The Papacy and Art,* pp. 200–203. New York, 1982.

D'Ambra, Alessandro. "Canova e le vicende politiche del suo tempo." *La cultura moderna natura ed arte* 31 (1922): 506–9.

Daniel-Rops, Henri. *The Church in an Age of Revolution, 1789–1870.* Translated by John Warrington. Garden City, N.Y., 1967.

Da Sesso, G. Vinco, and Paolo Marton. *Antonio Canova: Opere a Possagno e nel Veneto: Works in Possagno and in the Venetian Region.* Bassano del Grappa, 1992.

Debenedetti, Elisa. "Il ruolo di Thorvaldsen nell'ambito delle istituzioni culturali a Roma." In *Thorvaldsen: L'ambiente, l'influsso, il mito,* edited by Patrick Kragelund and Mogens Nykjaer, pp. 43–57. Rome, 1991.

De Castro, Giovanni. *Storia d'Italia dal 1799 al 1814.* 2 vols. Milan, 1907.

Degenhardt, Michael A. B. "Winckelmann as Art Educator." *Journal of Aesthetic Education* 20 (1986): 55–69.

Del Bravo, Carlo. "'Idee' del Canova." *Intersezioni* 7 (1987): 73–83.

Demoriane, Hélène. "Canova Napoléon l'admirait." *Connaissance des arts* 209 (1969): 26–37.

De' Rossi, Giovanni Gherardo. *Lettera sopra tre bassirilievi recentemente modellati dall'illustre scultore sig. Antonio Canova.* Bassano, 1793.

———. *Lettera sul deposito di Clemente XIII. nella Basilica Vaticana.* Bassano, 1792.

———. "Sopra il gruppo del Teseo vincitore del minotauro." In *Memorie per servire alla storia letteraria e civile.* Venice, 1796.

Descrizione della statua di un pugliatore eseguita in Roma da celebre scultore Sig. Antonio Canova, con una lettera del medesimo che accompagna il gesso di essa statua da lui spedito in dono a questa Veneta Accademia di Belle Arti: Questo sarà esposto Domenica 23 del corrente mese di maggio 1802 a pubblica vista nella Sala degli Orfei Vecchj a S. Benedetto. Venice, 1802.

D'Este, Alessandro, ed. *Memorie di Antonio Canova scritte da Antonio D'Este.* Florence, 1864.

Di Rezzonico, Castone della Torre. *Lettera di Dorillo Dafneio a Diodoro Delfico.* [Naples, ca. 1795].

Disegni di Canova del Museo di Bassano. Edited by Fernando Rigon et al. Catalogue of an exhibition held at the Pinacoteca Capitolina, Rome, April 29–June 10, 1982. Milan, 1982.

Driault, Edouard. "Mémoires et documents: Palais Impérial du Quirinal." *Revue des études napoléoniennes* (1929): 163–90, 216–44.

———. "Rome et Napoléon." *Revue des études napoléoniennes* 20 (1918): 5–43.

Duppa, Richard. *A Journal of the Most Remarkable Occurrences that took place in Rome, upon the Subversion of the Ecclesiastical Government, in 1798.* London, 1799.

Du Teil, Joseph. *Rome, Naples et le Directoire: Armistices et traités, 1796–1797.* Paris, 1902.

Eaton, Charlotte. *Rome in the Nineteenth Century: Containing a Complete Account of the Ruins of the Ancient City, the Remains of the Middle Ages, and the Monuments of Modern Times: With Remarks on the Fine Arts, on the State of Society, and on the Religious Ceremonies, Manners, and Customs, of the Modern Romans in a Series of Letters Written during a Residence at Rome in the Years 1817 and 1818.* 3 vols. Edinburgh, 1820.

Ellis, Geoffrey. *The Napoleonic Empire.* Studies in European History. Atlantic Highlands, N.J., 1991.

Ellis, John Tracy. *Cardinal Consalvi and Anglo-Papal Relations, 1814–1824.* Washington, D.C., 1942.

Emiliani, Andrea. *Leggi, bandi e provvedimenti per la tutela dei beni artistici e culturali negli antichi stati italiani, 1571–1860.* Bologna, 1978.

———. *Una politica dei beni culturali.* Turin, 1974.

Eustace, Katharine, ed. *Canova: Ideal Heads.* Oxford, 1997.

Everett, Edward. "Canova and His Works." *North American Review,* n.s. 1 (1820): 372–86.

Falco, Carmela. *Iconologia neoclassica fra il Monte e l'Appiani.* Rome, 1979.

Falier, Giuseppe. *Memorie per servire alla vita del marchese Antonio Canova.* Venice, 1823.

Fallani, Giovanni. "Nota informativa sull'arte sacra di Canova." *Fede ed arte* 4 (1957): 133–38.

Farington, Joseph. *The Diary of Joseph Farington.* 16 vols. New Haven, Conn., and London, 1978–84.

Fasolo, Luigi, and Giuseppe Fasoli, eds. *Lettere inedite di Antonio Canova.* Nozze Jonoch–Chemin-Palma. Bassano, 1876.

Favaretto, Irene. *Arte antica e cultura antiquaria nelle collezioni venete al tempo della Serenissima.* Rome, 1990.

Federici, Fortunato, ed. *Lettere di Giuseppe Bossi ad Antonio Canova.* Padua, 1839.

Fedi, Francesca. *L'ideologia del bello: Leopoldo Cicognara e il classicismo fra Settecento e Ottocento.* Milan, 1990.

Fehl, Philipp H. "Canova's 'Hercules and Lichas.'" *North Carolina Museum of Art Bulletin* 8 (1968): 3–25.

———. "Canova's Tomb and the Cult of Genius." *Labyrinthos* 1–2 (1982): 46–66.

———. "Improvisation and the Artist's Responsibility in St. Peter's, Rome: Papal Tombs by Bernini and Canova." In *Eröffnungs- und Plenarvorträge: Arbeitsgruppe "Neue Forschungsergebnisse und Arbeitsvorhaben."* International Congress for the History of Art, vol. 25, no. 9, edited by Elisabeth Liskar, pp.111–23. Vienna, 1985.

———. "The Placement of Canova's 'Hercules and Lichas' in the Palazzo Torlonia." *North Carolina Museum of Art Bulletin* 11 (1972): 14–27.

———. "A Statuette of the Pugilist Creugas by Antonio Canova." *Register of the Museum of Art of the University of Kansas* (1958): 13–24.

———. "Thomas Appleton of Livorno and Canova's Statue of George Washington." In *Festschrift Ulrich Middeldorf,* edited by Antje Kosegarten and Peter Tigler, pp. 523–52. Berlin, 1968.

Fernow, Carl Ludwig. *Über den Bildhauer Antonio Canova und dessen Werke.* Zurich, 1806.

Ferraioli, Alessandro, ed. *Lettere inedite di Antonio Canova al Cardinale Ercole Consalvi.* Rome, 1888.

Filangieri di Candida, A. *Ferdinando I di Borbone: Statua del Canova nel Museo Nazionale di Napoli.* Naples, 1898.

Fiorani, Fabio. "La calcografia del Canova a Roma: Storia della raccolta dei rami desunta dall'inventario del 1823." In *Canova e l'incisione,* edited by Grazia Pezzini Bernini and Fabio Fiorani, pp. 37–43. Bassano del Grappa, 1993.

Foratti, Aldo. *Antonio Canova (1757–1822).* Milan, 1922.

———. "Canova disegnatore." *Bollettino d'arte* 2 (1922): 162–75.

Ford, Brinsley. "The Earl-Bishop: An Eccentric and Capricious Patron of the Arts." *Apollo* 99 (1974): 426–34.

Forsyth, Joseph. *Remarks on Antiquities, Arts, and Letters during an Excursion in Italy, in the Years 1802 and 1803.* 2d ed. Boston, 1818.

I francesi a Roma: Residenti e viaggiatori nella città eterna dal Rinascimento agli inizi del romanticismo. Catalogue of an exhibition held at the Palazzo Braschi, Rome, May–July 1961. Rome, 1961.

Francia, Ennio, ed. *Delfina de Custine, Luisa Stolberg, Giulietta Récamier a Canova: Lettere inedite.* Rome, 1972.

———. *Pinacoteca Vaticana.* Milan, 1960.

Fratini, Francesca Romana. "Opere di scultura e plastica di Antonio Canova, di Isabella Teotochi Albrizzi." In *Studi Canoviani,* pp. 43–70. Rome, 1973.

Fried, Michael. "Antiquity Now: Reading Winckelmann on Imitation." *October* 37 (1986): 87–97.

Fugier, André. *Napoléon et l'Italie.* Paris, 1947.

Galliazzo, Vittorio. *I cavalli di San Marco.* Treviso, 1981.

Gambarin, G. "P. Giordani, il Canova e i Manzoni di Forlì." *Giornale della storia della letteratura italiana* 87 (1926): 282–326.

Gambinossi, Giorgio. "Antonio Canova e Napoleone I." *L'Italia moderna* 3 (1905): 3–20.

Geatti, Angelo. *Napoleone Bonaparte e il trattato di Campoformido del 1797.* Udine, 1989.

George, Hardy. "Turner, Lawrence, Canova, and Venetian Art: Three Previously Unpublished Letters." *Apollo,* n.s. 144 (1996): 25–32.

Ghetti, Fabrizio M. Apollonj. "A proposito di un dipinto nella Galleria Comunale d'Arte Moderna: 'La famiglia Vitali' di Antonio Canova." *Bollettino dei musei comunali di Roma* 7 (1960): 22–28.

Giaccone, Carla Michelli. "A proposito di Missirini biografo di Canova." *Atti e memorie dell'Arcadia* 8 (1986–87): 269–82.

Giordani, Pietro. *Per l'aspettato arrivo di Canova in Bologna: Poesie.* Bologna, 1810.

Giovanelli, Roberto. "Nuovi contributi per Bernardino Nocchi." *Labyrinthos* 7–8 (1985): 119–99.

Giovannoni, Gustavo. "'L'Ercole e Lica' del Canova nella nuova sala della Galleria Nazionale di Palazzo Corsini." *Bollettino d'arte* (1908): 39–46.

Giucci, Gaetano. *Storia della vita e del pontificato di Pio VII.* 2 vols. Rome, 1857.

Giuntella, Vittorio E. "La giacobina repubblica romana (1798–1799): Aspetti e momenti." *Archivio della società romana di storia patria* 73 (1950): 1–213.

———. "Roma nell'età napoleonica." In *Atti del convegno sul tema: Napoleone e l'Italia,* 1: 357–69. Rome, 1973.

———. *Roma nel Settecento.* Storia di Roma, vol. 15. Bologna, 1971.

Gonzalez-Palacios, Alvar. "Ristudiando i Righetti." *Antologia di belle arti* 39–42 (1991–92): 17–46.

———. "Sei fogli di Antonio Canova." *Arte illustrata* 5 (1972): 160–67.

Gould, Cecil. *Trophy of Conquest: The Musée Napoléon and the Creation of the Louvre.* London, 1965.

Graf, Arturo. *L'anglomania e l'influsso inglese in Italia nel secolo XVIII.* Turin, 1911.

Graham, Robert A. *Vatican Diplomacy: A Study of Church and State on the International Plane.* Princeton, N.J., 1959.

Grant, Hamil. *Napoleon and the Artists.* London, 1917.

Gross, Hanns. *Rome in the Age of Enlightenment: The Post-Tridentine Syndrome and the Ancien Régime.* Cambridge and New York, 1990.

Gualandi, Michelangelo, ed. *Dodici lettere inedite di Antonio Canova scritte a diversi.* Nozze Zambrini–Della Volpe. Bologna, 1868.

Guattani, Giuseppe Antonio. *Memorie enciclopediche romane sulle belle arti, antichità, etc.* 7 vols. Rome, 1806–19.

Guerrini, Paolo. "Il carteggio canoviano della Queriniana di Brescia." *Archivio veneto-tridentino* 2 (1922): 151–77.

Guiffrey, Jules. "L'Académie de France à Rome de 1793 à 1803." *Journal des Savants* (1908): 655–68.

Hales, E. E. Y. *The Emperor and the Pope: The Story of Napoleon and Pius VII.* New York, 1961. Reprint, New York, 1978.

———. *Revolution and Papacy, 1769–1846.* New York, 1960.

Hartmann, Jörgen Birkedal. "Appunti sui ritratti canoviani di Pio VII." *L'urbe* 31 (1968): 11–19.

———. "Canova e Thorvaldsen." *Colloqui del sodalizio* 2 (1956): 71–89.

———. "Canova, Thorvaldsen, and Gibson." *English Miscellany* 6 (1955): 205–35.

———. "Die Genien des Lebens und des Todes." *Römisches Jahrbuch für Kunstgeschichte* 12 (1969): 9–38.

———. "Tre lettere inedite di Pinelli a Canova." *L'urbe* 20 (1957): 7–8.

———. "Il 'Trionfo di Alessandro' e l'appartamento napoleonico al Quirinale." *Palatino* 9 (1965): 97–109.

———. *La vicenda di una dimora principesca romana.* Rome, 1967.

Haskell, Francis. "Cicognara eretico." In *Giuseppe Jappelli e il suo tempo,* edited by Giuliana Mazzi, 1:217–25. Padua, 1982.

———. "La dispersione e la conservazione del patrimonio artistico." In *Storia dell'arte italiana,* edited by Federico Zeri, 3:3–35. Turin, 1981.

———. *History and Its Images: Art and the Interpretation of the Past.* New Haven, Conn., 1993.

———. *An Italian Patron of French Neoclassical Art.* Oxford, 1972.

———. "More about Sommariva." *Burlington Magazine* 114 (1972): 691–95.

———. "Les musées et leurs ennemis." Translated by Rosine Christin. *Actes de la recherche en sciences sociales* 49 (1983): 103–6.

Haskell, Francis, and Nicholas Penny. *Taste and the Antique: The Lure of Classical Sculpture, 1500–1900.* New Haven, Conn., 1981.

Hautecoeur, Louis. *Rome et la renaissance de l'antiquité à la fin du XVIIIe siècle.* Paris, 1912.

Hawley, Henry. "Antonio Canova: 'Terpsichore.'" *Bulletin of the Cleveland Museum of Art* 56 (1969): 287–305.

Hayez, Francesco. *Le mie memorie.* Milan, 1890.

Henry, Jean. "Antonio Canova and Early Italian Nationalism." In *La scultura nel XIX secolo,* edited by Horst W. Janson, pp. 9–16. Atti del XXIV congresso internazionale della storia dell'arte, vol. 6. Bologna, 1984.

———. "Antonio Canova and the Tomb to Vittorio Alfieri." Ph.D. diss., Florida State University, 1978.

———. "Antonio Canova, the French Imperium, and Emerging Nationalism in Italy." *Proceedings of the Consortium on Revolutionary Europe, 1750–1850* 2 (1980): 82–94.

Hiesinger, Ulrich. "Canova and the Frescoes of the Galleria Chiaramonti." *Burlington Magazine* 120 (1978): 655–65.

———. "The Paintings of Vincenzo Camuccini, 1771–1844." *Art Bulletin* 60 (1978): 297–313.

Hodgkinson, Terence. "Christopher Hewetson, an Irish Sculptor in Rome." *Walpole Society* 34 (1952–54): 42–54.

Holtman, R. B. *Napoleonic Propaganda.* Baton Rouge, La., 1950.

Honour, Hugh. "Gli amorini del Canova." *Arte illustrata* 55–56 (1973): 312–20.

———. "A bust of 'Sappho' by Antonio Canova," *Artibus et historiae* 12 (1991): 193–200.

———. "Canova and David." *Apollo* 96 (1972): 312–17.

———. "Canova and the Anglo-Romans, I." *Connoisseur* 143 (1959): 241–45.

———. "Canova and the Anglo-Romans, II." *Connoisseur* 144 (1960): 225–31.

———. "Canova and the Archbishop of Taranto." In *Oxford China and Italy: Writings in Honour of Sir Harold Acton,* edited by E. Chaney and N. Ritchie, pp. 209–21. Florence, 1984.

———. "Canova e l'incisione." In *Canova e l'incisione,* edited by Grazia Pezzini Bernini and Fabio Fiorani, pp. 11–21. Bassano del Grappa, 1993.

———. "Canova's Diary (1779–1780)." *Arte veneta* 13–14 (1959–60): 254–55.

———. "Canova's 'Napoleon.'" *Apollo* 98 (1973): 180–84.

———. "Canova's Statue of a Dancer." *National Gallery of Canada Bulletin* 6 (1968): 2–14.

———. "Canova's Statues of Venus." *Burlington Magazine* 114 (1972): 658–70.

———. "Canova's Studio Practice, I: The Early Years." *Burlington Magazine* 114 (1972): 146–59.

———. "Canova's Studio Practice, II: 1792–1822." *Burlington Magazine* 114 (1972): 214–29.

———. "La decorazione scultorea nel Quirinale napoleonico, 1811–14." In *Il palazzo del Quirinale: Il mondo artistico a Roma nel periodo napoleonico,* pp. 167–79. Rome, 1989.

———. "Eight Letters from Antonio Canova." *Apollo* 104 (1976): 290–97.

———. "An Italian Monument to Nelson." *Country Life Annual* (1962): 137–38.

———. *Neoclassicism.* Harmondsworth, Middlesex, 1968.

———. "The Rome of Vincenzo Pacetti: Leaves from a Sculptor's Diary." *Apollo* 78 (1963): 368–76.

———. "Theseus and the Minotaur." *Victoria and Albert Museum Yearbook* 1 (1969): 1–15.

———, ed. *Edizione nazionale delle opere di Antonio Canova: Scritti, I.* Rome, 1994.

Howard, Seymour. "The Antiquarian Market in Rome and the Rise of Neo-Classicism: A Basis for Canova's New Classics." *Studies on Voltaire and the Eighteenth Century* 151–55 (1976): 1057–68.

———. "Bartolomeo Cavaceppi and the Origins of Neo-Classic Sculpture." *Art Quarterly* 33 (1970): 120–33.

Hubert, Gérard. "Josephine, a Discerning Collector of Sculpture." *Apollo* 106 (1977): 34–43.

———. *Les sculpteurs italiens en France sous la Révolution, l'Empire et la Restauration, 1790–1830.* Paris, 1964.

———. *La sculpture dans l'Italie napoléonienne.* Paris, 1964.

Idzerda, Stanley J. "Iconoclasm during the French Revolution." *American Historical Review* 60 (1954): 13–26.

Incerpi, Gabriella. "I restauri sui quadri fiorentini portati a Parigi." In *Florence et la France: Rapports sous la Révolution et l'Empire,* pp. 215–49. Florence and Paris, 1979.

Iozzi, Oliviero. *Il palazzo Torlonia in Piazza Venezia ora demolito.* Rome, 1902.

Irwin, David. "Flaxman: Italian Journals and Correspondence." *Burlington Magazine* 101 (1959): 212–17.

———. "Gavin Hamilton: Archaeologist, Painter, and Art Dealer." *Art Bulletin* 44 (1962): 87–102.

Ivanoff, Nicola. "Leopoldo Cicognara ed il gusto dei primitivi." *Critica d'arte* 19 (1957): 32–46.

Janson, Horst W. *Nineteenth-Century Sculpture.* New York, 1985.

———. "Observations on Nudity in Neoclassical Art." In *Sixteen Studies,* pp. 189–210. New York, 1973.

———. *The Rise and Fall of the Public Monument.* New Orleans, La., 1976.

Jenkins, Ian. *Archaeologists and Aesthetes in the Sculpture Galleries of the British Museum, 1800–1939.* London, 1992.

Johns, Christopher M. S. "Antonio Canova and Austrian Art Policy." In *Austria in the Age of the French Revolution,* edited by Kinley Brauer and William E. Wright, pp. 83–90. Minneapolis, 1990.

———. "Antonio Canova's Drawings for 'Hercules and Lichas.'" *Master Drawings* 27 (1989): 358–67.

———. "Antonio Canova's 'Napoleon as Mars': Nudity and Mixed Genre in Neoclassical Portraiture." *Proceedings of the Consortium on Revolutionary Europe, 1750–1850* (1990): 368–82.

———. "Portrait Mythology: Antonio Canova's Representations of the Bonapartes." *Eighteenth-Century Studies* 28 (1994): 115–29.

———. "Subversion through Historical Association: Canova's 'Madame Mère' and the Politics of Napoleonic Portraiture." *Word and Image* 13 (1997): 43–57.

Johnson, Dorothy. *Jacques-Louis David: Art in Metamorphosis.* Princeton, N.J., 1993.

Jonsson, Marita. *La cura dei monumenti alle origini: Restauro e scavo di monumenti antichi a Roma 1800–1830.* Skrifter Utgivna av Svenska Institutet i Rom, vol. 14. Stockholm, 1986.

Jourda, Pierre. "Stendhal et Canova." *Revue des études italiennes* 2 (1937): 116.

Kaczmarzyk, Dariusz. "Le Persée d'Antonio Canova de la collection Tarnowski à Dzikow." *Bulletin du Musée National de Varsovie* 10 (1969): 102–16.

Kann, Robert A. *A History of the Habsburg Empire, 1526–1918.* Berkeley, Los Angeles, and London, 1974.

Kantner, Leopold M. "Die französischen Besatzungen in Rom 1798–1800 und 1807–1814 im Blickwinkel des Zeremonialdiaristen von S. Pietro." *Römische Historische Mitteilungen* 15 (1973): 67–91.

Kenworthy-Brown, John. "British Patrons of Sculpture in Italy, 1814–1830." In *La scultura nel XIX secolo,* edited by Horst W. Janson, pp. 45–48. Atti del XXIV congresso internazionale di storia dell'arte, vol. 6. Bologna, 1979.

Klein, Bruno. "Napoleons Triumphbogen in Paris und der Wandel der offiziellen Kunstanschauungen im Premier Empire." *Zeitschrift für Kunstgeschichte* 59 (1996): 244–69.

Kotzebue, Augustus von. *Travels through Italy, in the Years 1804 and 1805.* 4 vols. London, 1806.

Krasa, Selma. "Antonio Canovas Denkmal der Erzherzogin Marie Christine." *Albertina Studien* 5–6 (1967–68): 67–134.

Kreikenbom, Detlev. "Canovas Ferdinand IV. von Neapel: Minerva, Imperator oder Griechischer Staatslenker?" *Städel-Jahrbuch* 13 (1991): 227–44.

Krudener, Alexis de. *Voyage en Italie en 1786: Notes sur l'Italie, la Savoie, Lyon et la Suisse.* Edited by Francis Ley. Paris, 1983.

Lanzac de Laborie, León de. *Paris sous Napoléon.* 8 vols. Paris, 1905–13.

La Padula, Attilio. "Lavori francesi di abbellimento a Roma 1809–1814: La chiesa del Nome di Maria e la Piazza della Colonna Traiana." *Fede ed arte* 6 (1958): 456–63.

———. *Roma e la regione nell'epoca napoleonica.* Rome, 1969.

———. *Roma 1809–1814: Contributo alla storia dell'urbanistica.* Rome, 1958.

Lapauze, Henri. *Histoire de l'Académie de France à Rome.* 2 vols. Paris, 1924.

Larson, James L. "Winckelmann's Essay on Imitation." *Eighteenth-Century Studies* 9 (1976): 390–405.

Latreille, André. *Napoléon et le Saint-Siège (1801–1808): L'ambassade du Cardinal Fesch à Rome.* Paris, 1935.

Lavagnino, Emilio. "Il momento della 'conversione' del Canova." In *Arte neoclassica: Atti del convegno 12–14 ottobre 1957,* pp. 173–84. Civiltà Veneziana Studi, vol. 17. Venice and Rome, 1957.

Lavin, Sylvia. *Quatremère de Quincy and the Invention of a Modern Language of Architecture.* Cambridge, Mass., and London, 1992.

Lazzari, Francesco. *Della seconda Psiche scolpita da Canova.* Nozze Bigaglia-Bertolini. Venice, 1858.

Lees-Milne, James. *The Last Stuarts: British Royalty in Exile.* New York, 1984.

Lelièvre, Pierre. *Vivant Denon: Directeur des Beaux-Arts de Napoléon.* Paris, 1942.

Lemmi, Francesco. "Documenti sulla restituzione delle opere d'arte e di antichità trasportate in Francia durante la Repubblica francese e l'Impero." *Revue napoléonienne* 7 (1902): 256–69.

Levey, Michael. "Lawrence's Portrait of Pope Pius VII." *Burlington Magazine* 117 (1975): 194–204.

Lewine, Milton Joseph. "The Roman Church Interior, 1527–1580." Ph.D. diss., Columbia University, 1960.

Licht, Fred. *Canova.* Photographs by David Finn. New York, 1983.

———. "Canovas Monumentalplastik." In *Ideal und Wirklichkeit der bildenden Kunst im späten 18. Jahrhundert,* edited by Herbert Beck, Peter C. Bol, and Eva Maek-Gérard, pp. 163–75. Berlin, 1984.

———. "Thorvaldsen and Continental Tombs of the Neoclassic Period." In *Bertel Thorvaldson: Untersuchungen zu seinem Werk und zur Kunst seiner Zeit,* pp. 173–202. Cologne, 1977.

Lilli, Maria Sofia. *Aspetti dell'arte neoclassica: Sculture nelle chiese romane 1780–1845.* Rome, 1991.

Liscombe, R. W. "Canova, Aberdeen, and the Pitt Monument." *Burlington Magazine* 119 (1977): 700–705.

Lombardini, Gabrielle. "La ricchezza del Canova." *Odeo Olimpico* 8 (1969–70): 33–39.

Luiso, Francesco Paolo. "L'ultima dimora a Parigi di A. Canova e l'ultima sua grande opera di scultura." *Atti e memorie della società istriana di archeologia e storia patria* 43 (1931): 420–34.

Macco, Michela di. "Cicognara e Canova." In *Studi Canoviani,* pp. 89–107. Rome, 1973.

Madelin, Louis. *La Rome de Napoléon: La domination française à Rome de 1809 à 1814.* 2d ed. Paris, 1906.

Magrini, Antonio, ed. *Lettere inedite di Antonio Canova intorno il cenotafio da lui scolpito pel cav. Ottavio Trento in Vicenza.* Nozze Piovene-Sartori. Vicenza, 1854.

Mainardi, Patricia. "Assuring the Empire of the Future: The 1798 'Fête de la Liberté.'" *Art Journal* 48 (1989): 155–63.

Malagoli, Giuseppe. "Notizia storica intorno ad una scultura del Canova in Lovere." *Archivio storico dell'arte* 6 (1893): 330–32, 369–72.

Malamani, Vittorio. *Un'amicizia di Antonio Canova: Lettere di lui al conte Leopoldo Cicognara.* Città di Castello, 1890.

———. *Canova.* Milan, 1911.

———. *Memorie del conte Leopoldo Cicognara tratte dai documenti originali.* 2 vols. Venice, 1888.

Maltese, Corrado. *Storia dell'arte in Italia, 1785–1943.* Turin, 1960.

Maras, Raymond. "Napoleon and Levies on the Arts and Sciences." *Proceedings of the Consortium on Revolutionary Europe, 1750–1850* (1987): 433–46.

Marchini, Giampaolo. "La battaglia di Magnano e un mancato monumento del Canova a Verona." *Vita veronese* 28 (1975): 329–39.

Mariacher, Giovanni. "Il bozzetto canoviano per il monumento di Francesco Pesaro in S. Marco." *Bolletino dei Musei Civici Veneziani* 1–2 (1957): 17–20.

Maria Luigia donna e sovrana: Una corte europea a Parma. Edited by Giuseppe Cirillo et al. Catalogue of an exhibition held at the Palazzo Ducale di Colorno, May 10–July 26, 1992. Parma, 1992.

Marini, Giorgio. "Giovanni Volpato e l'opera di traduzione." In *Giovanni Volpato, 1735–1803,* edited by Giorgio Marini, pp. 16–21. Bassano del Grappa, 1988.

Marini, Paola. "Antonio Canova e i musei civici di Bassano e di Asolo." In *Canova e l'incisione,* edited by Grazia Pezzini Bernini and Fabio Fiorani, pp. 81–83. Bassano del Grappa, 1993.

Markov, Walter. *Die Napoleon-Zeit: Geschichte und Kultur des Grand Empire.* Leipzig, 1985.

Marsuzj, Giovanni Battista. *La visione di Canova: Canti tre di Gio. Battista Marsuzj romano per le statue di Venere e Marte ossia della guerra e della pace.* Rome, 1817.

Martin, Andrew. "Three Representations of Napoleon." *French Studies* 43 (1989): 31–46.

Martinelli, Valentino, and Carlo Pietrangeli. *La Protomoteca Capitolina.* Rome, 1955.

Mazzocca, Fernando. "Canova e Wicar." In *Florence et la France: Rapports sous la Révolution et l'Empire,* pp. 399–436. Florence and Paris, 1979.

———. "G. B. Sommariva o il borghese mecenate: Il 'cabinet' neoclassico di Parigi, la galleria romantica di Tremezzo." *Itinerari* 2 (1981): 145–293.

———. "La ricomparsa di 'Polimnia': Creazione e vicende di un capolavoro di Antonio Canova." *Per Giuseppe Mazzariol: Quaderni di Venezia Arti* 1 (1992): 171–77.

McClellan, Andrew. *Inventing the Louvre: Art, Politics, and the Origins of the Modern Museum in Eighteenth-Century Paris.* Cambridge and New York, 1994.

———. "The Politics and Aesthetics of Display: Museums in Paris, 1750–1800." *Art History* 7 (1984): 438–64.

———. "The Responsible Republic: Art, Conservation, and the Museum during the French Revolution." *Apollo* 130 (1989): 5–8.

McInnis, Maurie D., and Robert A. Leath. "Beautiful Specimens, Elegant Patterns: New York Furniture for the Charleston Market, 1810–1840." *American Furniture* 4 (1996): 137–72.

Mellini, Gian Lorenzo. *Canova: Disegni.* Florence, 1984.

———. "Canoviana." *Antichità viva* 29 (1990): 21–30.

———. *Notti Romane e altre congiunture pittoriche tra Sette e Ottocento.* Florence, 1992.

———. "Per la 'Beatrice' di Canova." *Labyrinthos* 12 (1987): 20–38.

———. "Presenza dell'antico nella pittura di Antonio Canova." In *Congresso internationale Venezia*

e l'archeologia: Un importante capitolo nella storia del gusto dell'antico nella cultura artistica veneziana, edited by Gustavo Traversari, pp. 216–20. Supplement to *Rivista di Archeologia* 7. Rome, 1990.

Mellon, Stanley. "Alexandre Lenoir: The Museum versus the Revolution." *Proceedings of the Consortium on Revolutionary Europe, 1750–1850* (1979): 75–88.

Memes, John S. *Memoirs of Antonio Canova with a Critical Analysis of His Works, and an Historical View of Modern Sculpture.* Edinburgh, 1825.

Meneghelli, Antonio. *Del Canova discorso letto nell'I. R. Accademia di Belle Arti in Venezia per la distribuzione de' premi nell'anno MDCCCXXVIII.* 2d ed. Padua, 1829.

———. *Tredici bassirilievi di Canova posseduti del D. Antonio Piazza di Padova.* Padua, 1837.

Meneghelli, Pierantonio. *Lettera sopra di un basso-rilievo del celebre scultore Antonio Canova.* Padua, 1802.

Mereu, H. "Canova diplomate." *Courrier de l'art* 8 (1888): 275–77.

Merlo, Giovanni. *Diario di Canova a Parigi, 1810.* Nozze Avogadro-Michiel. Bassano, 1865.

Merrick, Jeffrey. "Politics on Pedestals: Royal Monuments in Eighteenth-Century France." *French History* 5 (1991): 234–64.

Messina, Maria Grazia. "L'arte di Canova nella critica di Quatremère de Quincy." In *Studi Canoviani,* pp. 119–51. Rome, 1973.

Meyer, Alfred Gotthold. *Canova.* Bielefeld and Leipzig, 1898.

Michelli, Maria Elisa. "Antonio Canova e le antichità." In *Canova e l'incisione,* edited by Grazia Pezzini Bernini and Fabio Fiorani, pp. 22–30. Bassano del Grappa, 1993.

———. "Le raccolte di antichità di Antonio Canova." *Rivista dell'Istituto Nazionale d'Archeologia e Storia dell'Arte* 8–9 (1985–86): 205–322.

Miggiani, M. G. "Documenti sul bozzetto per il monumento a Francesco Pesaro di Antonio Canova." *Venezia arti* 4 (1990): 25–32.

Milizia, Francesco. *Lettere di Francesco Milizia al conte Fr. Di Sangiovanni, ora per la prima volta pubblicate.* Paris, 1827.

Milton, Henry. *Letters on the Fine Arts, Written from Paris in the Year 1815.* London, 1816.

Missirini, Melchior. *Della vita di Antonio Canova.* Prato, 1824.

———. *Memorie per servire alla storia della romana Accademia di S. Luca.* Rome, 1823.

Molajoli, Bruno. "Le benemerenze di Antonio Canova nella salvaguardia del patrimonio artistico." In *Da Antonio Canova alla convenzione dell'Aja: La protezione delle opere d'arte in caso di conflitto armato,* edited by Stefano Rosso-Mazzinghi, pp. 13–44. *Quaderni di San Giorgio* 35. Florence, 1975.

Montaiglon, Anatole de, and Jules Guiffrey, eds. *Correspondance des Directeurs de l'Académie de France à Rome avec les Surintendants des Bâtiments, publiée d'après les manuscrits des Archives Nationales.* 18 vols. Paris, 1887–1912.

Mooney, Gary. "British Diplomatic Relations with the Holy See, 1793–1830." *Recusant History* 14 (1978): 193–210.

Moore, John. *A View of Society and Manners in Italy with Anecdotes relating to Some Eminent Characters.* 3 vols. 4th ed. Dublin, 1792.

Morrison, Jeffrey. *Winckelmann and the Notion of Aesthetic Education.* Oxford, 1996.

Moulard, Jacques. *Le comte Camille de Tournon auditeur au Conseil d'Etat, Intendant de Bayreuth, Préfet de Rome, de Bordeaux, de Lyon, pair de France (1778–1833).* 3 vols. Paris, 1927–32.

Munoz, Antonio. "Gli amori di Antonio Canova." *L'urbe* 20 (1957): 8–19.

———. *Antonio Canova: Le opere.* Rome, 1957.

———. "La giovinezza di Antonio Canova." *Rassegna italiana: Politica, letteraria e artistica* 10 (1922): 675–82.

———. "Le prime opere di Antonio Canova in Roma." *Capitolium* 7 (1931): 117–28 and 187–202.

Müntz, Eugène. "Les annexations de collections d'art ou de bibliothèques et leur rôle dans les relations internationales principalement pendant la Révolution française." *Revue d'histoire diplomatique* 8 (1894): 481–99; 9 (1895): 375–93; 10 (1896): 481–508.

———. "La Bibliothèque du Vatican pendant la Révolution française." In *Mélanges Julien Havet: Recueil de travaux d'érudition dédiés à la mémoire de Julien Havet (1853–1893),* pp. 579–91. Paris, 1895. Reprint. Geneva, 1972.

———. "Les invasions de 1814–1815 et la spoliation de nos musées." *La nouvelle revue* 115 (1897): 703–16; 117 (1897): 193–207 and 420–39.

Musiari, Antonio. *Neoclassicismo senza modelli: L'Accademia di Belle Arti di Parma tra il periodo napoleonico e la Restaurazione (1796–1820).* Parma, 1986.

Napoléon. *Correspondance de Napoléon Ier publiée par ordre de l'Empereur Napoléon III.* 32 vols. Paris, 1858–70.

———. *Napoleon and Canova: Eight Conversations held at the Château of the Tuileries in 1810.* London, 1825.

Nardi, Carla. *Napoleone e Roma: La politica della Consulta Romana.* Collection de l'École Française de Rome, vol. 115. Rome, 1989.

Nel centenario della morte di Antonio Canova la R. Accademia di San Luca. Exhibition catalogue. Rome, 1922.

Nicholas, Lynn H. *The Rape of Europa: The Fate of Europe's Treasures in the Third Reich and the Second World War.* New York, 1994.

Nicodemi, Giorgio. "Le 'conquiste' di opere d'arte fatte da Napoleone." *Emporium* 53 (1921): 227–40.

Nistri, Tito, ed. *Canova: Lettere.* Nozze Cuturi-Ricci. Pisa, 1882.

Norwich, John Julius. *A History of Venice.* New York, 1989.

"Notizie ed osservazioni: Inedite di Antonio Canova." *Napoli nobilissima,* n.s. 3 (1922): 119.

O'Dwyer, Margaret M. *The Papacy in the Age of Napoleon and the Restoration: Pius VII, 1800–1823.* Lanham, Md., New York, and London, 1985.

Olson, Roberta J. M. "Representations of Pope Pius VII: The First Risorgimento Hero." *Art Bulletin* 68 (1986): 77–93.

Ost, Hans. *Ein Skizzenbuch Antonio Canovas, 1796–1799.* Römische Forschungen der Bibliotheca Hertziana, vol. 19. Tübingen, 1970.

Pantaleoni, Massimo. *Disegni anatomici di Antonio Canova.* Rome [1949].

Paolin, Elide. *Canova e Possagno.* Montana del Grappa, 1987.

Paravia, Pier-Alessandro. *Notizie intorno alla vita di Antonio Canova giuntovi il catalogo cronologico di tutte le sue opere.* Venice, 1822.

Patetta, Luciano. "Il neoclassicismo." In *L'Italia giacobina e napoleonica,* pp. 403–24. Storia della società italiana, vol. 13. Milan, 1985.

Patrizi, Maddalena. *The Patrizi Memoirs: A Roman Family under Napoleon, 1796–1815.* Translated by Mrs. Hugh Fraser. London, 1915.

Pavan, Massimiliano. "Antonio Canova e la discussione sugli 'Elgin Marbles.'" *Rivista dell'Istituto Nazionale d'Archeologia e Storia dell'Arte* 21–22 (1974–75): 219–344.

———. s.v. "Canova, Antonio." In *Dizionario biografico degli Italiani,* 18:197–219. Rome, 1975.

———. "Canova e il problema dei cavalli di San Marco." *L'ateneo veneto,* n.s. 12 (1974): 83–111.

———. "Luigi Angeloni, Antonio Canova e Pietro Giordani." *Studi romani* 20 (1974): 457–71.

———. "La visita a Londra del Canova nel 'Diary' del pittore Joseph Farington." *Atti Istituto Veneto di Scienze, Lettere ed Arti* 135 (1976–77): 251–73.

Pavanello, Giuseppe. "Antonio Canova: I bassorilievi 'Rezzonico.'" *Bollettino del Museo Civico di Padova* 73 (1984): 145–62.

———. "Antonio Canova per il re di Spagna." *Arte veneta* 46 (1994): 72–78.

———. "Antonio d'Este amico di Canova, scultore." *Antologia di belle arti* 35–38 (1990): 13–22.

———. "Una scheda per 'l'Apollo che si corona' di Antonio Canova." *Antologia di belle arti* 35–38 (1990): 4–12.

Pavanello, Giuseppe, and Mario Praz, eds. *L'opera completa del Canova.* Milan, 1976.

Pavanello, Giuseppe, and Giandomenico Romanelli, eds. *Canova.* Venice, 1992.

Pélissier, L. G. "Canova, la comtesse d'Albany et le tombeau d'Alfieri." *Nuovo archivio veneto* 3 (1902): 147–88 and 394–427; 4 (1902): 214–45.

Perot, Jacques. "Canova et les diplomates français à Rome: François Cacault et Alexis de Montor." *Bulletin de la Société de l'histoire de l'art français* (1980): 219–33.

Perry, Marilyn. "The Statuario Publico of the Venetian Republic." *Saggi e memorie di storia dell'arte* 8 (1972): 75–150.

Petrocchi, Massimo. *La restaurazione romana (1815–1823).* Studi e documenti di storia del Risorgimento, vol. 26. Florence, 1943.

Pezzini, Grazia Bernini. "La sistemazione museale del gruppo di 'Ercole e Lica' del Canova." In *La galleria Corsini a cento anni dalla sua acquisizione allo stato,* pp. 51–60. Rome, 1984.

Phillips, J. G. "Canova's 'Reclining Naiad.'" *Metropolitan Museum of Art Bulletin* 24 (1970): 1–10.

Pietrangeli, Carlo. "Come funzionava un museo nell'Ottocento: Il primo regolamento dei Musei Vaticani." *Strenna dei Romanisti* 43 (1981): 362–73.

———. "I Musei Vaticani al tempo di Pio VI." *Atti della Pontificia Accademia Romana di Archeologia* 49 (1976–77): 195–233.

———. "I Musei Vaticani dopo Tolentino." *Strenna dei Romanisti* 36 (1975): 354–59.

———. "Sculture Capitoline a Parigi." *Bollettino dei musei comunali di Roma* 14 (1967): 27–33.

———. "Storia di un monumento sfortunato." *Strenna dei Romanisti* 23 (1962): 271–78.

———. The Vatican Museums." In *The Vatican Collections: The Papacy and Art,* pp. 14–25. New York, 1982.

Pilo, Giuseppe Maria. "Due ritratti di Alvise Pisani e di Domenico Pellegrini: Lettere di Domenico Pellegrini ad Antonio Canova." *Paragone* 16, no. 185 (1965): 46–61.

Pinelli, Antonio. "Bello Ideale e 'Beau Romantique': Il 'Perseo' di Canova tra Winckelmann e Stendhal." In *Stendhal e Milano: Atti del 14º Congresso Internazionale Stendhaliano,* 2:749–76. Florence, 1982.

———. "Due quadri in cerca d'autore: Canova, i Torlonia e l'"Ercole e Lica.'" In *Studi in onore di Giulio Carlo Argan,* pp. 308–18. Florence, 1994.

———. "Il 'Perseo' del Canova." In *Piranesi e la cultura antiquaria: Gli antecedenti e il contesto,* pp. 421–39. Rome, 1983.

———. "Il 'Perseo' di Canova e il 'Giasone' di Thorvaldsen: Due modelli di 'nudo eroico' a confronto." In *Thorvaldsen: L'ambiente, l'influsso, il mito,* edited by Patrick Kragelund and Mogens Nykjaer, pp. 21–33. Rome, 1991.

———. "La sfida rispettosa di Antonio Canova: Genesi e peripezie del 'Perseo trionfante.'" *Ricerche di storia dell'arte* 13–14 (1981): 21–40.

———. "Storia dell'arte e cultura della tutela: Le 'Lettres à Miranda' di Quatremère de Quincy." *Ricerche di storia dell'arte* 8 (1978–79): 43–62.

Pinelli, Antonio, Andrea Emiliani, and Michela Scolaro. *Lo studio delle arti e il genio dell'Europa: Scritti di A. C. Quatremère de Quincy e di Pio VII Chiaramonti (1796–1802).* Bologna, 1989.

Pinelli, Orietta Rossi. "Artisti, falsari o filologi? Da Cavaceppi a Canova, il restauro della scultura tra arte e scienza." *Ricerche di storia dell'arte* 8 (1978–79): 41–56.

———. "Carlo Fea e il chirografo del 1802: Cronaca, giudiziaria e non, delle prime battaglie per la tutela delle 'Belle Arti.'" *Ricerche di storia dell'arte* 8 (1978–79): 27–40.

———. "Intellettuali e pubblico nel XVIII secolo: Mutamenti nella destinazione, definizione e descrizione delle opere d'arte." In *Studi in onore di Giulio Carlo Argan,* pp. 292–307. Florence, 1994.

Pistolesi, Erasmo. *Vita del Sommo Pontefice Pio VII.* 4 vols. Rome, 1824–30.

P. L. "Entretiens de Canova avec Napoléon Premier." *Revue universelle des arts* 18 (1863–64): 247–59.

Polvara, Giuseppe. "Osservazioni sull'arte religiosa di Antonio Canova." *Arte cristiana* 10 (1922): 314–17.

Poppi, Claudio. "From Avant-Garde to the Academy: A Line of Development for Italian Neoclassicism." In *Ottocento: Romanticism and Revolution in Nineteenth-Century Italian Painting,* edited by Roberta J. M. Olson, pp. 43–50. Philadelphia and Florence, 1992.

Potts, A. D. "Greek Sculpture and Roman Copies I: Anton Raphael Mengs and the Eighteenth Century." *Journal of the Warburg and Courtauld Institutes* 43 (1980): 150–73.

———. "Political Attitudes and the Rise of Historisicm in Art Theory." *Art History* 1 (1978): 191–213.

Pozzi, Arrigo. *Antonio Canova, 1822–1922.* Ferrara, 1923.

Praz, Mario. *On Neoclassicism.* Translated by Angus Davidson. Evanston, Ill., 1969.

———. *Perseo e la Medusa dal romanticismo all'avanguardia.* Milan, 1979.

Il primo '800 italiano: La pittura tra passato e futuro. Edited by Renato Barilli. Catalogue of an exhibition held at the Palazzo Reale, Milan, February 20–May 3, 1992. Milan, 1992.

"Prolusione alla nuova apertura dell'accademia del Signor Cavaliere Antonio Canova Marchese d'Ischia presidente nell'anno 1816 letta il 4 luglio dello stesso anno." *Atti dell'Accademia Romana di Archeologia* 1 (1821).

Pucci, Giuseppe. *Il passato prossimo: La scienza dell'antichità alle origini della cultura moderna.* Rome, 1993.

Puccinelli, Filippo, and Stefano Piale. *Descrizione della Sacrosanta Basilica Vaticana delle sue piazze portici grotte sacristie parti superiori interne ed esterne e loro misure.* 4th ed. Rome, 1828.

Quatremère de Quincy, Antoine-Chrysostome. *Canova et ses ouvrages; ou, Mémoires historiques sur la vie et les travaux de ce célèbre artiste.* Paris, 1834.

———. *Considérations morales sur la destination des ouvrages de l'art, ou de l'influence de leur emploi sur le génie et le goût de ceux qui les produisent ou qui les jugent, et sur le sentiment de ceux qui en jouissent ou en reçoivent les impressions.* Paris, 1815.

———. *Lettres écrites de Londres à Rome et adressées à M. Canova; sur les marbres d'Elgin, ou les sculptures du temple de Minerve à Athènes.* Paris, 1818.

———. *Lettres sur l'enlèvement des ouvrages de l'art antique à Athènes et à Rome écrites les unes au célèbre Canova les autres au Général Miranda.* Paris, 1836.

———. "Notice sur M. Canova, sur sa réputation, ses ouvrages et sa statue du Pugilateur."*Mélanges de litterature, d'histoire et de philosophie* 3 (1804): 3–24.

———. "Réflexions critiques sur les mausolées en général, et en particulier sur celui de l'archiduchesse Christine exécuté par Canova." *Revue universelle des arts* 22 (1865–66): 77–94.

Quynn, Dorothy Mackay. "The Art Confiscations of the Napoleonic Wars." *American Historical Review* 50 (1945): 437–60.

R. A. "Le restituzioni artistiche del 1815 a proposito del Canova." *Rassegna d'arte antica e moderna* 9–10 (1922): 266–72.

Raffaelli, Filippo. *Due lettere inedite di Antonio Canova.* Recanati, 1889.

Ragghianti, Carlo Lodovico. "Studi sul Canova." *Critica d'arte* 22 (1957): 3–102.

Raggio, Olga. "Canova's Triumphant 'Perseus.'" *Connoisseur* 172 (1969): 204–12.

Rath, Reuben John. *The Fall of the Napoleonic Kingdom of Italy.* New York, 1941.

Rava, Luigi. "Antonio Canova ambasciatore." *L'archiginnasio* 18 (1923): 27–43.

Refice, Claudia. "Antonio Canova e gli inglesi." *English Miscellany* 3 (1952): 221–33.

Reinerman, Alan J. *Austria and the Papacy in the Age of Metternich: Between Conflict and Cooperation.* Washington, D.C., 1979.

Ricci, Corrado. "Antonio Canova." *Rassegna d'arte antica e moderna* 9–10 (1922): 261–72.

Ridley, Ronald T. *The Eagle and the Spade: The Archaeology of Rome during the Napoleonic Era, 1809–1814.* Cambridge, 1992.

Rinieri, Ilario. *La diplomazia pontificia nel secolo XIX: Il concordato tra Pio VII e il Primo Console.* Rome, 1902.

———. *Napoleone e Pio VII (1804–1813): Relazioni storiche su documenti inediti dell'archivio vaticano.* 2 vols. Turin, 1906.

Rizzoli, Luigi. "Alcune lettere di Antonio Canova al marchese Tommaso degli Obizzi e la musa Melpomene del R. Museo Archeologico di Venezia." *Atti del Reale Istituto Veneto di Scienze, Lettere ed Arti* 82 (1922–23): 401–12.

Roberti, Tiberio. "Canova e le principesse Borghese e di Canino." *Antologia veneta* 1 (1900): 3–8.

———. "Canova e l'imperatrice Giuseppina." *Arte e storia* 2 (1883): 260–61.

———. "Un invito al Canova." *Arte e storia* 17 (1898): 69–70.

———. "Lettere di Teresa Pelli-Fabroni al Canova." *Arte e storia* 3 (1884): 130–31.

Robinson, John Martin. *Cardinal Consalvi, 1757–1824.* London, 1987.

Rocca, Sandra Vasco, and Gabriele Borghini. *S. Antonio dei Portoghesi.* Rome, 1992.

Rocher-Jauneau, Madeleine. "Les Trois Graces d'Antonio Canova au Musée des Beaux-Arts de Lyon." *Bulletin des musées lyonnais* 8 (1959): 177–82.

Rosa, Mario. "Introduzione all'Aufklärung cattolica in Italia." In *Cattolicesimo e lumi nel Settecento italiano,* edited by Mario Rosa, pp. 1–47. Italia sacra, vol. 33. Rome, 1981.

Rosenberg, Martin. "Raphael's 'Transfiguration' and Napoleon's Cultural Politics." *Eighteenth-Century Studies* 19 (1985–86): 180–205.

Rosenblum, Robert. *Transformations in Late Eighteenth Century Art.* Princeton, N.J., 1967.

Rosini, Giovanni. *Saggio sulla vita e sulle opere di Antonio Canova.* 2d ed. Pisa, 1830.

Rossi, Adamo. "Documenti sulle requisizioni dei quadri fatte a Perugia dalla Francia ai tempi della Repubblica e dell'Impero." *Giornale di erudizione artistica* 5 (1876): 224–56 and 288–303.

Rossi, Luigi, ed. *Quattro lettere inedite di Antonio Canova.* Nozze Bentivoglio–Da Mila. Venice, 1846.

Rothenberg, J. *"Descensus ad Terram": The Acquisition and Reception of the Elgin Marbles.* New York and London, 1977.

Rouchès, Gabriel. "L'oeuvre iconographique de Canova." *Gazette des Beaux-Arts,* 5th ser., 6 (1922): 265–75.

Rudolph, Stella. *Giuseppe Tambroni e lo stato delle belle arti in Roma nel 1814.* Rome, 1982.

———. "Il monumento Stuart del Canova: Un committente dimenticato e il primo pensiero ritrovato." *Antologia di belle arti* 4 (1980): 44–54.

Ruggieri, Ugo. "Un taccuino di Antonio Canova." *Critica d'arte* 136 (1974): 65–80; 137 (1974): 77–88; 138 (1974): 47–58.

Rusconi, Luigi, ed. *Lettere inedite di Leopoldo Cicognara ad Antonio Canova.* Padua, 1839.

Russell, Francis. "A Distinguished Generation." *Country Life* 175, no. 4530 (June 14, 1984): 1746–48.

St. Clair, William. *Lord Elgin and the Marbles.* London, 1967.

Salerno, Luigi. "Dal rococò al neoclassico." *Storia dell'arte* 1–2 (1969): 117–28.

Sassetti, Angelo Sacchetti. "Angelo Maria Ricci e Antonio Canova." *Roma* 9 (1931): 251–64.

———. "Antonio Canova e Gaetano Marchetti Tomassi." *L'arte* 57 (1958): 52–66.

Saunier, Charles. *Les conquêtes artistiques de la Révolution et de l'Empire reprises et abandons des alliés en 1815, leurs conséquences sur les musées d'Europe.* Paris, 1902.

Scarfone, Giuseppe. "Per una lapide ad Antonio Canova." *Alma Roma* 33 (1992): 20–27.

Scarpati, Maria Antonietta. "La decorazione degli appartamenti imperiali del Quirinale 1811–1814, cronistoria del progetto." In *Il palazzo del Quirinale: Il mondo artistico a Roma nel periodo napoleonico,* pp. 143–66. Rome, 1989.

Schenk, H. G. *The Mind of the European Romantics.* Oxford and New York, 1979.

Schlegel, Ursula. "Canovas Tänzerin." *Jahrbuch Preussischen Kulturbesitz* 18 (1981): 187–200.

Schneider, René. "L'art de Canova et la France impériale." *Revue des études napoléoniennes* 1 (1912): 36–57.

———. *Quatremère de Quincy et son intervention dans les arts (1788–1830).* Paris, 1910.

Sciolla, Gianni Carlo. *Canova: La trilogia dell'amore, della morte, dell'eroismo.* Novara, 1983.

Segarizzi, A. "La Biblioteca Querini Stampalia nel sessennio 1910–1915." *L'ateneo veneto* 38 (1915): 191–203.

Selva, Domenico. *Lettere familiari inedite di Antonio Canova e di Gianantonio Selva.* Nozze Persico-Papadopoli. Venice, 1835.

Serafini, Camillo, and Stanislao Le Grelle. *Le monete e le bolle plombée pontificie del medagliere vaticano.* 4 vols. Milan, 1910.

Sherman, Daniel J. "Quatremère / Benjamin / Marx: Art Museums, Aura, and Commodity Fetishism." In *Museum Culture: Histories, Discourses, Spectacles,* edited by Daniel J. Sherman and Irit Rogoff, pp. 123–93. Minneapolis, 1994.

Sica, Paolo. *Storia dell'urbanistica: Il Settecento.* Rome, 1976.

Siegfried, Susan Locke. "Naked History: The Rhetoric of Military Painting in Postrevolutionary France." *Art Bulletin* 75 (1993): 235–58.

Silvagni, David. *La corte e la società romana nei secoli XVIII e XIX.* 3 vols. Florence and Rome, 1881–85.

Spencer, Vicki. "Towards an Ontology of Holistic Individualism: Herder's Theory of Identity, Culture, and Community." *History of European Ideas* 22 (1996): 245–60.

Sperduti, Giuseppe. "L. Angeloni e il Canova per la restituzione delle opere d'arte." *Lunario romano* 11 (1982): 253–72.

Springer, Carolyn. *The Marble Wilderness: Ruins and Representation in Italian Romanticism, 1775–1850.* Cambridge and New York, 1987.

Stecchini-Fedeli, Maria. *Alcune lettere inedite di uomini illustri al Canova.* Venice, 1853.

Stefanelli, Lucia Pirzio Biroli. "La medaglia di Giuseppe Girometti per le solenni esequie romane di Antonio Canova." *Bollettino dei musei comunali di Roma,* n.s. 10 (1996): 130–48.

Stefani, Ottorino. *Canova pittore: Tra Eros e Thanatos.* Milan, 1992.

———. *La poetica e l'arte del Canova.* Treviso, 1984.

———. *I rilievi del Canova: Una nuova concezione del tempo e dello spazio.* Milan, 1990.

Steinmann, Ernst. "Die Plünderung Roms durch Bonaparte." *Internationale Monatsschrift für Kunstwissenschaft und Technik* 11 (1917): 642–76 and 819–76.

Stringa, Nico. "Antonio Canova: Il testamento olografo." *Arte veneta* 47 (1995): 100–107.

Tadini, Faustino. *Le sculture e le pitture di Antonio Canova pubblicate fino a quest'anno 1795.* Venice, 1796.

Tadolini, Giulio, ed. *Ricordi autobiografici di Adamo Tadolini scultore.* Rome, 1900.

Tadolini, Scipione. "Un bozzetto inedito del Canova." *Bollettino d'arte* 5 (1925): 185–89.

Tambroni, Giuseppe. *Intorno la vita di Antonio Canova commentario.* Venice, 1825.

Tancredi, Giuseppe. "Lettere di Luigi Angeloni e del Canova intorno all'esplorazione del Tevere." *Il Buonarroti* 2 (1867): 135–39.

Taylor, Francis Henry. *The Taste of Angels: A History of Art Collecting from Rameses to Napoleon.* Boston, 1948.

Ternois, Daniel. "Napoléon et la decoration du palais impérial de Monte Cavallo en 1811–1813." *Revue de l'art* 7 (1970): 68–89.

Theodoli, Olimpia. "Un appunto su Antonio Canova e Giovanni Volpato." *Antologia di belle arti* 23–24 (1984): 117–18.

Thompson, J. M. *Napoleon Bonaparte.* 2d ed. London, 1988. Reprint. New York, 1996.

The Three Graces: Antonio Canova. Edited by Hugh Honour et al. Catalogue of an exhibition held at the National Gallery of Scotland, Edinburgh, August 9–October 8, 1995. Edinburgh, 1995.

Tivaroni, Carlo. *L'Italia durante il dominio francese.* Vol. 2 of *Storia critica del Risorgimento Italiano.* Turin, 1889.

Toesca, Elena Berti. "Madame Récamier e il Canova." *L'urbe* 4 (1939): 22–26.

Tosi, Lina. "L'amicizia del Canova per il Bossi alla luce di nuove lettere." *Atti del Reale Istituto Veneto di Scienze, Lettere ed Arti* 99 (1939–40): 11–19.

Tournon, Philippe Camille Casimir De Simiane de. *Études statistiques sur Rome et la partie occidentale des états romaine; contenant une description topographique et des recherches sur la population, l'agriculture, les manufactures, le commerce, le gouvernement, les établissements publics, et une notice sur les travaux exécutés par l'administration française.* 2 vols. 2d ed. Paris, 1855.

Trebbi, O. "Antonio Canova a Bologna." In *Nella vecchia Bologna,* pp. 1–31. Bologna, 1924.

Turco, Tarcisio. "Canova a Parigi." *Strenna dei Romanisti* 45 (1984): 535–40.

Turner, Martha L. "French Art Confiscations in the Roman Republic, 1798." *Proceedings of the Consortium on Revolutionary Europe, 1750–1850* (1980): 43–51.

Urbini, Giulio. "Canova (1757–1822)." *Nuova rivista storica* 6 (1922): 5–35.

Valery, M. *Voyages historiques et littéraires en Italie, pendant les années 1826, 1827 et 1828; ou l'indicateur italien.* Brussels, 1835.

Vallet, Huguette. *Les 'Voyages en Italie' (1804): Journal d'un compagnon d'exil de Lucien Bonaparte.* Memorie e documenti su Roma e l'Italia meridionale, vol. 2. Rome, 1986.

Valmarana, A., ed. *Lettere scelte dell'inedito epistolario di Antonio Canova.* Vicenza, 1854.

Van de Vivere, E. C. J. *Le mausolée de S. A. R. Marie-Christine d'Autriche exécuté par le chev. Antoine Canova et expliqué.* Rome, 1805.

Venezia nell'età di Canova. Edited by Elena Bassi et al. Catalogue of an exhibition held at the Museo Correr, Venice, October–December 1978. Venice, 1978.

Verrua, P. O. *Nelson nel pensiero e nell'arte del Foscolo e del Canova.* Padua, 1919.

Vici, Andrea Busiri. "Funzionari napoleonici a Roma." *Arte illustrata* 50 (1972): 332–45.

———. "Un ignorato ritratto del "roi de Rome" di Antonio Canova." *Strenna dei Romanisti* 41 (1980): 115–18.

———. "La situazione romana durante l'occupazione napoleonica." *L'urbe* 198 (1980): 1–10.

———. "La statua della Religione del Canova e le sue vicende." *Palatino* 10 (1966): 228–34.

———. "Un vaso di Sèvres documentata le asportazioni napoleonici dall'Italia." *Antichità viva* 10 (1971): 55–64.

Visconti, Filippo Aurelio, and Giuseppe Guattani. *II Museo Chiaramonti descritto e illustrato.* 2d ed. Milan, 1820.

Vossilla, Francesco. "Antonio Canova, Pasquale Poccianti e la Loggia della Signoria." *Studi di storia dell'arte* 3 (1992): 285–95.

Wardropper, Ian, and Thomas F. Rowlands. "Antonio Canova and Quatremère de Quincy: The Gift of Friendship." *Art Institute of Chicago Museum Studies* 15 (1989): 38–46.

Watkin, David. *Thomas Hope, 1769–1831, and the Neo-Classical Idea.* London, 1968.

Watson, Francis J. B. "Canova and the English." *Architectural Review* 122 (1957): 403–6.

Welschinger, Henri. "Canova et Napoléon." *Revue d'histoire diplomatique* 27 (1913): 341–62.

Wescher, Paul. *Kunstraub unter Napoleon.* Berlin, 1976.

Wind, Edgar. "Studies in Allegorical Portraiture I." *Journal of the Warburg and Courtauld Institutes* 1 (1937–38): 138–62.

Wiseman, Nicholas Patrick Stephen. *Recollections of the Last Four Popes and of Rome in Their Times.* London, 1858.

Wittkower, Rudolf. "Imitation, Eclecticism, and Genius." In *Aspects of the Eighteenth Century,* edited by Earl A. Wasserman, pp. 143–61. Baltimore, Md., 1965.

Woolf, Stuart. *A History of Italy, 1700–1860: The Social Constraints of Political Change.* London, 1979.

Zaghi, Carlo. *L'Italia di Napoleone dalla Cisalpina al Regno.* Turin, 1986.

Zanella, Andrea. *Canova e Roma.* Rome, 1991.

Zanella, Vanni. *Giacomo Quarenghi architetto a Pietroburgo: Lettere e altri scritti.* Venice, 1988.

Zanker, Paul. *The Power of Images in the Age of Augustus.* Translated by Alan Shapiro. Ann Arbor, Mich., 1990.

Zeitler, Rudolf. *Klassizismus und Utopia: Interpretationen zu Werken von David, Canova, Carstens, Thorvaldsen, Koch.* Stockholm, 1954.

Zeri, Federico, ed. *Storia dell'arte italiana.* 3 vols. Turin, 1981.

Zucconi, Angela. "Antonio Canova e Luigi I di Baviera." *Nuova antologia* (October 1, 1941): 223–32.

Zurla, Placido. *Dissertazioni del Cardinale D. Placido Zurla dei vantaggi recati dalla religione cattolica alla geografia e scienze annesse sull'unità del soggetto nel quadro della Trasfigurazione di Raffaele: Sull'opere di religioso argomento di Antonio Canova.* Rome, 1835.

INDEX

Fries, Count Moritz Christian von, 53, 123

Friuli, 208n15

Frosini, Antonio, 163

Frosinone (Lazio), 175

Fuseli, Henry, 6, 157, 171, 180

Gabii (Lazio), 36

Gabrielli, Cardinal Giulio, 64

Gaetani, Onorato, 124, 125, 222n7

Gallicanism, 11, 61, 111

Gasparri, Carlo, 28, 205n38

Gazzetta Romana, 83

Genoa, 100, 109, 188–89

George III, 160

George, Prince Regent (later George IV), 159, 160, 161, 162, 163, 164, 165, 167, 168, 169, 176, 177, 178, 179, 198, 228n39

Germanicus, 113

Gibraltar, straits of, 152

Gibson, John, 156

Giordani, Pietro, 26, 40, 182–83

Giornale del Campidoglio, 83

Giornale Italiano, 152

Giornale Romano, 83, 214n42

Girodet-Trioson, Anne-Louis, 25; *Dream of Ossian,* 217n18

Gisors, Pierre-François-Léonard, 138

Giuli, Luigia, 221n77

Giustinian collection, 34

Giustiniani family, 41

Giustiniani Philosopher, 35

Goëss, Count Peter von, 59

Goethe, Johann Wolfgang von, 71, 212n6

Golden Levy, 84, 121, 214n44

Goya y Lucientes, Francisco de, 6

Grande Armée, 84, 101, 142, 176

Gregory XV Ludovisi, Pope, 180

Grenoble, 232n35

Greville, Charles Francis, 155

Grimani collection, 34

Gros, Antoine-Jean, 9, 88, 101

Gruber, Father Gabriel, 29

Guérin, Pierre-Narcisse, 23

Habsburg dynasty, 39, 49, 54, 58, 59, 60, 61, 112, 118, 122, 123–44, 181, 196, 221n86, 224n28

Hamilton, Gavin, 17, 34, 36, 48, 146, 149, 226n6, 226n7

Hamilton, Hugh Douglas, 148–49, 151

Hamilton, Lady Emma, 154

Hamilton, Richard William, 159, 174, 176, 177, 178, 180, 192

Hamilton, Sir William, 154, 155, 156

Hanoverian dynasty, 161, 162

Hayez, Francesco, 32, 80, 140

Head, Guy, 76

Heidelberg, University of, 180, 181

Heliopolis, battle of, 98

Henri IV, 98

Henry Stuart (Henry Benedict Stuart, Cardinal duke of York; Henry IX; bishop of Frascati), 161, 229n46

Hercules, 75, 124, 125, 126, 127, 128, 129, 142

Herder, Johann Gottfried, 39, 207n1, 234n53

Hervey, Elisabeth, duchess of Devonshire, 197–98, 235n11

Hervey, Frederick, earl of Bristol and bishop of Derry, 103, 147, 148, 151, 152, 226n8

Hesse, elector of. *See* Wilhelm I, elector of Hesse

Hewetson, Christopher, 148, 149, 226n10

Hohenzollern dynasty, 61

Holland, Lady, 152

Holy Roman Empire, 111, 135, 203n6, 221n1

Homer, 17

Hope, Thomas, 151

Humboldt, Alexander von, 173

Hundred Days, 172, 178, 184

Ickworth (Suffolk), 147, 150

If, château d', 84

Imola (Romagna), 228n39

Ingres, Jean-Auguste-Dominique, 79, 80, 104, 214n32

Ino (mythological figure), 147

Institut de France, 109

Istria, 208n15

Jacobins (Jacobinism), 2, 3, 63, 69, 70, 213n19, 217n25

Jacobites, 161–62

James I, 26

James III (the Old Pretender), 161

Jansenism, 11, 29

Jena, battle of, 135, 142

Jenkins, Thomas, 36, 150

Jenkinson, Robert Banks, Lord Liverpool, 178, 181

Johnson, Samuel, 151

Josephine, Empress, 19, 25, 26, 61, 63, 65, 89, 100, 101, 112, 117, 119, 120, 121, 129, 183, 185, 204n23, 216n4, 221n72

Designer: Sandy Drooker
Compositor: Integrated Composition Systems
Text: Granjon
Display: Granjon
Printer and Binder: Malloy Lithographing, Inc.